The
ChessCa*f*e
Puzzle Book

Test and Improve Your Tactical Vision

by

Karsten Müller

Foreword by
Susan Polgar

2008
Russell Enterprises, Inc.
Milford, CT USA

The ChessCafe Puzzle Book

© Copyright 2004, 2008

Karsten Müller

ISBN: 1-888690-21-6

First printing 2004
Second printing 2008

Published by:
Russell Enterprises, Inc.
PO Box 5460
Milford, CT 06460 USA

http://www.chesscafe.com
info@chesscafe.com

Cover design by Pamela Terry, Opus 1 Design.

Chess set courtesy the House of Staunton, www.houseofstaunton.com.

Printed in the United States of America

Contents

Foreword by Susan Polgar

Ever since I was a young girl, I have spent time each and every day solving tactical puzzles. When my sisters started to learn the game, they did the same thing. Since then, I have taught thousands of students and I have used tactical puzzles as one of the most effective training methods. I strongly believe that tactics is a very important part of the game of chess; the conscientious study and application of tactical principles have helped my sisters and me a great deal throughout our careers. I absolutely agree with the well-known maxim: "Chess is 99% tactics."

This book by German grandmaster Karsten Müller is unique and I personally like it a lot. It offers every type of tactical motif imaginable, from the more common back rank mates, pins, skewers, forks and the like up to and including some of the most beautiful and rare combinations. This is a tactical book that will prove exceptionally useful for a wide range of players, intermediate through master strength and even beyond. In fact, I have worked with the puzzles in this book to keep my own game sharp.

I have enjoyed many of Müller's previous books, especially *The Magic of Chess Tactics* and *Fundamental Chess Endings*. In addition, his "Endgame Corner" column at www.ChessCafe.com is very instructional. He is a wonderful author; his work is typically very thorough yet quite readable.

I particularly like this book for a number of reasons:

- It covers a wide range of tactical motifs appearing in all phases of the game;
- It offers various levels of difficulty;
- The puzzles are taken from actual, modern games played by top-level players; and
- It offers a rating scale to help you gauge your tactical strength.

I can heartily give this book two thumbs up. It will help you develop and improve your tactical skills tremendously.

Susan Polgar
New York
April 2004

Introduction

The old aphorism "Chess is 99% tactics" is certainly true in many respects. Without mastery of tactical complications, even the best strategy will not help. There will always come a moment when concrete variations *must* be calculated and you can't just automatically act on some general principle, like improving the position of your worst piece.

To further emphasize the importance of tactics and to warn you always to be alert, I want to show you the following recent example by the great Garry Kasparov, who is certainly one of the strongest players of all time:

A.Huzman (2574) - G.Kasparov (2830)
ECC Rethymnon 2003

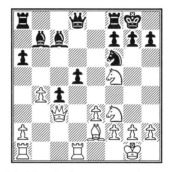

20...♗c8?? An unbelievable blunder for a player of this caliber! When you remove a defender from a critical point, make sure that the opponent can't profit from it, and be sure to check all possible tactics! **21.♖xd5!** The pawn is protected twice, but in fact no black piece can take back. **21...♕e8** 21...♘xd5?? is refuted by 22.♕xg7#; while 21...♕xd5? runs into the knight fork 22.♘e7++−. **22.♗xc4 1–0**

Don't be deceived by this example. Kasparov is tactically extremely strong (see for example Kasparov-Topalov on page 171). After studying this puzzle book, you may also pick up a collection of his games and analyze them to improve your understanding of dynamic power chess and the importance of the initiative. But how to study tactics? Before you immerse yourself in game collections of Tal and Nezhmetdinov, or delve into works like *Secrets of Chess Tactics* by Mark Dvoretsky or *The Magic of Chess Tactics* by C.D.Meyer and myself, I suggest that you first test and improve your tactical skills with a puzzle book like this. When coaching young players I have always given them a set of tactical exercises as homework, like my trainers did when I was young. I have benefited greatly from this, and still do. From my own experience I have decided that it is best to sort the tactics by motifs first. This will help your *pattern recognition*, an extremely important skill. I believe that it is crucial in becoming a strong player. You can of course also

solve the easy exercises first, either to warm up if you are able to solve them quickly, or to get used to solving this kind of puzzle. I even suggest that you solve them several times. Michael de la Maza advises you to do it seven times in his "Seven Circles" training program (see *Rapid Chess Improvement* p.41). Of course you should wait about one week each time. It should come more and more and quickly from your memory, so that in the end you will never forget the relevant pattern. It is of course important to do this regularly, but don't force yourself too much. It should remain fun! You should not tackle the final tests until you have gone through and are able to master almost all of the previous exercises. In choosing the material, I have tried to avoid old, familiar positions, so mostly recent games from the period 2000–2003 are included. Of course I could not resist the temptation to use a few of my favorite combinations. I wish you a lot of fun with the puzzles and hope that your overall performance will improve!

I want to thank Taylor Kingston for his superb job editing the book and providing a few combinations, Susan Polgar for writing the foreword, and last but not least Hanon W. Russell for his friendly attitude towards the whole project.

> Karsten Müller
> Hamburg
> April 2004

Signs and Symbols

+− White is winning

± White is clearly better

⩲ White is slightly better

− The position is equal

∓ Black is slightly better

∓ Black is clearly better

−+ Black is winning

∞ The position is unclear

⩱ with sufficient compensation for the material

→ dangerous attack (for the side which has made the last move, e.g. 11.♘xf7→ means that White has a dangerous attack)

↑ dangerous initiative (not "coffee house compensation," e.g. two pawns and a check for a piece) for the side which made the last move

!! a strong and beautiful move

! a strong move

!? an interesting and probably strong move

?! a dubious move

? a mistake

?? a blunder

Abbreviations

CBM	ChessBase Magazine
CC	Chess Club
ch	Championship
chT	Team Championship
corr	Correspondence
GP	Grand Prix
int	Internet
it	International Tournament
jun	Junior
K.O.	Knock Out Tournament
m	Match
mem	Memorial
ol	Olympiad
op	Open Tournament
rap	Rapid Tournament
sf	Semi Final
Wch	World Championship
zt	Zonal Tournament

Back Rank Mate
The unfortunate pawn shield

This theme occurs quite often, so you should be very familiar with it. One of the reasons is that after castling short the kingside pawns not only shield the king, but also take all the squares on the second rank. And even if they have moved already the problem is not automatically solved, as enemy pieces may control the flight squares. Spectacular deflections of the defenders occur quite often, so your alarm bells should ring whenever your king has no Luft (no flight square on the second rank) and your opponent threatens to land on your first rank with a rook or queen. Make Luft, bring your heavy pieces back or shield the king with a securely protected piece e.g. on f1. The example illustrates what happens if you neglect the defense:

O.Bernstein - J.Capablanca
Moscow 1914

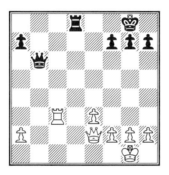

29...♕b2! This typical deflection made White resign. When solving the exercises you should calculate to the end, of course: 29...♕b1+? 30.♕f1 ♖d1?? backfires due to Black's own weak back rank: 31.♖c8+ ♖d8 32.♖xd8#; 29...♕b5?? is refuted by 30.♕xb5 ♖d1+ 31.♕f1 +−. **30.♕d3** 30.♕xb2 ♖d1#. **30...♕a1+** 30...♕xc3?? is a fatal blunder, as 31.♕xd8# turns the tables. **31.♕f1 ♕xc3 −+**.

Another famous example of deflecting the defender of the back rank is Adams vs. Torre on page 177.

Sometimes the attacking queen voluntarily enters a protected back rank to overload the defenders:

J.Gdanski (2557) - L.Schandorff (2520)
German Bundesliga 2001

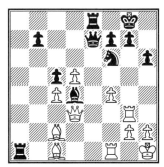

31...♕e1! 32.♖gf3? 32.♕d1 was called for, but Black keeps the upper hand after 32...♕b4 33.♖b3 ♕xc4 34.♖xb7 ♕xd5−+. **32...♕xc1!** Now White's back rank collapses. **33.♖xc1 ♖xc1+ 34.♗d1** 34.♖f1 ♖ee1−+. **34...♖e1+ 35.♖f1 ♖xf1+ 36.♕xf1 ♘e4 0−1** The threat ♖xd1 can't be parried.

An uncastled king is not immune to a back rank mate:

A.Shirov (2706) - A.Motylev (2641)
FIDE-Wch K.O. Moscow 2001

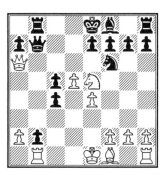

13.♖xb2! Black resigned due to **13...♕xa6** 13...♕xb2 14.♕c6+ ♔d8 15.♘xf7#. **14.♖xb8+ ♕c8 15.♖xc8#.** 13.♕a4+ ♘d7 14.♖xb2 wins as well.

Now you should not neglect to solve the exercises to absorb more important motifs.

Exercises (Solutions on page 232)

1. K.Sasikiran (2654) - C.Hansen (2618)
18th North Sea Cup Esbjerg 2003

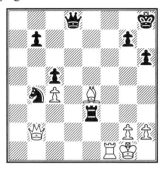

The bishop e4 is hanging, isn't it? White is to move.

2. R.Kempinski (2549) - A.Galkin (2535)
Rilton Cup Stockholm 2000

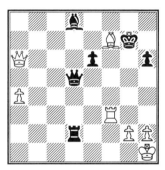

Kempinski resigned as there are two ways to win for Black. Find one of them!

3. A.Wirig (2347) - M.Kazhgaleyev (2604)
FRA-chT 2003

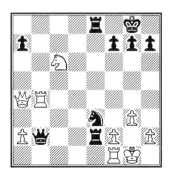

White has already played g2-g3 to get some fresh air. Did it help him?

4. V.Moskalenko (2509) - A.Mirzoev (2516)
Hostafrancs op Barcelona 2001

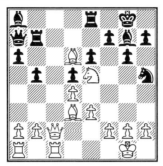

Black's forces are badly coordinated. Can White to move use this?

5. S.Lputian (2598) - V.Ivanchuk (2719)
Montecatini Terme 2000

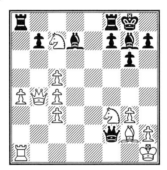

Black is an exchange up, but White has some compensation, doesn't he? Black is to move.

6. T.Gelashvili (2551) - S.Atalik (2551)
GRE-chT 31st Halkidiki 2002

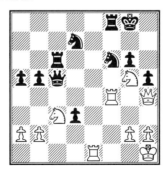

How to assess 1.♘e6?

7. J.R.Capablanca - G.Thomas
Hastings Victory Congress 1919

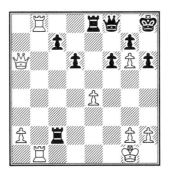

Capablanca played 1.♕a8. Was this a fortunate choice?

8. Kviletsky - Roslinsky
Poznan 1953

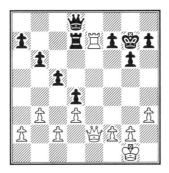

Must White move his rook?

9. NN - Richter
1957

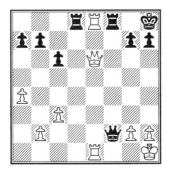

Which back rank is weaker? Black is to move.

10. S.Reshevsky - R.Fischer
Palma de Mallorca Interzonal 1970

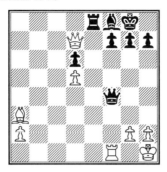

Reshevsky played 1.♔g1? and was punished. Find out how, and what should he have done instead?

11. V.Mikenas - D.Bronstein
URS-ch33 Tallinn 1965

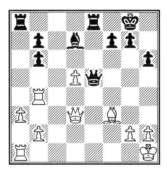

Black to move and win

12. Alden - Nilsson
Sweden 1972

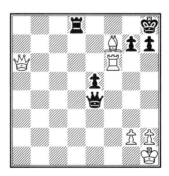

White's back rank looks terribly weak, doesn't it? Black to move.

The Bishop-Pair
Shoulder to shoulder

Two bishops are usually very strong, since the main disadvantage of a single bishop, his monochromacity, does not exist with a second bishop. Jonathan Rowson describes this in *The Seven Deadly Chess Sins* (page 130) as follows: "Although the pair of knights can be very effective, we don't see them as 'a pair' because there is nothing one knight can do that the other can't in principle ... There may be something good about 'the two knights' in a particular position, but this is purely accidental, for there is no reason in principle why a pair of them should be more than the sum of their parts. On the other hand, one bishop makes up for the shortcomings of the other, and takes care of its own shortcomings in the process. So what happens when you capture the opponent's bishop is not only that you remove one piece of value, but that you 'weaken' the other bishop too." A single bishop can pin, skewer, make double attacks and can defend on one wing, while attacking on the other. So it is easy to understand that both bishops as long range pieces have mighty tactical power, at least in open positions. When they control two diagonals aiming at the enemy king they are often called "Horwitz bishops." Here is a case in point:

Crepinssk - Boto
Yugoslavia 1980

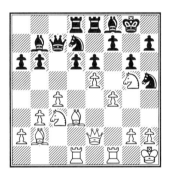

1.♘b5!! A knockout blow. 1.♘xh7?! with the idea 1...♔xh7? 2.♕xh5+ ♗h6 *(2...♔g8? 3.♗xg6 fxg6 4.♕xg6+ ♗g7 5.exd6 +−)* 3.exd6 +− can be met by 1...♗g7 2.exd6 ♕c5±. **1...axb5** 1...♘g3+ 2.hxg3 axb5 3.♕h5!! +− . **2.♕xh5! gxh5** 2...♘f6 3.♕h3 h6 4.exd6 +− . **3.♗xh7+ ♔g7 4.exd6+ ♘f6 5.dxc7 ♖xd1 6.♖xd1 ♖e7 7.♗e5 1–0**

Exercises (Solutions on page 233)

13. A.Dreev (2676) - Zhang Zhong (2636)
Tan Chin Nam Cup 6th Beijing 2000

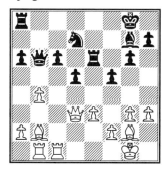

Black's pawns restrict the ♗g2, don't they? White is to move.

14. P.Morphy - J.Thompson
New York 1859

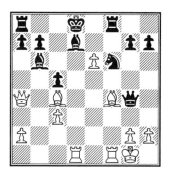

White to move and mate in three moves.

15. K.Müller (2513) - M.Chiburdanidze (2545)
Lippstadt 2000

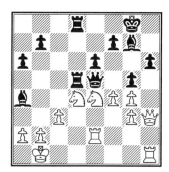

Whose attack is faster? Black is to move.

16. K.Müller (2490) - C.Lutz (2565)
GER-ch Dudweiler 1996

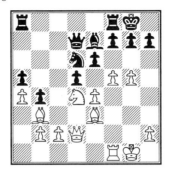

I have a very bad score against Christopher Lutz. But this time I managed to defeat him. How?

17. I.Stohl (2547) - R.Tischbierek (2523)
German Bundesliga 2002

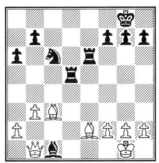

Two rooks are usually at least as strong as the queen. Is this valid here as well? White is to move.

18. E.Lasker - J.Bauer
Amsterdam 1889

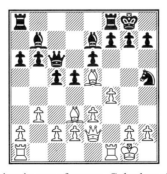

The following combination is very famous. Calculate the fireworks to the end! White is to move.

In the next three examples the question is: Can the bishops be sacrificed or not? In the first two it is White to move and in the last Black:

18A. N.Ibraev - V.Sergeev
St. Petersburg 2003

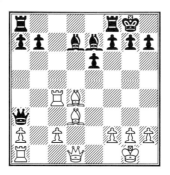

18B. J.Polgar (2722) - A.Karpov (2693)
Essent Hoogeveen 2003

18C. Y.Afek (2430) - E.Liss (2405)
Rishon le Zion 1993

19. A.Nimzowitsch - S.Tarrasch
St. Petersburg 1914

Another well known classic. Whose king is weaker? Black is to move.

20. M.Tal - V.Ljavdansky
URS-ch32 Kiev 1964

Tal loved this type of position. But his pieces seem to be very scattered. How could Black have made use of this?

21. S.Volkov (2558) - R.Ponomariov (2673)
2nd IECC Ohrid 2001

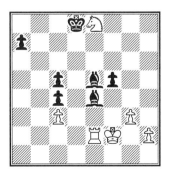

It is an old question, whether ♖+♘ or two bishops are stronger in the endgame. Who is better here? Black is to move.

22. G.Kasparyan
Revista Romana de Sah 1978, 1st hon. mention

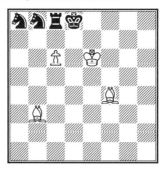

Kasparyan composed several studies with the theme 2♗ vs. ♖+2♘, underlining the power of the bishop-pair on an open board. How do they manage to survive here?

23. H.Stefansson (2570) - L.Bruzón Bautista (2589)
36th Capablanca mem Elite Havana 2001

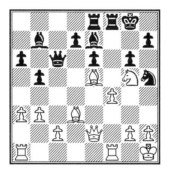

Blackburne's mate is hanging like a Damocles sword over Black, isn't it? White is to move.

24. Riga - Orel
City corr match 1896

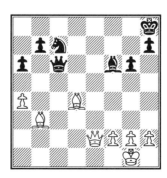

Don't underestimate the difficulty of this little puzzle! White to move and win.

Dangerous Passed Pawn
Every soldier wants to become a general

Are you aware of the fact that there are two ways to win material? Obviously one way is to take the opponent's men, while keeping one's own. The other way is to promote a pawn to a queen. This gains no less than eight material points! This sharp increase in power is the reason that a far-advanced passed pawn usually increases the tactical possibilities, as in the following example:

J.Kaiser - F.Hoppe
Berlin-ch 2001

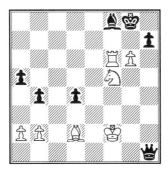

41.♖xf8+! ♚xf8 42.♗h6+ ♚e8! 42...♛xh6? 43.♘xh6 hxg6 44.♚f3 ♚g7 45.♘g4 g5 46.♚e4 ♚g6 47.♚xd4 ♚f5 *(47...♚h5 48.♘e5 +−)* 48.♘f2+− ; 42...♚g8?? 43.♘e7+ ♚h8 44.g7#. **43.gxh7 ♛h2+ 44.♚f3 ♛e5?** Black missed the perpetual check with 44...♛h1+ 45.♚g4 ♛e4+ 46.♚g5 ♛g2+ 47.♚f6 ♛c6+ 48.♚g5= *(48.♚g7? even loses: 48...♛d7+ 49.♚g6 ♛f7+ −+).* **45.♘g7+ ♚f7 46.h8♛ ♛d5+ 47.♚f2 ♚g6 48.♛e8+ ♚h7** 48...♚xh6 49.♛e6++−. **49.♛e6 ♛b7 50.♘f5 1–0**

Two connected, mobile passed pawns are usually a mighty force:

V.Neverov (2540) - V.Kramnik (2490)
URS-ch58 Moscow 1991

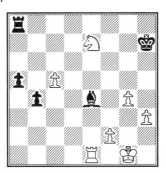

Kramnik just pushed them: **36...a4! 37.c6** 37.♖xe4 a3 38.♖xb4 *(38.♖e1 a2 39.♖a1 b3 −+)* 38...a2 39.♚g2 a1♛ and Black should win in the long run. **37...a3 38.c7 b3 39.c8♛ ♖xc8 40.♘xc8 b2** White resigned as the pawns are landing: **41.♘d6 b1♛ 42.♖xb1 ♗xb1 43.♘b5 a2 −+.**

In the middlegame a far-advanced passed pawn can be used to divide the board in two and destroy the enemy's coordination:

G.Kasparov (2595) - J.Pribyl (2395)
EU-chT (Men) Skara 1980

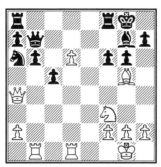

20.d7! fxg5

20...♖ad8 21.♕c4+ ♔h8 22.♘e5! fxe5 *(22...fxg5 23.♘f7+ ♖xf7 24.♕xf7 ♕c7 25.♕e8+ ♗f8 26.♖b3 ♕b8 27.♖e1±)* 23.♗xd8 ♖xd8 24.♕e6 ♘c7 *(24...♕b8 25.♖b3 c4 26.♖h3 +−)* 25.♕e7 ♕b8 26.♖b3±.

21.♕c4+ ♔h8 22.♘xg5 ♗f6 22...♗d4? 23.♖xd4+−. **23.♘e6 ♘c7** 23...♘b4?! 24.♕f4 ♖f7 25.♘g5 ♗xg5 26.♕xf7 ♖d8 27.a3 ♘c6 28.♖d6 ♗e7 29.♖e1+−. **24.♘xf8 ♖xf8 25.♖d6!?**

Kasparov wants more than the slightly better endgame after 25.♕xc5 ♕xg2+ 26.♔xg2 bxc5 27.♖b7.

25...♗e7

If 25...♕b8 26.♖bd1 ♕d8 27.♖c6 ♗g7 28.h4 a6 29.♕g4±. After 25...♗d8!?, 26.h4 gives White a strong initiative, but matters are not completely clear. Such a move is quite typical: the advance does not weaken the king's pawn shield so much, it avoids a back rank mate (remember the last chapter!) and threatens to weaken the black king's shelter.

26.d8♕! ♗xd8 26...♖xd8 27.♖xd8+ ♗xd8 28.♖d1±. **27.♕c3+ ♔g8 28.♖d7! ♗f6 29.♕c4+ ♔h8 30.♕f4 ♕a6?** This overlooks White's next. 30...♗g7 was called for: 31.♕xc7 ♕xc7 32.♖xc7 ♗d4 33.♖f1±. **31.♕h6! 1–0**

Exercises (Solutions on page 235)

25. Medina - Tal
Mallorca 1979

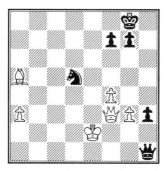

The bishop is supposed to be better in a pure ♘ vs. ♗ endgame with pawns on both flanks. Should Black exchange queens anyway?

26. W.Arencibia (2513) - Ye Jiangchuan (2670)
Istanbul ol (Men) 2000

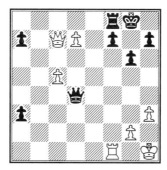

White won with a nice blow. Can you spot it?

27. M.Krasenkow (2702) - P.Svidler (2689)
Rubinstein mem Polanica Zdroj 2000

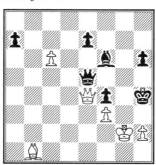

Is there more than a draw, with White to move?

28. A.Shabalov (2601) - J.Benjamin (2577)
USA-ch playoff Seattle 2000

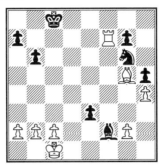

Black is a whole exchange down, but his e-pawn more than compensates for that, doesn't it? Black to move.

29. R.Vaganian (2623) - V.Topalov (2707)
Istanbul ol (Men) 2000

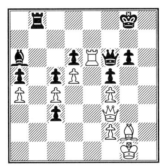

White wants to start a counter-attack against Black's king. What measures should be taken?

30. L.Ftacnik (2608) - J.Ehlvest (2627)
Istanbul ol (Men) 2000

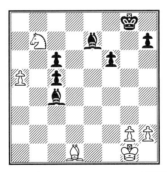

Black's bishop-pair is a very dangerous weapon, if White does not manage to profit from his a-pawn.

31. Z.Hracek (2615) - I.Stohl (2561)
SVK-chT 2000

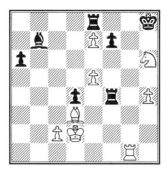

Is White's e7-pawn doomed, or is Black doomed? White is to move.

Decoy
Just lure the defenders away

A decoy is used to lure one of the enemy pieces to a harmful square, for example where it blocks a king's Luft or allows a knight fork. It can also force the king to leave his home, of course:

L.Ftacnik (2585) - O.Cvitan (2570)
German Bundesliga 1997

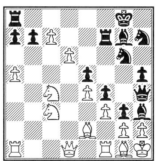

23...♗xg2+! 24.♔xg2 ♕h3+!! What a beautiful poisonous gift! 24...♘g5? is met by 25.♖f2! +−. **25.♔xh3 ♘g5+ 26.♔g2 ♘h4+** And Lubomir Ftacnik submitted to the inevitable **27.♔h1 g2# 0-1**

By the way: White's last move 23.bxc7?, which produced the diagram position, was a terrible mistake. Instead the exchange sacrifice 23.gxh3! ♕xh3 24.♖f2! stops Black's attack and gives White a clear advantage due to his activity and the weak light squares in Black's camp.

Deflection
When the guard must leave its post

When a piece has an important job to do, like protecting a mating square or an attacked piece, it is vulnerable to deflection. So the difference between decoy and deflection is, that in the first case the enemy man is lured onto a particular square, while in the second case it is lured away from its post. Here is a typical example:

A.Rustemov (2553) - N.Rashkovsky (2523)
Bydgoszcz Bank Pocztowy op 2000

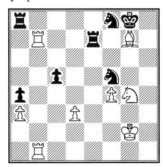

Black's knight on f5 seemed to have everything under control, until White struck with **40.♘h6+! ♘xh6** 40...♔xg7 41.♘xf5++−. **41.♖xe7 1−0** 41...♘f5 42.♗xf8+−.

Decoy and deflection go often hand in hand, as in the following example:

W.Uhlmann - Mädler
East Germany 1983

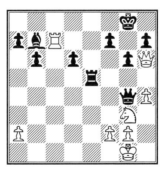

1...♖e1+ 2.♔h2 ♖h1+!! A beautiful decoy to lure White's king to h1 or deflect White's knight. **3.♔xh1** 3.♘xh1 ♕xg2#. **3...♕h3+ 4.♔g1 ♕xg2# 0-1**

So the exercises for decoy and deflection are mixed together:

Exercises (Solutions on page 235)

32. A.Aleksandrov (2633) - A.Lugovoi (2540)
Moscow Aeroflot op 2003

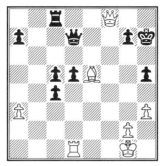

 Aleksandrov made one more move and Lugovoi resigned. What move was it?

33. B.Avrukh (2606) - L.Fressinet (2588)
EU-chT (Men) León 2001

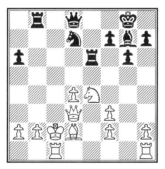

White's pieces lack coordination. How did Black exploit this?

34. V.Bologan (2630) - P.Smirnov (2572)
Moscow Aeroflot op 2003

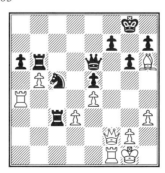

How did White exploit the shaky position of Black's pieces?

35. O.Nikolenko (2520) - A.Aleksandrov (2605)
RUS-Team Smolensk 2000

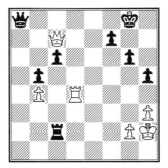

How to deal with the threat of 1.♖d8+?

36. A.Delchev (2550) - M.Gurevich (2641)
EU-ch 3rd Batumi 2002

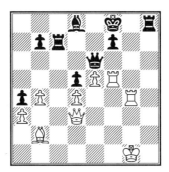

Gurevich to move and win.

37. V.Golod (2590) - A.Gershon (2502)
ISR-ch Ramat Aviv/Modiin 2000

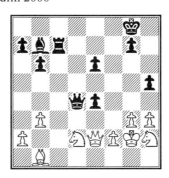

Does Black have anything better than 1...e3+?

38. M.Gurevich (2634) - B.Gelfand (2704)
Cap d'Agde-B 2002

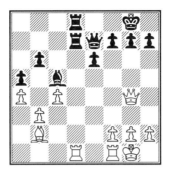

How did Gelfand react to White's mating threat?

39. Z.Izoria (2547) - E.Prokopchuk (2508)
Moscow Aeroflot op 2002

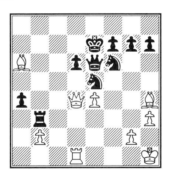

Black's king is not really safe on e7, is it? White is to move.

40. L.McShane (2568) - R.Lau (2506)
German Bundesliga 2003

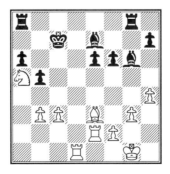

White has to act quickly as otherwise Black's bishops will reign supreme.

41. T.Radjabov (2610) - V.Zvjaginsev (2673)
RUS-The World Moscow 2002

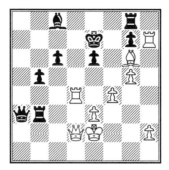

Can White to move shatter Black's defense?

42. K.Sasikiran (2664) - A.Barsov (2525)
Asia-ch 4th Doha 2003

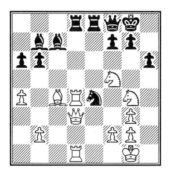

Where is Black's Achilles heel?

43. J.Speelman (2623) - T.Luther (2547)
Lippstadt 10th 2000

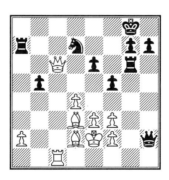

How did Speelman activate his army?

44. E.Ubilava (2552) - L.Galego (2511)

ESP-chT1 Mondariz Balneario 2002

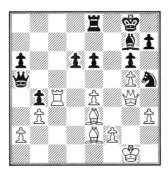

White has something better than 1.♖c2. Find it!

45. E.van den Doel (2594) - S.Conquest (2537)

Bled ol (Men) 2002

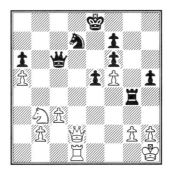

Whose king is safer? White is to move.

46. H.Zieher - Stippekohl

German Bundesliga 76/77

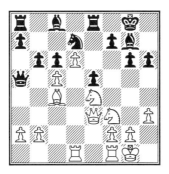

How to convert White's space advantage and activity into a full point?

47. V.Anand (2753) - C.Hansen (2610)
SIS-MH Masters Middelfart 2003

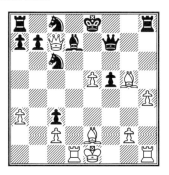

Did Anand find a way to justify his piece sacrifice?

48. V.Babula (2573) - A.Rustemov (2553)
German Bundesliga 2000

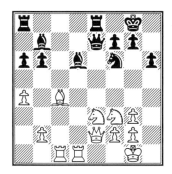

Black needs one more move to consolidate, but White struck now. Can you do the same?

49. M.Brodsky (2510) - L.Mikhaletz (2510)
Swidnica op-A 2000

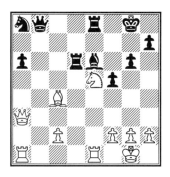

♗xa6 is playable, of course. But Brodsky found a much more powerful stroke!

50. M.Cebalo (2524) - V.Tkachiev (2643)
CRO-Cup Rabac 2003

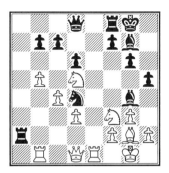

How did Black profit from the pin?

51. Z.Hracek (2596) - V.Kramnik (2809)
Eurotel Trophy Prague 2002

Black's f4-knight is a powerhouse. How did Kramnik use it to decide the game?

52. R.Hübner (2620) - A.Beliavsky (2640)
Julian Borowski-A Essen 2000

Winning a pawn by 1.axb7 is not White's best way to exploit Black's momentary lack of coordination.

53. A.Jussupow (2610) - R.Dautov (2606)
Borowski mem op 15 Essen 2000

Is there anything better than 1.d7?

54. R.Kempinski (2549) - E.Gleizerov (2520)
Rilton Cup Stockholm 2000

Black's last move was c7-c5, so you could take en passant ...

55. Z.Kozul (2601) - R.Kasimdzhanov (2680)
Bosnia GM Sarajevo 2003

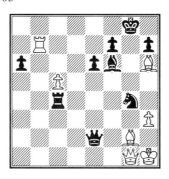

It looks precarious for Black, but he had calculated that there is a narrow path to a win. Can you find it?

56. H.W.Russell - Vigorito
Bradley op USA 2003

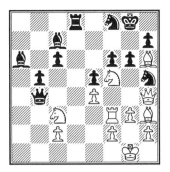

Editing many columns seems to help! How did the ChessCafe webmaster shatter Black's defense?

57. M.Krasenkow (2633) - A.Karpov (2688)
Corus Wijk aan Zee 2003

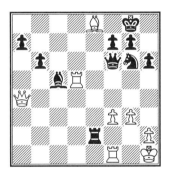

Karpov's superb technique has given him this position. How did he finish off tactically now?

Destroying the Guard
Everyone picks on the poor guard

Instead of deflecting the guard, you can of course also destroy it:

R.Slobodjan (2561) - G.Bagaturov (2501)
Arco op 22nd 2000

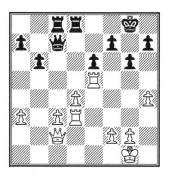

The rook on e5 seems to be securely protected, but in fact it is not: **27...♖xd4!**
28.♖xd4. The c-pawn is pinned, so 28.cxd4?? loses to 28...♕xc2–+ . Sometimes
an attacked piece can try to sell itself as expensively as possible, but here 28.♖xe6??
♖xd3 –+ just loses outright. This way of defending an attacked piece is sometimes
called **desperado defense**. If White's ♖d3 were on e4, then 2.♖xe6! would be
the best answer to Black's shot 1...♖xd4?. But of course Black would win easily
with 1...♕xc3 in that case.

28...♕xe5 29.♕d2 ♕c5–+ And Black converted his material advantage later.

Exercises (Solutions on page 238)

58. R.Antonio (2521) - M.Paragua (2500)
zt 3.2a Playoff g5+10 Ho Chi Minh City 2003

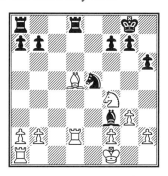

How can Black profit from the tactical quagmire he has created?

59. C.Lutz (2644) - A.Jussupow (2618)
Julian Borowski 4th Essen 2002

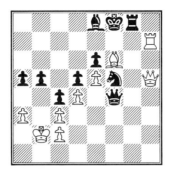

Did Christopher Lutz resign now?

60. E.Bareev (2729) - L.van Wely (2668)
Amber blindfold Monte Carlo 2003

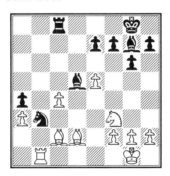

How to punish White's awkwardly placed pieces?

Discovered Attack
Where did that arrow come from?

If one of your long-range attacking pieces is blocked only by one of your own men, then the conditions for a successful discovered attack are good. As the blocking piece usually has many possibilities to get out of the way, this often spells trouble for the opponent. Your chances are especially good, when the attacked piece is the enemy king, who may be vulnerable to a double check. Double check is a deadly tactical weapon, as the king always must move. But discovered check is usually also quite dangerous as the following combination, which is sometimes called "the windmill," shows:

C.Torre - E.Lasker
Moscow 1925

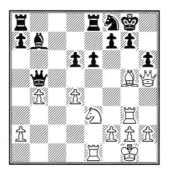

In this famous classic the Mexican player surprised the great Emanuel Lasker with **25.♗f6!!** ♕xh5 **26.♖xg7+** ♔h8 First White clears the seventh rank. **27.♖xf7+** ♔g8 **28.♖g7+** ♔h8 **29.♖xb7+** ♔g8 **30.♖g7+** ♔h8 And now Torre reaps the harvest: **31.♖g5+** There was nothing wrong with 31.♖xa7+ first. **31...♔h7 32.♖xh5 ♔g6!** The old fox Lasker always fought to the end. **33.♖h3** 33.g4!? ♔xf6 34.♖xh6+ ♔g7 35.g5 +−. **33...♔xf6 34.♖xh6+** And Torre converted his material advantage later.

Exercises (Solutions on page 238)

61. A.Romero Holmes (2524) - B.Damljanovic (2550)
TCh-ESP Mondariz 2002

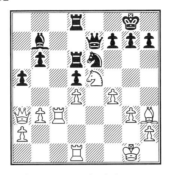

White seems better at first glance. But Black is to move ...

62. J.Gustafsson (2542) - H.Banikas (2520)
GER-GRE Fürth 2002

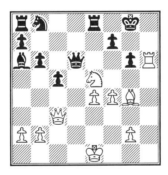

How did White justify his rook sacrifice?

63. K.Müller (2527) - I.Farago (2467)
Hamburg-ch int 2000

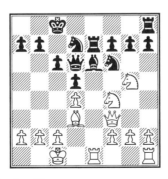

Where is Black's Achilles heel?

64. O.Duras – R.Spielmann
Bad Pistyan 1912

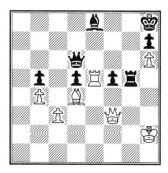

How to fire White's mighty battery?

65. Analysis of A.Shirov (2670) - J.Lautier (2635)
München 1993

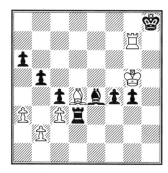

I was Shirov's second in Munich and shortly before resumption of the adjourned game we found out that White to move can win in this sideline. Can you spot it?

66. Maroczy - Romih
San Remo 1930

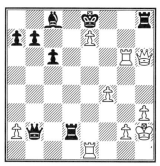

In the game it was White to move and the solution is fiendishly difficult. Black to move would win easily. Solve both cases!

67. R.Réti - S.Tartakower
Vienna 1910

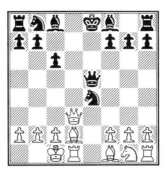

If you don't know this classic, it is high time to enjoy it. It is White to move and win.

68. T.Kingston – R.Roach
Golden Bear op, Berkeley, California 1983

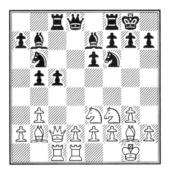

Black has just played 13...Nd7-b6. How does White show this to be a mistake?

Double Attack
The mother of all attacks

The double attack is one of the deadliest and most fundamental tactical weapons. It is usually possible to protect one attacked piece, or move it away. But to rescue two men often proves impossible. A special form of double attack, the **knight fork**, will be dealt with later in the chapter "The Mighty Knight." Here is one example of a quick finish due to a deadly double attack:

M.Markovic (2586) - K.Sakaev (2629)
JUG-Cup Herceg Novi 2000

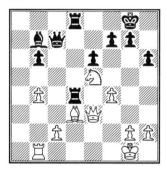

27...♖xd3! And White resigned due to **28.cxd3** After 28.♘xd3 ♕xc2, Black even has three deadly threats, and 29.♖b2 is met by ♕xd3 −+. **28...♕c2** And White can't parry the threats ♕xg2 mate and ♕xb1+.

Exercises (Solutions on page 239)

69. Zhang Zhong (2636) - M.Gurevich (2667)
Cap d'Agde-B 2000

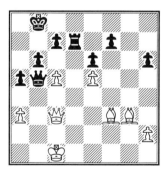

John Nunn coined the acronym "LPDO" (loose pieces drop off), which applies here. Black is to move.

70. V.Akopian (2654) - A.Greenfeld (2570)

EU-ch 2nd Ohrid 2001

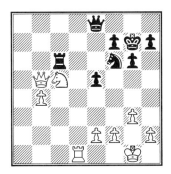

White has just taken a black pawn on b5. Was it poisoned?

71. K.Chernyshov (2520) - V.Zakharstov (2526)

Voronezh op 6th 2002

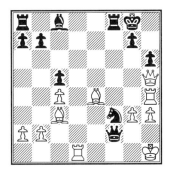

White's mighty bishops look very impressive. Prove that he is winning!

72. L.Christiansen (2620) - A.Karpov (2725)

Hoogovens Wijk aan Zee 1993

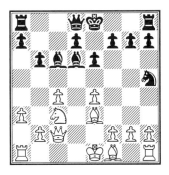

Karpov loses extremely rarely in the opening, but his last move was a terrible blunder. How did Larry Christiansen exploit it?

73. I.Glek (2576) - M.Gurevich (2634)
AUT-chT2M 2002

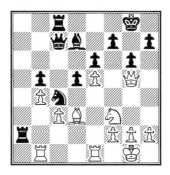

Is 1...♘d2 a good idea?

74. A.Delchev (2629) - V.Tukmakov (2604)
CRO-chT Pula 2001

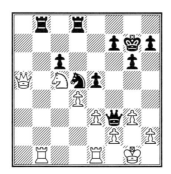

Find White's best move!

75. D.Rogozenko (2548) - Z.Peng (2391)
Dieren op 2001

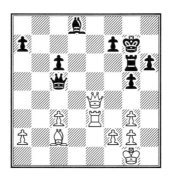

White is better, of course. But how to make progress?

76. S.Rublevsky (2639) - Peng Xiaomin (2629)
CHN-RUS Summit Men Shanghai 2001

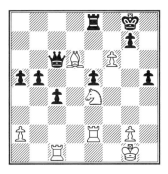

Who is better? Black is to move.

77. G.Sax (2609) - M.Sadler (2630)
German Bundesliga 2000

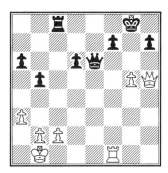

Find Black's best move!

78. P.Svidler (2672) - S.Rublevsky (2662)
RUS-Team Smolensk 2000

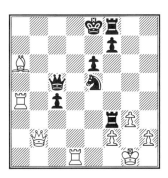

In such a sharp position having the move is usually very important. Here it was
White who struck first.

79. Xu Jun (2643) - O.Cvitan (2562)
Bled ol (Men) 2002

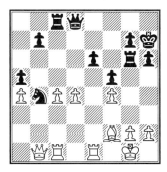

Which minor piece is stronger? Black is to move.

Finding the Draw
Better Safe than Sorry

Winning is of course the ultimate goal of the game, but sometimes saving a valuable half-point gives just as much pleasure. So study this chapter carefully. It includes exercises on **stalemate, perpetual check, forcing repetition of moves, creating a fortress, reaching a drawn endgame,** etc. The following example shows many of these motifs:

D.Bocharov (2502) - A.Vaulin (2549)
Chigorin mem 10th St. Petersburg 2002

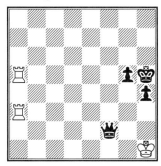

80.♖xg5+! ♔xg5 81.♖g3+! a desperado rook

81.♖a5+? ♔f6 82.♖a6+ ♔f7 and it is all over as White has no further check.

81...hxg3 Stalemate ½–½. 81...♔f5 does not help, as White's rook just keeps checking on the g-file: 82.♖g5+ ♔e4 83.♖g4+ ♔e3 84.♖g3+ ♔e2 85.♖g2=.

Solve the exercises, and don't miss the chapter "Find the Defense" to further improve your defensive skills!

Exercises (Solutions on page 240)

80. A.Morozevich (2756) - A.Minasian (2595)
Istanbul ol (Men) 2000

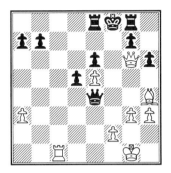

Morozevich has boldly sacrificed an exchange. How did he justify it?

81. I.Nataf (2526) - C.Bauer (2562)
Mondariz zt 1.1 2000

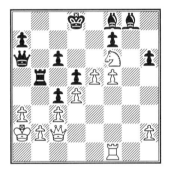

How can Black force a draw?

82. L.van Wely (2714) - A.Fedorov (2599)
EU-chT (Men) León 2001

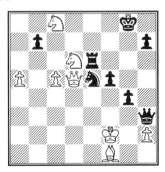

Can Black still save himself?

83. A.Shirov (2722) - A.Morozevich (2749)
Astana 2001

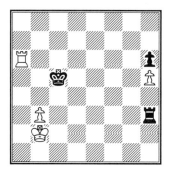

Both players missed the importance of this moment. Black to move and draw.

84. M.Fehling - U.Rüetschi
Biel 1984

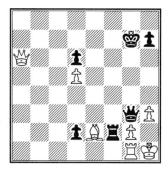

It sounds unbelievable, but Black managed to escape to the safe haven of a draw. Can you spot how?

85. A.Herbstmann and L.Kubbel
1st Price Troitzky Tourney 1937

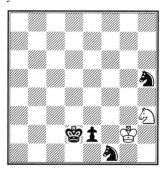

This is one of my favorite studies. Remember that three knights usually win against one, when you search for the way for White to reach a draw.

86. M.Erdogdu (2295) - I.Cheparinov (2457)
EU-ch 3rd Batumi 2002

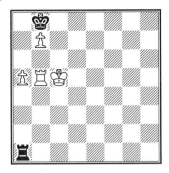

Can Black to move save himself?

87. B.Arab (1827) - M.Riesenbeck (1283)
GER-chT U20 Hamburg 2001

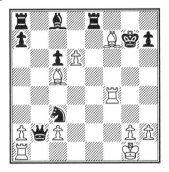

White has boldly sacrificed his queen. Could he justify it?

Greek Gift
Don't Take Trojan Horses or Bishops

The bishop sacrifice on h7 is as old as the hills. When an attacking knight can land on g5 and the queen can reach the h-file, your alarm bells should start ringing. It is easier to give the conditions under which it does *not* work, first:

1) Black's king is on g8, White's knight on g5 and his queen on h5, *and*:

1.1) Black can play ♘f8, ♘f6, ♗f5 or something like ♕c2 or ♕d3 to protect h7.

1.2) Black's king can safely escape via f8 because f7 is protected.

1.3) Black's material advantage is already so large that he can afford ♕xg5.

In other cases it is not so easy to give exact conditions, as White's compensation against a king on g6 or h6 can be long-term. You should study the exercises carefully as this motif occurs quite often. One typical example is:

Razinger - F.Harum
Ebensee fin-B 1933

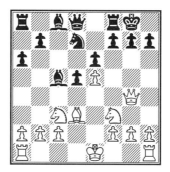

12.♗xh7+! ♔xh7 12...♔h8? 13.♕h5 loses at once. **13.♘g5+** 13.♕h5+ is even more precise as it forces the king to g8. **13...♔g8** 13...♔h6!? 14.f4 ♘xe5 15.♕h4+ ♔g6 16.♕h7+ ♔f6 17.fxe5+ ♔e7 *(17...♔xg5 18.♕xg7+ ♔h5 19.h4 +−)* 18.♕xg7 +−; 13...♔g6? 14.♘xe6+ ♔h6 15.♕xg7+ ♔h5 16.♕h7+ ♔g4 17.♕h3#. **14.♕h5 ♖e8** Now White won with the typical **15.♕xf7+!** 15.♕h7+? is refuted by 15...♔f8 16.♕h8+ ♔e7 17.♕xg7 ♖f8. **15...♔h8 16.♕h5+ ♔g8 17.♕h7+ ♔f8 18.♕h8+** And Black folded due to **18...♔e7 19.♕xg7#.** Remember this procedure!

Exercises (Solutions on page 241)

88. Zieher - Vormum
German Bundesliga 1977/78

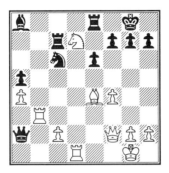

In this and the following exercises the question is always: does ♗xh7+ work or not?

89. Z.Lanka (2504) - M.Vokac (2523)
Steinitz mem-A 1st Prague 2001

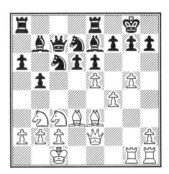

90. E.Rozentalis (2563) - Z.Kozul (2565)
Bled ol (Men) 2002

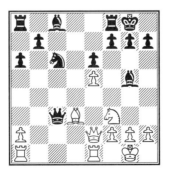

91. L.Paulsen - A.Schwarz
Leipzig m 1879

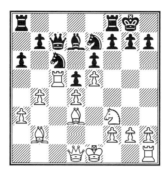

92. E.Colle - J.O'Hanlon
Nice 1930

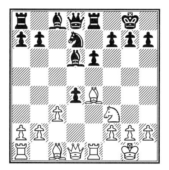

93. J.de Soyres - A.Skipworth
Counties Chess Association Boston 1880

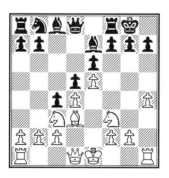

94. J.Cochrane - H.Staunton

London m 1842

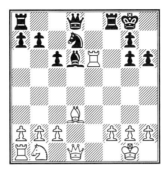

Here it is Black's move for a change.

95. H.Bird - W.Steinitz

London m 1866

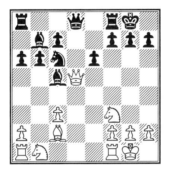

Does ♗xh7+ win?

Interference
Cut him off!

When your opponent protects crucial squares you should always search for ways to cut his lines of communication. The following two examples illustrate the theme:

I.Stohl (2578) - I.Smirin (2677)
CRO-chT Pula 2000

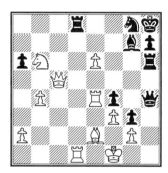

Black prevented White's vital defensive queen retreat ♕g1 with **30...♗d4! 0-1** 30...♖d4 wins as well.

Ye Jiangchuan (2676) - J.Polgar (2677)
Eurotel Trophy Prague 2002

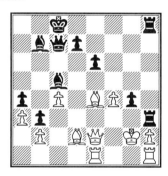

The bishop on e4 is of crucial importance for White's defense. So Judit Polgar searched for ways to negate it and she found **28...♗e3! 0-1** 28...♖e3 works as well.

Exercises (Solutions on page 243)

96. A.Goloshchapov (2543) - B.Jobava (2566)
Dubai op 2002

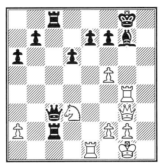

How to continue White's attack?

97. R.Kempinski (2576) - Zhang Pengxiang (2522)
Linares Anibal op 9th 2002

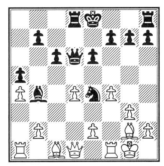

Black's knight is hanging in the air. What to do about it?

98. H.Hamdouchi (2541) - P.Tregubov (2620)
Cap d'Agde-A 2000

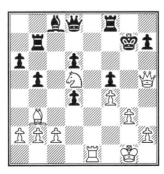

Find White's next move!

99. A.Reggio - J.Mieses
Monte Carlo 1903

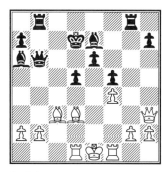

Who is better and why? Black is to move.

100. T.Kingston - T.Zilius
Burlington CC, Vermont, 1995

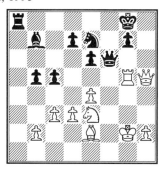

White's attack looks strong. How best to cap it off?

Attack on the King
Centralize and sacrifice

This is a very important chapter, as the ultimate aim of the game is to mate the enemy king. It is of course a vast topic, and I can not deal with all aspects systematically here. I just want to mention some general principles:

1) Invite everyone to the party (bring all available forces into the attack).
2) Taking away flight squares is often very important.
3) Calculate the forced lines first (checks, captures), but do not forget to watch out for other possibilities, if you can't crash through only with checks. Especially the moves that bring fresh forces or control important flight squares.
4) Bishop of opposite colors tend to favor the attacker.
5) Sacrifice to open lines or to destroy the pawn shield, if necessary.
6) Horwitz bishops (two bishops on neighboring diagonals, which fire at the king's castle) or two rooks on the seventh can wreak havoc.
7) Queen and knight are a strong attacking duo.

As examples I only want to show two attacks with opposite-colored bishops, and one typical rook sacrifice, but in the exercises you will see many more motifs.

A.Aleksandrov (2645) - S.Sulskis (2579)
Goodricke 13th op Calcutta 2002

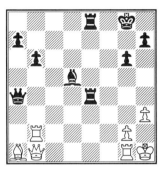

Both kings are exposed, but Black is much more active and strikes first: **38...♖e3!** 38...♖h4? can be met by 39.♕d3; 38...♖f8? 39.♖d2 ♕b3 40.♖xd5 ♕xd5 41.♕b2 gives White counterplay, but Black is better after 41...♔f7!. **39.♖f1** 39.♔h2 ♕f4+ 40.g3 ♖e2+ 41.♖g2 ♕f3 42.♕g1 ♖xb2 43.♗xb2 ♖e2 -+. **39...♖xh3+ 40.♔g1 ♕h4 0–1**

The next example is a very famous classic:

A.Karpov (2720) - G.Kasparov (2700)
Wch 32nd Moscow 1985

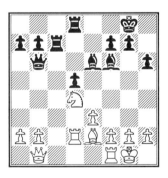

Is ♘xe6 a threat or not? A very difficult question, which was answered with "no" by Kasparov, but Karpov showed the dangers of White's attack. Study his strategy carefully! **20...♖dc8?!** Dvoretsky prefers 20...♗xd4 21.♖xd4 ♖dc8 22.♗d3 ♖c5 23.h3 ♕c7 which is only very slightly better for White. **21.♘xe6! fxe6 22.♗g4!** White's long-term aim is to open more lines with e3-e4 and to double on the diagonal b1–h7, but first he reminds Black of his weakness on the light squares. **22...♖c4 23.h3 ♕c6 24.♕d3 ♔h8?!** The king is a sitting duck here. **25.♖fd1 a5 26.b3 ♖c3 27.♕e2 ♖f8 28.♗h5 b5 29.♗g6 ♗d8 30.♗d3 b4 31.♕g4 ♕e8 32.e4 ♗g5 33.♖c2 ♖xc2?** A strategic mistake as Black needed his active rook to

fight against White's strategic initiative on the kingside. Dvoretsky gives 33...♕c8! 34.exd5 exd5 35.♕xc8 ♖fxc8 36.♖e2 ♖c1 37.♖xc1 ♖xc1+ 38.♔h2 ♖c8 39.♗g6 ♗f6 as tenable for Black in *Positionelles Schach*. **34.♗xc2 ♕c6 35.♕e2 ♕c5 36.♖f1 ♕c3 37.exd5 exd5 38.♗b1! ♕d2 39.♕e5 ♖d8 40.♕f5 ♔g8 41.♕e6+ ♔h8 42.♕g6 ♔g8 43.♕e6+ ♔h8 44.♗f5 ♕c3 45.♕g6 ♔g8 46.♗e6+ ♔h8 47.♗f5 ♔g8 48.g3 ♔f8 49.♔g2 ♕f6 50.♕h7 ♕f7 51.h4! ♗d2** 51...♗f6 52.♖e1 ♕g8 53.♕g6 ♕f7 54.♕g4 and White's attack continues. **52.♖d1 ♗c3 53.♖d3**

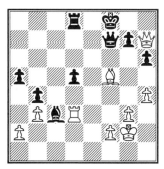

53...♖d6?

53...♕f6? 54.♖f3 ♕b6 55.♖e3 d4 56.♖e6 ♕b7+ 57.♖e4 ♕d5 58.♗e6 +−. 53...♗f6! was tougher.

54.♖f3! ♔e7

54...♖f6 55.♖e3 ♖xf5 56.♕h8+ ♕g8 57.♖e8+ ♔xe8 58.♕xg8+ ♔e7 59.♕c8 +−.

55.♕h8?!

55.♖e3+ ♔d8 56.♕h8+ ♔c7 57.♕c8+ ♔b6 58.♕b8+ ♔c5 59.♗d3 ♖b6 60.♕d8 ♗d4 61.♖e2 g5 62.h5 gives White a very strong attack as Black's king has no home anymore.

55...d4?

55...♕f8? 56.♖e3+ ♔f7 57.♗e6+ +−. 55...♗d4 offers much tougher resistance.

56.♕c8 ♖f6

56...♕d5 57.♕c7+ ♔e8 58.♗e4 ♕xe4 59.♕xd6 +−.

57.♕c5+ ♔e8

58.♖f4 The rook creeps nearer and nearer. **58...♛b7+ 59.♖e4+! ♔f7**

59...♔d8 60.♕xa5+ ♖b6 *(60...♔b6 61.♕a8+ ♔c7 62.♖e7+ ♔d6 63.♖d7+ ♔e5 64.♕d5#)* 61.♔h2 g6 62.♖e6+−.
59...♖e6!? is met by 60.♕c4! ♖xe4 61.♕g8+ ♔e7 62.♕xg7++−.

60.♕c4+ ♔f8 61.♗h7 ♖f7 62.♕e6 ♛d7 63.♕e5! 1–0 Black resigned due to **63...♛d8 64.♕c5+ ♖e7 65.♖f4+ ♔e8 66.♕c6+ ♛d7** (66...♖d7 67.♕e6+ ♔e7 68.♖f8+ ♔xf8 69.♕g8#) **67.♗g6+ ♔d8 68.♖f8++−.**

A highly instructive power play on the light squares!

In a way the next example also features opposite-colored bishops, as Black can't oppose White's mighty bishop d5:

T.M.Haub - K.Müller
Nordhorn rap 2003

1.♖xh7! ♖xd2 1...♔xh7 2.♕f6 ♕xg4 3.♖h1+ ♔h5 4.♖xh5+ gxh5 5.♕xf7+ ♔h8 6.♕xh5+ ♔g7 7.♕h6#. **2.♖xf7 ♖xf2+ 3.♕xf2 ♕xd5 4.exd5 ♗xf2 5.♖xf2 ♘c3 6.♖b3 ♘xd5 7.♖e2 1–0**

Exercises (Solutions on page 243)

101. A.Kveinys (2530) - J.Speelman (2583)
Bled ol (Men) 2002

Is Black's king really safe on e7? White is to move.

102. S.Lputian (2627) - K.Spraggett (2533)
Bled ol (Men) 2002

How to storm Black's castle?

103. T.Kingston – R.Patterson
Corr, USCF 82-V-27, 1982

White has a decisive attack.

104. I.Nataf (2527) - M.Apicella (2524)
FRA-ch Pool B Marseilles 2001

The opposite-colored bishops make White's attack terribly dangerous. How to continue it?

105. A.de Groot (2421) - M.Bulgarini (2347)
XXX APA Magazine section B ICCF corr 2001

Whose king is safer? White is to move.

106. R.Kasimdzhanov (2674) - V.Korchnoi (2635)
Julian Borowski 4th Essen 2002

White started a ferocious attack. Can you spot how?

107. K.Müller (2503) - V.Dinstuhl (2402)
German Bundesliga 2002

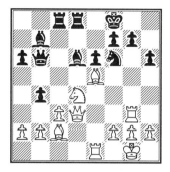

Black's last move 1...♗e7-d6? was a blunder. How did White exploit it?

108. K.Müller - M.Sadler
Altensteig 1992

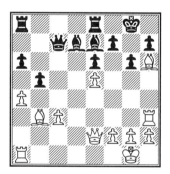

Find White's best move!

109. K.Müller - T.Kastek (2255)
Hamburg-ch 1988

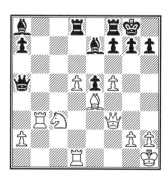

White wins by using a typical attacking motif. Which one?

110. J.Plaskett (2515) - N.Short (2683)
BCF-chT 99/00 (4NCL)

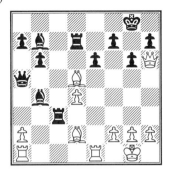

Remember that these puzzles are about attacking the king, not winning the exchange! White to move.

111. A.Riazantsev (2537) - V.Nevostrujev (2502)
RUS-ch Krasnodar 2002

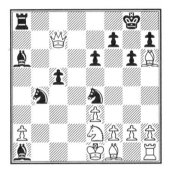

How to assess this position with Black to move?

112. A.Shirov (2697) - A.Motylev (2634)
RUS-The World Moscow 2002

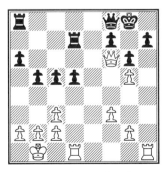

I am sure that Shirov spotted the win immediately. Can you do the same?

113. R.Vaganian (2605) - K.Müller (2558)
German Bundesliga 1999

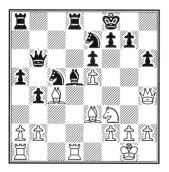

Find White's best move!

114. R.Vera (2509) - I.Nataf (2549)
TIM2003 Montreal 2003

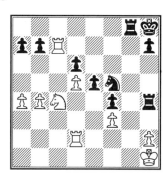

Black started a typical King's Indian attack. Can you do the same?

115. S.Movsesian (2659) - V.Belov (2549)
4th IECC Istanbul 2003

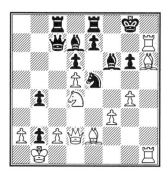

Slay the dragon!

116. J.Arizmendi Martínez (2503) - V.Tukmakov (2566)
Biel MTO op 2002

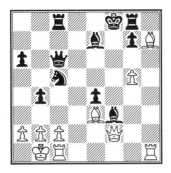

How to continue White's attack?

117. E.Agrest (2563) - E.Bacrot (2653)
EU-chT (Men) León 2001

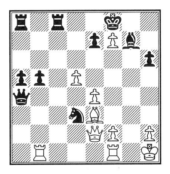

White won in an incredible fashion. Don't let Black's king off the hook!

118. R.Antonio (2519) - E.Vladimirov (2592)
Asian Cities 13th Aden 2002

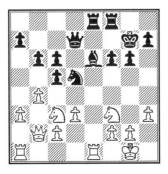

White's queen is not defending at the moment. Use this and get going!

119. L.Aronian (2562) - A.Yegiazarian (2551)
ARM-ch Yerevan 2001

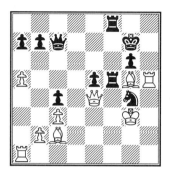

White acted boldly and quickly to blow Black's king up. Can you spot how?

120. B.Avrukh (2595) - E.Sutovsky (2657)
ISR-ch Tel Aviv 2002

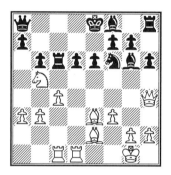

How to get at Black's vulnerable monarch?

121. E.Bacrot (2653) - R.Kasimdzhanov (2674)
FIDE GP Moscow 2002

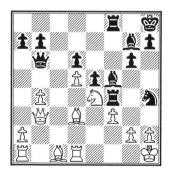

How did Black sacrifice?

122. E.Bacrot (2653) - V.Kramnik (2809)
Grand Prix du Senat Paris 2002

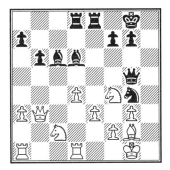

Black's mighty attacking force brought him victory. What did Kramnik play?

123. E.Bareev (2702) - V.Akopian (2660)
Dortmund SuperGM 2000

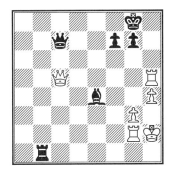

Has Black more than a draw?

124. A.Barsov (2525) - Zhang Zhong (2657)
Hastings 2001

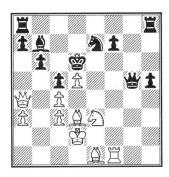

How to get at Black's king?

125. P.Blatny (2512) - J.Horvath (2557)
Budapest zt 1.4 2000

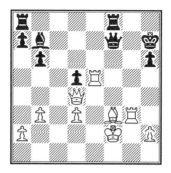

White opened the floodgates. Can you do the same?

126. D.Campora (2513) - O.Korneev (2600)
Coria del Rio 2001

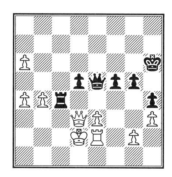

Can Black to move use his initiative?

127. L.Dominguez (2596) - A.Wojtkiewicz (2573)
Carlos Torre mem 14th Mérida 2001

White started a violent fire here. Can you spot how?

128. A.Dreev (2677) - K.Georgiev (2654)
FIDE GP Moscow 2002

White has something better than trying to convert his extra piece. Find it!

129. A.Dreev (2690) - S.Tiviakov (2635)
XII It I Dos Hermanas 2003

White started a murderous attack. Can you spot how?

130. D.Fridman (2621) - I.Nataf (2559)
4th IECC Istanbul 2003

White's defense looks vulnerable. How to shatter it?

131. I.Glek (2553) - S.Volkov (2554)
Korinthos op 4th 2000

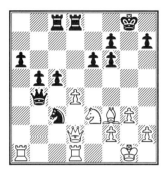

How to get close to Black's open king?

132. M.Golubev (2528) - A.Grischuk (2702)
German Bundesliga 2003

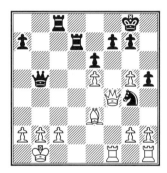

How to strengthen Black's attack?

133. A.Grischuk (2666) - A.Graf (2610)
WchT 5th Yerevan 2001

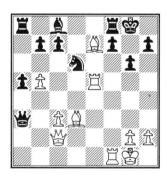

Black's king has very few defenders. Too few actually, as White proved. Can you do the same?

134. M.Gurevich (2667) - V.Milov (2626)
Lost Boys op Amsterdam 2000

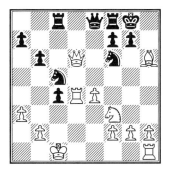

How to deal with Black's threat 1...♘b3+ ?

135. S.Hansen (2545) - S.Tiviakov (2628)
North Sea Cup 17th Esbjerg 2002

What is your opinion: Has White's attack dried up or is it still a strong flood?

136. A.Hauchard (2527) - M.Narciso Dublán (2529)
FRA-chT France 2001

How to develop Black's attack?

137. F.Hellers (2605) - M.Markovic (2515)
chT-SWE 2003

Can Black manage to strike first?

138. V.Iordachescu (2594) - L.van Wely (2643)
ROM-chT Eforie Nord 2000

To take on e5 or not to take on e5, that is the question here.

139. A.Karpov (2690) - M.Taimanov (2530)
October Revolution 60 Leningrad 1977

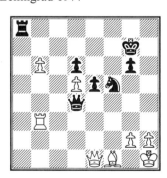

This is Mark Taimanov's most famous victory. How did he overcome the world
champion's resistance?

140. G.Kasparov (2851) - A.Shirov (2751)
Fujitsu Siemens Giants Frankfurt 2000

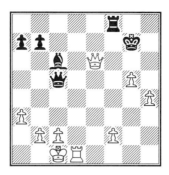

How did Kasparov conduct his attack?

141. A.Khalifman (2690) - P.Acs (2591)
Essent Crown Hoogeveen 2002

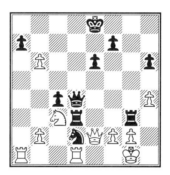

How did Peter Acs take an axe to the palace of White's king?

142. V.Korchnoi (2634) - P.Kotsur (2579)
Olympiad Bled 2002

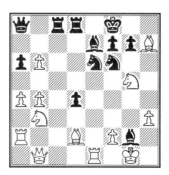

Victor Korchnoi can still strike very hard as the next two examples show. In both cases it is White to move and win.

143. V.Korchnoi (2633) - D.Solak (2501)

Hilton op 4th Basel 2002

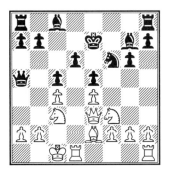

144. A.Korotylev (2550) - E.Alekseev (2567)

RUS-chT 9th Ekaterinburg 2002

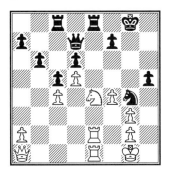

How did White use his powerful pieces to destroy Black?

145. H.Langrock (2171) - C.Engelbert (2209)

Hamburg-ch int 2000

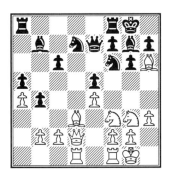

White cracked the nutshell round the enemy king with ease. Can you spot how?

146. B.Macieja (2588) - R.Kempinski (2595)
POL-chT Glogow 2001

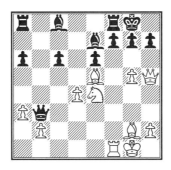

How to storm Black's citadel?

147. I.Miladinovic (2518) - J.Hickl (2605)
Bled ol (Men) 2002

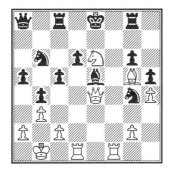

How to justify White's sacrifice?

148. V.Milov (2606) - M.Chiburdanidze (2516)
EU-ch 3rd Batumi 2002

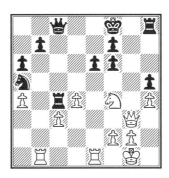

How did White open lines for the attack?

149. N.Mitkov (2532) - S.Rublevsky (2670)
EUCup 16th Neum 2000

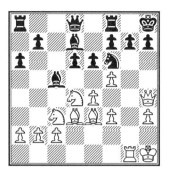

How did White open the floodgates?

150. A.Motylev (2552) - A.Iljushin (2515)
RUS-ch 53rd Samara 2000

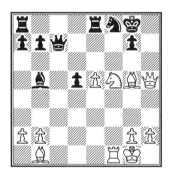

How to destroy the black king's bastion?

151. S.Movsesian (2624) - E.Sutovsky (2660)
SVK-ch Kaskady 2002

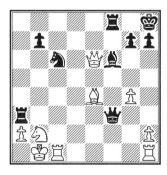

A very cold wind blows around the ears of White's monarch. How to make it a thunderstorm?

152. P.Nikolic (2652) - A.Anastasian (2588)
FIDE-Wch K.O. Moscow 2001

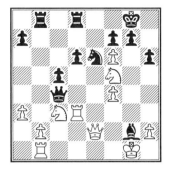

Should White take the bishop g2 or strike elsewhere?

153. T.Oral (2550) - D.Navara (2580)
CZE-ch Luhacovice 2003

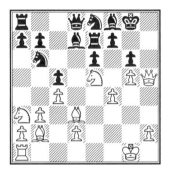

White has sacrificed a rook. What was his point?

154. J.Polgar (2715) - F.Berkes (2578)
It Budapest 2003

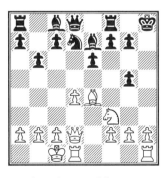

Take the rook on a8 or strengthen the attack?

155. R.Ponomariov (2630) - S.Conquest (2529)
3rd Torshavn op 2000

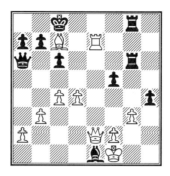

How to conquer Conquest?

156. A.Skripchenko (2501) - M.Ulibin (2562)
5th Dubai op 2003

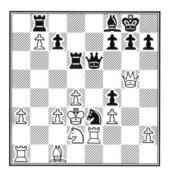

How to punish the white king's frivolity?

157. P.Smirnov (2511) - A.Motylev (2601)
RUS-ch 54th Elista 2001

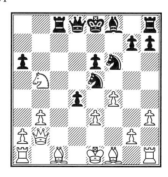

How to assess this position with Black to move?

158. P.Svidler (2689) - M.Adams (2755)

EUCup 16th Neum 2000

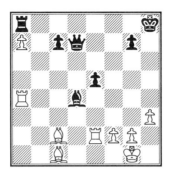

Find White's best move!

159. V.Topalov (2739) - E.Bareev (2707)

Amber-rapid 11th Monaco 2002

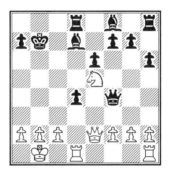

Can White get at Black's king or is it safe?

160. V.Topalov (2745) - E.Bareev (2726)

Candidates semifinal playoff Dortmund 2002

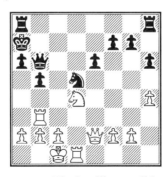

White must seize this moment or Black will consolidate. But how?

161. P.Tregubov (2628) - S.Atalik (2537)
EU-ch 2nd Ohrid 2001

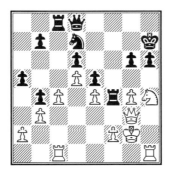

Black is positionally better, but White is to move ...

162. R.Vaganian (2667) - A.Berelovich (2541)
German Bundesliga 2002

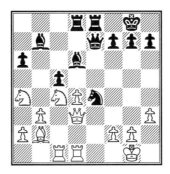

The clouds are gathering around White's king. How did Black start the storm?

163. F.Vallejo Pons (2554) - P.Blehm (2518)
EU-ch U20 Aviles 2000

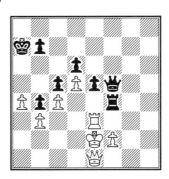

How did Black exploit the disharmony in White's camp?

164. L.van Wely (2681) - P.Acs (2591)
Essent Crown Hoogeveen 2002

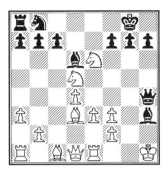

Peter Acs has used his bishop as an axe, and now he axed Van Wely. Can you spot how?

165. L.van Wely (2646) - A.Jussupow (2628)
Fujitsu Siemens Masters Frankfurt 2000

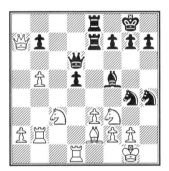

Black's attackers outnumber the defenders. But where to strike first?

166. L.van Wely (2697) - J.Timman (2605)
Corus Wijk aan Zee 2002

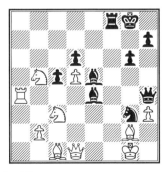

How to crown Black's attack?

167. R.Vera (2534) - W.Arencibia (2542)
CUB-ch Holguin City 2002

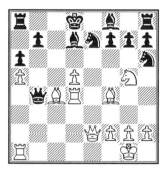

Black is underdeveloped and there is no harmony in his camp. But how to exploit this?

168. R.Vera (2544) - B.Kurajica (2548)
Benidorm Hotel Bali 2002

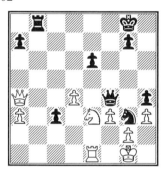

Black to move and win.

169. S.Volkov (2558) - M.Grabarczyk (2506)
EU-ch 2nd Ohrid 2001

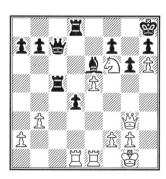

Such a well-posted knight usually spells trouble. But how did White get at Black's king?

170. A.Volokitin (2551) - A.Crisan (2635)
Vidmar mem Portoroz 2001

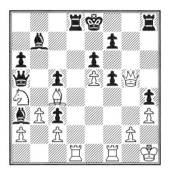

Black's king is not very safe. How did the young Ukrainian exploit this?

171. A.Zontakh (2576) - B.Ivanovic (2502)
Niksic 2000

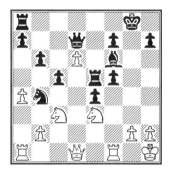

Black only needs one more move to consolidate. Don't give him the chance!

172. Bu Xiangzhi (2601) - C.Sandipan (2510)
41st WJun Goa 2002

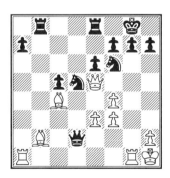

How to profit from the pressure against g7?

173. B.Vladimirov - A.Zakharov
Agler Trud-ch 1969

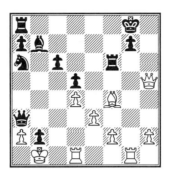

Whose attack comes first? White is to move.

174. M.Apicella (2501) - N.Giffard (2317)
FRA-chT 2003

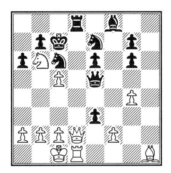

Where should White's queen go?

175. A.Fedorov (2646) - A.Gershon (2502)
EU-ch 1st Saint Vincent 2000

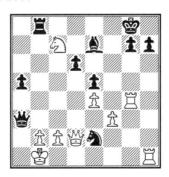

White now forced mate. Can you spot how?

176. Zhang Pengxiang (2550) - Y.Seirawan (2618)
Tan Chin Nam Cup Qingdao 2002

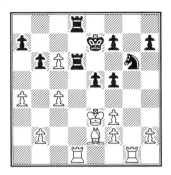

Should Black just take on c6?

177. C.Lutz (2595) - L.Ftacnik (2608)
German Bundesliga 2001

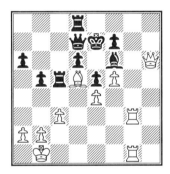

White's next move came down like lightning from a clear blue sky. Find it!

178. R.Janssen (2469) - I.Sokolov (2647)
Essent ch-NED Leeuwarden 2002

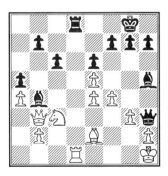

Black to move and win.

179. Z.Kozul (2611) - Z.Ribli (2569)
SLO-chT Bled 2000

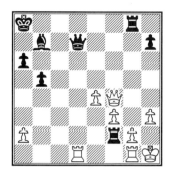

How to convert Black's advantage?

180. P.Morphy - C.Maurian
New Orleans knight odds 1869

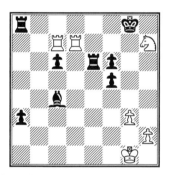

How to assess this position with White to move?

181. A.Cramer - P.Zilverberg
Leeuwarden op 1992

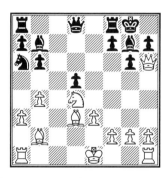

To where should White's queen retreat?

Vacating Lines and Squares
Free your pieces!

Sometimes open lines are more valuable than material. The same applies of course to the ability to block lines or squares that the opponent could use for his forces. The young grandmaster Arkadij Naiditsch got a brilliancy prize for the following masterpiece:

A.Naiditsch (2586) - F.Zeller (2454)
GER-ch 74th Saarbrücken 2002

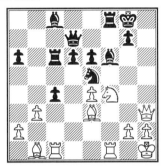

28.♘g6!! the knight is sacrificed on an empty square to open the diagonal b1–h7. **28...♘xg6 29.e5!** The prelude to a powerful kingside attack. The finish could also have been used in the previous chapter: **29...♘xe5 30.♕h7+ ♔f7 31.♖xf6+!** Blows the first important defender away. The next hammer blow follows soon. **31...♔xf6 32.♖f1+ ♔e7 33.♕xg7+ ♘f7 34.♖xf7+!** This second exchange sacrifice opens the floodgates. **34...♖xf7 35.♗g5+ ♔e8 36.♕g8+ 1-0** And Frank Zeller had seen enough and resigned. A possible finish is **36...♖f8 37.♗g6+ ♕f7 38.♗xf7+ ♔d7 39.♕xf8 cxb3 40.♕d8#.**

Exercises (Solutions on page 252)

182. Zinn - Sveshnikov
Decin 1974

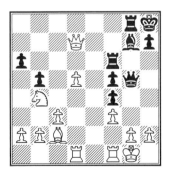

How to use Black's battery?

183. Ivkov - Portisch
Bled 1961

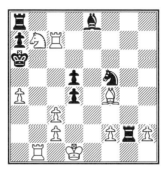

How did White force mate?

184. Rotstein - Katalymov
USSR 1952

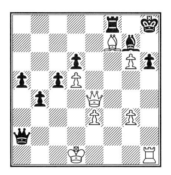

Black's passed pawns look menacing. But it is White's move...

185. R.Lima – T.Kingston
Corr, USCF 83-VM-31, 1983

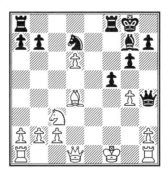

White here played 16.♗xg7. Should Black simply recapture, or can he do better?

The Mighty Knight
"A horse! A horse! My kingdom for a horse!"

The knight is a very tricky and tactical piece. Whenever it moves it loses control of all the squares it had just been protecting. It has a short range and always moves from a light to a dark square or vice versa. It is hard to maneuver and very sensitive to the square complex it is on. It may prove extremely difficult to redirect, e.g. to go from e4 to g6 it needs at least four moves. In the center it has eight moves on an otherwise empty board, while in the corner only two and at the edge three or four. But it can nevertheless be a far-reaching octopus:

R.Hübner (2640) - T.Luther (2538)
GER-ch 74th Saarbrücken 2002

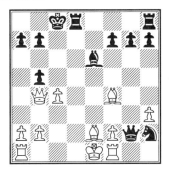

17...♛xf1+!! 17...♞xf1? 18.cxb5 gives White some counterchances. **18.♗xf1 ♞f3+ 19.♚e2 ♞d4+ 20.♚d2 ♞c6+ 21.♛d6 ♖xd6+ 22.♗xd6 ♗xc4 23.♚c3 ♖d8−+** And Black converted his two extra pawns later.

One of the main tactical motifs is of course the knight fork:

A.Shchekachev (2546) - R.Dautov (2617)
Mainz Ordix op 2002

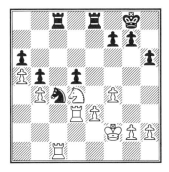

26...♞e5 26...♞b2!? works as well. **27.♖dc3** 27.♖xc8 ♞xd3+ 28.♚e2 ♞xf4+ 29.♚f3 ♖xc8−+; 27.fxe5 ♖xc1−+. **27...♞d3+** This fork wins an exchange, which

allows Dautov to coast home to victory: **28.♖xd3 ♖xc1 29.♘f5 ♖b1 30.♖d4 ♖e4 31.♖xd5 ♖bxb4 32.♖d8+ ♔h7 33.g4 g6 34.♘d6 ♖e7 35.♘e8 f5** 35...♖a4?? 36.♘f6+ ♔g7 37.g5 +−. **36.♘f6+ ♔g7 37.♘d5 ♖b2+ 38.♔f3 ♖a7 39.h4 ♖d2 40.h5 b4 41.hxg6 fxg4+ 42.♔xg4 b3 43.e4 ♖b7 44.f5 b2 45.f6+ ♔xg6 46.♖g8+ ♔h7 47.♘e7 ♖xe7!** 47...b1♕?? 48.♖g7+ ♔h8 49.♘g6#. **48.fxe7 ♖g2+ 0–1**

Exercises (Solutions on page 253)

186. K.Müller (2518) - M.Holzhäuer (2407)
GER-ch 74th Saarbrücken 2002

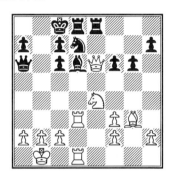

Find White's most convincing way to victory!

187. E.Sutovsky (2657) - I.Smirin (2683)
ISR-ch Tel Aviv 2002

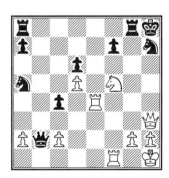

White forced mate. Can you do the same?

188. L.Ljubojevic (2570) - A.Morozevich (2678)
Amber blindfold Monte Carlo 2003

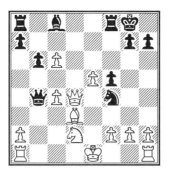

Is Black's knight strong or weak?

189. A.Shabalov (2613) - V.Akobian (2531)
USA-ch Seattle 2003

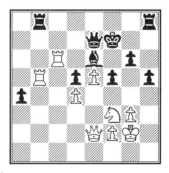

Find White's best move!

190. E.Sutovsky (2597) - M.Chandler (2527)
Hastings Premier 2000

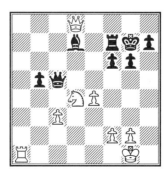

White won easily. Can you spot how?

191. D.Tyomkin (2516) - B.Chatalbashev (2522)
Verona op 2000

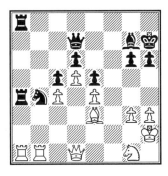

How to assess this position with Black to move?

192. E.Gausel (2504) - L.Johannessen (2525)
NOR-ch Roros 2002

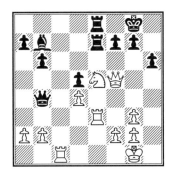

Black has attacked two pawns. How to react?

193. S.Conquest (2529) - Y.Yakovich (2585)
EU-ch 1st Saint Vincent 2000

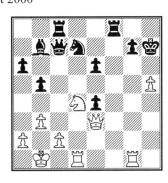

Conquest came, saw, and conquered. How?

194. A.Rychagov (2506) - H.Banikas (2542)
GRE-chT 29th Athens 2000

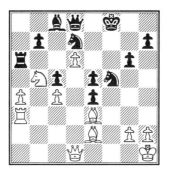

Black's pieces lack coordination at the moment. Don't give him time, strike!

195. A.Grischuk (2606) - R.Ponomariov (2630)
3rd Torshavn op 2000

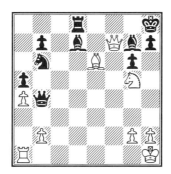

White to move and win.

The Pin
Pin and win

A piece is pinned, if it is between a valuable piece of its own and a less valuable piece of the opponent that attacks along the same line. A pin is absolute if the pinned piece shields the king; it is relative if the pinned piece is allowed to move. To move it loses the more valuable piece behind it, of course. If it is pinned in two directions then it is said to be "cross-pinned" (sometimes called a Maltese cross). An example is Pidorich vs. Chernusov in the exercises. The usual method to exploit a pin is to attack the pinned man, or to exploit its immobility:

L.Ljubojevic (2566) - V.Ivanchuk (2717)
Amber blindfold 10th Monte Carlo 2001

Black's rook on c5 is pinned. White won with **32.♖c2! 1–0**. But not 32.♖a5?? as that is only a relative pin and the rook can move away with check: 32...♖c1+−+.

The next example illustrates the whole procedure:

I.Smirin (2666) - A.Grischuk (2581)
New York op 2000

First the knight is pinned: **40.♖d1! ♕c5** 40...♕c7 41.♕c4 ♕b7 42.♖d4+−. **41.♕c4 ♕d6 42.♕d4! ♖d7 43.♘e5 ♖d8** 43...♖e7 44.♘c4 ♕d7 45.♘e3+− *(45.♕xd5?? is refuted by 45...♖e1+!).* **44.♘c4 ♕f8 45.♘b6 1–0**

Exercises (Solutions on page 254)

196. F.Berkes (2541) - Cao Sang (2507)
Budapest FS12 GM-A 2001

Black's last move 1...♘d5-c7? was highly unfortunate. Why?

197. B.Gelfand (2704) - L.Bruzón Bautista (2613)
Bled ol (Men) 2002

The bishop on d7 is doomed. But how to win it?

198. E.Ghaem Maghami (2513) - A.Aleksandrov (2645)
Goodricke 13th op Calcutta 2002

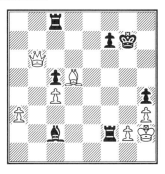

How did White convert his advantage?

199. J.Hickl (2556) - Z.Lanka (2503)
AUT-chT 2000

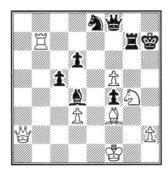

White used the old rule "pin and win." How?

200. S.Iuldachev (2515) - E.Vladimirov (2598)
Penta Media GM Kelamabakkam 2000

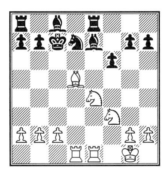

Black's lack of development spells trouble. How to exploit it?

201. S.Karjakin (2547) - A.Kosteniuk (2456)
Brissago Dannemann m 2003

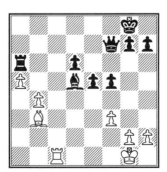

White won very beautifully. Can you spot his amazing combination?

202. K.Müller (2425) - J.van Mil (2430)
Cansys Budapest 1991

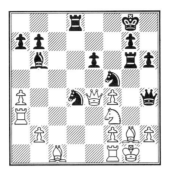

How did Van Mil finish me off?

203. D.Paunovic (2532) - A.Karpov (2688)
Benidorm Hotel Bali 2002

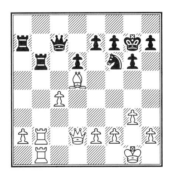

A *petite combinaison* brought Karpov a long-lasting advantage. What did he play?

204. Pidorich - Chernusov
Tjumen 1981

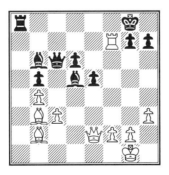

How did White construct a Maltese Cross?

205. L.Psakhis (2611) - F.Nijboer (2537)
Vlissingen HZ op 2000

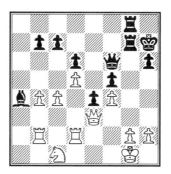

Black must act quickly before White consolidates. Can you spot his next move?

206. G.Sax (2566) - E.Berg (2503)
Hamburg-ch int 2002

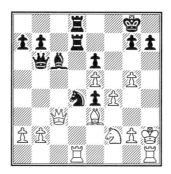

How to exploit the pin of the knight on d4?

207. J.Speelman (2603) - T.Luther (2604)
German Bundesliga 2002

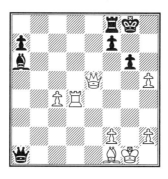

Whose attack is stronger? Black is to move.

208. S.Volkov (2636) - V.Nevostrujev (2502)
RUS-ch Krasnodar 2002

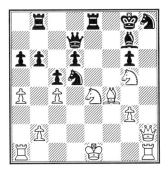

How to deal with White's attack?

The Skewer
Force it out of the way!

This term was coined by the Liverpool school teacher Edgar Pennell in 1937. It means that a long-range piece attacks a man that has to move out of the way, after which another man that lies beyond can be taken. The following position shows a line skewer for Black and a diagonal skewer for White:

Illustrative Example

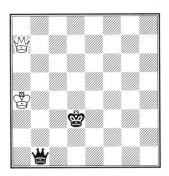

1.♕h7+! wins the queen. Black to move wins with **1...♕a1+** or **1...♕a2+.**

Exercises (Solutions on page 255)

209. L.Fressinet (2536) - V.Tukmakov (2582)
Salona Solin/Split 2000

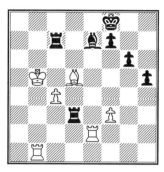

Is White's king active or exposed? Black is to move.

210. I.Morovic Fernandez (2551) - A.Zapata (2543)
Capablanca mem Elite Havana 2003

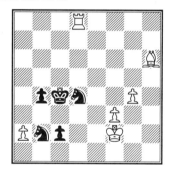

How to deal with Black's passed c-pawn?

211. D.Solak (2515) - V.Popov (2579)
EUCup 18th Halkidiki 2002

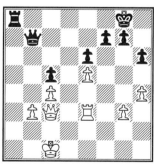

How did Black start the hunt?

212. N.Short (2685) - A.Karpov (2725)
Candidates sf1 Linares 1992

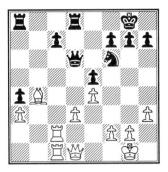

Was 1...♕xd3 a wise decision?

213. Illustrative Example

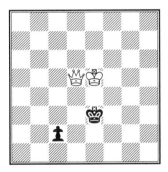

White's king is outside the winning zone, isn't it? Nevertheless, it is White to move and win.

214. Rey Ardid
Dedicated to H.Rinck 1938

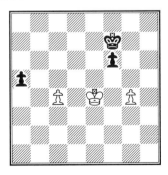

Black has the more remote passed pawn. Is he winning ? (White is to move.)

215. I.Madl (2408) - M.Chiburdanidze (2545)
EU-ch (Women) Batumi 2000

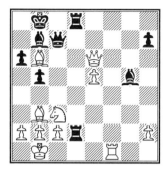

Not all skewers are deadly. How did Black counteract this one?

Trapped Pieces
Mobility is important

If pieces are restricted in their mobility, you have to watch out for possibilities to trap or dominate them completely, for example:

M.Apicella (2506) - L.Fressinet (2536)
FRA-ch Pool B Vichy 2000

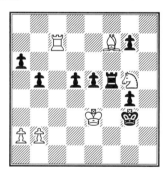

Apicella decided to keep it simple by dominating Black's rook, forcing it into passivity, a very strong idea, because a rook is at its best in the endgame when it can create active counterplay. It does not like passivity at all:

39.♗xd5!? ♖xg5 40.♗e4 ♔h3 40...♖h5 41.♖xg7 ♖h2 42.♗f5 ♖xb2 43.♖xg4+ ♔h2 44.♗e6+−. **41.♖c1 g3** 41...a5 42.a3 b4 43.axb4 axb4 44.♔f2 g3+ 45.♔g1 ♔h4 46.♖c4+−. **42.♖h1+ ♔g4** White has surrounded Black's pieces. **43.b4 1−0** Black resigned as his rook is dominated after **43...g2** 43...♖h5? 44.♗f3++−. **44.♗xg2 ♔f5 45.♗e4+** 45.♖f1+ wins as well. **45...♔e6 46.♔f3+−.**

Exercises (Solutions on page 256)

216. H.Gretarsson (2505) - H.Stefansson (2588)
ISL-ch Seltjarnarnes 2002

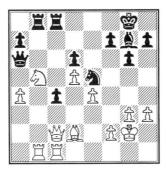

Did White play 1.♗c3 here?

217. Z.Gyimesi (2602) - P.Svidler (2695)
2nd German Bundesliga 2002

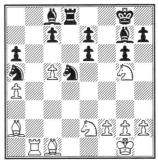

It is incredible that two players of this caliber played in the *2nd* German league. But Svidler (2695 at the time) is even stronger than Gyimesi (2602). How did he prove it?

218. N. deFirmian (2567) - A.Ivanov (2567)
USA-ch Seattle 2000

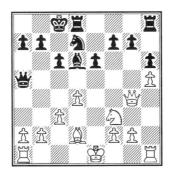

Can White take on g7 now?

219. V.Mikhalevski (2501) - D.Rogozenko (2548)
WCN K.O. int 2001

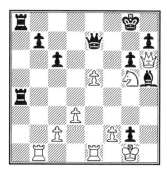

Such a pawn on g2 may shield White's king, or it may spell doom. What is the case here? (Black is to move.)

220. V.Neverov (2562) - E.Vladimirov (2612)
Dubai op 2001

To take on e6 or not to take on e6?

221. R.Hübner (2625) - R.Vaganian (2667)
German Bundesliga 2003

"All rook endings are drawn," they say, but this is an exception. What surprise did Black uncork?

X-Ray Attack
There is more than meets the eye

You know of course, what the term "a piece is attacked" means. But what on earth is an x-ray attack? Let me explain it this way: when the attacking line of a long-range piece is blocked by another piece, but the attacker has a way to use this influence through the blockading piece, like in the following example:

Csanadi - Pogats
Hungary 1963

The bishop on d6 is pinned, and the diagonal b8-h2 is blocked by White's queen, but the bishop's influence is nevertheless felt on h2: **1...♛xh2+!! 2.♛xh2 2.♚xh2 ♗xe5+ 3.f4 ♖xd1 –+ ; 2.♚f1 ♛xe5 –+. 2...♗xh2+ 3.♚xh2 ♖xd1 0–1**

Exercises (Solutions on page 256)

222. V.Jansa - V.Antoshin
Chigorin mem Sochi 1965

The x-rays from the ♗b7 are felt even on h1. But how should Black use them?

Zugzwang
One of the sharpest endgame weapons

Usually it is an advantage to have the right to move. You can create or parry threats, or just follow your strategic plan. But when all your pieces are already optimally placed the right to move is a real curse: you don't want to move, but you have to! This occurs most often in endgames, like the following:

V.Topalov (2739) - A.Karpov (2693)
Cannes NAO Masters 2002

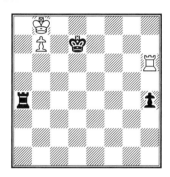

70.♖h7+!? ♔d8

70...♔d6 71.♔c8 ♖c4+ 72.♔d8 ♖b4 73.♖h6++−.
70...♔e6 71.♔c7 ♖c4+ 72.♔b6 ♖b4+ 73.♔c5 ♖b1 74.♖h6+ ♔f5 75.♖b6 ♖c1+ 76.♔d6 ♖d1+ 77.♔e7 +−.

71.♖h8+ ♔d7 72.♖h6! Topalov has deliberately lost a tempo in order to create zugzwang: Black's rook must protect h4 and the a-file, his king the squares c8, c7 and d6, and his pawn obviously can't move. The strong endgame fox Karpov is outfoxed! **72...♔d8 73.♖h7!?** Zugzwang is a very sharp weapon! **73...♖b4 74.♔a7 ♖a4+ 75.♔b6 1–0**

In rare cases zugzwang can occur in the middlegame as you will see in the exercises.

Exercises (Solutions on page 256)

223. A.Minasian (2473) - M.Marin (2556)
EU-ch 3rd Batumi 2002

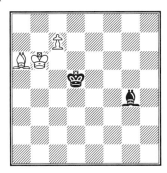

Prove that White wins regardless of who moves first.

224. M.Podgaets - M.Dvoretsky
URS-ch sf Odessa 1974

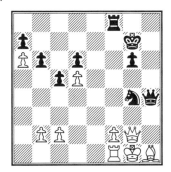

What did the famous Russian trainer Mark Dvoretsky play now?

225. E.Kengis (2594) - J.Heissler (2455)
German Bundesliga 2002

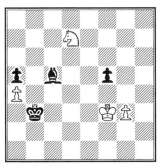

Black's bishop is much better than White's lame knight. But how to convert this into a full point?

226. J.Ehlvest (2589) - A.Khalifman (2688)
Keres mem rap Tallinn 2002

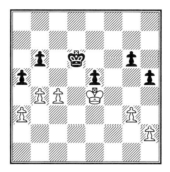

White's path to victory is very narrow. Find it!

227. Claus Dieter Meyer

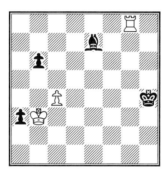

How can White outwit Black? A tough nut to crack!

228. After Maiselis

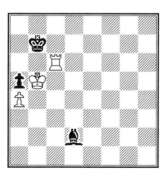

White has to confine Black's king near the a8 corner in order to convert his extra exchange using zugzwang. Can you see how?

The Zwischenzug
Chess is not checkers!

Zwischenzug is German for "in-between move." It should remind you that in chess there is no automatic capture or recapture. Only when your king is in check are you absolutely required to deal with it. In all other cases you can ignore threats and captures as long as you are sure that your zwischenzug is so strong that your opponent can't just carry on with his plans. A very common form of zwischenzug is a zwischenschach (in-between check):

P.San Segundo Carrillo (2523) - R.Vera (2544)
Benidorm Hotel Bali 2002

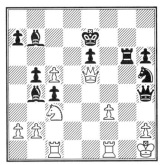

22.♕c7+ ♔f8 23.♕b8+! The immediate 23.♕xb7? loses to 23...♘g3+ 24.♔g2 ♘xf1+ 25.♔xf1 ♕h3+ 26.♔e2 ♕g2+ 27.♔e3 ♗xc5+ 28.♔e4 ♖g4+ 29.♔e5 ♕xh2+ 30.♔f6 ♕f4+ 31.♔xe6 ♕d6+ 32.♔f5 ♖f4#. **23...♔g7 24.♕xb7+** With check! **24...♔h8 25.♘e2 ♕f6 26.♕xb5 ♗d2 27.♕e8+ ♔h7 28.♕d7+** This double attack finishes Black off. **28...♘g7 29.♕xd2 ♕f5 30.♕c2 ♕h3 31.♕xg6+ 1–0** Black resigned due to 31...♔xg6 32.♘f4++−.

Exercises (Solutions on page 257)

229. U.Kersten (2331) - K.Müller (2518)
GER-ch 74th Saarbrücken 2002

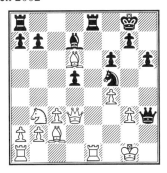

Has Black something better than 1...♘xd6 ?

230. A.Romero Holmes (2524) - D.Solak (2515)
EUCup 18th Halkidiki 2002

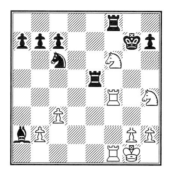

White to move and win.

231. N.Hornstein - T.Kingston
Corr, 81-NF-2 Golden Knights Finals, 1983-84

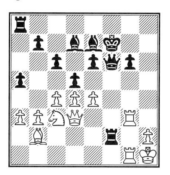

White now played 28.♖xg6. Was this a good idea or not? How should Black respond?

232. J.van der Wiel (2509) - E.van den Doel (2583)
NED-ch Leeuwarden 2002

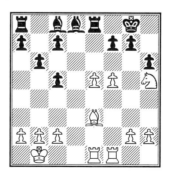

What did White miss, when he chose 1.♘h5 ?

233. A.Yermolinsky (2596) - G.Kaidanov (2624)
USA-ch Seattle 2000

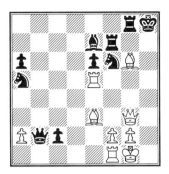

To take on a5 or not to take on a5?

Easy Exercises

You can start with the easy ones to warm up or to get to the next level. In this case you should make sure that you repeat solving them until they all seem trivial to you (de la Maza thinks that seven times is right).

Exercises (Solutions on page 258)

234. E.Bacrot (2653) - J.Lautier (2675)
Grand Prix du Senat 3rd place Paris 2002

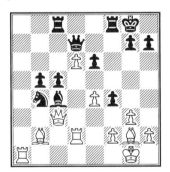

Find White's next move!

235. C.Bauer (2612) - A.Grischuk (2668)
Enghien les Bains 2001

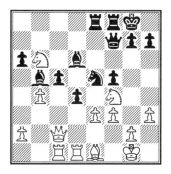

White's position looks shaky. How to make it crumble?

236. C.Bauer (2582) - V.Korchnoi (2632)
It Enghien les Bains 2003

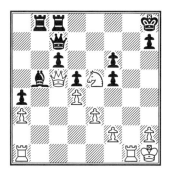

How to assess this position with White to move?

237. A.Beliavsky (2650) - Wu Shaobin (2544)
Bled ol (Men) 2002

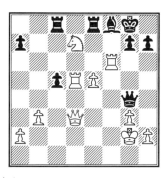

Find White's quickest win!

238. S.Brynell (2506) - V.Popov (2578)
Rilton Cup Stockholm 2002

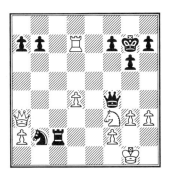

Black to move and win

239. B.Damljanovic (2587) - H.Banikas (2542)
4th IECC Istanbul 2003

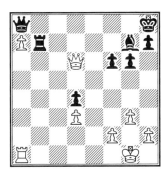

How did White justify his piece sacrifice?

240. B.Damljanovic (2545) - A.Onischuk (2655)
Skopje op 18th 2002

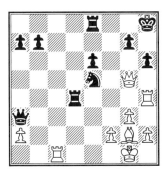

Don't lose your way in the jungle of complications! It is White to move and get a clear advantage.

241. Z.Efimenko (2546) - A.Korobov (2511)
Alushta Puchko mem 2002

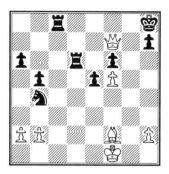

All Black pieces are unprotected. How did White use this?

242. L.Fressinet (2588) - J.Moreno Carnero (2514)
Pamplona 2002

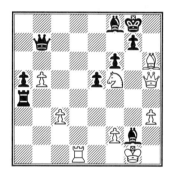

White got in first. Can you spot how?

243. B.Gelfand (2700) - J.Polgar (2715)
It Enghien les Bains 2003

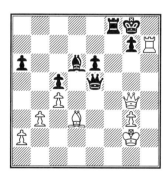

Both sides use the opposite-colored bishops for their attack. But White strikes first. Can you spot how?

244. I.Glek (2590) - A.Mikhalchishin (2533)
Zürich op 2001

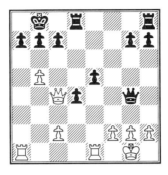

White won in typical fashion. How did he start?

245. S.Grigoriants (2506) - B.Socko (2577)
4th IECC Istanbul 2003

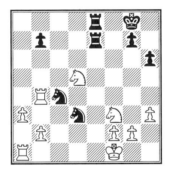

How to solve Black's problems?

246. M.Illescas Córdoba (2599) - M.Gurevich (2635)
TCh-ESP Lanzarote 2003

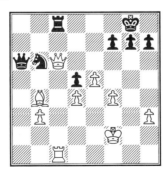

Is White losing?

247. M.Illescas Córdoba (2585) - F.Vallejo Pons (2635)
TCh-ESP Mondariz 2002

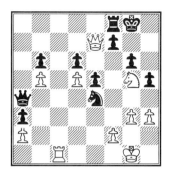

Should White exchange knights?

248. S.Iuldachev (2508) - S.Arkhipov (2500)
Abu Dhabi AdCF Masters 2001

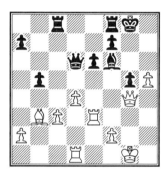

Find White's next move!

249. V.Ivanchuk (2717) - V.Kramnik (2809)
Amber blindfold 11th Monaco 2002

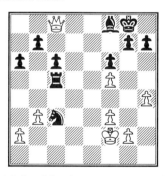

Black has enough material, but his pieces are scattered around the board. How did Ivanchuk use this?

250. D.Jakovenko (2570) - E.Ghaem Maghami (2511)
41st WJun Goa 2002

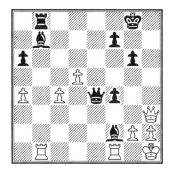

Where is Black's Achilles heel?

251. A.Khalifman (2698) - A.Beliavsky (2661)
FIDE GP Moscow 2002

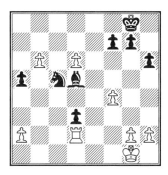

In the game it was Khalifman's turn to move. How to assess the position? What about with Black to move?

252. A.Kharlov (2638) - L.Nisipeanu (2608)
Metalska Trgovina CC 90 Ljubljana 2002

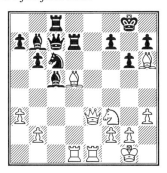

White controls the kingside and the center almost completely. How did he use this now?

253. S.Klimov (2507) - E.Solozhenkin (2514)
City-ch St. Petersburg 2003

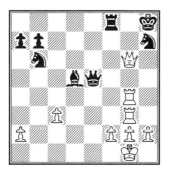

Has White's attack dried up or did he find a way to continue it?

254. A.Kogan (2540) - W.Arencibia (2540)
Capablanca mem Elite 37th Havana 2002

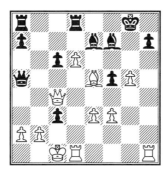

Whose attack will come in first? White is of course to move.

255. P.Kotsur (2572) - A.Skripchenko (2501)
5th Dubai op 2003

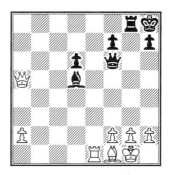

Black's position looks suspect at first sight, but Almira Skripchenko's first move shows that the contrary is in fact true.

256. M.Krasenkow (2655) - P.Wells (2522)
EU-ch 2nd Ohrid 2001

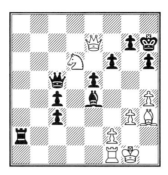

How did Peter Wells crown his original play now?

257. A.Kveinys (2522) - J.Zezulkin (2529)
POL-chT Zakopane 2000

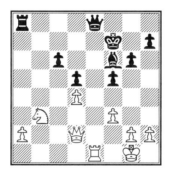

Did Black move his queen?

258. N.Legky (2507) - F.Vallejo Pons (2629)
FRA-chT France 2003

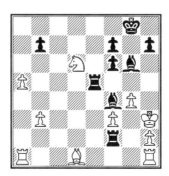

Black can force mate. How?

259. L.Ljubojevic (2570) - P.Leko (2736)
Amber rapid Monte Carlo 2003

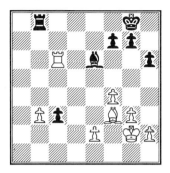

Find Black's next move!

260. V.Loginov (2524) - A.Lugovoi (2510)
St. Petersburg-ch 2002

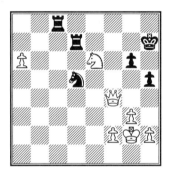

White has many ways to win, but which beautiful strike is the clearest?

261. C.Lutz (2644) - V.Korchnoi (2635)
Julian Borowski 4th Essen 2002

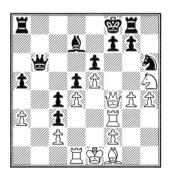

How to continue White's attack?

262. B.Macieja (2582) - B.Avrukh (2606)
FIDE-Wch K.O. Moscow 2001

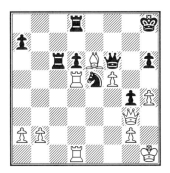

What did Macieja play?

263. G.Milos (2614) - T.Radjabov (2558)
Najdorf mem Buenos Aires 2001

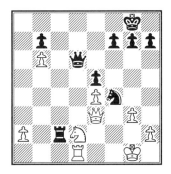

How did Black shatter White's defenses?

264. A.Moiseenko (2627) - V.Potkin (2522)
4th IECC Istanbul 2003

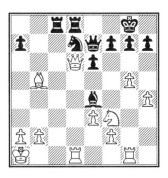

Should Black try to win the knight on f3?

265. A.Morozevich (2678) - S.Savchenko (2539)
Moscow Aeroflot op 2003

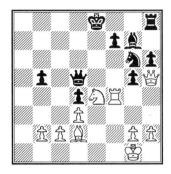

Where should White's rook go?

266. A.Motylev (2622) - P.Acs (2529)
Dubai op 2002

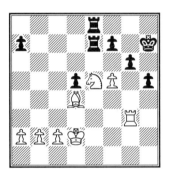

Find White's next move!

267. D.Paunovic (2532) - R.Vera (2544)
Benidorm Hotel Bali 2002

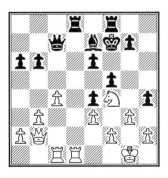

How should White deal with Black's mounting attack?

268. J.Polgar (2676) - E.Bareev (2709)
World Cup of Rapid Chess K.O. Cannes 2001

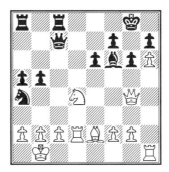

Black's bishop is a tower of power. Use it!

269. S.Rublevsky (2655) - M.Drasko (2500)
JUG-chT Budva 2002

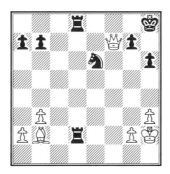

Can White to move prove that his queen is stronger than the rooks?

270. S.Rublevsky (2655) - A.Kalinin (2512)
Moscow Aeroflot op 2002

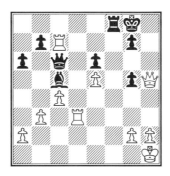

Before you suggest 1.♖xc6?, find out what Black threatens!

271. D.Sadvakasov (2523) - A.Korotylev (2586)
Moscow Aeroflot op 2003

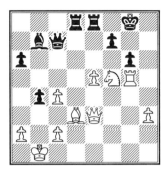

How to finish Black off?

272. S.Savchenko (2537) - S.Safin (2525)
Dieren op 2002

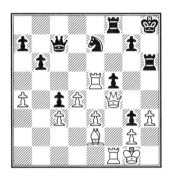

White was better anyway, but his next move made this very clear.

273. A.Shirov (2715) - J.Piket (2659)
Amber blindfold 11th Monaco 2002

Shirov started a fire on the board. Can you do the same?

274. I.Smirin (2698) - J.Ehlvest (2626)

FIDE-Wch K.O. Moscow 2001

Is Black's house safe or can White manage to open the gate?

275. I.Smirin (2676) - Y.Pelletier (2571)

Biel GM 2002

Find White's next move!

276. K.Spraggett (2526) - M.Adams (2746)

FRA-chT France 2001

How did Adams finish Black off?

277. S.Sulskis (2579) - M.Sorokin (2551)
Goodricke 13th op Calcutta 2002

White won easily. Can you spot how?

278. E.Sutovsky (2604) - A.Volzhin (2528)
EU-ch 2nd Ohrid 2001

How to play around Black's mighty battery?

279. P.Svidler (2713) - A.Delchev (2577)
National I Clermont-Ferrand 2003

Find White's next move!

280. J.Timman (2594) - T.Wedberg (2530)
chT-SWE 2002

Did Timman take on d7?

281. A.Timofeev (2521) - A.Naiditsch (2524)
Wch U18 Oropesa del Mar 2001

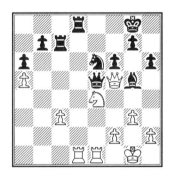

Can White justify his piece sacrifice?

282. A.Timofeev (2558) - Ni Hua (2545)
41st WJun Goa 2002

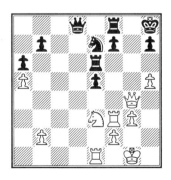

Find White's next move!

283. M.Turov (2518) - E.Vorobiov (2542)
RUS-ch Krasnodar 2002

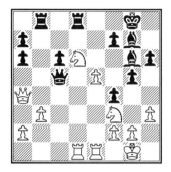

Did White take on a6?

284. L.van Wely (2714) - A.Fedorov (2599)
EU-chT (Men) León 2001

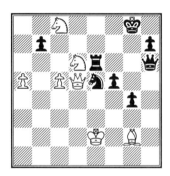

Find White's easiest win!

285. L.van Wely (2695) - E.Vladimirov (2612)
EUR-ASIA m 30' Batumi 2001

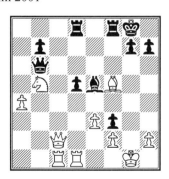

How to assess this position with Black to move?

286. E.van den Doel (2574) - P.van der Sterren (2576)
NED-ch Leeuwarden 2001

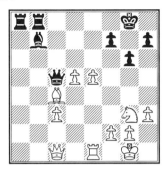

Did Van den Doel manage to break through Black's defense?

287. R.Vaganian (2623) - M.Wahls (2568)
German Bundesliga 2001

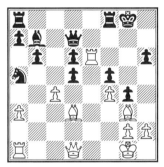

In Germany, Armenian GM Rafael Vaganian is often called "Mr. Bundesliga" because he has won so many games there. How did he axe Wahls?

288. M.Adams (2746) - A.Fedorov (2575)
Corus Wijk aan Zee 2001

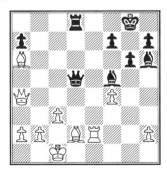

Micky Adams has snatched a pawn in the opening. Did he get away with it? (Black is to move.)

289. U.Adianto (2584) - J.Ehlvest (2622)
Japfa Classic Bali 2000

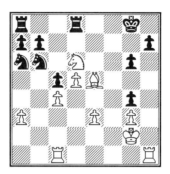

Find White's next move!

290. Z.Almasi (2640) - J.Piket (2632)
Amber blindfold 10th Monte Carlo 2001

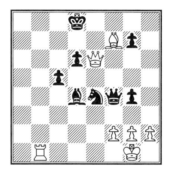

White to move would be an easy mate in two. What about Black to move?

291. L.Bruzón Bautista (2534) - D.Pavasovic (2523)
Istanbul ol (Men) 2000

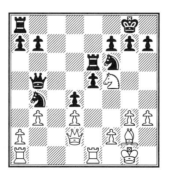

Did White play 1.♖ad1?

292. B.Chatalbashev (2518) - J.Degraeve (2589)
EU-ch 2nd Ohrid 2001

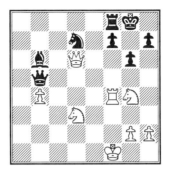

How to assess the position with White to move?

293. M.Makarov (2513) - I.Ibragimov (2611)
RUS-ch 53rd Samara 2000

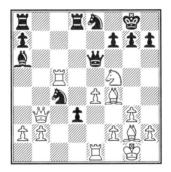

What measures did White take against Black's dangerous d-pawn?

294. V.Filippov (2593) - I.Sokolov (2611)
EU-ch 1st 30' Neum 2000

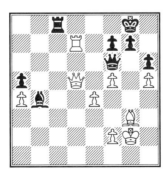

It is not easy to convert White's extra pawn, is it?

295. S.Galdunts (2510) - J.Maiwald (2509)
2nd Austrian Staatsliga 2002

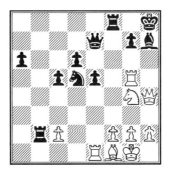

Find Black's best move!

296. L.Gofshtein (2548) - G.Kallai (2543)
FRA-chT 2001

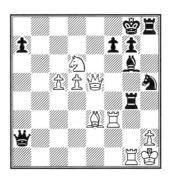

White's king is in the crosshairs. How to fire the final shot?

297. M.Grabarczyk (2508) - K.Jakubowski (2483)
POL-ch 60th Warsaw 2003

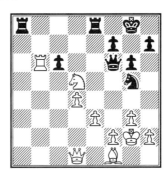

Black is an exchange up, but the win will be very far away if you don't find the best move now!

298. A.Graf (2635) - R.Schmaltz (2529)
German Bundesliga 2003

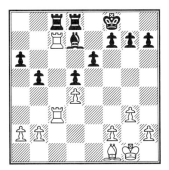

White has to act quickly before Black's king arrives in the center. What is your choice?

299. P.Haba (2517) - V.Beim (2563)
Linz op 2000

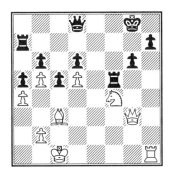

Find White's best move!

300. J.Hodgson (2640) - C.Ward (2508)
GBR-ch Millfield 2000

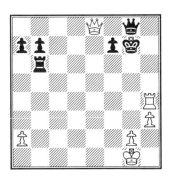

White to move and win.

301. V.Ivanchuk (2731) - V.Georgiev (2584)
EUCup 17th Panormo 2001

The opposite-colored bishops strengthen White's attack. How to continue it?

302. G.Kasparov (2849) - E.Bareev (2709)
World Cup of Rapid Chess-A Cannes 2001

How did Kasparov finish Black off?

303. A.Kovchan (2507) - Z.Efimenko (2546)
UKR-ch U20 Kramatorsk 2002

Find White's best move!

304. M.Narciso Dublán (2544) - S.Fedorchuk (2503)
EU-ch 2nd Ohrid 2001

Black has traded his bishop-pair for development. How did he profit from this?

305. Y.Pelletier (2549) - A.Jussupow (2611)
SUI-chT 2002

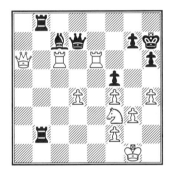

White is of course better. But how to make progress?

306. K.Müller - Z.Azmaiparashvili
ECC Rethymnon 2003

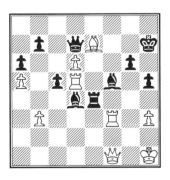

How to assess the position with Black to move?

307. J.Pinter (2547) - R.Slobodjan (2527)
FRA-chT2 2002

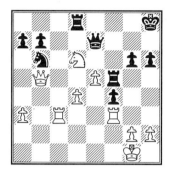

Which is Black's best move?

308. E.Prokopchuk (2508) - I.Smirin (2702)
Moscow Aeroflot op 2002

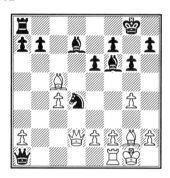

Why did White resign here?

309. I.Rogers (2558) - I.Efimov (2520)
Istanbul ol (Men) 2000

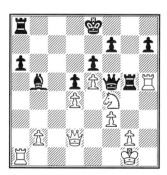

Good knight, bad bishop. White to move and win.

310. K.Sakaev (2627) - A.Zontakh (2578)
JUG-chT Novi Sad 2000

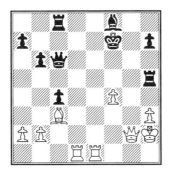

To exchange queens or not to exchange queens? That is the question here for White.

311. A.Shabalov (2601) - Y.Seirawan (2647)
USA-ch playoff Seattle 2000

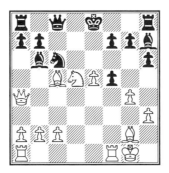

White must be winning, but how to prove it?

312. A.Shirov (2718) - A.Karpov (2679)
Amber blindfold 10th Monte Carlo 2001

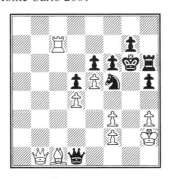

Both kings are insecure, but White is to move ...

313. K.Spraggett (2526) - J.Gallagher (2519)
FRA-chT 2001

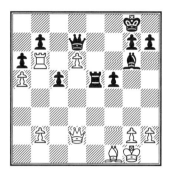

White's passed pawn is securely blockaded, isn't it? White is to move.

314. J.Sunye Neto (2555) - G.Milos (2620)
Sao Paulo zt 2.4 2000

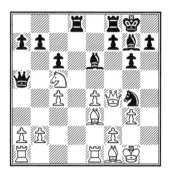

White probably expected 1...♗c8, but a rude shock awaited him.

315. P.van der Sterren (2526) - D.Reinderman (2561)
NED-chT 2000

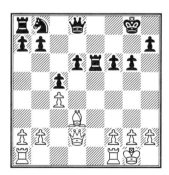

How did White capitalize on Black's lack of development?

316. E.Vladimirov (2612) - E.Bacrot (2653)
EUR-ASIA m 30 Batumi 2001

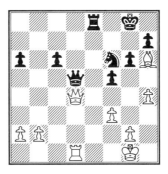

Black won by a typical motif. Which one?

317. S.Volkov (2578) - T.Luther (2604)
FIDE-Wch K.O. Moscow 2001

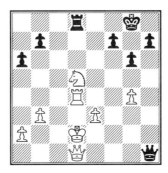

Luther had calculated well in advance that he would win now. Can you spot how?

318. M.Wahls (2568) - I.Rogers (2558)
German Bundesliga 2001

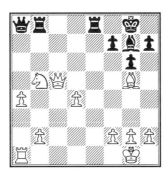

How did Rogers shatter White's stronghold?

319. Wang Pin (2504) - E.Kovalevskaya (2507)
CHN-RUS Summit (Women) Shanghai 2001

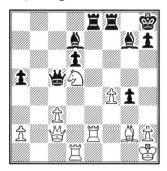

Who controls the light squares? Black is to move.

320. Ye Jiangchuan (2677) - P.Svidler (2695)
CHN-RUS Summit Men Shanghai 2001

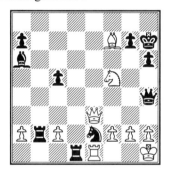

The strong Russian grandmaster Peter Svidler overlooked something, didn't he? White is to move.

321. E.Vladimirov (2612) - V.Mikhalevski (2500)
Goodricke 12th op Calcutta 2001

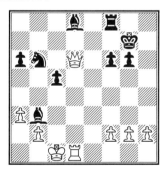

How long did this interesting material balance remain on the board? White is to move.

322. Xie Jun (2562) - Y.Seirawan (2618)
Queens-Kings Jinan 2002

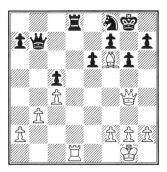

Did Seirawan exchange rooks?

323. H.Banikas (2535) - Z.Gyimesi (2518)
Bolzano op 2000

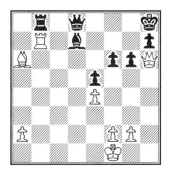

How to assess the position with Black to move?

324. A.Dreev (2676) - Peng Xiaomin (2657)
Tan Chin Nam Cup 6th Beijing 2000

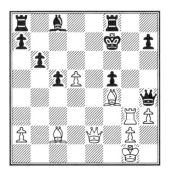

How to finish Black's king off?

325. V.Filippov (2593) - A.Korotylev (2528)
Chigorin mem op St. Petersburg 2000

How to culminate the cooperation of Black's queen and knight?

325. J.Gallagher (2514) - B.Kurajica (2534)
Istanbul ol (Men) 2000

Can you spot Black's best move?

327. A.Goldin (2566) - Y.Shulman (2552)
World op Philadelphia 2000

How did White deal with the pin on the d-file?

328. M.Krasenkow (2702) - V.Mikhalevski (2532)
EU-ch 1st Saint Vincent 2000

White's material advantage is slight and may not be at all easy to convert, but Krasenkow's next move answered all questions. Can you spot it?

329. N.Legky (2520) - I.Nikolaidis (2512)
Martínez op-A Cannes 2000

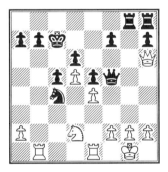

Which king is weaker? Black is to move.

330. A.Grischuk (2581) - N.Short (2683)
Reykjavik op 19th 2000

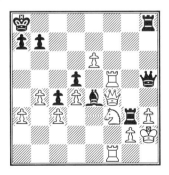

Should Black's rook on g3 move?

331. F.Vallejo Pons (2554) - V.Topalov (2707)
ESP-chT Barcelona 2000

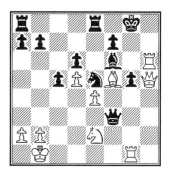

How to storm Black's barricades?

332. L.Oll (2465) - A.Yermolinsky (2445)
URS-FL Sverdlovsk 1987

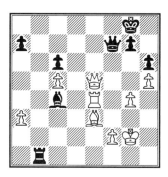

How did White conclude his attack?

333. N.Cattus - V.Tatenhorst (2230)
German Oberliga North 1992

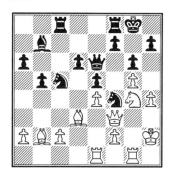

Which knight is stronger: the f4 or the g4? White is to move.

Endgames

This short chapter contains some exercises to remind you that tactics go hand in hand with technique in the endgame. If you want to learn more about this fascinating phase of the game, I suggest *Dvoretsky's Endgame Manual* (Mark Dvoretsky, Russell Enterprises 2003) or *Fundamental Chess Endings* (Müller & Lamprecht, Gambit 2001).

Exercises (Solutions on page 265)

334. Analysis of M.Tal - V.Korchnoi
Candidates sf1 Moscow 1968

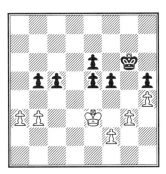

Can Black to move survive?

335. P.Acs (2591) - S.Conquest (2537)
Bled ol (Men) 2002

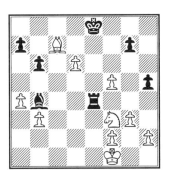

How did Acs give Black the axe?

336. R.Antonio (2547) - A.Giaccio (2505)
Istanbul ol (Men) 2000

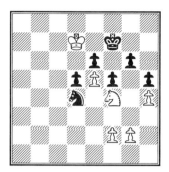

Black is on the edge of an abyss, but there still is a narrow path to survival. Find it!

337. L.Aronian (2551) - J.Plaskett (2525)
Hastings Premier 76th 2001

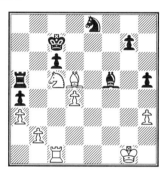

Both sides have many weak pawns, but it is White's move ...

338. K.Aseev (2577) - L.van Wely (2670)
EU-ch 2nd Ohrid 2001

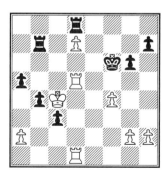

Black to move proved that his queenside pawns are more dangerous.

339. V.Baklan (2590) - A.Kovalev (2539)
EU-chT (Men) León 2001

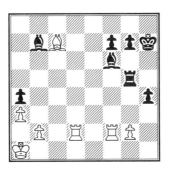

Black's bishops are a mighty force. How did they finish White off?

340. E.Bareev (2707) - L.van Wely (2697)
Corus Wijk aan Zee 2002

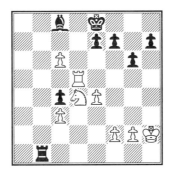

White to move and win.

341. V.Bologan (2655) - Z.Azmaiparashvili (2674)
EUCup 17th Panormo 2001

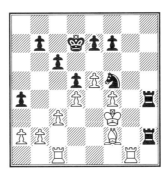

How did Black say "good night" to White's bad bishop?

342. M.Damjanovic (2455) - M.Dvoretsky (2525)
Vilnius 1978

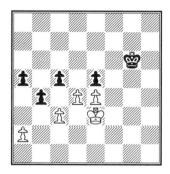

Pawn endings are usually more tricky than they look, aren't they? Black is to move.

343. A.Delchev (2587) - J.Moreno Carnero (2506)
FRA-chT 2001

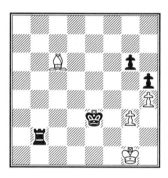

White's position is a well known fortress, but which was the move to maintain it?

344. J.Dorfman (2600) - A.Onischuk (2627)
Cap d'Agde-B 2000

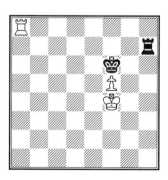

How to assess **74.罩a6+** ?

345. A.Fedorov (2598) - J.Radulski (2501)
EU-ch 3rd Batumi 2002

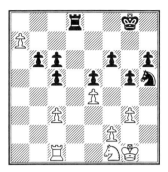

"The lord of the endgame is the passed pawn," (Cecil Purdy). How did White support it?

346. E.Gleizerov (2508) - O.Korneev (2619)
Málaga op 3rd 2000

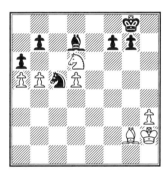

White won by using an old trick. What was it?

347. A.Grischuk (2581) - L.Fressinet (2501)
Lausanne Young Masters 2000

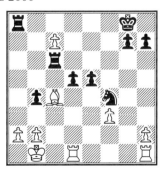

How to assess this position with White to move?

348. A.Grischuk (2702) - S.Lputian (2627)
Bled ol (Men) 2002

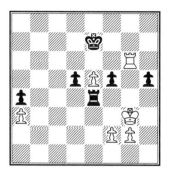

Black is better, that is clear, as he can capture on e5 for example. But aren't all rook endings drawn?

349. A.Grischuk (2671) - J.Timman (2605)
Corus Wijk aan Zee 2002

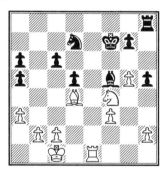

Can White to move convert his advantage?

350. D.Gurevich (2542) - Y.Seirawan (2647)
USA-ch Seattle 2000

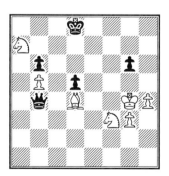

White's pieces lack coordination. How did Black exploit that?

351. J.Nielsen (2220) - P.Rewitz (2260)
Aarhus op 1989

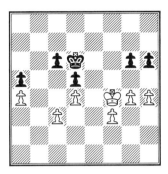

How did White break through?

352. A.Khasin (2518) - A.Shomoev (2533)
RUS-Cup03 Tomsk 2002

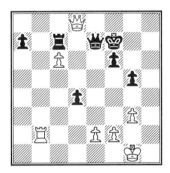

White won very easily. How?

353. V.Kramnik (2770) - G.Kasparov (2849)
BGN World Chess Championship London 2000

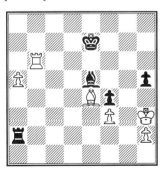

How did Kramnik lay the foundation for his victory over Kasparov?

354. K.Kuenitz (2120) - M.Dvoretsky (2475)
Bayern-chI Bank Hofmann Bad Wiessee 1997

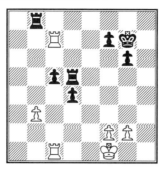

The famous Russian trainer found an instructive way to cash his advantage in. Can you do the same?

355. B.Lalic (2523) - J.Rowson (2512)
Redbus K.O. Southend 2002

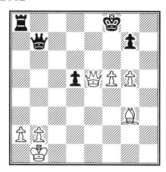

Winning when down an exchange is usually quite tricky, even when you have some pawns for it. So I advise you to play precisely to give Black no counterchances.

356. J.Lautier (2632) - V.Anand (2769)
Amber blindfold 9th Monte Carlo 2000

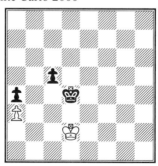

Do you know how to win this position with Black to move?

357. V.Zvjaginsev (2641) - K.Bischoff (2544)
Julian Borowski-A Essen 2000

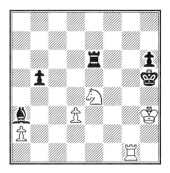

Can White make use of Black's precarious king position?

358. A.Moiseenko (2559) - B.Macieja (2612)
Moscow Aeroflot op 2002

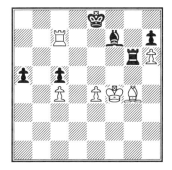

White won easily. Can you do the same?

359. J.Piket (2628) - B.Kantsler (2507)
EU-ch 2nd Ohrid 2001

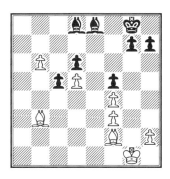

White to move and win.

360. R.Ponomariov (2684) - A.Aleksandrov (2646)
Governor's Cup Kramatorsk 2001

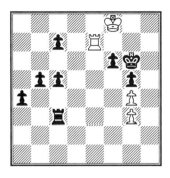

Is 1...♖xg3, 1...♖d3 or 1...f5 the right way to win?

361. O.Romanishin (2559) - S.Smagin (2613)
Julian Borowski-A 3rd Essen 2001

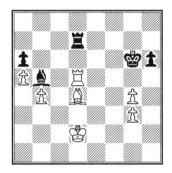

Must White content himself with a draw?

362. G.Rotlewi - H.Fahrni
Karlsbad 1911

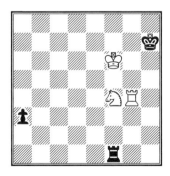

White to move and win. Is this still possible without the black pawn on a3?

363. N.Short (2663) - H.Stefansson (2604)
Arason m Reykjavik 2002

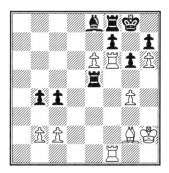

What short straw broke Black's back?

364. I.Smirin (2677) - A.Grischuk (2606)
FIDE-Wch K.O. New Delhi/Theran 2000

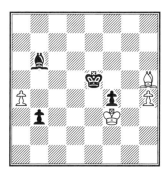

Looks like a dead draw, doesn't it? Black is to move.

365. J.Timman (2620) - N.de Firmian (2545)
Sigeman & Co Malmo 2001

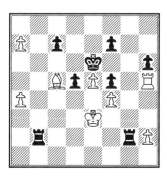

Why did Black resign here, not waiting for White's next move?

366. P.Tregubov (2594) - T.Markowski (2549)
AIG Life rapid pl 5-8 Warsaw 2002

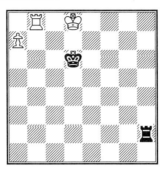

The winning method here is important for the theory of rook endings. How does White prevail?

367. L.van Wely (2695) - R.Kasimdzhanov (2704)
EUR-ASIA m 30' Batumi 2001

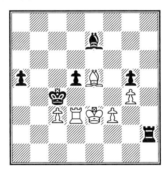

At first sight it looks drawish, but Black proved that this view is superficial.

368. S.Volkov (2636) - P.Genov (2526)
Korinthos op 6th 2002

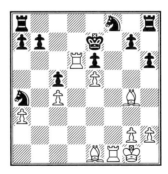

White has more than enough compensation for the pawn. How did he proceed?

369. J.Votava (2518) - B.Macieja (2629)
TCh-CZE 2003

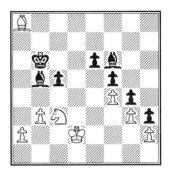

How did Black convert his bishop-pair?

370. L.van Wely (2675) - A.Aleksandrov (2650)
4th IECC Istanbul 2003

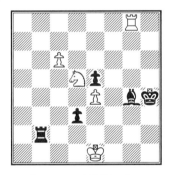

Whose passed pawn is more dangerous? White is to move.

371. P Conners (Computer) - M.Chiburdanidze (2545)
Lippstadt 10th 2000

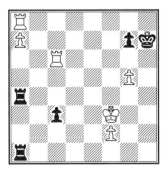

Lippstadt 2000 was the first GM tournament to be won by a computer. What was its unpleasant surprise here?

Opening Traps

Chess is a very tactical game from the very start, unlike Shogi (Japanese Chess), which usually starts with a long maneuvering phase. So have fun with the examples and let's hope that you can even use one of them later!

Exercises (Solutions on page 270)

372. Greco's Trap

1.e4 e5 2.♘f3 f6? 3.♘xe5 fxe5?

White to move and win. Calculate to the end!

373. S.Safin (2529) - S.Iuldachev (2508) [D20]
Asian-ch Calcutta 2001

1.d4 d5 2.c4 dxc4 3.e4 ♘f6 4.e5 ♘d5 5.♗xc4 ♘b6 6.♗d3 ♘c6 7.♘e2 ♗g4
8.f3 ♗e6 9.♘bc3 ♕d7 10.♘e4 ♗d5 11.♘c5 ♕c8 12.a3 e6 13.♕c2 ♗xc5
14.♕xc5 ♕d7 15.b4 a6 16.0–0?

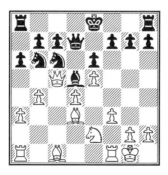

How did Black exploit White's careless last move?

374. Legall's Mate
1.e4 e5 2.♘f3 d6 3.♗c4 ♗g4 4.♘c3 h6?

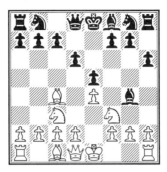

If you don't know this very famous classical trap, it is high time to enjoy it!

375. An Old Trap
1.e4 e5 2.♘f3 ♘c6 3.♗c4 ♘d4?!

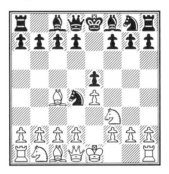

Many white players have fallen for this old trick and played **4.♘xe5?**. How were they punished?

376. Albin's Countergambit [D08]

1.d4 d5 2.c4 e5?! 3.dxe5 d4

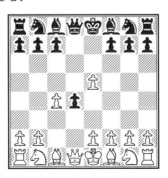

Why is the innocent looking **4.e3** a serious mistake?

377. Another Old Trap [D51]

1.d4 d5 2.c4 e6 3.♘c3 ♘f6 4.♗g5 ♘bd7 5.cxd5 exd5

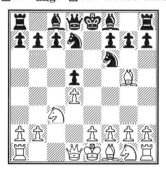

Why is **6.♘xd5** a decisive mistake?

378. The Fantasy Trap [B12]

1.e4 c6 2.d4 d5 3.f3 dxe4 4.fxe4 e5 5.♘f3 exd4?! 6.♗c4 ♗b4+? 7.c3 dxc3?

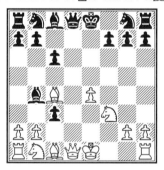

How to exploit Black's reckless play?

379. Nezhmetdinov's Trap [B86]

1.e4 c5 2.♘f3 d6 3.d4 cxd4 4.♘xd4 ♘f6 5.♘c3 a6 6.♗c4 e6 7.♗b3 ♘bd7 8.♗g5 b5 9.♗xe6 fxe6 10.♘xe6 ♛b6? 11.♘d5 ♘xd5 12.♛xd5

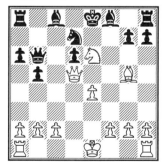

Why does 12...♗b7 lose? What is Black's best move?

380. L.Aronian (2528) - P.Harikrishna (2504) [B33]
Lausanne Young Masters 2001

1.e4 c5 2.♘f3 ♘c6 3.d4 cxd4 4.♘xd4 ♘f6 5.♘c3 e5 6.♘db5 d6 7.♗g5 a6 8.♘a3 b5 9.♗xf6 gxf6 10.♘d5 f5 11.c3 ♗g7 12.exf5 ♗xf5 13.♘c2 0-0 14.♘ce3 ♗e6 15.♗d3 f5 16.0-0 ♘e7

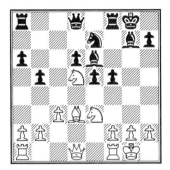

Black's last move is a typical mistake. Why?

381.P.Cirtek - K.Müller [B15]
Hamburg 1985

1.e4 c6 2.d4 d5 3.♘c3 dxe4 4.♘xe4 ♘f6 5.♘g3 h5 6.♗g5?! h4

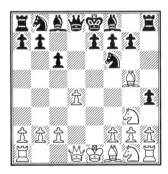

7.♗xf6? is a well known mistake. Fortunately I knew how to exploit it!

382. I.Glek (2566) - S.Arkhipov (2531) [B30]
RUS-chT Tomsk 2001

1.e4 c5 2.♘f3 ♘c6 3.♗b5 e6 4.0–0 ♘ge7 5.♖e1 a6 6.♗xc6 ♘xc6 7.d4 cxd4 8.♘xd4 ♕c7 9.♘xc6 bxc6 10.e5 ♗b7 11.♘d2 c5 12.♘c4 ♗d5?

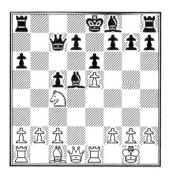

How to profit from Black's lack of development?

383. R.Kholmov (2430) - V.Fedorov (2405) [B33]
Moscow ch 1987

1.e4 c5 2.♘f3 ♘c6 3.d4 cxd4 4.♘xd4 ♘f6 5.♘c3 e5 6.♘f5 d5 7.exd5 ♗xf5 8.dxc6 bxc6 9.♕f3 ♕c8?! 10.♗a6 ♕xa6 11.♕xf5 ♗d6?

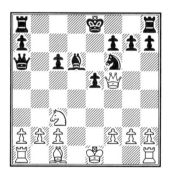

Find White's best move!

384. Siberian Trap [B21]
1.e4 c5 2.d4 cxd4 3.c3 dxc3 4.♘xc3 ♘c6 5.♘f3 e6 6.♗c4 ♕c7 7.♕e2 ♘f6
8.0–0 ♘g4

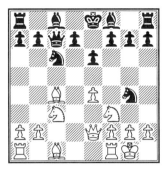

Why is **9.h3** a fatal mistake?

Find the Defense

Most chess players find it easier to attack than to defend. So training in the art of
defense is very valuable. You should not only look at your plans, but also switch
sides: what would you play as attacker? To repel onslaughts you need a clear head
and cold-bloodedness. Don't only look at passive moves, as a counterattack can
be part of the right defense. If these exercises are too difficult, you should study
the chapter on draws again. If you need further food for thought, I suggest *Secrets
of Chess Defense* by Mihail Marin, Gambit 2003.

Exercises (Solutions on page 272)

385. A.Motylev (2570) - E.Najer (2616)
Linares Anibal op 8th 2001

White's attack looks dangerous, but Black is to move. Can he defend himself?

386. S.Agdestein (2578) - M.Palac (2591)
Gibraltar Masters Catalan Bay 2003

Is 1.♖xh6+ winning?

387. J.R.Capablanca - M.Fonaroff
New York casual 1918

Capablanca played 17.♖xd6 ♖xd6 18.♗xe5. Does this win or can Black still defend?

388. R.Dautov (2606) - B.Kurajica (2534)
Istanbul ol (Men) 2000

Black has just landed a blow on f2. How do you react?

389. L.Dominguez (2608) - D.Johansen (2512)
Bled ol (Men) 2002

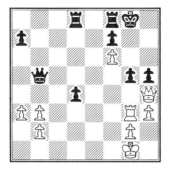

Black seems to be busted — or can he still defend?

390. B.Gelfand (2695) - J.Polgar (2718)
George Marx Rapid Match Pacs 2003

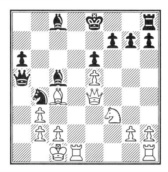

What did Black play and how did White answer?

391. F.Janz - D.Fötsch
German Youth Championship U20 Schierke 1998

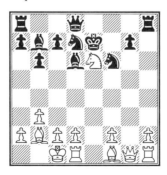

White won the last German U20 championship, but Black still had a defense here. What is it?

392. S.Klimov (2507) - E.Solozhenkin (2514)
City-ch St. Petersburg 2003

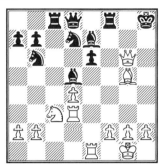

White's attack is dangerous, so you need a very clear head to find Black's defense.

393. Kunneman - NN
Berlin 1934

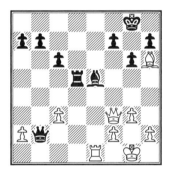

Kunneman played 1.♕f6 and soon won brilliantly. But Black had a defense. Can you find it?

394. A.Lastin (2627) - A.Sokolov (2568)
EU-ch 2nd Ohrid 2001

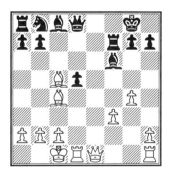

White has an attack, of course. But it is hard to believe that Black is already lost. What resource did he miss?

395. V.Neverov (2587) - P.Eljanov (2561)
Ljubljana op 13th 2002

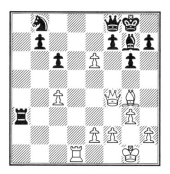

White's attack is dangerous due to the presence of opposite-colored bishops. So play carefully for Black!

396. V.Potkin (2516) - P.Zarnicki (2536)
IV Dos Hermanas int Final ICC 2003

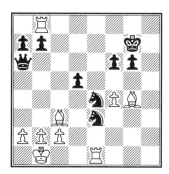

White's first move is forced. Find it! How does Black defend then?

397. E.Rozentalis (2588) - M.Turov (2550)
COQ op Quebec 2001

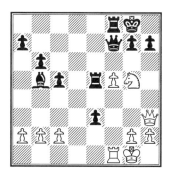

How to parry White's mating threat?

398. C.Sandipan (2510) - A.Graf (2635)
German Bundesliga 2003

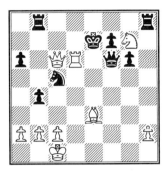

How to deal with White's onslaught?

399. A.Shirov (2723) - L.van Wely (2668)
Amber Rapid Monte Carlo 2003

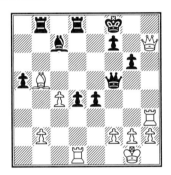

Shirov played ♖f3 to open new lines for his attack. How do you react?

400. N.Short (2684) - H.Gretarsson (2508)
Bled ol (Men) 2002

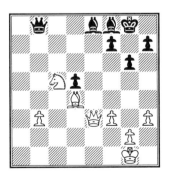

How to defend after 35.♘a6 ?

401. P.Smirnov (2615) - F.Jenni (2516)
4th IECC Istanbul 2003

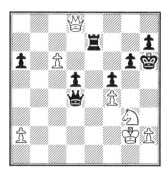

Is Black lost or did he manage to survive?

402. E.Sutovsky (2664) - E.Bacrot (2653)
Albert m 2001

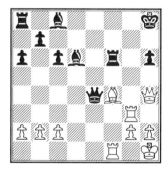

White has some compensation for the sacrificed piece, but Bacrot easily repelled his attack. Can you do the same?

403. V.Tkachiev (2672) - E.Bacrot (2627)
Enghien les Bains 2001

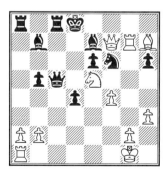

Black to move and defend.

404. V.Topalov (2743) - V.Anand (2753)
Corus Wijk aan Zee 2003

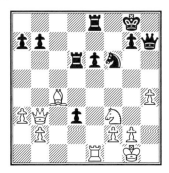

White to move and draw.

405. H.Nowarra - L.Schmitt
GER-ch 5th Bad Oeynhausen 1938

How to tame Black's mighty bishop-pair?

The Five Most Beautiful Combinations of All Time

In *Secrets of Spectacular Chess*, Levitt and Friedgood developed a theory of beauty in chess. They claim that the main ingredients are paradox, geometry, depth and flow. Paradox and geometry are more or less self-explanatory and so I give only some explanations on depth and flow. Depth does not necessarily mean that one has to calculate ten forced moves before the point is in sight. Its meaning is better explained by the following comparison: in mathematics a result is called deep, if a lot of work has to be done and many theorems must be proven before it can be obtained. So a move is deep, if first many aspects of the position must be checked and understood, before you come to the heart of the problem and find the right move. Flow describes a sequence of several moves, in which each single move is nothing special. But taken together they make a strong impression, e.g. a king march from one corner to another or a staircase maneuver of the queen. I will try to use these four elements in the description of the following five combinations. Their choice is of course highly subjective and I did not use studies, mate problems or correspondence games to make my job easier. Furthermore, I want to emphasize that two players are needed to produce a beautiful game. The loser also deserves praise as without him the beauty just wouldn't be there. First place on my "greatest hits" list goes to the amazing game

G.Kasparov (2812) - V.Topalov (2700) [B07]
Hoogovens Wijk aan Zee 1999

1.e4 d6 2.d4 ♘f6 3.♘c3 g6 4.♗e3 ♗g7 5.♕d2 c6 6.f3 b5 7.♘ge2 ♘bd7 8.♗h6 ♗xh6 9.♕xh6 ♗b7 10.a3 e5 11.0–0–0 ♕e7 12.♔b1 a6 13.♘c1 0–0–0 14.♘b3 exd4 15.♖xd4 c5 16.♖d1 ♘b6 17.g3 ♔b8 18.♘a5 ♗a8 19.♗h3 d5 20.♕f4+ ♔a7 21.♖he1 d4 22.♘d5 ♘bxd5 23.exd5 ♕d6

Now Kasparov starts a fantastically deep combination that also contains paradox, flow and some geometry: **24.♖xd4! cxd4?** Topalov underestimates the deadly danger to his king and accepts the challenge. We should be very grateful! 24...♔b6! was better and should lead to a more or less equal ending. **25.♖e7+!!** The first point of the combination. **25...♔b6**

I The rook can't be taken: 25...♕xe7? 26.♕xd4+ ♔b8 27.♕b6+ ♗b7 28.♘c6+ ♔a8 29.♕a7#.

II 25...♔b8 26.♕xd4 +− .

26.♕xd4+ ♔xa5

After 26...♕c5 27.♕xf6+ ♕d6, the paradoxical 28.♗e6!! +− wins.

27.b4+ ♔a4

28.♕c3

Kasparov had an easier, and equally beautiful way to win, which was discovered by Kavalek: 28.♖a7! ♗b7 *(28...♘xd5 29.♖xa6+!! ♕xa6 30.♕b2 ♘c3+ 31.♕xc3 ♗d5 32.♔b2* It is highly paradoxical that the whole black army is powerless after this king move: *32...♕e6 33.♗xe6 fxe6 34.♕b3+! ♗xb3 35.cxb3#)* 29.♖xb7 and:

A) 29...♘xd5 30.♗d7!! ♖a8 *(30...♖xd7 31.♕b2 ♘c3+ 32.♕xc3 ♕d1+ 33.♔a2 ♖d3* and now comes the deep point: *34.♖a7! +−)* 31.♗xb5+ axb5 32.♖a7+ ♕a6 33.♕xd5 ♕xa7 34.♕b3#.

B) 29...♕xd5 30.♖b6 a5 *(30...♖a8 31.♕xf6 a5 32.♗f1 +−)* 31.♖a6 ♖a8 32.♕e3!! ♖xa6 *(32...♖he8 33.♖xa8 ♖xa8 34.♔b2 +−)* 33.♔b2 axb4 34.axb4 ♕a2+ *(34...♔xb4 35.♕c3+ ♔a4 36.♕a3#)* 35.♔xa2 ♔xb4+ 36.♔b2 ♖c6 37.♗f1 +− .

28...♕xd5 29.♖a7

Of course not 29.♔b2? ♕d4 −+ .

29...♗b7 30.♖xb7

30.♕c7? is refuted by 30...♕d1+ with perpetual check.

30...♕c4

After 30...♖he8!?, Kasparov had some tough nuts to crack, e.g. 31.♖b6 ♖a8

32.♗f1!! (G.Ligterink) 32...♖e1+ *(32...♘d7 33.♖d6 ♖e1+ 34.♔b2 +−)* 33.♕xe1 ♕d4 *(33...♘d7 34.♖b7 ♕xb7 35.♕d1! +−* (Greengard)*)* 34.♖d6 ♘d5 35.♖xd5 ♕xd5 36.♕c3 ♖d8 37.♗d3 ♖d7 38.♗e4 ♕c4 39.♕xc4 bxc4 40.♗c6++−.

31.♕xf6

31...♔xa3?!

31...♖d1+ was more tenacious: 32.♔b2 ♖a8 *(32...♕d4+? 33.♕xd4 ♖xd4 34.♖xf7 ♖d6 35.♖e7 ♖a8 36.♗e6 +−)* 33.♕b6 ♕d4+ *(33...a5 34.♗d7! ♖d5 35.♕e3 +−)* 34.♕xd4 ♖xd4 35.♖xf7 a5 36.♗e6 axb4 37.♗b3+ ♔a5 38.axb4+ ♔b6 *(38...♖xb4 is met by 39.c3 winning an exchange.)* 39.♖xh7 and White should win in the long run.

The following almost forced moves show elements of (1) flow (In the king hunt, White's queen dances with the king, forcing it from one edge of the board to the other), (2) depth (the point 36.♗f1 followed by 37.♖d7) and (3) geometry (White's queen visits two corners; the fantastic pin with ♖d7):

32.♕xa6+ ♔xb4 33.c3+! ♔xc3 34.♕a1+ ♔d2

34...♔b4 35.♕b2+ ♔a5 *(35...♔b3 36.♖xb5+ +−)* 36.♕a3+ ♔a4 37.♖a7++−.

35.♕b2+ ♔d1

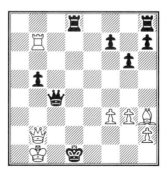

This position makes an excellent tactical puzzle: **36.♗f1!!** A hammer blow! **36...♖d2**

36...♛xf1? 37.♛c2+ ♔e1 38.♖e7+ ♔e2 39.♛xe2#.

37.♖d7! The fantastic point. The fact that the queen eyes the ♖h8 finally decides the day. Really unbelievable! **37...♖xd7 38.♗xc4 bxc4 39.♛xh8 ♖d3 40.♛a8 c3 41.♛a4+ ♔e1 42.f4 f5 43.♔c1 ♖d2 44.♛a7 1–0**

Such a collection must contain the next example:

V.Topalov (2740) - A.Shirov (2710)
Linares 1998

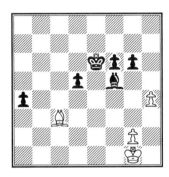

Black has surprisingly only one move to win:

47...♗h3!!

An incredibly paradoxical move, which was selected as the "Most Amazing Move of All Time" by a jury of the *British Chess Magazine*. Vacating the square f5 is more important than the bishop itself, which highlights its relative value in opposite-colored bishop endings, according to Timman. 47...♗e4? 48.♔f2 ♔f5 49.g3 is only drawn as bishop and king can stop the passed pawns on the diagonal a1–h8 by well known maneuvers. **48.gxh3** 48.♔f2 does not help: 48...♔f5 49.♔f3 ♗xg2+ and White loses as in the game.

48...♔f5 49.♔f2 ♔e4 50.♗xf6

50.♔e2 a3 51.♔d2 d4 52.♗a1 f5 and the three passed pawns decide the day.

50...d4 51.♗e7 51.♔e2 a3 −+. **51...♔d3! 52.♗c5 ♔c4 53.♗e7** 53.♗xd4 ♔xd4 54.♔e2 ♔c3 55.♔d1 ♔b2 −+. All Black's moves were forced until now, which increases the value of the combination considerably. Now he has two possibilities: **53...♔b3 0-1** or 53...♔c3 54.♔e1 ♔c2 55.♗c5 d3 56.♗b4 a3 −+.

This combination would also qualify as study.

H.Bird - P.Morphy [C41]
London m 1858

1.e4 e5 2.♘f3 d6 3.d4 f5 4.♘c3 fxe4 5.♘xe4 d5 6.♘g3 e4 7.♘e5 ♘f6 8.♗g5 ♗d6 9.♘h5 0–0 10.♕d2 ♕e8 11.g4 ♘xg4 12.♘xg4 ♕xh5 13.♘e5 ♘c6 14.♗e2 ♕h3 15.♘xc6 bxc6 16.♗e3 ♖b8 17.0–0–0

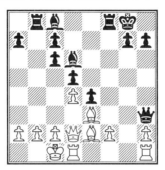

Black has an extra pawn, but the position is quite sharp as the kings are on different wings. So Morphy decides to start a fantastically deep combination: **17...♖xf2! 18.♗xf2 ♕a3!!** 18...♗a3? is met by 19.♕e3!. A beautiful, geometric and paradoxical move from one end of the board to the other. **19.c3!** The only defense.

19.♕g5? ♖xb2 20.♕d8+ ♔f7 21.♗h5+ g6 −+ .
19.bxa3?? ♗xa3#.

19...♕xa2!

19...e3? is refuted by 20.♗xe3 ♗f5 21.♕c2!!.

20.b4 ♕a1+ 21.♔c2 ♕a4+

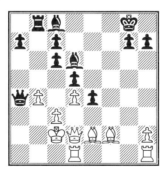

Black's attack flew nicely until this critical point. **22.♔b2?**

Bird crumbles under the pressure and loses quickly. This position makes a good tactical exercise, which is solved by Morphy easily. 22.♔c1! is better, but should

lose as well, e.g. 22...a5! and:

A) 23.♖dg1 ♗f5 *(23...axb4? allows the thunderbolt 24.♖xg7+! +−)* 24.♕g5 ♗g6 25.♔d2 e3+ 26.♗xe3 ♕c2+ 27.♔e1 ♕xc3+ 28.♗d2 ♕a1+ 29.♗c1 ♖f8 −+.

B) 23.♔c2 ♕a3+ 24.♔b2 axb4 25.♔xa3 bxa3 26.♗e3 ♖b3 27.♔d2 ♖b2+ 28.♔e1 a2 29.♖a1 ♗d7 30.♔d1 *(30.♔f2 ♗g4 31.♖he1 ♗xh2 −+)* 30...c5 31.dxc5 ♗e7 32.h4, so far my main line in Endgame Corner 23 at www. chesscafe.com. However, CC-GM Rolf Knobel from Switzerland now found 32...h6! −+ (see Endgame Corner 25), which wins much more easily than my suggestion. White's heavy pieces make a very poor impression.

22...♗xb4! And Black's king hunt flows nicely: **23.cxb4 ♖xb4+ 24.♕xb4** 24.♔c1? ♕a1+ 25.♔c2 ♕b2#. **24...♕xb4+ 25.♔c2** 25.♔a2 c5 26.dxc5 e3 27.♗e1 *(27.♗xe3 d4 28.♗xd4 ♗e6+ 29.♔a1 ♕a3+ 30.♔b1 ♗f5+ −+)* 27...♕e4 28.♗g3 ♕c2+ −+. **25...e3 26.♗xe3 ♗f5+ 27.♖d3 ♕c4+ 28.♔d2 ♕a2+ 29.♔d1 ♕b1+ 0–1**

R.Kholmov - D.Bronstein [B99]
URS-ch32 Kiev 1964

The next example shows a similarly deep combination: **1.e4 c5 2.♘f3 ♘f6 3.♘c3 d6 4.d4 cxd4 5.♘xd4 a6 6.♗g5 e6 7.f4 ♗e7 8.♕f3 ♕c7 9.0–0–0 ♘bd7 10.g4 b5 11.♗xf6 gxf6 12.f5 ♘e5 13.♕h3 0–0 14.g5 b4 15.gxf6 ♗xf6 16.♖g1+ ♔h8 17.♕h6 ♕e7**

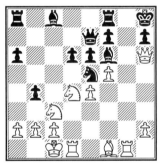

Black seems to have everything under control in this typical Sicilian position. But Kholmov shakes the foundation with a powerful blow: **18.♘c6!!** A paradoxical piece sacrifice on an empty square. **18...♘xc6 19.e5!!** To follow up by vacating the square e4. Very impressive! **19...♗g5+?!**

I 19...♗xe5 was more tenacious, but is still insufficient: 20.f6! ♗xf6 21.♗d3 ♗g5+ 22.♖xg5 f5 23.♖dg1! ♖a7 24.♘e2! ♘e5 25.♘f4 and White's attack will eventually crash through.

II After 19...♘xe5!?, White uses the vacated square by 20.♘e4 ♘g6 *(20...♘d7 21.♖xd6 +−)* 21.♘xf6 ♕xf6 22.fxg6 ♕g7 23.♕xg7+ ♔xg7 24.gxh7+ ♔h8 25.♖xd6 and White has good winning chances according to Nunn.

20.♖xg5 From now on White's attack flies like an arrow. **20...f6 21.exd6 ♕f7 22.♖g3 bxc3**

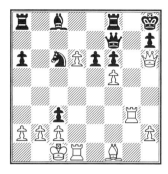

White must continue to play energetically: **23.♗c4! cxb2+ 24.♔b1 ♘d8 25.♖dg1!?** Threatening ♖g7. **25...♖a7 26.d7** Kholmov introduces a problem-like motif with this interference. But 26.♗e2!?, with the idea ♗h5, was more precise. **26...♖xd7 27.fxe6 ♘xe6 28.♗xe6 ♖d1+!? 29.♖xd1 ♗xe6 30.♔xb2 ♖b8+ 31.♔a1 ♗xa2 32.♖gd3 ♕e7 33.♔xa2 ♕e6+ 34.♖b3 1–0**

The last example is a classic which is hard to omit, although several sources claim that it is not a real game, that Carlos Torre composed it, leting himself appear to lose against his coach Adams (see for example Velasco's *The Life and Games of Carlos Torre*, p.287):

E.Adams - C.Torre
New Orleans 1920

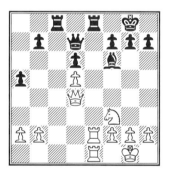

Black's weak back rank will be his undoing. All four elements: paradox, flow, geometry and depth, will play their role. **18.♕g4!! ♕b5 19.♕c4!! ♕d7 20.♕c7!!** A very paradoxical, collinear move **20...♕b5 21.a4!** 21.♕xb7? backfires due to White's (!) weak back rank: 21...♕xe2 22.♕xc8 ♕xe1+ 23.♘xe1 ♖xc8 –+. **21...♕xa4 22.♖e4!!** Again a collinear move. White's queen seems to be hanging for ages. **22...♕b5** 22...♕xe4 23.♖xe4+–; 22...♖xe4 23.♕xc8+ ♕e8 24.♕xe8+ ♖xe8 25.♖xe8#. **23.♕xb7 1-0**

Collinear moves (a geometrical element) are rare enough, but combined with the queen sacrifices they make a very deep impression. The combination is deep, due not least to the point 21.a4!, and obviously contains flow and paradox.

This article first appeared in the German magazine *KARL 1/2003*.

Tests

Now the time has come to check your progress. Do each of the ten tests with 16 exercises each on a different day and take two hours for each test (you can also split one and do the first eight in one hour and solve the second eight for example the next day). Solve without a board and write your solutions down. There are 42 points in each test, so altogether you strive for 420. The rough values in the score chart should not be taken too seriously, but they should get more accurate, when you take the average over all ten tests. Consulting the Hints costs you 2 points, so exercises with difficulty 1 or 2 have no hints, you will just find the difficulty then. Sometimes the aim is to win, sometimes to draw, but you should always try to find the best move and calculate as deeply as necessary to exclude unpleasant surprises. Write all the relevant variations of your solutions down! Enough for the moment and good luck!

Exercises Test 1 (Hints on page 276, Solutions on page 281)

406. N.Stanec (2530) - V.Burmakin (2593)
Graz op 2001

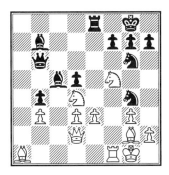

Black to move

407. E.Sutovsky (2651) - J.Speelman (2603)
North Sea Cup 16th Esbjerg 2001

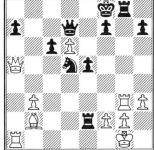

White to move

408. V.Chuchelov (2550) - R.Vaganian (2641)
EU-ch 2nd Ohrid 2001

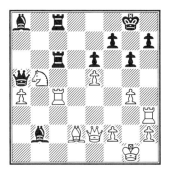

Black to move

409. A.Fedorov (2646) - U.Adianto (2583)
Istanbul ol (Men) 2000

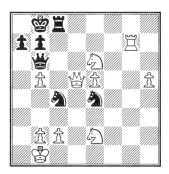

Black to move

410. P.Kiriakov (2553) - K.Aseev (2575)
RUS-ch Krasnodar 2002

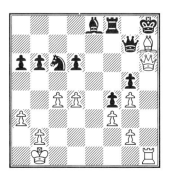

White to move

411. V.Kramnik (2797) - G.Kasparov (2827)
Zürich Korchnoi's birthday K.O. 2001

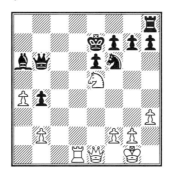

White to move

412. Liang Chong (2560) - Zhang Zhong (2632)
HeiBei zt 3.3 2001

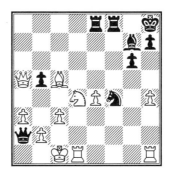

Black to move

413. D.Navara (2559) - M.Vokac (2502)
Pardubice Czech op 2002

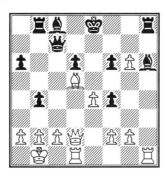

White to move

414. R.Kasimdzhanov (2690) - A.Shirov (2746)
German Bundesliga 2001

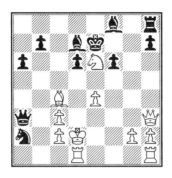

Black to move

415. P.Leko (2739) - E.Ghaem Maghami (2513)
WchT 5th Yerevan 2001

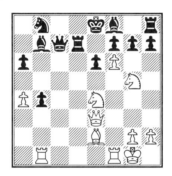

White to move

416. A.Zapata (2556) - L.Ljubojevic (2557)
Bled ol (Men) 2002

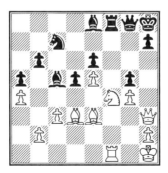

White to move

417. R.Zelcic (2503) - H.Stefansson (2570)
EU-ch 2nd Ohrid 2001

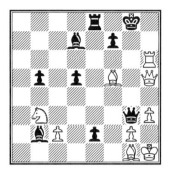

White to move

418.K. Müller (2518) - M.Stangl (2494)
German Bundesliga 2002

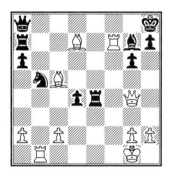

White to move

419. P.Svidler (2690) - R.Ruck (2572)
Bled ol (Men) 2002

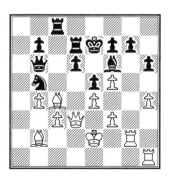

Black to move

420. K.Sasikiran (2670) - R.Kasimdzhanov (2653)
FIDE World Cup-C Hyderabad 2002

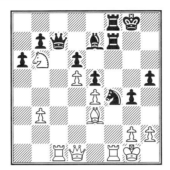

Black to move

421. L.Bruzón (2610) - P.Nielsen (2625)
18th North Sea Cup Esbjerg 2003

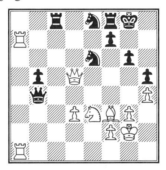

White to move

Exercises Test 2 (Hints on page 276, Solutions on page 283)

422. Analysis of Tompa - K.Honfi
Hungary 1973

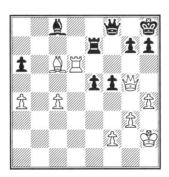

White to move

423. B.Lalic (2523) - E.van den Doel (2585)
Zwolle op 2002

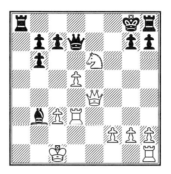

White to move

424. A.Lastin (2630) - S.Vokarev (2507)
Moscow Aeroflot op 2002

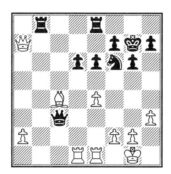

White to move

425. Z.Azmaiparashvili (2670) - P.Eljanov (2558)
EU-ch 2nd Ohrid 2001

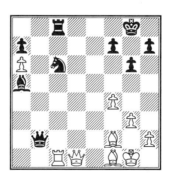

White to move

426. V.Anand - V.Bologan
Dortmund 2003

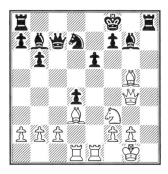

White to move

427. B.Gelfand (2703) - M.Adams (2742)
Corus Wijk aan Zee 2002

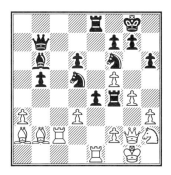

Black to move

428. H.Gretarsson (2520) - J.Ehlvest (2589)
Reykjavik op 2002

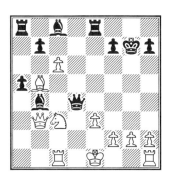

Black to move

429. M.Gurevich (2641) - V.Malakhov (2647)
Valle d'Aosta op 10th St. Vincent 2002

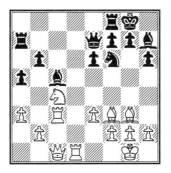

White to move

430. Z.Izoria (2556) - J.Ehlvest (2588)
EU-ch 3rd Batumi 2002

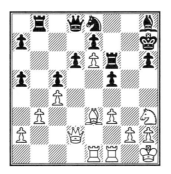

White to move

431. R.Kasimdzhanov (2704) - M.Golubev (2526)
German Bundesliga 2002

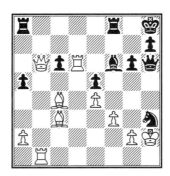

White to move

432. R.Leitao (2567) - I.Stohl (2578)
Istanbul ol (Men) 2000

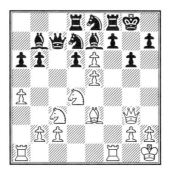

White to move

433. S.Mamedyarov (2542) - S.Sulskis (2577)
EU-ch 3rd Batumi 2002

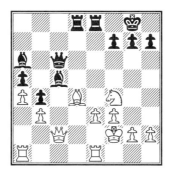

Black to move

434. J.Benjamin - W.Browne
Philadelphia World op 2000

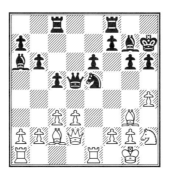

White to move

435. P.Svidler (2585) - J.Yedidia (2390)
New York op Newark 1995

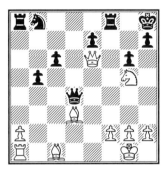

White to move

436. S.Grigoriants (2506) - I.Cheparinov (2508)
It Pancevo 2003

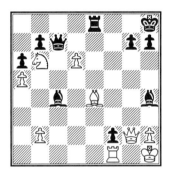

Black to move

437. I.Sokolov (2684) - R.Slobodjan (2521)
German Bundesliga 2003

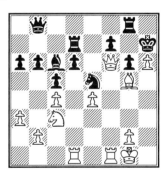

White to move

Exercises Test 3 (Hints on page 276, Solutions on page 285)

438. A.Miles (2565) - C.Pritchett (2410)

Lloyds Bank op London 1982

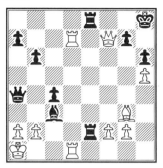

White to move

439. G.Kasparov (2810) - V.Kramnik (2750)

Siemens Giants Frankfurt 1999

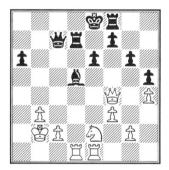

White to move

440. C.Vitoux - P.Torres

Naujac op 2000

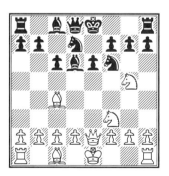

White to move

441. Bauer - Golner
Berlin 1956

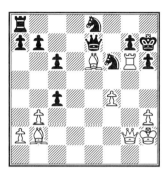

White to move

442. Schebler - Müller
GER-ch Höckendorf 2004

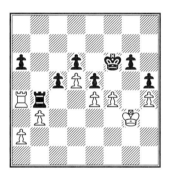

White to move

443. G.Kasparov (2812) - N.Short (2697)
Sarajevo 1999

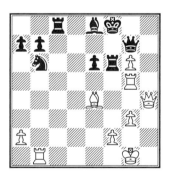

White to move

444. D.Rivera - R.Fischer
Varna ol (Men) 1962

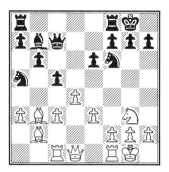

Black to move

445. A.Shirov (2751) - V.Akopian (2660)
Mérida 2000

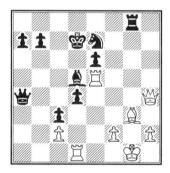

White to move

446. N.de Firmian (2570) - A.Minasian (2598)
New York op 2000

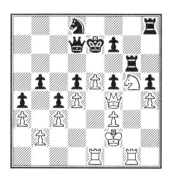

White to move

447. P.Svidler (2689) - D.de Vreugt (2511)
North Sea Cup Esbjerg 2000

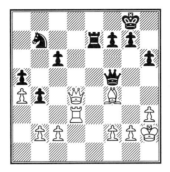

White to move

448. A.Vouldis (2515) - J.Gustafsson (2542)
GER-GRE Fürth 2002

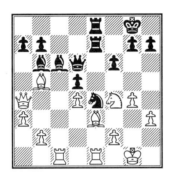

Black to move

449. L.van Wely (2675) - E.Agrest (2591)
National I Clermont-Ferrand 2003

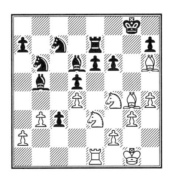

White to move

450. I.Nataf (2567) - H.Stefansson (2598)
Capablanca mem Elite 37th Havana 2002

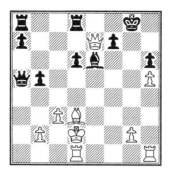

White to move

451. R.Leitao (2515) - A.Baburin (2600)
Europe vs. Americas Mermaid Beach Bermuda 1998

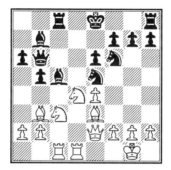

White to move

452. B.Gulko (2601) - A.Shabalov (2606)
USA-ch Seattle 2002

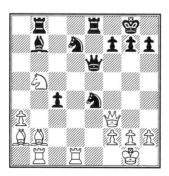

Black to move

453. V.Ivanchuk (2717) - A.Shirov (2718)
Corus Wijk aan Zee 2001

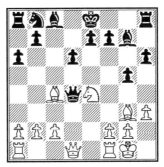

White to move

Exercises Test 4 (Hints on page 277, Solutions on page 287)

454. M.Al Modiahki (2523) - B.Avrukh (2582)
Biel MTO 2002

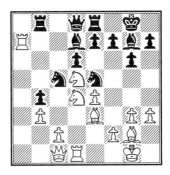

White to move

455. A.Dreev (2683) - Zhu Chen (2505)
FIDE GP Dubai 2002

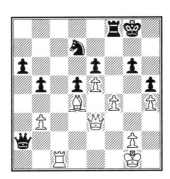

White to move

456. B.Macieja (2582) - V.Ivanchuk (2731)
FIDE-Wch K.O. Moscow 2001

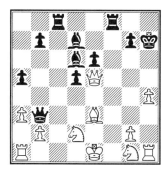

Black to move

457. N.Miezis (2510) - E.Agrest (2599)
Mainz Ordix op 2002

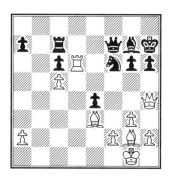

White to move

458. D.Sermek (2590) - V.Kovacevic (2500)
Salona 60 Solin/Spilt 2002

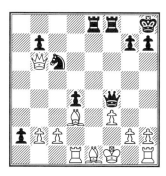

Black to move

459. E.Vladimirov (2597) - A.Fominyh (2529)
Commonwealth ch Mumbai 2003

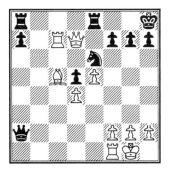

White to move

460. Hallier - Hermann
Hamburg 1965

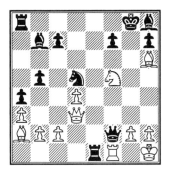

White to move

461. S.Hansen (2537) - J.Hector (2553)
Sigeman & Co 11th Malmo 2003

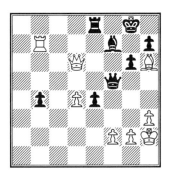

White to move

462. Vukovic - NN
Simul 1937

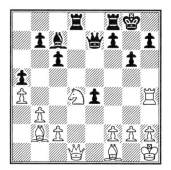

White to move

463. Novosibirsk - Saratov
City match

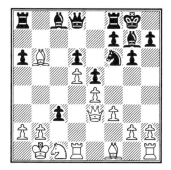

Black to move

464. A.Westermeyer (1946) - P.Stadler (1584)
Corr 2003 Chessfriend.com

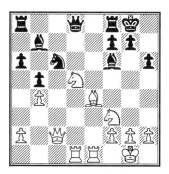

White to move

465. J.Benjamin (2577) - M.Gurevich (2667)
Cap d'Agde K.O. 2000

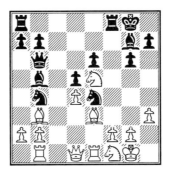

Black to move

466. A.Gershon (2540) - A.Lesiege (2582)
Elbow Beach Club GM-A Paget Parish Bermuda 2001

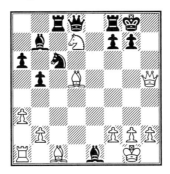

White to move

467. A.Grischuk (2702) - A.Graf (2635)
Bled ol (Men) 2002

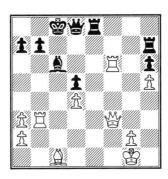

White to move

468. A.Korotylev (2558) - A.Timofeev (2558)
RUS-ch Krasnodar 2002

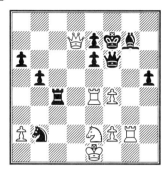

White to move

469. J.Gallagher (2526) - N.Eliet (2422)
FRA-chT 2003

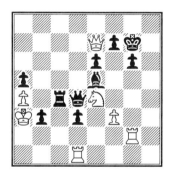

White to move

Exercises Test 5 (Hints on page 277, Solutions on page 289)

470. P.Smirnov (2615) - V.Meijers (2512)
4th IECC Istanbul 2003

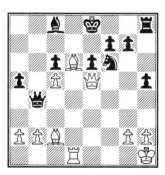

White to move

471.L.van Wely (2645) - F.Nijboer (2567)
Lost Boys op Amsterdam 2002

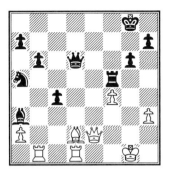

White to move

472. E.Vorobiov (2534) - S.Ivanov (2557)
St. Petersburg vs. Moscow St. Petersburg 2003

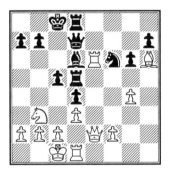

Black to move

473. Capablanca - Kalantarov
Simul St. Petersburg 1913

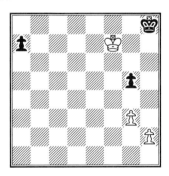

White to move

474. M.Marin (2556) - Z.Almasi (2672)
Bled ol (Men) 2002

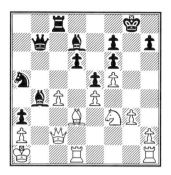

Black to move

475. Zhu Chen (2538) - L.Christiansen (2566)
USA-China Summit Seattle 2001

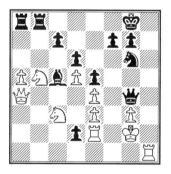

Black to move

476. P.Nielsen (2593) - J.Speelman (2603)
North Sea Cup 16th Esbjerg 2001

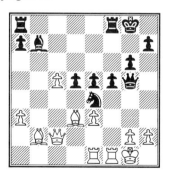

White to move

477. A.Graf (2642) - R.Slobodjan (2539)
GER-ch Heringsdorf 2000

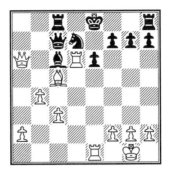

White to move

478. B.Gelfand (2680) - A.Shirov (2745)
Istanbul ol (Men) 2000

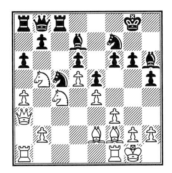

White to move

479. S.Fedorchuk (2503) - B.Jobava (2543)
EU-ch 2nd Ohrid 2001

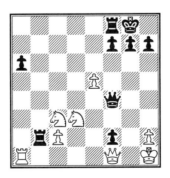

Black to move

480. I.Cheparinov (2508) - K.Georgiev (2516)
67th ch-BUL Sofia 2003

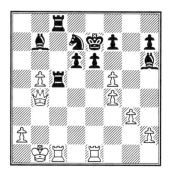

Black to move

481. V.Anand (2790) - L.Ljubojevic (2566)
Amber blindfold 10th Monte Carlo 2001

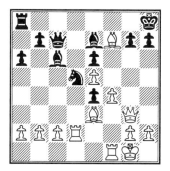

Black to move

482. R.Byrne - R.Fischer
USA-ch New York 1963

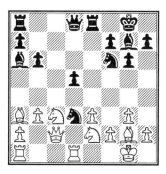

Black to move

483. I.Smirin (2686) - G.Rechlis (2525)
ISR-chT 2001

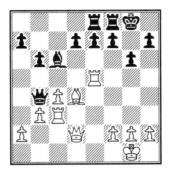

White to move

484. E.Sutovsky (2657) - O.Cvitan (2562)
Bled ol (Men) 2002

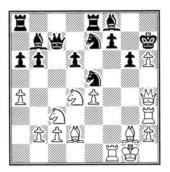

White to move

485. V.Tkachiev (2672) - H.Hamdouchi (2535)
World Cup of Rapid Chess-B Cannes 2001

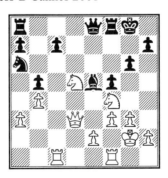

White to move

Exercises Test 6 (Hints on page 278, Solutions on page 291)

486. A.Dreev (2683) - Zhu Chen (2505)
FIDE GP Dubai 2002

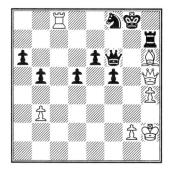

White to move

487. A.Shirov (2500) - A.Hauchard (2340)
Paris-ch 1990

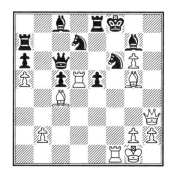

White to move

488. D.Sadvakasov (2577) - Dao Thien Hai (2564)
Asian Teams Jodhpur 2003

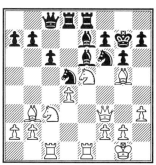

White to move

489. E.Richter - B.Thelen
Kautsky mem Prague 1930

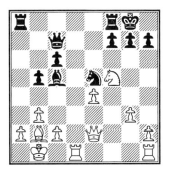

White to move

490. S.Movsesian (2663) - V.Babula (2581)
TCh-CZE 2002

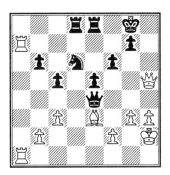

White to move

491. P.Nielsen (2593) - A.Rustemov (2607)
North Sea Cup 16th Esbjerg 2001

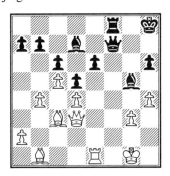

Black to move

492. E.van den Doel (2607) - L.van Wely (2695)
Lost Boys op Amsterdam 2001

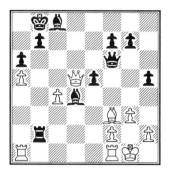

Black to move

493. T.Oral (2540) - W.Arencibia (2529)
Capablanca mem Elite Varadero 2000

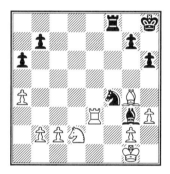

Black to move

494. V.Milov (2614) - S.Guliev (2510)
Biel MTO 2001

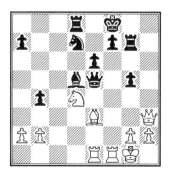

White to move

495. A.Gershon (2540) - A.Lesiege (2582)
Elbow Beach Club GM-A Paget Parish Bermuda 2001

White to move

496. A.Fedorov (2599) - Z.Gyimesi (2602)
CRO-chT Pula 2001

White to move

497. E.Bacrot (2653) - V.Anand (2770)
Corsica Masters rap Bastia 2001

Black to move

498. J.Piket (2633) - S.Tiviakov (2567)
NED-chT 2000

White to move

499. B.Gelfand (2665) - V.Kramnik (2765)
EUCup Gr4 Berlin 1996

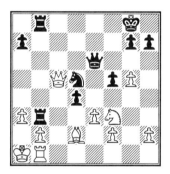

Black to move

500. A.Anderssen - J.Dufresne
Berlin 1852

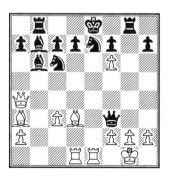

White to move

501. V.Anand (2762) - V.Bologan (2641)
FIDE-Wch K.O. New Delhi/Theran 2000

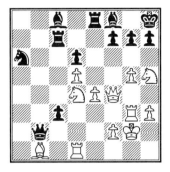

White to move

Exercises Test 7 (Hints on page 278, Solutions on page 293)

502. G.Kasparov (2812) - M.Adams (2716)
Sarajevo 1999

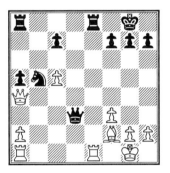

White to move

503. W.Lombardy - G.Kramer
USA-ch New York 1957

White to move

504. R.Schmaltz (2529) - B.Gikas (2254)
German Bundesliga 2003

White to move

505. K.Müller (2505) - C.Lutz (2590)
GER-ch Gladenbach 1997

White to move

506. Z.Lanka (2503) - M.Wahls (2561)
Hamburg-ch int 2002

White to move

507. O.Romanishin (2559) - S.Rublevsky (2657)
EU-ch 2nd Ohrid 2001

White to move

508. A.Motylev (2634) - J.Polgar (2681)
EUCup 18th Halkidiki 2002

Black to move

509. J.Polgar (2685) - S.Mamedyarov (2580)
Bled ol (Men) 2002

White to move

510. L.van Wely (2643) - M.Krasenkow (2702)
Istanbul ol (Men) 2000

White to move

511. B.Gelfand (2701) - L.van Wely (2714)
EU-chT (Men) León 2001

White to move

512. J.Degraeve (2586) - C.Bauer (2550)
FRA-ch Val d'Isere 2002

White to move

513. P.Leko (2701) - D.Bunzmann (2596)
Hamburg m 1999

White to move

514. P.Mai - D.Fötsch
German Youth Championship U20 Schierke 1998

White to move

515. H.Nakamura (2571) - I.Novikov (2719)
New York Masters 29th 2002

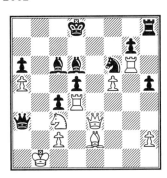

White to move

516. M.Prusikhin (2504) - L.Ftacnik (2603)
German Bundesliga 2002

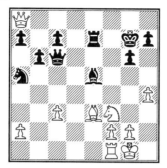

White to move

517. K.Müller (2505) - M.Wahls (2595)
GER-ch Gladenbach 1997

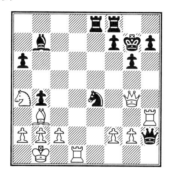

Black to move

Exercises Test 8 (Hints on page 279, Solutions on page 296)

518. G.Stahlberg - P.Keres
Bad Nauheim 1936

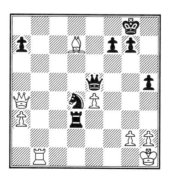

Black to move

519. G.Kasparov (2812) - A.Morozevich (2723)
Sarajevo 1999

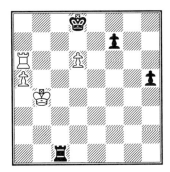

White to move

520. K.Müller - G.Schebler
GER-chT U20 Bochum 1984

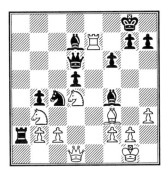

White to move

521. A.Anderssen - C.Mayet
Berlin m 1865

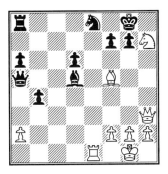

White to move

522. Zhang Pengxiang (2522) - V.Kotronias (2568)
Linares Anibal op 9th 2002

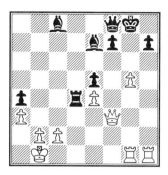

White to move

523. A.Poluljahov (2502) - S.Volkov (2558)
RUS-chT Tomsk 2001

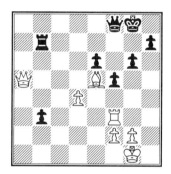

White to move

524. Z.Gyimesi (2605) - A.Shirov (2706)
FIDE-Wch K.O. Moscow 2001

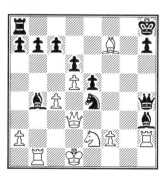

Black to move

525. A.Wirig (2347) - M.Kazhgaleyev (2604)
FRA-chT 2003

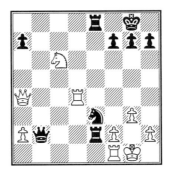

White to move

526. V.Kramnik (2797) - D.Sadvakasov (2585)
Astana 2001

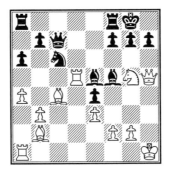

White to move

527. L.Johannessen (2525) - S.Agdestein (2574)
NOR-ch Roros 2002

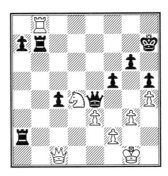

White to move

528. A.Fedorov (2646) - N.Miezis (2518)
Istanbul ol (Men) 2000

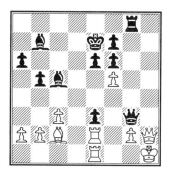

Black to move

529. V.Akopian (2678) - P.Nikolic (2653)
EUCup 18th Halkidiki 2002

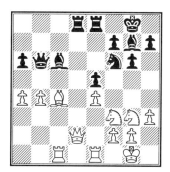

White to move

530. U.Bönsch (2540) - E.Berg (2535)
German Bundesliga 2002

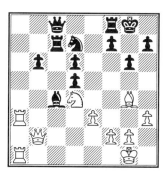

White to move

531. A.Alekhine - Vasic
Banja Luka sim 1931

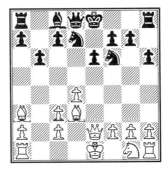

White to move

532. L.Mauro (2324) - S.Volkov (2627)
Corr 2003 email Chessfriend.com 2003

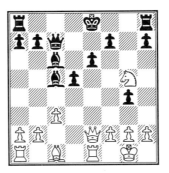

White to move

533. P.Acs (2509) - V.Korchnoi (2643)
EU-ch 2nd Ohrid 2001

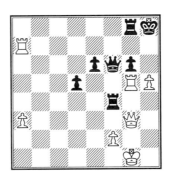

Black to move

Exercises Test 9 (Hints on page 279, Solutions on page 297)

534. C.Gómez (1822) - R.Csoma (1442)

SI-2003–0–00004 Chessfriend.com 2003

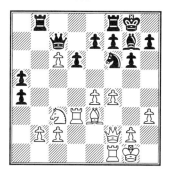

White to move

535. B.Ivkov - H.Westerinen

Halle zt 1963

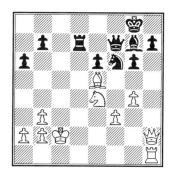

White to move

536. M.Ehrke - K.Müller (2505)

Hamburg 1997

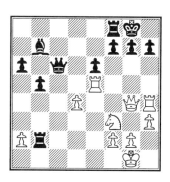

White to move

537. Gutman - Vitolinsh
Riga 1979

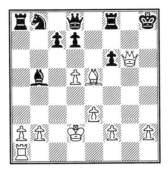

Black to move

538. B.Jansson - C.Tchalkhasuren
Tel Aviv ol (Men) fin-B 1964

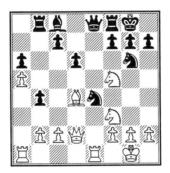

White to move

539. J.Degraeve (2540) - N.Borge (2360)
EUCup Gr2 Eupen 1997

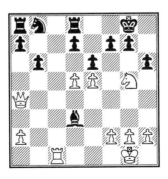

White to move

540. K.Yurenko (2275) - I.Kondrashov
RUS-chJM op Kolontaevo 1997

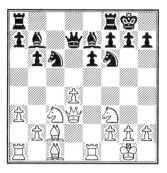

White to move

541. Schlosser - NN
Stettin 1940

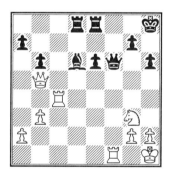

Black to move

542. T.Radjabov (2599) - V.Anand (2757)
FIDE GP Dubai 2002

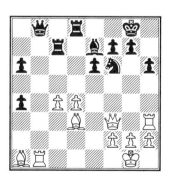

Black to move

543. V.Anand (2770) - A.Dreev (2676)
FIDE-Wch K.O. Moscow 2001

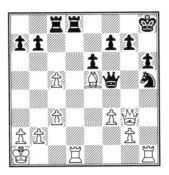

White to move

544. J.Arizmendi Martínez (2503) - A.Shariyazdanov (2562)
Biel MTO op 2002

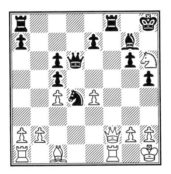

White to move

545. A.Grischuk (2669) - E.Bareev (2719)
EUCup 17th Panormo 2001

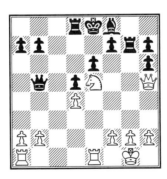

White to move

546. L.van Wely (2681) - E.Bacrot (2653)
Bled ol (Men) 2002

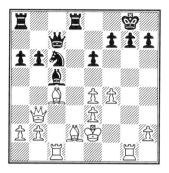

Black to move

547. M.Kazhgaleyev (2561) - N.Pushkov (2516)
18th Cappelle la Grande op 2002

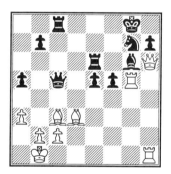

White to move

548. R.Vera (2544) - M.Gurevich (2634)
TCh-ESP Mondariz 2002

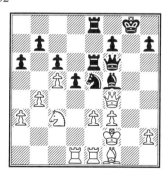

Black to move

549. S.Rublevsky (2634) - Z.Varga (2506)
WchT 5th Yerevan 2001

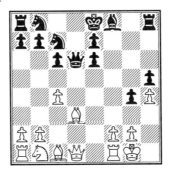

White to move

Exercises Test 10 (Hints on page 280, Solutions on page 299)

550. N.Cid (1810) - R.Klipper (2063)
FRA-chT 2003

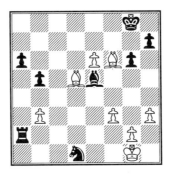

Black to move

551. H. Sonntag (2378) - R.Dautov (2611)
Echternach 45 2003

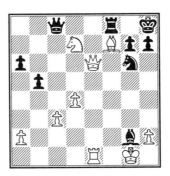

Black to move

552. A.Dreev (2683) - T.Radjabov (2599)
FIDE GP Dubai 2002

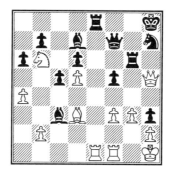

White to move

553. A.Motylev (2634) - Z.Sturua (2545)
5th Dubai op 2003

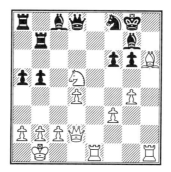

White to move

554. K.Sakaev (2637) - A.Delchev (2584)
EU-ch 2nd Ohrid 2001

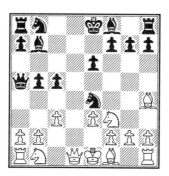

White to move

555. R.Slobodjan (2529) - K.Georgiev (2676)
EU-ch 2nd Ohrid 2001

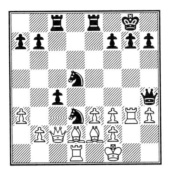

Black to move

556. K.Pilgaard (2437) - A.Dimitrijevic (2369)
Subotica TS03 GM 2003

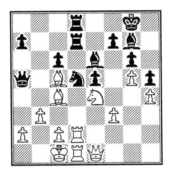

White to move

557. J.Timman (2655) - A.Khalifman (2656)
Japfa Classic Bali 2000

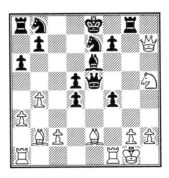

Black to move

558. R.Schmaltz (2547) - A.Vouldis (2515)
GER-GRE Fürth 2002

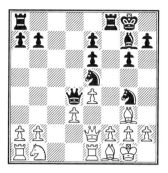

Black to move

559. K.Müller (2265) - A.Schneider (2390)
Spring Festival Budapest 1989

White to move

560. K.Georgiev (2676) - B.Kurajica (2567)
Bosna Sarajevo 2001

White to move

561. R.Kasimdzhanov (2690) - G.Hertneck (2541)
German Bundesliga 2001

White to move

562. Dao Thien Hai (2572) - G.Kasparov (2838)
EUR-ASIA m 30' Batumi 2001

Black to move

563. V.Mikhalevski (2524) - A.Shirov (2699)
Corsica Masters rap 6th Bastia 2002

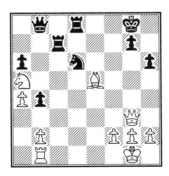

White to move

564. A.Morozevich (2748) - P.Nikolic (2659)
Corus Wijk aan Zee 2000

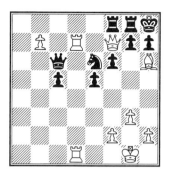

White to move

565. K.Müller (2533) - H.Matthias (2399)
Lippstadt 1999

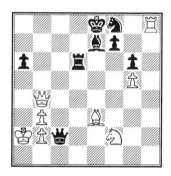

White to move

Solutions to the Exercises

1: 32.♕d2!! This double attack decides as White's queen is invulnerable. But not 32.♖f7? ♕d1+ 33.♔f2? ♕e1#. **32...♖d3** 32...♕xd2? 33.♖f8#. **33.♗xd3 ♕d4+ 34.♕f2 ♘xd3 35.♕xd4 cxd4 36.♖f8+ ♔h7 37.♖d8 ♘f4 38.g3 ♘e6 39.♖d6 ♘g5 40.♔g2 1–0**

2: 40...♗c7 40...♖d1+ 41.♖f1 ♕d6 42.♕e2 ♖xf1+ 43.♕xf1 ♗c7 44.g3 ♕d5+ 45.♕g2 ♕xf7–+. **41.♗e8** 41.♗xe6 ♖d1+ 42.♖f1 ♕d6–+. **41...♖d1+ 42.♖f1 ♕d6 0–1**

3: Black capitalized on White's weak back rank as follows: **26...♖xf2! 27.♘e7+** 27.♖xb2 ♖xf1#; 27.♖xf2 ♕c1+ 28.♖f1 ♕xf1#. **27...♖xe7 0–1**

4: 23.♕c8! ♘f6 23...♖xc8? 24.♖xc8+ ♗f8 25.♖xf8+ ♔g7 26.♖c8+–. **24.♘g4! ♖be7 25.♗xe7 ♕xe7 26.♘xf6++–** And White won later.

5: 24...♖xa4! And White resigned due to **25.♖xa4 ♗h3!! 26.♗xh3 ♕xf3+ 27.♔g1** 27.♗g2? ♕d1+ 28.♗f1 ♕xf1#. **27...♗xc3–+.**

6: 30.♘e6? 30.♘f3 was better, but Black's position is superior. **30...♖xe6! 31.♖xe6 g5 32.♕g3 h4! 33.♖xh4** 33.♕xd3 gxf4 34.♕g6+ ♔h8 35.♕h6+ ♘h7–+ (Atalik in CBM 89). **33...♕f5** "That is the trick behind the combination. Of course 33...♘g4?? 34.♖g6+ ♔f7 35.♕xg4 would be only a flash of stupidity!" (Atalik). **34.♖e1** Loses on the spot. 34.h3 ♕xe6 35.♕xg5+ ♔f7–+. **34...♘g4! 0–1** White's back rank defense collapses.

7: 29.♕a8? Thomas resigned instead of turning the tables with **29...♖xa2!** 29...♖c1+? defends as well, but is much weaker, of course: 30.♖xc1 ♖xb8 31.♕c6±. Correct was **29.♕b5 ♖c1+ 30.♔f2 ♖c2+ 31.♔e3+–** or **29.♖xe8 ♕xe8 30.♕a4** A deadly double attack. **30...♖xg2+ 31.♔xg2 ♕xg6+ 32.♔h1 ♕g4 33.♕c2+–.**

8: 1.♕e5+ ♔f8 1...♔h6 2.♕f4++–; 1...♔g8 2.♖e8++–. **2.♕f6!** And Black resigned as he is forced to block the square e7: **2...♕xe7 3.♕h8#.**

9: Black's king just needs some fresh air: **1...♖dxe8** 1...♕xe1+? 2.♕xe1 ♖dxe8 3.♕d1 is better for Black, but not that clear. **2.♕xe8 h6! 0–1**

10: 29.♔g1? was punished by **29...♕d4+ 30.♔h1** 30.♖f2? ♖e1#. **30...♕f2 0–1.** Instead, **29.♕b5** was called for.

11: Bronstein uncorked the amazing double attack **24...♖xa3!! 0-1** 24...♕e1+? can be met by 25.♕f1!, as the x-rays of the rook on a1 defend the queen.

12: Did a wave of inspiration hit you? **1...Qc6!!** a powerful double attack. The game finished 1...Qb7? 2.Qf1 1–0; if 1...Ra8? 2.Qf1! Ra1 3.Qxa1 gxf6 4.Qd1 +– . **2.Qg1** 2.Qxc6? Rd1+ 3.Rf1 Rxf1#. **2...Qxf6 –+.**

13: 25.Rxc6!! Qxc6 25...Rxc6 26.Qxd5+ Re6 27.Qxa8 +– . **26.Bxd5 Qd6 27.Bxg7 Nb6** 27...Qxg7 28.Qc3+ Nf6 29.Bxa8 +– . **28.Bxe6+ Qxe6 29.Ba1 Qxa2 30.Rd1 Qc4 31.Qd6 1–0**

14: 24.Rxd7+ Kc8 24...Ke8 25.Rc7+ Kd8 26.e7#. **25.Qc6+ bxc6 26.Ba6#** A nice version of Boden's mate.

15: 25...Rxd4! 25...gxf4 26.gxf4 Qxf4 27.Rf1 Qc7 28.g5 hxg5 29.Rh2 is not clear. **26.cxd4** 26.fxe5?? Rd1+ 27.Rxd1 Rxd1#. **26...Qxd4** White's army is badly coordinated and so Black's powerful bishops win easily: **27.Nf2** 27.Nc3 Qd3+ 28.Ka1 Bxc3 –+ . **27...Qb4** 27...Qc4 –+ . **28.a3** 28.Qh2!? Bb5! 29.Rc2 (29.a3 Qb3 30.Rc2 Bc4 –+) 29...d2! 30.a3 (30.Rhc1 Qxb2+! 31.Rxb2 Rxb2+ 32.Ka1 Rb4+ 33.Rc3 Bxc3#) 30...Qd4 31.Rxd2 Qxd2 32.Nh3 Be2! –+ (Finkel in CBM 78). **28...Qc4 29.Rhe1 Rc8 30.Ka1** 30.Qg2 Bc2+ 31.Ka1 Bxb2+ –+ . **30...Bb3 31.Qh1 Qc5 32.Re5 Bxe5 33.fxe5 Qxf2 34.Rb1 Bd5 35.Qxh6 Qe3 36.Qf6 Qb3 37.Qxg5+ Kf8 0–1**

16: 21.fxe6 fxe6 22.Nxe6!! Rxf1+ 22...Qxe6? 23.Bxd5 +– . **23.Kxf1 Kh8** 23...Nf7 24.Qxd5 Qxd5 25.Bxd5 Rc8 26.Bb3 Nd6 27.Bd4 +– ; 23...Rf8+? 24.Nxf8 Qh3+ 25.Ke1 +– . **24.Qxd5 Qb7 25.Qxb7 Nxb7 26.Bd5 Ra6 27.Bd4** Look at the mighty bishops! They fire at the king in one corner and at knight and rook in the other. **27...Nd8 28.Nxg7 Bc5 29.Bf6 Rxf6+ 30.gxf6 Bd4 31.Nh5 1–0**

17: 23.Bf3! 23.Bg4? Ne5 (23...Rd4 24.h3 Rxg4 25.hxg4 Nf4±) 24.Qe4 Red6 25.h4 Ng6 26.h5 Nf8 27.Be5 Rd8 28.Bc7 Rd4 29.Qxb7 Re8±. **23...Bc5 24.Qxc1 Nd4 25.Qd2 1–0**

18: 15.Bxh7+! 15.Qxh5? f5=. **15...Kxh7 16.Qxh5+ Kg8 17.Bxg7!!** "Today Lasker might have tried to copyright this idea." (Kasparov in the ChessBase Mainbase). **17...Kxg7 18.Qg4+ Kh7** 18...Nf6? 19.Qg5#. **19.Rf3!** Lasker brings fresh forces into the attack. **19...e5 20.Rh3+ Qh6 21.Rxh6+ Kxh6 22.Qd7!** The final point. This double attack wins one of the bishops. **22...Bf6 23.Qxb7 Kg7 24.Rf1 Rab8 25.Qd7 Rfd8 26.Qg4+ Kf8 27.fxe5 Bg7 28.e6 Rb7 29.Qg6 f6 30.Rxf6+ Bxf6 31.Qxf6+ Ke8 32.Qh8+ Ke7 33.Qg7+ Kxe6 34.Qxb7 Rd6 35.Qxa6 d4 36.exd4 cxd4 37.h4 d3 38.Qxd3 1–0**

18A: In general, the main requirements for the double bishop sacrifice are: (1) a castled enemy king at g8 (or g1 if Black is attacking), (2) bishops with clear lines aimed at h7 and g7 (or h2 and g2), (3) the possibility of a queen check, usually at h5 (h4), that drives the enemy king back to g8 (g1), and (4) a rook ready to lift to

the third or fourth rank, or already on that rank, and able to swing over to attack on the g- or h-file. All conditions for the sacrifice are satisfied here, so White lashed out: **18.♗xh7+!** 18.♗xg7? ♔xg7 19.♕g4+ ♔h8 20.♕d4+ ♔g8 21.♕xd7 ♗f6 and White is much better, but it is not over yet. **18...♔xh7 19.♕h5+ ♔g8 20.♗xg7! f5** 20...♔xg7? 21.♖g4+ ♔f6 22.♕g5#. **21.♗e5! ♖f6 22.♖h4 1–0**

18B: Judit Polgar seized the opportunity: **25.♗xh7+! ♔xh7 26.♕h5+** And the former world champion resigned due to **26...♔g8 27.♗xg7! f6** 27...♔xg7 28.♖g3+ ♔f6 29.♕g5#. **28.♗xf6 ♖xf6 29.♖g3+ ♔f8 30.♕h8+ ♔f7 31.♖g7#.**

18C: Here it does not work: **16...♗xh2+? 17.♔xh2 ♘g4+ 18.♔h3** 18.♔g3!? g5 19.♘xd5 ♕xd5 20.♔xg4 ♕xg2+ 21.♗g3 +− and it seems that Black can't profit from White's exposed king. **18...♗xg2+ 19.♔g3?** 19.♔xg2?! ♕xh4 20.♖h1 ♕g5 21.♔f1 ♕f4 22.♔g1 ♖e5 gives Black dangerous compensation.; 19.♔xg4!? was best: 19...g5 20.♔g3 ♗xf1 21.♖xf1±. **19...♕d6+! 20.♔xg4?** 20.♔xg2 ♕h2+ 21.♔f3 ♕h3+ 22.♔f4 (22.♗g3? ♘h2+ 23.♔f4 ♕g4#) 22...♘h2 −+. **20...h5+** And the net around White's king is closed, so Afek resigned: **21.♔xh5** 21.♔g5 ♕f6+ 22.♔xh5 ♗f3#. **21...♗f3+ 22.♔g5 ♕f6#**

19: 19...♗xh2+ 19...♗xg2!? works as well: 20.♔xg2 ♕g5+ 21.♔f3 (21.♔h1 ♕f4 −+) 21...♖fe8 −+ Taking away flight squares is often stronger than giving checks, to prevent the enemy king from getting back to safety. **20.♔xh2 ♕h4+ 21.♔g1 ♗xg2!! 22.f3** 22.♔xg2 ♕g4+ 23.♔h1 ♖d5 −+. **22...♖fe8 23.♘e4** 23.♖fe1 ♖xe1+ 24.♖xe1 ♕xe1+ 25.♔xg2 ♕e2+ 26.♔g3 (26.♔g1 ♖d5 27.f4 ♖h5 28.♕c3 ♕g4+ 29.♔f1 ♖h1+ 30.♔f2 ♖h2+ 31.♔e3 ♕e2#) 26...♖d5 27.f4 ♖h5 28.♕c3 ♕h2+ −+. **23...♕h1+ 24.♔f2 ♗xf1 25.d5 f5! 26.♕c3** 26.♘f6+ ♔f7 27.♘xe8 ♖xe8 28.♖xf1 ♕h2+. **26...♕g2+ 27.♔e3 ♖xe4+ 28.fxe4 f4+** 28...♕g3+!? 29.♔d2 ♕f2+ 30.♔d1 ♕e2#. **29.♔xf4 ♖f8+ 30.♔e5 ♕h2+ 31.♔e6 ♖e8+ 32.♔d7 ♗b5#.**

20: Ljavdanski self-destructed in the following two moves: **26...♗f4?**

I 26...♖fe8!! 27.♗xd8 (27.♕e3 ♗f4 28.♖xf4 ♖xd2 29.♕xd2 ♕xb6 30.♘e2 ♖xe6 31.♘d4 ♖e4 ∓) 27...♖xe6!! Black has only a pawn for the rook, but amazingly his attack crashes through: 28.♔g1 ♗f8!:
A) 29.♕f4? ♗c5+ 30.♖d4 b4 31.♗a5 (31.♘d1 ♖e4 −+) 31...bxc3 32.♗xc3 ♖e2 33.♔f1 ♗b5 −+.
B) 29.♕xh7+ ♕xh7 30.♖xh7 ♔xh7 ∓.
II 26...b4? 27.♘d5 ♗xd5 28.♗xd8 ♗xg2+ 29.♖xg2 ♖xd8 30.♖d4 ♕f3 31.♕d2 ±.

27.♕xf4 ♖xd2? 27...g5 28.♗xd8 gxf4 29.e7 ♖e8 30.♖xf4 is unclear. **28.♕xd2 ♕xb6 29.e7 ♖e8 30.♘d5! ♗xd5 31.♕xd5+ ♔g7 32.♖xh7+ ♔xh7 33.♕f7+ ♔h6 34.♕xe8 ♕f2 35.♕h8+ ♔g5 36.h4+ ♔g4** Now White can promote, as he can easily escape the checks: **37.e8♕ ♕f1+ 38.♔h2 ♕f4+ 39.♔g1 ♕c1+ 40.♔f2 ♕f4+ 41.♔e2 1–0**

21: Ponomariov uncorked the amazing **35...Qd7!!** After 35...Kxe8?, 36.g4! wins a bishop. **36.g4 Bxc3 37.gxf5 Bxf5 38.h4 Bd3 39.Ra2 Kxe8 40.Ke3 Bd4+ 41.Kd2 Bb1 42.Rxa7 c3+ 43.Kc1 Be4 0–1**

22: **1.Nf7! Rxc6 2.Bg5+** 2.Bxb8? Rb6 –+. **2...Kc7** 2...Kc8 3.Be6+ Nd7 4.Ke7 Rc7 5.Be3=. **3.Bf4+ Kc8 4.Be6+ Nd7 5.Ke7 Nab6 6.Be3 Kc7 7.Bf4+ Kc8 8.Be3=.**

23: **21.Be4! Qc8** 21...d5 22.Qxh5!! Bxg5 (22...gxh5 23.Bxh7#) 23.Bxg6 Qd7 24.Qxg5+–. **22.Qxh5!** Black resigned due to **22...gxh5** 22...Bxg5 23.Bxg6+–. **23.Bxh7#**

24: The surprising retreat **35.Bb2!!** forced Black to resign: 35.Qc4? Nd5! 36.Qxc6 bxc6 37.Bc5±. **35...h5** 35...Nd5 36.Bxd5 Qxd5 37.Bxf6+ Kg8 38.Qe8#; 35...Bxb2 36.Qxb2+ Qf6 37.Qxf6#; 35...Kg7 36.Qe7+ +–. **36.Qc4 Qxc4 37.Bxf6+ +–.**

25: **1...Qxf3+ 2.Kxf3 Ne3!! 0–1**

26: White finished nicely with **29.Rxf7!** 29.c6 a2 30.Qa5 Qd6 31.Rc1 Ra8 32.Rf1 wins as well. **29...Ra8** 29...Rxf7 30.d8Q+ +–; 29...Kxf7 30.d8Q+ +–. **30.Re7 Kf8 31.Rxh7 Kg8 32.d8Q+ 1–0**

27: **40.c7!! Qxc7 41.Qe1+** And Black struck his colors as the mate after **41...Kg5 42.h4+ Kh5 43.Qe6!** is unavoidable: **43...Qe5 44.Qg4#.**

28: **26...e2 27.Bd2 Be3!! 0–1**

29: **30...Qxe6!** 30...Qg7? is met by 31.Qe2. **31.dxe6 c2 32.Qe3 Rb1+ 33.Kh2 c1Q 34.Qg3** White's promotion combination does not work: 34.e7 Qxe3 35.Bd5+ Kg7 36.fxe3 Rb8 37.Bc6 Kf7 –+. **34...Qg7! 35.Qh4 Qg1+ 36.Kh3 0–1**

30: **30.Bb3!! Bxb3 31.a6 c4 32.a7 1–0**

31: **34.Rg8+! Rxg8 35.Nxg8 Bc6 36.Nf6 a5 37.h5!?** 37.e8Q+ Bxe8 38.Nxe8 Rxh4 39.Bc4 should win as well, but is more difficult due to the reduced material. So Hracek decides to sell his main trump for a higher price. **37...a4 38.Kc1 Rh4 39.Kb2 Rh3 40.Bf5 a3+ 41.Ka2 Re3 42.Bd7 1–0**

32: **35.Rxd5! 1-0** Black is defenseless: **35...Rxf8** 35...Qxd5 36.Qxg7#. **36.Rxd7+–.**

33: **21...Ne5! 22.dxe5** 22.Qc3 Nc6 23.Be3 Nxd4+ 24.Bxd4 Bxd4 25.Rhd1 Bxc3 –+. **22...Rc6+!?** 22...Rxb2+ 23.Kxb2 Qxd3 24.Rc8+ Kf8 25.Ka1 Qxf3 26.Re1 Kg7 should win in the long run as well. **23.Qc3** 23.Bc3?! Rxb2+ 24.Kxb2

♕xd3 25.♖hd1 ♕b5+ 26.♔a1 ♗xe5–+ (Hübner in CBM 86). **23...♕d5 24.♔b1**
♖xc3 25.♗xc3 ♗xe5 26.♔a1 ♗xc3 27.♖xc3 ♕e5 28.h4 h5 29.a3 ♕f4 30.♖e3
♖c8 31.♔b1 ♖c7 32.♖d3 ♖e7 33.♔a1 ♔g7 34.♖c3 ♖c7 35.♖e3 ♖c2 36.♘g5
♕c7 37.♔a2 ♕c4+ 38.♔b1 ♖xf2 39.♖c3 ♕b5 40.♖c2 ♕d3 0–1

34: 36.♖a3!! 36.♖c4 ♖xc4 37.dxc4 ♘xe4 38.♕e3±. **36...♘xd3** 36...♖xa3 37.♕xc5
♕d6 38.♕c8+ ♔f8 39.♕xf8#; 36...♘b3 37.d4!!+–. **37.♕h4 1–0**

35: 37...♖xg2+! **38.♔h1** 38.♔xg2 c5+–+. **38...♕a1+!** 0-1 A decisive double
attack.

36: 33...♖h5!! **34.♖ff4** 34.♖xh5? ♕xg4+ 35.♔f1 ♖xh5–+. **34...♗g5!** The
decisive strike. **35.♕g3 ♗xf4 36.♖g8+ ♔e7 37.♕xf4 ♕h6 0–1**

37: 31...♕xd2!! And White resigned due to **32.♕xd2 e3+–+.**

38: 20...♗xf2+! **21.♔h1** 21.♔xf2 ♖d2+ 22.♔g1 ♖xb2 23.♖xd8+ ♕xd8 24.♕f3
f5∓; 21.♖xf2?? ♖xd1+ 22.♖f1 ♕c5+–+. **21...f5 22.♕e2 ♗c5 23.♖xd7 ♕xd7**
24.h3 h6 25.♖e1 ♔h7 26.♕e5 ♕f7 27.♕e2 f4 28.♕g4 g5 29.♖xe6? This
backfires due to White's weak back rank. **29...♕xe6 30.♕xe6 ♖d1+ 31.♔h2**
♗g1+ 0–1 White can't escape: **32.♔h1 ♗f2+ 33.♔h2 ♗g3#**

39: 34.♗c8! **♕xc8** 34...♘c6 35.♕xa4 ♖xh3+ 36.gxh3 ♕xc8 37.♔g2+–.
35.♕xd6+ ♔e8 36.♕xe5+ ♔f8 36...♔e6 37.♕c7 ♔f8 (37...♖xh3+ 38.♔g1 +–)
38.♖d8+ ♘e8 39.♕c5+ ♔g8 40.♗e7+–. **37.♕d6+ ♔e8 38.e5 1–0**

40: 28.♗b6+! **♔xb6 29.♖xe6+ ♗d6** 29...♔xa5? 30.♖a1+ ♗a3 31.♖xa3#.
30.♖exd6+ ♔c7 31.♖d7+ ♔c8 31...♔b6? 32.♖b7+ ♔xa5 33.♖a1#; 31...♔b8?
32.♘c6+ ♔c8 33.♘e7+ ♔b8 34.♖1d6+–. **32.♘c6 ♖e8 33.♘e7+ ♔b8 34.♖1d6**
1–0

41: 36.♖d8!! **♖xe3+** 36...♖xd8? 37.♖xg7+ ♔f8 38.♕xd8+ ♔xg7 39.♕f6+ ♔g8
40.♕f7+ ♔h8 41.♕h7#. **37.♔f2 ♖f3+ 38.♔g2 1–0**

42: 26.♗xf7+! **♔xf7** 26...♔xf7 27.♘gxh6+ +–. **27.♕c4+ ♔g6 28.♕xc7 ♖xd4**
29.♘xd4?! 29.♘h4+ ♔h7 30.♖xd4 was better, according to Dautov in CBM 94.
29...♗c8 30.♘e5+ ♔h7 30...♖xe5 31.♕xe5 ♕xf2+ 32.♔h2 ♘f6 33.♕e1 ♕xb2
34.♘f3± (Dautov). **31.♘df3 ♕c5!** And White was only slightly better, but he
won nevertheless.

43: 25.♗xf5!! **♖f6** 25...exf5 26.♕d5+ ♔f8 27.♗b4++–. **26.♗xe6+ 1–0**

44: 24.♖c8!! And Black resigned due to **24...♖xc8 25.♕xe6+ ♔f8 26.♕xc8+**
♔e7 27.♗c4+–.

45: 34.♘c5!! 34.♕h6?? ♕xg2#. **34...♕xc5** 34...♘xc5? 35.♕d8#. **35.♕xd7+ ♔f8 36.♕d8+ ♔g7 37.♖d6 1–0**

46: 1.♗xf7+ ♔xf7 2.♕b3+ ♖e6 2...♔f8 3.♘fg5 hxg5 4.♘xg5 ♖e7 5.dxe7+ ♔xe7 6.♕f7+ ♔d8 7.♘e6#. **3.♘fg5+ hxg5 4.♘xg5+ ♔f6 5.h4 1–0**

47: 24.♗c4!! ♕xc4 24...♔h7 25.e6 ♗xe6 26.♖d8+ ♘xd8 27.♕xd8+ ♔f7 28.♕d7+ ♔f8 29.♕xe6 +−. **25.♕xd7+ ♔f8 26.♕xf5+ ♔e8** 26...♕f7 27.♕g4 ♘xe5 28.♖d8+ ♔g7 29.♗f6+ ♔xf6 30.0–0+ ♔e7 31.♕g5++−. **27.♕d7+** And Black resigned as White's king rook will enter the fray with decisive effect.

48: 21.♗xf7+! ♕xf7 21...♔xf7 22.♕c4+ ♔f8 *(22...♔g6 23.♘h4+ ♔h7 24.♘hf5±; 22...♔e6 23.♖xd6 ♕xc4 24.♖xc4±)* 23.♘f5 ♖ac8 24.♘xe7 ♖xc4 25.♘g6+ ♔f7 26.♖xc4 ♗d5 27.♘gh4±. **22.♖xd6 ♖ad8** 22...♘d5 23.♕d2 ♘xe3 24.♖d7! ♖e7 25.♖cc7 ♖xd7 26.♖xd7 ♕c4 27.♕xe3± (Donev in CBM 76). **23.♘e5 ♕b3 24.♖xd8 ♖xd8 25.♖c7 ♗e4 26.♕xa6 ♕xb2 27.♕c4+ ♗d5 28.♖xg7+! ♔xg7 29.♕c7+ ♘d7 30.♕xd8 ♕a1+ 31.♔h2 ♕xe5 32.♕xd7+ ♗f7 33.♕c6 ♕e6 34.♕c3+ ♕f6 35.♕d2 ♕e5 36.♕b4 ♕f6 37.f3 h5 38.♕e4 ♗e6 39.♕b7+ ♗f7 40.♕e4 ♗e6 41.♘d5 ♗xd5 42.♕xd5 ♔h6 43.f4 1–0**

49: 30.♘d7!! ♖xd7 30...♕c7 31.♘f6++−; 30...♗xc4 31.♘xb8+−. **31.♗xe6+ ♖xe6 32.♖xe6 ♘c7 33.♖e7 1–0**

50: 21...♗xf3 22.♗xf3 ♖d2!! 0–1

51: 21...♗e3! 22.♕c2 ♖fc8 23.♘c4 d5 0–1 Due to **24.exd5 ♖xc4−+.**

52: 18.♕b4! bxa6 18...♖e8 19.♖ab1 ♖e6 20.♖fe1 +−. **19.♗h7+!** A typical deflection. Remember it! **19...♔xh7 20.♕xf8 +−** And White won later.

53: 27.♖xf6 ♖xf6? 27...♕xf6! 28.♗xf6+ ♖xf6 29.d7 ♖f2 30.♕e1 e5 is not totally clear. Did you calculate this far? In the ten tests you should certainly try to dig as deep as you can within the limited time. **28.♕g4 ♕h6** 28...♕xg4 29.♗xf6+ ♔g7 30.♖xg7 ♗d4 31.♗xd8 *(31.♗xd4? ♖xd6 32.♖d7+? is refuted by 32...♖xd4)* 31...e2 32.♗h4 +−. **29.♕xe6 ♖df8 30.d7 e2 31.♗xf6+ ♕xf6 32.♖g8+ 1–0**

54: Black's last move was c7-c5, but taking en passant is not the solution: **26.♕xg7+!! ♖xg7 27.♖xf8+ ♔h7 28.♖1f7 ♗a4 29.♖xg7+ ♔h6 30.♕d2 ♗b5** 30...♕xd5+ 31.♔e1 ♕d1+ 32.♔f2 ♕c2+ 33.♔g3 ♕xc3 34.♖xg6 +−. **31.♖h8+ ♔g5 32.h4+ ♔f5 33.♖h5+ ♔g4** 33...gxh5? 34.♖g5#. **34.♖g5+ ♔xh4 35.♗f6 1–0**

55: 39...♘f2+ 40.♕xf2 ♖c1+! 0–1

56: 26.♘g7! ♕e7 26...♘xg7? 27.♕xf6 ♘h5 28.♕f7+ ♔h8 29.♕xc7 +−. **27.♘xh5 gxh5 28.♖xf6 ♗d6 29.♗g5** 29.♗f5!? +−. **29...♔g7 30.♖h6 b4 31.♖xh5 ♘g6 32.♗e6+ ♔f8 33.♕g4 bxc3 34.♗h6 ♕xh6 35.♕f5+ ♔g7 36.♕f7+ 1–0**

57: 29...♖e1!! 0–1 The rook is used as a decoy to deflect white's rook from the defence of f3: **30.♔g2** 30.♖xe1 ♕xf3#. **30...♖xf1 31.♔xf1 ♕xf3+ 32.♔e1 ♕xd5 −+.**

58: 30...g5! In the game, 30...♗xd5?= was played. **31.♖e1 gxf4** 31...♘g4!?. **32.♖xe5 ♖ac8 33.♖e8+ ♖xe8 34.♗xf3 fxg3 35.hxg3 ♖e7 −+.**

59: 39.♕xf5! ♖g4? 39...♕c1+! was more tenacious, but not sufficient: 40.♔xc1 ♖g1+ 41.♔d2 exf5 42.e6 ♖g6 43.♖h8+ ♔g8 44.♗e7+ ♔g7 45.♖xg8+ ♔xg8 46.♔e3 f4+ 47.♔xf4 ♗g6 48.♔e5 ♗e4 49.♗c5 ♔g7 50.♔d6 +− (Psakhis in CBM 90); 39...♕xf5?? 40.♗e7#. **40.♖h8+** 40.♗g7+ ♔e7 *(40...♔g8 41.♖h8+ ♔xg7 42.♕h7#)* 41.♕f8+! ♕xf8 *(41...♔d7 42.♗f6+ +−)* 42.♗f6#. **40...♔f7 41.♕h7+ 1–0**

60: 29...♗xf3 And White resigned due to **30.♗xb3** 30.gxf3 ♘xd2 −+. **30...♗e4 31.♖e1 axb3 32.♖xe4 ♖d8 −+.**

61: 21...♘xf4! 22.♗g4! 22.gxf4?? ♖g6+ 23.♘xg6 ♕xa3 −+. **22...♘g6?!** 22...♘e6 23.♖e3 ∓. **23.♖e1 f6** 23...♖e6 24.♗xe6 *(24.♕c1!?)* 24...♕xa3 25.♘xf7=. **24.♘f3** And White had some compensation and even won eventually.

62: 24.♖h8+!! ♔g7 24...♔xh8 25.♘xf7+ ♔h7 26.♘xd6 +−. **25.♖xe8 ♕d4 26.♕xd4 cxd4 27.♖e7 ♔g8 28.♖xf7 ♘c6 29.♗e6 1–0**

63: 15.♕g3! ♗g4 15...♖he8? 16.♘g6 ♕xg3 17.♘xe7+ ♖xe7 18.hxg3 +−; 15...♘e8 16.♖e2 *(16.♘xh7!?)* 16...♘f8 17.♖he1 h5 18.♘xf7 ♖xf7 19.♘xe6 ♕xg3 20.hxg3 ♘xe6 21.♖xe6 +−. **16.♖xe7 ♕xe7 17.f3 h6** 17...♕e3+ 18.♔b1 ♗h5 19.♗f5 ♕xd4?! 20.♘xh5 ♘xh5 21.♗xd7+ ♔xd7 22.♕h3+ +−. **18.♖e1 ♕f8 19.♘xf7 ♕xf7 20.♗g6! ♕f8 21.fxg4 ♕d6 22.♖e6 ♕f8? 23.♗f5 ♕f7 24.♖xf6!** And Black resigned due to **24...♕xf6 25.♘e6 +−.**

64: 1.♕g3! 1...♕e3 +−. **1...♕xh6+** 1...♖xg3?? 2.♖xe8#. **2.♕h3 ♕d6 3.♔h1 ♔g8 4.♖xe8+ ♔f7 5.♖h8 1–0**

65: 65.♖e7+ ♖xd4 66.cxd4 g3 66...♗d5 67.♔xf4 +−. **67.♖xe4 g2 68.♖e1 f3 69.♔g6 f2 70.♖e8# 1-0**

66: 41.♕h5!! ♖xg2+ 41...♖xh5 42.♖g8+ ♔d7 43.e8♕+ ♔c7 44.♕xh5 +−. **42.♖xg2+ ♖xh5 43.♖xb2 ♖xh3+ 44.♔g1 ♖h7 45.♖h2 ♖g7+ 46.♔f2 ♖g8 47.♖h6 ♔f7 48.e8♕+ ♖xe8 49.♖h7+ 1-0** Black to move wins easily with 1...♖xg2+! 2.♖xg2 ♕xg2+ 3.♔xg2 ♖xh6 −+.

67: 9.♕d8+! ♔xd8 10.♗g5+ ♔c7 10...♔e8 11.♖d8#. **11.♗d8# 1–0**

68: Before he became known for his book reviews at www.ChessCafe.com, Taylor Kingston played a good game now and then: **14.♘g5! ♗xg2 15.♗xf6 g6** 15...Bxf6?? 16.Qxh7#. **16.♘xe6! fxe6 17.♗xe7 ♕xe7 18.♔xg2** Winning an important pawn and eventually the game.

69: Nunn coined the acronym "LPDO" (loose pieces drop off), which applies here: **39...♖d3! 0–1**

70: 31...♖d6!! 32.♘e6+ 32.♕xe8? ♖xd1+ 33.♔g2 ♘xe8 –+; 32.♖xd6? ♕xb5 –+. **32...♕xe6 33.♖a1 ♖d5 34.♕a4 ♕h3 35.f3 e4 36.♕a7 exf3 0–1**

71: 27.♕d5+ ♔f7 28.♕xf7+ 28.♕d8+ ♖f8 29.♕xf8+ ♔xf8 30.♖f4+ +–. **28...♔xf7 29.♖f4+ ♔e7 30.♖xf3 ♔e2 31.♖e1 1–0**

72: The deadly double attack **12.♕d1 1-0** decided immediately. Karpov does not often lose in just twelve moves, so watch out for loose pieces!

73: 25...♘d2? was a fatal error: **26.♘xd2 ♕xc3 27.♘b3! ♕xb4?** 27...♕xd3! was called for: 28.♘c5 ♕c2 29.♘xd7 ♕xf2+ 30.♔h1 h6 31.♕g3 ♖cc2 32.♕xf2 ♖xf2 33.♘f6+ ♔g7 34.♖g1 and Black still has some drawing chances due to his activity. **28.h4 ♕c3** 28...♕b2 29.♖xb2 ♕xe1+ 30.♗f1 +–. **29.♗xb5 ♗xb5 30.♖ec1 d4 31.♘xd4 ♖b2 32.♖a1 ♖a2 33.♖xc3 ♖xa1+ 34.♔h2 ♖xc3 35.♘xb5 1–0**

74: 30.♘e6+ 30.dxe5? ♖xb1 31.♖xb1 ♘xe3 32.fxe3 ♕xe3+ 33.♔h1 ♖d2 –+; 30.♖xb8!? may be even stronger: 30...♖xb8 31.♘d7 *(31.dxe5? ♖b2 32.♘d3 ♖c2 gives Black good compensation for the pawn.)* 31...♖b2 32.♖f1 e4 *(32...♘xe3? 33.♕xe5+ +–)* 33.♕a8 h5 34.♕f8+ ♔h7 35.♘e5 ♕f6 36.♘xf7+–. **30...fxe6?** 30...♔g8! 31.♘xd8 ♘xe3 32.fxe3 ♖xb1 33.♖xb1 ♕xe3+ 34.♔f1 ♕d3+ 35.♔f2 ♕xd4+ 36.♔e2 ♕e4+ 37.♔d2 ♕xb1 38.♕xe5 ♕b4+ still offered some drawing chances. **31.♖xb8 ♖xb8 32.♕a7+ ♔h6 33.♕xb8 e4 34.♕e5 1–0**

75: 29.♕e8! ♗f6 30.♕d7 The rook can't run away. **30...h5 31.♗xg6 ♔xg6 32.♕d3+ ♔g7 33.♖f3 ♕e7 34.♔h2 1–0**

76: 34...♖e6! 35.♖f1 35.f7+ ♔xf7 36.♘g5+ ♔g6 37.♘xe6 ♕xd6 –+ (Postny in CBM 85). **35...♖xd6 36.♘xd6 ♕xd6 37.f7+ ♔f8 38.♖f5 g6 39.♖fxe5 c3 40.♖e6 c2 0–1**

77: 35...♖xc2! 36.♕f3 36.♔xc2 ♕c4+ 37.♔d2 ♕xf1 –+. **36...♖c5 37.♕a8+ ♔g7 38.♕xa6 ♖xg5 39.♕c6 ♕d5 40.♕c3+ 0–1**

78: 31.♖xc4! 31.♕b7? ♕xf2+ 32.♔h1 ♖d3 33.♗b5+ ♘d7 34.♗xd7+ ♔e7

35.♗c6+ ♔f6 36.♖aa1 ♖h8 37.♗g2 ♖xh2+ 38.♔xh2 ♕xg3+ (Ribli in CBM 77) 39.♔g1 *(39.♔h1? ♕h4+ 40.♔g1 ♕d4+ 41.♔h2 ♕d6+ −+)* 39...♕e3+=. **31...♘xc4 32.♕b8+ ♔e7 33.♕b7+ ♔f6 34.♕xf3+ ♔e7 35.♖c1 1–0**

79: 29...♖xc4! 30.♖xc4 ♕d5 31.g3 ♕xc4 32.♖c1 ♕e2 33.♖c8 ♘d5 34.♕f1 ♕f3 35.♕g2 ♕b3 36.♕f1 ♘xf4 37.♖c5 ♕xa4 38.♖c7 ♕b3 0–1

80: 24.♗e7+!! ♔xe7 24...♖xe7? 25.♖c8+ ♖e8 26.♖xe8#. **25.♖c7+ ♔d8 26.♕f7 ♕e1+ 27.♔g2 ♕xf2+!** Minasian fights back! 27...♕e4+? 28.♔h2 ♕a4 29.♖xb7 ♕c6 30.♖b8+ ♔c8 31.♕xa7±. **28.♔xf2 ♖gf8 29.♖d7+ ♔c8 30.♖xb7 ♖xf7+ 31.♖xf7 ♖d8 32.♖xa7 ♖d7 33.♖a8+** The pawn ending after 33.♖xd7?? ♔xd7 is won for Black due to his protected passed pawn: 34.♔e3 ♔c6 35.♔d4 ♔b5 36.♔c3 ♔a4 37.♔b2 g5 38.♔a2 d4 39.♔b2 d3 40.♔c3 ♔xa3 41.♔xd3 ♔b4 42.♔d4 ♔b5−+. **33...♔c7 34.♔e3 ♔b6 35.♖e8 ♖a7 36.♖xe6+ ♔c5 37.♖g6 ♖xa3+ 38.♔f4 ♖a7 39.h4 ♖f7+ 40.♔e3 ♖e7 41.♔f4 ♔d4?!** 41...♖f7+=. **42.e6 ♖a7?!** 42...♔c3 43.♔e5 d4 44.♔d6 d3 45.♔xe7 d2 46.♔f8 d1♕ 47.e7 ♕f3+ 48.♔xg7 ♕e4=. **43.♖g4 h5?** 43...♔c5 44.♔e5 ♔c6 45.h5 ♖b7=(Svidler). **44.♖g5 ♖e7 45.♔f5 ♔c5 46.♔e5 d4 47.♖xh5 d3** 47...♖e8 48.♖g5 ♖e7 49.♖f5 d3 50.♖f3 ♔c4 51.♔d6+−. **48.♖h8** The rook belongs behind the passed pawn. **48...♔c4** 48...♖a7 49.♖d8 ♔c4 50.♖d7 ♖a1 51.♖d4+ ♔c3 52.e7 d2 53.e8♕ ♖e1+ 54.♖e4 ♖xe4+ 55.♔xe4 d1♕ 56.♕e5++−. **49.♖c8+ ♔b3 50.♖d8 ♔c2 51.♔d6 ♖e8 52.e7 d2 53.♔e6 1–0**

81: 30...♖a5! 30...♖b3? 31.♕c1 ♕a4 was played in the game and now White could have won immediately with 32.♖g1+−. **31.♕c1** 31.♕g2 ♗xa3 32.♕xg8+ ♗f8+ 33.♔b1 ♖a1+ 34.♔c2 ♕a4+ 35.♔d2 ♖xf1 36.♕xf8+ ♔c7=. **31...♕b6 32.♕c2 ♕a6 33.♕c1=** (Lukacs in CBM 79).

82: 35...g3+!! 35...♕xh2+? 36.♔g2 ♕f4+ 37.♔e2! ♕h6 38.♕xe6+! ♕xe6 39.♗d5!! 1–0 was the actual end of the game. **36.♔e2!** 36.hxg3? ♘g4+ 37.♔g1 ♕h2#. **36...♕g4+ 37.♔d2 ♕b4+ 38.♔c2 ♕a4+ 39.♔b1** 39.♕b3? ♕xb3+ 40.♔xb3 gxh2 41.♗g2 f4−+. **39...♕b4=** with perpetual check.

83: 55...♖xh5!! The game went 55...♔b4? 56.♖b6+ ♔c5 57.♖xh6 ♔b4 58.♔c2 ♖c3+ 59.♔d2 ♖h3 60.♖h8 ♔c5 61.♔c2 ♔b5 62.♔d2 ♔c6 63.h6 ♔b7 64.b4 ♔a7 65.♔e2 ♖h4 66.♔f3 ♖xb4 67.♖g8 ♖h4 68.♖g6 ♔b7 69.♔g3 ♖h1 70.♔f4 ♔c7 71.♔f5 ♔d7 72.♔f6 ♔e8 73.♔g7 1–0. **56.♖a5+ ♔b4 57.♖xh5** Stalemate.

84: 1...♔h6!! 2.♕d3 2.♕c8 ♖xe2 3.♕f8+ ♔g5 4.♕g7+ ♔f4 5.♕d4+=; 2.♗g4 d1♕ 3.♗xd1 ♖xh3+ 4.gxh3 ♖h2+ stalemate. **2...d1♕ 3.♕xd1** 3.♕xg3 ♕xg1+ 4.♔xg1 ♖xg2+ 5.♔xg2 stalemate **3...♕xh3+ 4.gxh3 ♖h2+ 5.♔xh2** Stalemate.

85: 1.♘g1 1.♔g5? ♔e3 2.♘f3 ♘f4+−+. **1...♘e3+** 1...e1♕ 2.♘f3+=; 1...e1♘+ 2.♔xf1=. **2.♔h3! ♘f4+** 2...e1♕ 3.♘f3+ ♘xf3 stalemate. **3.♔h2 ♘g4+** 3...e1♘ 4.♘f3+ ♘xf3+ 5.♔g3 and one of the knights is lost. **4.♔h1 ♘f2+** 4...e1♕ 5.♘f3+

♘xf3 stalemate. **5.♔h2 e1♘ 6.♘f3+ ♘xf3+ 7.♔g3 ♔e3** Stalemate. A magnificent opus!

86: 56...♖c1+ 57.♔b6 ♖c7! 58.♔a6 58.a6 ♖xb7+ 59.axb7 stalemate. **58...♖c6+ 59.♖b6** ½–½ A draw was agreed due to **59...♖xb6+ 60.♔xb6** Or 60.axb6 stalemate.

87: 19.♗d4+ ♔h6 20.♖h4+ ♔g5 21.♖h5+ ♔g4 21...♔f4? *22.♖f1+ ♔g4 (22...♔e4 23.♖h4+ ♗g4 24.♖xg4#)* 23.h3+ ♔g3 24.♖f3#. **22.h3+?!** 22.♖f1!? ♘e2+ 23.♔h1 ♘xd4 24.h3+ ♔g3 25.♖g5+ ♔h4 26.♖h5+=. **22...♔g3 23.♗f2+** 23.♖f1 may also be sufficient to draw. One possible line runs 23...♗g4 24.♗f2+ ♔f4 25.hxg4 ♘e2+ 26.♔h2 ♔e4 27.♖h3 ♕e5+ 28.♔h1 ♔g5 29.♖e1 ♕d2 30.♗xe8 ♖xe8 31.♖d3 ♔h6+ 32.♖h3 ♕d2=. **23...♔f4 24.♖h4+?** 24.♖f1 ♗g4 25.hxg4 was called for (see 23.♖f1). **24...♔g5 25.♖h5+ ♔f6 26.♗d4+ ♔xf7 27.♖f1+ ♔e6 28.♖f6+ ♔d7 29.♖xh7+ ♔d8 30.♖f2 ♕c1+ 31.♔h2 ♘d5 32.c4 ♕d1 33.♗xa7 ♖xa7 34.♖xa7 ♕d4 35.♖ff7 ♕e5+ 0–1**

88: 1.♗xh7+ ♔xh7 2.♕h4+ Even stronger is 2.♖h3+ ♔g8 3.♘f6+ gxf6 *(3...♔f8 4.♕c5+ ♘e7 5.♖h8#)* 4.♕h4 ♔f8 5.♕xf6 ♘e7 6.♕h6+ ♔g8 7.♕h8#. **2...♔g8 3.♘f6+ gxf6** 3...♔f8 4.♘xe8 ♕xc2 5.♕h8+ ♔e7 6.♖bd3 +–. **4.♖h3 ♔f8 5.♕xf6 ♘e7 6.♕h6+ 1–0**

89: 16.♗xh7+! ♔f8 16...♔xh7 17.♕h5+ ♔g8 18.g6! fxg6 19.♖xg6 ♗f8 20.exd6 ♕xd6 21.♖hg1 ♘ce5 22.fxe5 ♘xe5 23.♖xg7+ ♗xg7 24.♖xg7+ ♔xg7 25.♗h6+ +– (Bangiev in CBM 81). **17.♗e4! dxe5 18.♕h5 ♗b4 19.f5 ♘d4 20.f6 gxf6 21.gxf6 ♘xf6 22.♕h6+?!** 22.♗h6+!? ♔e7 23.♕xf7+ was much easier. **22...♔e7 23.♗xb7 ♗xc3 24.♘xd4 ♕xb7 25.♖f1 ♘d7?!** 26.♖xf7+!! ♔d8 27.♘f3 ♗d4 28.♖d1 ♔c8 29.♘xd4 exd4 30.♗xd4 ♕c6 31.♗f2 ♘e5 32.♖g7 ♖f8 33.♗g3 ♘f7 34.♕f4 ♕b7 35.♕b4 1–0

90: 16.♗xh7+? 16.♘xg5 was forced. **16...♔xh7!** 16...♔h8? is extremely risky, e.g. 17.♘xg5 g6 18.♖ac1 ♖a3 19.h4 ♔g7 20.h5 ♖h8 21.hxg6 fxg6 22.♗xg6 ♔xg6 23.♕e4+ with attack. **17.♘xg5+ ♔g6!** 17...♔g8? 18.♕h5 ♕d3 19.♖e4+–; 17...♔h6? 18.♕e4 ♔xg5 *(18...f5? 19.♕h4+ ♔g6 20.♕h7+ ♔xg5 21.f4+ ♔g4 22.♕g6+ ♔xf4 23.g3+ ♔f3 24.♕h5#)* 19.♕h7 ♕xe5 20.♖xe5+ ♘xe5 21.f4+ ♔xf4 22.♖f1++–. **18.♕e4+ f5! 19.♕h4 ♘xe5 20.♖ac1 ♕d2 21.♘h3 ♔g4 22.♖ed1 ♕h6 23.♕e7 ♖f7 24.♕d8 ♖d7 25.♕e8+ ♔h7 26.f4 ♘f6 27.♕f8 ♖xd1+ 28.♖xd1 ♘e4 29.♘g5+ ♘xg5 30.fxg5 ♕xg5 31.♖d8 ♗d7 0–1**

91: 16.♗xh7+?! 16.♕c2 was better. **16...♔xh7** 16...♔h8? 17.♘g5 g6 18.♕f3 ♘f5 19.♗xg6+–. **17.♘g5+ ♔g6** 17...♔g8? 18.♕h5 ♖fc8 19.♕xf7+ ♔h8 20.♖c3+–; 17...♔h6? 18.♕g4 ♘f5 *(18...g6 19.♕h3+ ♔xg5 20.♗c1#)* 19.♗c1 +–. **18.♕g4 f5?** 18...f6! 19.♘xe6+ ♔f7 20.♘xc7 ♗xg4 21.♘xa8 ♖xa8 with unclear play was Black's best option. **19.♕g3 ♔c8** 19...f4 20.♕h4 ♖h8 21.♕xf4 ♖af8 22.♕g4 with strong attack. **20.♖c3 f4 21.♕g4 ♘f5** 21...♖f5 22.♘e4+ ♔h7

23.♘f6+ ♖xf6 24.exf6 ♘f5 25.♖h3+ ♔g8 26.♕g6+–. **22.♖h3 ♖h8 23.♘xe6+ ♔f7 24.♕xf5+ ♔e7 25.♕g5+ ♔xe6 26.♕g6+ ♔e7 27.♕xg7+ 1–0**

92: 12.♗xh7+?! ♔xh7 13.♘g5+ ♔g6? 13...♔g8! was forced: 14.♕h5 ♕f6! *(14...♘f6? 15.♕xf7+ ♔h8 16.♖e4! +–; 14...♘e5? 15.♖xe5 ♗xe5 16.♕xf7+ ♔h8 17.♕h5+ ♔g8 18.b3 d3 19.♕h7+ ♔f8 20.♗a3+ ♗d6 21.♕h8+ ♔e7 22.♕xg7#)* 15.♕h7+ ♔f8 16.♘e4 ♕e5 17.cxd4 ♕xh2+=. **14.h4 ♖h8?** 14...f5 15.h5+ ♔f6 16.♕xd4+ ♗e5 17.♕h4 ♕a5 18.b4 ♕d5 19.♗b2+–. **15.♖xe6+**

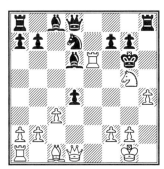

15...♘f6 15...fxe6 16.♕d3+ ♔h5 17.g4+ ♔xg4 18.♕f3+ ♔xh4 19.♕h3#. **16.h5+ ♔h6** 16...♖xh5 17.♕d3+ ♔h6 18.♕h7#. **17.♖xd6 ♕a5 18.♘xf7+ ♔h7 19.♘g5+ ♔g8 20.♕b3+ 1–0**

93: 10.♗xh7+! ♔xh7 11.♘g5+ ♔h6

I 11...♔g6 12.♘e2:
A) 12...♗xg5 13.hxg5:
A1) 13...f5 14.gxf6 ♖h8 15.♘f4+ ♔f7 16.♕g4 ♖xh1+ 17.♔e2 +–.
A2) 13...♕xg5 14.♘f4+ ♔f5 *(14...♕xf4? 15.♕h5#)* 15.♖h5 +–.
A3) 13...♖h8 14.♘f4+ ♔f5 15.♘h5 ♕xg5 16.♘g3+ ♕xg3 17.♖xh8 +–.
B) 12...♔h6 13.♕d2 ♕b6 14.c3 *(14.0–0–0!?)* 14...♘c6 15.♘f4 ♘xd4 16.♘gxe6 ♘xe6 17.♘xd5+±.
II 11...♗xg5? 12.hxg5+ ♔g8 13.♕h5 f5 14.g6+–.

12.♕d2 ♗xg5 12...♕b6 13.0–0–0 ♕c6 14.♕f4 +–. **13.hxg5+ ♔g6 14.♘e2 ♕xg5 15.♘f4+ ♔f5 16.♖h5 ♕xh5 17.♘xh5 g5 18.c3 ♔g6 19.♕c2+ ♔xh5 20.♕h7+ 1–0**

94: 15...♗xh2+! 16.♔xh2 ♕h4+ 17.♔g1 ♕xf2+ 18.♔h1 18.♔h2 ♖f4 19.♖e4 ♕h4+ 20.♔g1 ♖xe4 21.♗xe4 ♕xe4 22.♕xd7?! ♕e1+ 23.♔h2 ♕e5+ 24.♔h3 ♕xb2–+. **18...♖f4 19.♖e4 ♕h4+ 20.♔g1 ♖xe4 21.♗xe4 ♕xe4 22.♕xd7?! ♕e3+ 23.♔h2 ♕e5+ 24.♔h1 ♕xb2 0–1**

95: White has a very bad position in any case, so the Greek Gift sacrifice was not a bad bet. But it does not work: **15.♗xh7+ ♔xh7 16.♕h5+ ♔g8 17.♘g5 ♖e8?**

17...♕d3! –+ and the attack is over. **18.♕xf7+ ♔h8 19.♕h5+ ♔g8 20.♕h7+ ♔f8 21.♕h8+ ♔e7 22.♕xg7+ 1–0**

96: 28.♖e5!! ♕a1+ 28...dxe5 29.♖xg7+ ♔h8 *(29...♔f8 30.♖g8#)* 30.♖g4+– . **29.♔h2 ♖c1 30.♖xg7+ ♔h8 31.♘xc1 ♕xe5 32.♖xf7 ♖xc1?** 32...♕xg3+ 33.♔xg3 ♖xc1 34.♖xe7+– . **33.f4 1–0**

97: 20...♘d2! 21.♗xd2 ♕xd4+ 22.e3 ♕xb2! Much stronger than 22...♕xd2 23.♕xd2 ♖xd2 24.♖f2 ∓ . **23.♖f2 ♖xd2 24.♖xd2 ♕xd2 –+** And Black eventually won the endgame.

98: 22.♘e7! d5 22...♖xe7 23.♕g5+ ♔h8 24.♖xe7 +– ; 22...♖xe7 23.♖xe7+ ♖xe7 24.♕g5+ +– . **23.♗xd5 ♖b6** 23...♖d7 24.♖e6 ♖xd5 25.♕h6+ ♔h8 *(25...♔f7 26.♕f6+ ♔e8 27.♘xd5+ ♗xe6 28.♕xe6+ ♔e7 29.♕xe7#)* 26.♖f6 ♖g8 27.♖f7 +– . **24.♘xc8 ♖h6 25.♖e7+ ♕xe7 26.♕xh6+ ♔xh6 27.♘xe7 +–** And White won after some further moves.

99: 22...♖g3!! 22...♖xg2 23.♕xg2 ♕e3+ 24.♕e2 ♗h4+ 25.♖f2 ♗xf2+ 26.♔f1 ♗xd3 27.♖xd3 ♕xe2+ 28.♔xe2 ♗c5 is better for Black, but not as clear as the main line. **23.♕xg3** 23.hxg3? ♕e3+ 24.♗e2 ♕xe2#. **23...♗h4 24.♗xa6** 24.♕xh4? ♕e3+ 25.♗e2 ♕xe2#. **24...♗xg3+ 25.hxg3 ♕xa6 –+** And Black won later.

100: 30.♘g4 ♕f4 30...♕f8 2.♘h6+ ♔h8 31.♘f5+ ♔g8 32.♖xg7+. **31.♘h6+ ♔f8 32.♖f5!+ ♕xf5** (32...exf5/♘xf5 4.♕f7#) **33.♘xf5** And Black resigned shortly.

101: 26.♖xe6+!! fxe6 27.♕g7+ ♔d6 28.♖xe6+ The second uninvited guest on e6. **28...♔xe6 29.♕xc7 ♖5d6 30.♗c4+ +–** And White won later.

102: 35.♖e6 ♕d3 36.♖xh6+ And Black resigned due to **36...♗xh6 37.♕e5+ ♔g8 38.♕e6+ ♔h8 39.♕xh6+ ♔g8 40.♕g7#.**

103: 22.♕h5 g6 23.♗xg6! 1-0 In view of **23...hxg6 24.♖g4**, etc. 22...h6 was better, but would only prolong matters slightly, viz. 23.♕g6 ♕g5 24.♕h7+ ♔f8 25.♖xc5+ bxc5 26.♗xc5+ ♖e7 27.f4 ♕g4 28.♗g6 forcing 28...♕xg6 29.♕xg6 +– .

104: 35.♕h6+ ♔f7 35...♔e7?! 36.♕d6+ ♔f7 37.♖f2 ♕g5 38.♕xd5+ ♔e7 39.♗d6+ ♔f6 40.♕e5+ ♔g6 41.♕e6+ ♕f6 42.♕xc8 +– . **36.♖f2!** 36.g3 wins as well. **36...♗d7** 36...♕xf2 37.♕f6+ ♔g8 38.♕g7#. **37.♕g7+ ♔e6 38.♕g6+ ♔e7 39.♕d6+ ♔e8 40.♗f6 1–0**

105: The bold strike **29.♘xb7!!** wins directly. Note that Black's ♗h6 plays no role in either attack or defense. Usually a very bad sign in this kind of position! **29...♖d7** 29...♔xb7 30.♕b5+ ♔a8 *(30...♔c8 31.♘e4 ♕g6+ 32.♔f1 ♕xe4*

33.♖c3+ +−) 31.♘d5 ♘xd5 32.♕xd5+ ♔b8 33.♖b3+ ♔c7 34.♕b7#; 29...♕g5+ 30.♔f1 ♔xb7 31.♕a6+ ♔a8 32.♘d5 +−. **30.♕c4+** And Black resigned due to **30...♔xb7 31.♘d5 ♕g5+ 32.♔f1 ♘xd5 33.♖xd5 ♕d8 34.♖b5++−.**

106: 27.♗xg6! Much stronger than 27.♘xe6+?! ♔h7 28.♖e1 *(28.♘xc5?? ♖d1+ 29.♖e1 ♖xe1#)* 28...♕e7 29.♘xd8 ♖xd8 (Kasimdzhanov in CBM 90) when Black can still fight. **27...fxg6** After 27...♕e7, Kasimdzhanov gives: "28.♗c2+ ♔f8 29.♕f4 ♘d5 30.♕xh6+ ♔e8 31.♖g3 +− and Black is completely helpless 31...♔d7 32.♘xe6! ♖xe6 33.♗f5! ♕xf5 34.♕d6+ ♔e8 35.♖g8#." **28.♗xf6+ ♔h7** 28...♔xf6 29.♖xe6+ ♔g7 30.♕xg6+ ♔h8 31.♕xh6+ ♔g8 32.♖g6+ +−. **29.♗xd8 ♖xd8 30.♖xe6 ♕g5 31.♕xg5 hxg5 32.♖e7+ ♔h6 33.h3 ♗d5 34.♘c2 1–0**

107: 25.♗xf6 gxf6 25...♖xg3 26.♗xd8 ♗xf2+ 27.♔xf2 +−. **26.♘xe6+** 26.♖xe6 works as well: 26...fxe6 *(26...♗d5 27.♖g8+ ♔xg8 28.♕h7+ ♔f8 29.♕h8#)* 27.♖g8+ ♔xg8 28.♕h7+ ♔f8 29.♘xe6+ ♔e8 30.♗g6#. **26...fxe6 27.♖g8+ ♔xg8 28.♕g6+ ♔f8 29.♕xf6+ ♔g8** 29...♔e8 30.♕xe6+ ♔f8 31.♕xh6+ ♔g8 32.♗b3++−. **30.♕xe6+ ♔g7 31.♕g6+ ♔f8 32.♕xh6+** And Black folded his hand as he is mated: **32...♔f7 33.♗b3+ ♖c4 34.♗xc4+ ♗d5 35.♗xd5#.**

108: 19.♕d2! f5 19...bxa4? 20.♗g7! ♖f8 21.♗xf8 ♔xf8 22.♕h6+ ♔e7 23.♕g5+ ♔f8 24.♖xh7 axb3 25.♕f6 +−. **20.♗g7! ♖f8** 20...♔xg7? 21.♕h6+ ♔g8 22.♕xh7+ ♔f8 23.♕h8+ ♔f7 24.♖h7#. **21.♗xf8 ♖xf8 22.♖d3 ♗c8** 22...♗c6 23.♗xe6+ ♔h8 24.♖d6 bxa4 25.♕d4 +−. **23.axb5 ♖b8?!** 23...♕xe5! 24.bxa6 ♕b5 25.c4 ♕b6 26.c5 ♕xc5 27.♕e2 ♕b6 28.♗c4±. **24.♕a2 ♕b6 25.♖d6 ♕xb5 26.♗xe6+ ♔h8 27.♗d5 ♖e8 28.e6 ♕c5 29.♖c6 ♕e7 30.c4 ♕f6 31.♖e1 ♖b2 32.♕a1 ♔g7** 32...♕d4 33.♖c7 ♗xe6 34.♖b7 ♖d2 35.♕xd4+ ♖xd4 36.f3 +−. **33.♖c7+ ♔h6 34.♕c1+ g5 35.h4 f4 36.hxg5+ ♔xg5 37.g3 h5 38.♖f7 1–0**

109: 22.f6! ♗xf6 22...gxf6? 23.♕f5 ♖fe8 24.♕xh7+ ♔f8 25.♕h8#. **23.♕f5 ♖fe8 24.♕xh7+ ♔f8 25.d6 g6 26.♗xa8 ♖xa8 27.♖f1 ♖e6 28.♖xf6 1–0**

110: 24.♖xe6!! 24.♗xb7? ♖xb7 25.♗xc3 ♗xc3 26.♖ac1 ♖b8 gives Black some drawing chances. **24...fxe6?!** 24...♖c8 25.♖xg6+ hxg6 26.♕xg6+ ♔h8 27.♕h5+ ♔g8 28.♕g4+ ♔h8 29.♗g5 +−. **25.♗xe6+ ♔h8** 25...♖f7 26.♕f4 ♖cc7 27.♕xc7 +−. **26.♗xc3 ♖d8 27.♕f4 1–0**

111: 17...♗e5! 17...♘d3+ 18.♔d1 ♗e5 transposes. **18.♕d7** 18.♕b6 ♘d3+ 19.♔d1 ♖b8 −+. **18...♘d3+ 19.♔d1 ♖b8 20.♘d4 ♖b1+ 21.♔e2 ♘e1+ 22.♘b5 ♘c3+ 0–1**

112: 27.♖xh7! And Black gave up due to **27...♔xh7 28.♖h1+ ♔g8 29.♕h8#.**

113: 22.♗xh6!! 22.♖ac1? ♘f5 23.♗xd5 ♘xe3= **22...♘g6** 22...gxh6 23.♕xh6+ ♔e8 24.♘g5 ♘g6 25.♗xd5 exd5 26.♕h7 ♖a7 27.e6 +−. **23.♗xg7+ ♔xg7 24.♕f6+ ♔f8** 24...♔g8 25.♘g5 ♕b7 26.♖ac1 ♘xe5 27.♕xe5 ♗xc4 28.♕g3 ♔h8

29.♕h4+ ♔g8 30.♕xc4 +–. **25.♘g5 ♕a7 26.♖ac1 ♖dc8 27.♗xd5 exd5 28.♖xd5 ♘d3 29.♖xc8+ ♖xc8 30.♖d8+ ♖xd8 31.♘e6+ ♔e8 32.♕xd8# 1–0**

114: 33...e4! 34.♖f7 34.fxe4 ♖hg4 35.♖d1 f3! 36.♘e5 *(36.exf5 f2 37.♘e3 ♖g1+ 38.♗xg1 ♖xg1#)* 36...dxe5 37.exf5 f2 38.♖cc1 e4–+ (Notkin in *Chess Today 993*); 34.♖g2 ♘g3+ *(34...e3!?)* 35.♔g1 exf3 36.hxg3 fxg3! –+ (Notkin). **34...♘g3+ 35.♔g1 ♘e2+ 36.♔f1 ♖g1+ 0–1**

115: 26.♗g7!! ♘c4 26...♗xg7 27.♖xg7+ ♔xg7 28.♕h6+ ♔f7 29.♕h7+ ♔f6 30.g5+ ♔xg5 31.♕h4#; 26...♘f7 27.♗xf6 exf6 28.♖xf7 ♔xf7 29.♕h7+ ♔g8 30.♕h6 +–. **27.♗xc4 ♗xg7 28.♖xg7+ ♔xg7 29.♘e6+** And Black resigned due to **29...♗xe6** 29...♔f7 30.♕h7+ ♔g8 31.♖g7+ ♔h8 32.♕h2#. **30.♕d4+ ♔f8 31.dxe6 ♕xc4 32.♖h8#.**

116: 29.♖h4! ♕e6?! 29...♔f7 30.♖f4+ ♔e6 31.♗f5+ ♔d6 32.♖xf3 ♔c7 *(32...exf3? 33.♗f4+ ♔d5 34.♕xf3+ ♔c4 35.♗d3+ ♘xd3 36.♕xd3+ ♔c5 37.♗e3#)* 33.♖h3±; 29...♔d5 30.♗xe4 ♘xe4 31.♕xf3+ ♘f6 32.♕f2±. **30.♗xe4 ♘xe4 31.♕xf3+ ♘f6 32.gxf6 gxf6 33.♖e4 ♕c6 34.♗h6+ ♔e8 35.♖ce1! ♕xc2+ 36.♔a1 ♖c7 37.♕h5+ ♔d7 38.♕d5+ 1–0**

117: 25.♕g4!! ♘e5 25...h5 26.♕f5! *(26.♕g6? ♖a6! 27.♕xa6 ♘xf2+!! 28.♗xf2 ♕xe4+ 29.♔g1 ♕g4+=)* 26...♕c2 *(26...♘e5 27.♖g1 ♘g4 28.♕h7 ♔xf7 29.♕xh5 +–; 26...♘c5 27.f3 +–; 26...♕c4 27.♖g1 ♕c3 28.♗h6 e6! 29.♖xg7 exf5 30.♖h7+ ♔g7! 31.♖xg7 ♔e7 32.exf5* with a winning endgame for White)* 27.♕h7 ♔xf7 28.♗d4 ♔g8 29.♖g1 e5 30.dxe6+ ♔xe6 31.♕f5+ ♔e7 32.♕g5+ +–. All lines are from Krasenkow in CBM 86. **26.♕f5 ♘xf7** 26...♖a6? 27.♕xc8+ +–. **27.♖g1 ♗f6 28.♖g6 ♗g5** 28...♘g5 29.♗xg5 hxg5 30.♕e6 ♗g7 31.d6 ♕d4 32.♕xe7+ ♔g8 33.♕e6+ ♔f8 34.♖xb5 +–. All forces to the attack! **29.♗xg5** 29.♖g1!? ♕c2 30.♗xg5 hxg5 31.♖6xg5 +– was easier. **29...hxg5 30.♖xg5 ♕d4 31.♖bg1 ♕h8 32.e5 e6 33.dxe6 ♖c7 34.♖h5 ♕xe5 35.♖g8+ ♔e7 36.♕xf7+ ♔d6 37.♖xe5 ♖xg8 38.♕xg8 1-0** This nice victory brought Agrest the brilliancy prize.

118: 18...♗xh3! 19.gxh3 ♘f4 20.♕c1 20.♖xe8 ♖xe8 21.♘g5 *(21.♕c1 ♕f5 22.♕f1 ♘xh3+ 23.♔g2 ♕g4+ –+)* 21...♕h6 –+. **20...♖xe1+ 21.♘xe1 ♕d4! 22.♖b1 g5 23.♖b3 ♖e8 24.♕d2 c4 25.♖b1 ♕xc3 26.♕xc3 ♘e2+ 27.♔f1 ♘xc3 –+** And Black won after some further moves.

119: 31.♖f1! 31.♔xg4? ♖f4+! 32.♗xf4 ♖xf4+ 33.♕xf4 gxh5+ –+ (Atlas in CBM 86); 31.♕xg4 e4+ 32.♔h3 ♖f3+ 33.♔g2 gxh5 34.♕h4 ♖f2+ 35.♔h1 ♕f7 36.♕xe4 ♖f1+ –+. **31...♕f7** 31...gxh5 32.♖xf5+ –. **32.♕h1!** 32.♔xg4 wins as well. **32...gxh5 33.♖xf5 ♕c7 34.♕xh5 1–0**

120: 24.c5!! bxc5 24...dxc5 25.♕a4 ♘d7 26.♖xd7 ♔xd7 27.♘xa7 ♔c7 28.♗f4+ ♗d6 29.♖d1 ♗xf4 30.♕xf4+ +–. **25.♕a4! ♘d7** 25...♔e7 26.♖xd6! ♖xd6 27.♘xd6

♔xd6 28.♗xc5++− (Avrukh in CBM 93). **26.♘xa7 ♖c7 27.♘b5! ♕xa4 28.♘xc7+ ♔d8 29.♘xe6+ fxe6 30.bxa4+−** And White won later.

121: 23...♘xg2! 24.♔xg2? 24.♗xf4! ♘xf4 25.a4 was called for. Black is better, but matters are not completely clear. **24...♖xf3!! 25.♕c4** 25.♔xf3 ♗xe4+ 26.♔g3 *(26.♖xe4 ♕d4#)* 26...♕f2+ 27.♔h3 ♕g2+ 28.♔h4 ♗f6+ 29.♗g5 ♗xg5#. **25...♖xd3! 26.♖xd3** 26.♕xd3 ♕xb4 27.♔g1 ♗xe4 28.♗d2 ♕a4−+) **26...♖c8** (26...♗xe4+ 27.♕xe4 ♕f2+ 28.♔h3 ♗f5−+. **27.♕xc8+ ♗xc8 28.♗d2 ♗f5 29.♖e1 ♕b5 30.♖de3 ♕xd5 31.♗c3 ♗h6 32.♖3e2 ♕d3 33.♗a1 ♗xe4+ 34.♖xe4 ♔g8 35.♗xe5 dxe5 36.♖xe5 ♗f8 37.b5 ♗d6 38.♖e8+ ♔f7 39.♖8e4 ♕xb5 40.h4 ♕d5 41.♖1e2 b5 42.♔f1 b4 43.♖4e3 ♕h1+ 44.♔f2 ♗c5 0−1**

122: 25...♗xf4! 26.♗xc6 26.exf4 ♕h5 27.d5 ♖e2−+; 26.gxf4 ♕h4 27.d5 ♕xf2+ 28.♔h1 ♖d6−+. **26...♕h6 27.♗g2 ♗xg3! 28.fxg3** 28.♖d2 ♖e6 29.♔f1 ♖f6 30.f3 ♖c8 31.♖e2 ♘h2+ 32.♔g1 ♘xf3+−+. **28...♕h2+ 29.♔f1 ♕xg3 30.♖d2 ♖d6 0−1**

123: 69...♕d7! 70.♔f2 70.♖e5 ♖h1+ 71.♔xh1 ♕h3+ 72.♔g1 ♕xg2#. **70...♕d1** And White resigned due to **71.g4** 71.♖g1 ♕xh5 72.♖xb1 ♗xb1−+. **71...♕d6+ 72.♕g3 ♖h1+ 73.♔xh1 ♕xg3−+.**

124: 29.♖f6+! ♔e5 29...♔xf6 30.♗g3+ ♔e5 31.♗xe5+ ♔xe5 32.♕d7+−; 29...♔c7 30.d6+ ♔d8 31.dxe7+ ♔xe7 32.♖f5 ♕g8 33.♗h4++−. **30.♖f3?!** 30.♖xf7!+−. **30...f5 31.♗xf5 ♖hd8 32.♗g3+ ♔f6 33.♗c8+ ♔g7 34.♗xb7 ♖f8 35.♗f4 ♖xf4 36.♖xf4 ♕d8** 36...♕xf4 37.♗xa8+−. **37.♖f2 ♘g6 38.♖g2 ♕f4 39.♕c2 ♖d6 40.♕f5 1−0**

125: 27.♖e6!! h5 27...♖g8 28.♖xh6+! ♔xh6 29.♕h4+ ♕h5 30.♕xh5#; 27...♕xe6? 28.♕g7#. **28.♕e3** And Black resigned due to **28...♕f4 29.♖e7+ ♔h8 30.♕xf4 ♖xf4 31.♖xb7+−.**

126: 48...♕b2+! 49.♔e1 49.♔d1? ♖c1#. **49...♖c1+ 50.♔f2 ♕e5** And White resigned in view of **51.e4** 51.♖c2 ♕g3+ 52.♔e2 ♕xg2#. **51...fxe4 52.♕e3 ♕f6+−+.**

127: 16.♘xe6!! ♕c8 16...fxe6? 17.♕xe6+ ♕e7 *(17...♗e7 18.♕g6+ ♔f8 19.♖hf1+ ♗f6 20.gxf6 +−)* 18.♕g6+ ♔d8 19.♘c5+−. **17.♘b6 ♘xb6 18.♖d8+ ♕xd8 19.♘xd8 ♖xd8 20.♗xb6±** And White eventually converted his advantage into a full point.

128: 19.♖xh7!! ♔xh7 19...♕xg2 20.♖h8+ ♔xh8 21.♗c3+ f6 22.♕xg2+−. **20.♖h1+ ♔g8 21.♖h8+!! ♔xh8 22.♗c3+ e5 23.♕xf2 f6 24.g4 g5 25.♕f5 1−0**

129: 20.♖e6!! ♗xe6 20...fxe6? 21.♕xg6#. **21.dxe6 f5 22.h5 gxh5** 22...g5 23.e7 ♗xe7 24.♖d1 ♕c7 25.♗d5+ ♔h7 26.♗e6 ♕f4 27.♖d5 +−. **23.♖xh5 ♕e7 24.♘h4 ♕xe6 25.♘xf5 ♗e5 26.♗d5 1–0**

130: 27...♖xe4! 28.fxe4 ♘g5 28...cxd4 29.♗f4 ♖xh3 30.♔g1 ♖h1+ 31.♔f2 ♕h4+ 32.♔g3 ♖xf1+ wins as well. **29.♕c2** 29.♗xg5? ♕xh3+ 30.♔g1 ♖g3+ 31.♖g2 ♗xd4+ 32.♖ff2 ♕xg2#. **29...♕xh3+ 30.♔f2 ♖xe3 0–1**

131: 24.♘g4! ♘xd1 24...♖xd4 25.♘xf6+ ♔f8 26.♕h6+ ♔e7 27.♖xd4 ♕xd4 28.♖xa6 +−; 24...♔h8 25.♕h6 ♖g8 26.♕xf6+ ♖g7 27.♖e1 ♕xd4 28.♘e5 ♔g8 29.♖ed1 +−. **25.♕h6! ♕e1+ 26.♔g2 ♘e3+ 27.fxe3 ♕d2+ 28.♔h3 ♕d3 29.♘xf6+ ♔h8 30.e4 1–0**

132: 23...♖xc2! 23...♕e2?! 24.♗c1 ♕xc2+ 25.♔a1 ∓. **24.♗c1** 24.♔xc2? ♕d3+ 25.♔c1 ♖c7+ 26.♗c5 ♖xc5+ 27.♕c4 ♖xc4#. **24...♘xe5 25.♕e4 ♖e2 26.♕a8+ ♔h7 27.♖e1 ♖dd2 28.♗xd2 ♘c4 29.♗c3 ♖xb2+ 30.♔a1 ♖xa2+ 0–1**

133: 26.♕d2!? 26.♗xf8 wins as well: 26...♔xf8 27.♗xg6! hxg6 28.♕xg6 ♗f5 29.♖exf5 ♘xf5 30.♕xf5 ♕e7 31.♕h7 ♔e8 32.♕h8+ ♔f8 33.♖e1+ ♔d7 34.♕h3+ f5 35.♖e5 +−. **26...♗g4** 26...♗d7 27.♕h6 f5 28.♗c4+ ♘xc4 29.♗xa3 ♘xe5 30.♗xf8 ♖xf8 31.♕d2 +− (Postny in CBM 86). **27.♕h6 f5 28.♗c4+ ♖f7 29.♗xd6 ♕xd6 30.♗xf7+ ♔xf7 31.♕xh7+ ♔f6 32.♖fe1 ♖f8 33.♖e7 ♔g5 34.h4+ ♔f4 35.♕h6+ ♔g3 36.♖7e3+ 1–0**

134: 21.♗xg7! 21.♕g3? ♘h5 22.♕g4 ♘d3+ 23.♖xd3 cxd3+ 24.♔b1 ♖c5 25.e5 f5 and Black is better. **21...♘b3+** 21...♔xg7 22.♕g3+ ♔h8 23.♕h4+ ♔g8 24.♕g5+ ♔h7 25.♕xf6 +−. **22.♔b1 ♘xd4 23.♕xf6 ♕xe4+ 24.♔a2 ♕xf3 25.♗xf8 ♖xf8 26.gxf3 ♕g6 27.♕c3 b5 28.♖d1 ♕g7 29.♖d4 f5 30.♕d2 ♖f7 31.♖d8+ ♔h7 32.♕f4 ♖f6 33.♕d4 ♕g6 34.♔b1 ♕e7 35.♖g8+ ♔f7 36.♖a8 ♖d6 37.♕h8 ♕d7? 38.♖xa7 1–0**

135: 34.♖d1! Invite everyone to the party! 34.♗xe6?! ♕xe6 35.♗xg7+ ♔f7 is not as convincing. **34...♗c7 35.♗xe6! ♗xa5?** 35...♕xe6 36.♗xg7+ ♔f7 37.♕xe6+ ♖xe6 38.f5 +− (Psakhis in CBM 91). **36.♗d5 ♕g6 37.♕c8+ ♖e8 38.♕xc5+ ♖ee7 39.♗xg7+ 1–0**

136: 21...♖xf2!! 22.♔xf2 ♕h2+ 23.♗g2 ♗e6 24.♖g1 24.♖h1? ♖f8+ 25.♘f3 ♖xf3+ −+; 24.♕d3 ♖f8+ 25.♔e2 ♕xg2+ 26.♔d1 ♘g6 27.♖e2 ♕h3 28.♔c2 ♖d8 −+ trapping the queen. **24...♖d8** 24...♖f8+ 25.♔e2 ♕xg3 −+. **25.♖ad1 ♖f8+ 26.♔e2 ♕xg3 27.♖df1 ♕e3+ 28.♔d1 ♖d8 29.♗c1 ♗b3 30.♖f8+ ♖xf8 0–1**

137: 28...a3! 29.♗f6 29.bxa3 ♕b5 30.♖d1 bxa2+ 31.♔a1 ♖ab8 32.♕xa2 ♕a4 33.♖b1 ♕d4+ 34.♖b2 ♖c2 −+. **29...♕b5 30.♖d1** 30.♔f1 axb2 31.♗xb2 ♕a5

32.a3 ♖c2 33.♖e2 ♖xb2+ 34.♖xb2 ♕xa3 –+. **30...bxa2+ 31.♔a1 ♕b3** And White resigned due to **32.♕e1 ♖c2 33.bxa3 ♖b8 34.♗d4 ♖b2–+.**

138: 17.gxh6! 17.♕xe5? ♕c5 18.♕e2 hxg5 19.♕h5 f5 and Black defends. **17...♘xd3+** 17...♗f6 18.hxg7 ♘xd3+ 19.♕xd3 ♖e8 20.♕h3 ♗xg7 21.♖xg7++–; 17...♘g6 18.hxg7 ♖d8 *(18...♗xg7 19.♕e5+! ♗f6 20.♕h5 ♖h8 21.♖xg6+ +–)* 19.♕h5 ♖d5 20.♕h6 ♖f5 21.♖g3+–. **18.♕xd3 ♖d8** 18...g6 19.♖xg6+ +–. **19.♖xg7+ ♔f8 20.♖dg1 ♗f6 21.♖xf7+! 1–0**

139: 37...♖a1 38.♖b1 38.♕e2 ♕xd5 39.♖d3 ♘d4 40.♕f2 ♕c4 41.b7 ♕xd3 –+. **38...♘g3+!!** And Karpov resigned due to **39.hxg3 ♖a8!** with the devastating threat ♖h8#.

140: 34.♖d6! ♗e8 34...♖xf2 35.♕e7+ ♔f7 36.♖g6+! +– (A.Finkel in CBM 78); 34...♕xf2 35.♕g6+ ♔h8 36.♕h6+ ♔g8 37.♖g6+ ♔f7 38.♕g7+ ♔e8 39.♕e6+ ♔d8 40.♕e7+ ♔c8 41.♕c7#. **35.♕e7+** And Black resigned due to **35...♖f7 36.♖g6+ ♔xg6 37.♕xc5+–.**

141: 30...♖xg2+! 30...♘f3+? 31.♔f1 ♖xg2 32.♕xf3 ♖xf3 33.♖xd4 ♖fxf2+ 34.♔e1 ♖xb2 35.♔f1 ♖h2 36.♔g1 axb6 is not as good as the game continuation, and may even be drawn. **31.♔xg2 ♕g7+ 32.♔h2 ♘f3+ 33.♕xf3** 33.♔h1 ♕g4 34.♕f1 ♕xh4+ 35.♔g2 ♕h2#. **33...♖xf3 34.♖g1 ♖xf2+ 35.♔h1 ♕d4 0–1**

142: 28.♖xe6!! 28.♘xf7? ♗xh3 is only dangerous for White as his king is very exposed. **28...♗xh3** 28...fxe6? 29.♕g6+–. **29.♗e4 ♘xe4 30.♕xe4 ♗xg5 31.b7 ♕b8 32.bxc8♕ ♖xc8 33.♖e5 f5 34.♖xf5+ 1–0**

143: 15.♖xd6!! ♘g4 15...♔xd6 16.♕d2+ **A)** 16...♔e6 17.♘g5+ ♔e7 18.♘d5++–; **B)** 16...♔c6 17.♘xe5+ ♔c7 *(17...♔b6? 18.♕d6#)* 18.♘d5+–; **C)** 16...♔c7 17.♘b5+ ♕xb5 *(17...♔b6? 18.♕d6#)* 18.cxb5+–. **16.♕g5+ ♔xd6 17.♕d2+ ♔e6?** Black shortens his suffering by walking straight into a nice mate: **18.♘g5+ ♔f6? 19.♘d5# 1–0**

144: 30.♕f6!! ♕d8 30...♖xe4 31.♕g5+ ♔h7 32.♖xe4 +–; 30...♔h7 31.♕g5 ♖g8 32.♕xh5+ ♔g7 33.♘xc5 ♖xc5 34.♖e7 +–. **31.♕f5 ♔g7 32.♘xd6 1–0**

145: 16.♘f5!! ♕c5 16...gxf5 17.♕g5 ♘e8 18.♕xe7 +–. **17.♗xg7 gxf5 18.♕g5 1–0**

146: 23.♘c3! After 23.♘f6+?, Black can defend with 23...♗xf6 24.gxf6 ♕e3+ 25.♔h1 g6 26.♕h4 ♔h8. **23...f5** 23...♕xb2? 24.♗e4 g6 25.♕h6 f6 26.♗xg6+–. **24.gxf6 ♗xf6** 24...gxf6 25.♗e4 ♖f7 26.♗xh7+ ♖xh7 27.♕e8+ ♗f8 28.♖xf6 ♖g7+ 29.♔h1 +–. **25.♗e4 g6 26.♗xg6 ♖a7 27.♗xf6 ♖xf6 28.♗xh7+ ♔g7 29.♖xf6 ♔xf6 30.♕g6+ ♔e7 31.♕g7+ ♔d8 32.♕xa7 ♕xb2 33.♕c5 ♕c1+ 34.♔g2 e5 35.♕b6+ 1–0**

147: 31.♖xd6!! And Black is busted, so he called it a day: **31...♗xd6** 31...♘f6 32.♕xe5+−; 31...♕xe4 32.♘c7+ ♖xc7 33.♖d8#. **32.♘c7+ ♔d7 33.♖f7+ ♗e7 34.♖xe7+ ♔d8 35.♘e6#.**

148: 28.♘xe6+! "I rejected 28.♕f3 because of 28...f5 and Black holds, for example 29.d5 ♕c7" (Milov in CBM 90). **28...fxe6 29.♕g6 ♔e7** 29...♕d8 30.♖xe6 ♖c6 31.♖be1+−. **30.♕g7+ ♔d6 31.♕xf6 ♕d8** 31...♘c6 32.d5 ♔xd5 33.♖ed1+ ♔c5 34.♕g5+ e5 35.♕e3++− (Milov). **32.♖xe6+ ♔c7 33.♕e5+ ♔c8 34.♖xa6 bxa6 35.♖b8+ ♔d7 36.♖xd8+ ♖xd8 37.♕xa5 1–0**

149: 18.e5! dxe5 18...♗xd4 19.♗xd4 ♘e8 20.f6 g6 21.♖xg6!! fxg6 22.♗xg6+− (Ribli in CBM 80). **19.♖xg7!! ♖g8** 19...exf5 20.♘d5! ♘h5 21.♕xh5 ♔xg7 22.♕h6+ ♔g8 23.♗xf5+−; 19...♗xd4 20.♖xh7+! ♔xh7 21.f6+− (Ribli); 19...♔xg7 20.♗h6+ ♔h8 21.♗g5 ♔g7 *(21...♗e7 22.fxe6+− (Ribli))* 22.♕h6+ ♔g8 23.♗xf6 ♕xf6 24.♕xf6 ♗xd4 25.♕g5+ ♔h8 26.f6 ♖g8 27.♕h6 ♖g1+ 28.♔h2+−. **20.♖xg8+ ♔xg8** 20...♘xg8 21.f6!+−). **21.♗g5 ♗e7 22.♘e4 ♘d5 23.f6! ♕b6** 23...♗f8 24.♘f2 h6 25.♕e4 ♘xf6 26.♗xf6+−. **24.♘c5 ♕xc5 25.♕xh7+ 1–0**

150: White's attack flew like an arrow: **31.♗f6!! ♕b6+** 31...gxf6 32.♘h6+ ♔h8 33.exf6 ♕b6+ 34.♔h1 ♗xf1 35.♘f7+ ♔g8 36.♗h7+ ♘xh7 37.♕g6+ ♔f8 38.♕g7#. **32.♔h1 ♗xf1 33.♘h6+! gxh6** 33...♔h8 34.♘f7+ ♔g8 35.♕h8+ ♔xf7 36.♕xg7+ ♔e6 37.♕g4+ ♔f7 38.♕h5+ ♔g8 39.♗h7+ ♘xh7 40.♕g6+ ♔f8 41.♕g7#. **34.♕g4+ ♔f7 35.♕g7+ ♔e6 36.♕g4+ ♔f7 37.♕h5+ ♔g8** 37...♔e6 38.♗f5#. **38.♗h7+!! 1–0**

151: 29...♖xa2!! "Great combination and a nasty surprise for White, suddenly his king remains naked in the cold." (Ftacnik in CBM 90) 29...♕e3 is also better for Black, but not as convincing as the game continuation. **30.♖c2** 30.♔xa2 ♕e2 31.♔b3 ♖a8+ 32.♔b1 ♕xe4+ 33.♔c2 ♕b4 34.♖he1 ♕a3−+; 30.♕xa2 ♕xe4+ 31.♔a1 ♗xb2+ 32.♔xb2 *(32.♕xb2 ♖a8+−+)* 32...♖f2+−+ (Ftacnik); 30.♗xf3? ♖xb2+ 31.♔a1 ♖a8+ 32.♕a2 ♖axa2#. **30...♖xb2+ 31.♖xb2 ♕a3 32.♕b3** 32.♖a2 ♕b4+ 33.♔c1 ♗g5+ 34.♔d1 ♕d4+−+. **32...♗xb2 33.♕xb2 ♕e3 34.♗c2 ♘d4 35.♖d1 ♘xc2 36.♕xc2 ♕b6+ 37.♔c1 ♕e6 38.♕a4 ♕h6+ 39.♔b1 ♕xh2 40.♕b4 ♖a8 41.♕xb7 ♖b8 42.♔c1 ♕f4+ 43.♔c2 ♕c4+ 0–1**

152: 28.♘xh6+! ♔h7 28...gxh6? 29.♖g3+ ♔h8 30.♕xc4+−. **29.♘f5** 29.♘xf7 wins as well: 29...♕xf4 30.♕g4 ♕xf7 31.♕xf4 ♗c6 32.♖h4+ ♔g8 33.♖g3+−. **29...g6 30.♕g4 ♖e8 31.♘d5!! ♔g8** 31...♕xd3 32.♕h4+ ♔g8 33.♘de7+ ♖xe7 34.♘xe7+ ♔f8 35.♕h8#; 31...♗xd5 32.♖h3+−. **32.♕h4 ♕xd5! 33.♖xd5 ♗xd5 34.♘e7+ ♖xe7 35.fxe7 ♘d4 36.♕f6 ♘f5 37.♖e1 ♖e8 38.♔f2 ♗e6 39.♖xe6 fxe6 40.♕xg6+ ♘g7 41.♕f6 d5 42.♔f3 d4 43.h4 ♔h7 44.♕f8 c4 45.h5 1–0**

153: 18.♘xg6!! fxg6 18...♗g7 19.♗xg7 fxg6 20.♕h8+ ♔f7 21.♕f8#. **19.♕h8+**

♔f7 20.♕h7+ ♗g7 21.♗xg7 e5 21...♘xg7 22.♗xg6+ ♔f8 23.♕h8#. **22.♕xg6+
♔g8 23.♕h7+ ♔f7 24.♗h6+ 1–0**

154: 14.g4!! The h-file must be blown open! 14.♗xa8? g4 15.♘e5? ♗g5–+;
14.h4? is met by 14...g4. **14...♖b8 15.h4! g6** 15...gxh4 16.g5 ♔g8 17.♗h7+ ♔xh7
18.♕f4 ♔g8 19.♕xh4 f5 20.♕h8+ ♔f7 21.♕h5+ g6 22.♕h7+ ♔e8 23.♕xg6+
♖f7 24.♖h7 ♗xg5+ 25.♘xg5 ♕xg5+ 26.♕xg5 ♖xh7 27.♕g6+ ♖f7 28.♕xe6+
♖e7 29.♕g6+ ♔f8 30.♖g1 +–. **16.hxg5+ ♔g7 17.♕f4! ♗b7 18.♖h7+!! ♔xh7
19.♕h2+ ♔g8 20.♖h1 ♗xg5+ 21.♘xg5 ♕xg5+ 22.f4 ♕xf4+ 23.♕xf4 ♗xe4
24.♕xe4 1-0** A fantastic attack!

155: 35.♕e5! b5 35...hxg3 36.♕xf5+ ♖e6 37.♕xe6#; 35...♖f8 36.♗d8 +–.
36.♗d8 ♗a5 37.♖c7+ ♔b8 38.♖xc6+ 1–0

156: 27...♖xd4+!! 27...c5 wins as well. **28.cxd4** 28.♔xd4? ♕d6+ 29.♔e4 ♖e8+
30.♕e5 ♕xe5+ 31.♔d3 ♖d8#. **28...♕a6+ 29.♔c3 ♕xe2** 29...♕c6+!? 30.♔c5
(30.♔b2 ♕c2#; 30.♔b3 ♕c2#; 30.♔d3 ♕c2#) 30...♖xc5 –+. **30.♖b1 ♘d1+
31.♔c2 ♘e3+ 32.♔c3 ♕d1 33.♔d3 ♕c2+ 34.♔e2 ♘d1 35.♔f1 ♘c3 36.♖a1
♕d1+ 37.♔g2 ♖xb7 38.♕xf4 ♘e2 39.♕e4 ♖b6 40.♘f1 ♘xc1 0–1**

157: 15...♘e4 15...♗b4+ 16.♗d2 ♗xd2+ 17.♕xd2 ♘e4 wins as well. **16.♕xd4
♕h4+ 17.♔e2 ♕f2+ 18.♔d1 ♕c2+ 19.♔e1 ♗c5 20.♘d6+ ♗xd6 21.fxe5
♗b4+ 0–1** In view of 22.♕xb4 ♕f2+ 23.♔d1 ♖d8+ 24.♕d4 ♘c3#.

158: 29.♖xe5! g6 29...♗xe5 30.♖h4+ ♔g8 31.♗b3+ ♕f7 *(31...♔f8 32.♖h8+
♔e7 33.♖xa8 ♕d4 34.♖e8+ ♔xe8 35.a8♕+ +–)* 32.♗xf7+ ♔xf7 33.♗e3 +–.
30.♖e4 c5?! 31.♖a6 ♖xa7 32.♖xg6 ♗g7 33.♗b2 ♕b5 34.♗c3 1–0

159: 17.g3! ♕f5 17...♕f6 18.♕e4+ ♔c7 19.♕xd4 ♗c6 20.♕c3 +–. **18.♖xd4
♗c5 19.♖f4 ♕g5 20.h4 1–0**

160: 23.♘xb5+! axb5 24.♖xb5 ♕c6 24...♕a6 25.♖dxd5 exd5 26.♕e7+ ♔b7
27.♕xb7#. **25.♖dxd5! exd5 26.♕e7+ ♔a6 27.♖b3 1–0**

161: 35.♘f5! ♕g5?! 35...gxf5? 36.♖xh6+ ♔xh6 37.♖h1+ ♔g7 38.gxf5+ ♔f7
39.♕g6+ ♔e7 40.♖h7+ ♔f8 41.♕f7#; 35...h5! 36.♘xd6 ♘f6 37.♘f7 ♕e7
38.♘g5+ ♔g8 39.f3 hxg4 40.♘e6 gxf3+ 41.♔f1 ♖g4 42.♕h3 ♕h7 43.♕xf3
♖g3 *(43...♕f7 44.♔e2 ♖xe4+ 45.♔d1 ♖g4 46.♖f1 +–)* 44.♖xh7 ♖xf3+ 45.♔e2
♘xh7 46.♔xf3 +– (Atalik in CBM 84). **36.♖xh6+ ♔g8 37.♖xg6+! ♕xg6
38.♘e7+ ♔g7 39.♘xg6 ♔xg6 40.♖h1 ♘f6 41.f3 ♔f7 42.♖h6 ♖g8 43.g5 1–0**

162: 20...♘xf2!! 21.♔xf2 ♕g5! 22.d5 22.g3 ♗e4 23.♘xd6 *(23.♕e3 ♕f5+
24.♔g1 ♕xh3 –+)* 23...♖xd6 24.♖e1 ♖f6+ 25.♔g1 ♖f1+!! 26.♖xf1 ♗xd3 –+.
22...♗xd5 23.g3 23.♕xd5 ♗g3+ –+. **23...♗xg3+ 24.♕xg3 ♖e2+ 25.♔xe2 ♕xg3
26.♘e5 ♕g2+ 27.♔e1 f6 28.♖d3 fxe5 0–1**

163: 45...♖d4! 46.♕h1 46.♔f1 ♕h5 47.♔g2 *(47.f3 ♖h4 –+)* 47...♖d1 48.♕e2 ♕h1+ 49.♔g3 ♖g1#. **46...♕c2+ 0-1** And it is over, so Black resigned, e.g. **47.♔f1** 47.♔f3 ♖f4+ 48.♔g2 ♕xf2+ 49.♔h3 ♖h4#. **47...♖d1+ 48.♖e1 ♖xe1+ 49.♔xe1 ♕c1+−+.**

164: 16...♗f5+! 17.♔g1 17.♔g2 ♕h3+ 18.♔g1 ♗h2+ 19.♔h1 ♗g3+ 20.♔g1 ♕h2+ 21.♔f1 ♕xf2#. **17...♕h2+ 18.♔f1 ♗g3** And Black resigned due to **19.fxg3** 19.♔e2 ♕xf2#; 19.♗xf5 ♕xf2#. **19...♗h3#.**

165: 24...♖xe3!! The move order 24...b6 25.♕a4 ♖xe3 –+ wins as well. **25.fxe3** 25.♘xh4 ♕h2+ 26.♔f1 ♕h1#; 25.♕xe3 ♖xe3 26.fxe3 ♕g3 –+. **25...♕g3** And White resigned in light of **26.♗d3** 26.♘xh4 ♕h2+ 27.♔f1 ♕h1#. **26...♘xf3+ 27.♔f1 ♗xd3+ 28.♖xd3 ♕e1#.**

166: 25...♘e2+!! 26.♕xe2 26.♘xe2? ♕f2+ 27.♔h1 ♕xg2#. **26...♕g3 27.♗f4** 27.♖xe4? ♕h2#. **27...♕xf4 28.♗xe4** 28.♗f3 ♕c1+ 29.♕d1 ♕e3+−+. **28...♕g3+ 29.♔h1 ♖f1+ 30.♕xf1 ♕h2# 0–1**

167: 21.♘e6+!! fxe6 22.dxe6 ♘hf5 22...♖c8 23.♕h5 ♘g6 24.♕d5 +–; 22...♘ef5 23.♖xd7+ ♔e8 24.g4 ♘d6 25.e7 ♔xd7 26.♕e6+ ♔c7 27.♖c1 +–. **23.♕e5! ♘d6 24.♖xd6 ♕xc4 25.♖xd7+ ♔e8 26.♖c1 ♕b5 27.♕c7 ♕b3 28.♖xe7+** And Black resigned as he is mated: **28...♗xe7 29.♕d7+ ♔f8 30.♖c8+ ♖xc8 31.♕xc8+ ♗d8 32.♕xd8#.**

168: 39...♕xe3+!! 40.♖xe3 ♖b1+ 41.♖e1 The king can't move due to mate in one. **41...♖xe1+ 42.♔f2 ♖e2+ 43.♔g1** And now Black's c-pawn seals White's fate: **43...c2 0–1**

169: 31.♕f4 d3 31...♕e7 32.♖xd4 ♗f5 33.♖ed1 ♖dc8 34.♘e4 ♗xe4 35.♖d7 +–. **32.♘d5** And Black resigned as the threat ♕f6+ is deadly.

170: 25.♗xe6! ♖d2 25...fxe6 26.♕g6+ ♔f8 27.♕f6+ +–. **26.♗xf7+ ♔d7** 26...♔xf7 27.♖xd2 cxd2 28.♕xf5+ ♔e8 29.♕e6+ ♔d8 30.♘b6 +–. **27.♕g7 ♖d8 28.♗d5+ 1–0**

171: 22.♘xf5! ♔h8 22...♖xf5 23.♕g4+ ♗g7 24.♖xf5 e3 25.♘e4 +–. **23.♘h6 ♔g7** One possible line after 23...♖e6 runs 24.♕h5 ♖ae8 25.♘xe4 ♖xe4 26.♘xf7+ ♔g8 27.♖xf6 ♖e1+ 28.♖f1 ♖xa1 29.♕g5+ ♔f8 30.♖xa1 ♕xf7 31.d7 ♕xd7 32.♖f1+ ♕f7 33.♖xf7+ ♔xf7 34.♕f4+ +–. **24.♖xf6 ♔xf6 25.♘g4+ ♔f5 26.♘xe5 ♔xe5 27.♘xe4! ♖g8** 27...♔xe4 28.♕f3+ +–. **28.♕e1 ♘c2 29.♕c3+ ♘d4 30.♖e1 ♕c6 31.d7 ♕d5 32.♕h3 ♘e2 33.♘c3 1–0**

172: 24.♖xg7+!! 24.♕g5? g6 25.♖g2 *(25.♗xf6 ♘xf6 26.♕xf6 ♖b2 27.♕h4 ♕xe3)* 25...♖xb2 26.♖xd2 ♖xd2 27.e4 h6 28.♕e5 ♘e3 and in both cases Black is still fighting. **24...♔f8** 24...♔xg7 25.♖g1+ ♔f8 *(25...♔h8? 26.♕xf6+ ♘xf6*

27.♗xf6#) 26.♕d6+ ♘e7 27.♕xd2 +–. **25.♖g2 ♕b4 26.♗xd5 ♘xd5 27.♕d6+ 1–0**

173: 24.♖xg7+!! 24.♗h6 ♖xh6 *(24...♕e7 25.♖xg7+ ♕xg7 26.♗xg7 ♔xg7 27.♖g1+ ♔f8 28.♕h8+ ♔e7 29.♖g7+ ♖f7 30.♖xf7+ +–)* 25.♖xg7++– works as well. **24...♔xg7 25.♗h6+ ♖xh6 26.♖g1+ ♔f8 27.♕xh6+ ♔e8 28.♖g8+ ♔e7 29.♖g7+ 1–0**

174: 20.♕xd8+!! ♘xd8 21.♖d7+ ♔b8 22.♖xd8+ ♔c7 22...♔a7 23.♖a8#. **23.♖d7+ ♔b8 24.♖xb7#.**

175: 34.♖xg7+! 34.b3 also wins. **34...♔f8** 34...♔xg7 35.♕h6+ ♔f7 36.♕xh7+ ♔f6 37.♖h6+ ♔g5 38.♘e6#. **35.♘e6+ ♔e8 36.♖g8+ ♔f7 37.♖xb8 ♕xf3 38.♖f8+ 1–0**

176: 28...f4+ 29.♔e4 ♔e6! 30.♖d5 30.c7? f5#. **30...♖xd5 31.cxd5+ ♖xd5** And White resigned due to **32.♗c4 f5#.**

177: The fastest way to win is also the most beautiful: **32.♕xf6+!! ♔xf6 33.♖g6+! fxg6** 33...♔e7 34.f6+ ♔e8 35.♖g8#. **34.♖xg6+ ♔e7 35.f6+ 1–0**

178: A powerful collinear move decided the issue at once: **23...♖d2!! 0–1**, e.g. **24.♖xd2** 24.♗xh5 ♕xh2#; 24.♖e1 ♗f3+ 25.♗xf3 ♕xh2#; 24.♘b1 ♖xe2 25.♖d8+ ♗f8 –+. **24...♗f3+ 25.♗xf3 ♕f1#.**

179: 30...♖fxg2!! 31.♖xg2 31.♖xd7? ♖xg1+ 32.♔h2 ♖8g2#. **31...♕xd1+ 32.♔h2 ♖d8 –+** And Black won after some further moves.

180: 35.♖g7+ ♔h8 36.♘f8!! And Black resigned due to **36...♖e1+ 37.♔f2 ♖e2+ 38.♔f3 ♖xf8 39.♖h7+ ♔g8 40.♖cg7#.**

181: 16.♕xg7+!! ♔xg7 17.♘f5+ ♔g8 18.♘h6# A beautiful mate!

182: First the long diagonal is opened: **1...♖f7!** And White resigned as Black will clear the line for the♖g8 with check: 1...♖d6? 2.♕a7! +– as 2...♗d4+ is met by 3.♕xd4+ with check!; 1...♗f8? 2.♖d2 +–. **2.♕xf7 ♗d4+ 3.♖xd4 ♕xg2#.**

183: 1.♖c6+! vacates c7 for the bishop. 1.♘c5+ ♔a5 2.♖e7 wins as well. **1...♗xc6 2.♘c5+ ♔a5 3.♗c7# 1–0**

184: 1.♖xh6+!! ♗xh6 2.g7+! Black has the choice of making the square or the line clearance the decisive one: **2...♔xg7** 2...♗xg7 3.♕h4+ ♗h6 4.♕xh6#. **3.♕g6+ ♔h8 4.♕xh6# 1–0**

185: Automatic recaptures can be missed opportunities! In this case Black could afford instead to give up a rook in exchange for a lethal opening of the f-file: **16....fxg4+! 17.♔e2** 17.♗xf8 actually loses even faster. **17...♕f2+ 18.♔d3 ♖f3+ 19.♔c4 ♖c8+ 20.♔b3 ♕b6+ 0–1** In view of the mate in five to follow.

186: 29.♕xd6! 29.♘xd6+? cxd6 30.♕xd6 ♕b6 is better for White, but not nearly as convincing as the game continuation. **29...cxd6 30.♘xd6+ ♔c7** 30...♔b8 31.♘xe8+ ♔a8 32.♘c7++–. **31.♘xe8+ ♔b6** 31...♔c8 32.♘d6+ ♔c7 33.♘f7++–; 31...♔b7 32.♘xf6+– ♘xf6? 33.♖b3+ ♔c8? 34.♖b8#. **32.♖b3+ ♔c5** 32...♔a5 33.♗c7+ ♘b6 34.♗xd8+–. **33.♗d6+** And Black resigned due to **33...♔c4 34.♖b4#.**

187: The brilliant **24.♕xh7+!** forced immediate resignation: **24...♔xh7 25.♖h4+ ♔g6 26.♖h6+ ♔g5 27.h4+ ♔g4 28.♘e3+ ♔g3 29.♖f3#**

188: 20...♕b2!! 20...♘xg2+? 21.♔d1 is slightly better for White. **21.♕xf4** 21.♕xb2 ♘xd3+ 22.♔e2 ♘xb2∓. **21...♕xa1+ 22.♗b1 ♖e8 23.0–0 ♕xe5∓** And Black won later.

189: 35.♘g5+? Shabalov makes it difficult for himself. 35.♖xb8 ♖xb8 36.♕a6!+– was best as 36...a3? is refuted by 37.♖xe6 ♕xe6 38.♘g5++–. **35...♕xg5 36.♖c7+ ♕e7 37.♖xe7+ ♔xe7 38.♖c5!** ♖hc8 39.♕a6 ♖xc5 40.♕a7+ ♔e8 41.dxc5 ♖c8 42.♕xa4+ ♗d7 43.♕d4 ♗e6 44.f4 ♔e7 45.♕b4 ♖c6 46.♔h3 ♗d7 47.♔h4 ♔f7 48.♔g5 ♔e7 49.♕b3 ♖e6 50.♕xd5 ♗c6 51.♕a2 ♗d7 52.♔h6 ♗e8 53.♔g7 ♗d7 54.♕h2 ♖c6 55.♕h4+ ♔e8

56.♕f6! ♖xf6 57.exf6 ♗e6 58.c6 g5 59.fxg5 f4 60.g6 fxg3 61.f7+ 1–0

190: 38.♕xd7 ♕xc3 38...♖xd7 39.♘e6++–. **39.♘e6+ ♔h6 40.♕xf7 ♕xa1+ 41.♔h2 ♕e5+ 42.f4 1–0**

191: 29...♘c2! 30.♖xa4 30.♕xc2? ♖xa1 31.♖xa1 ♖xa1–+. **30...♕xa4 31.♗f2 ♕xc4 32.♕e2 ♕a2 33.♖b6 ♘d4 34.♕xa2 ♖xa2 35.♔g2 c4 36.♖xd6 c3 37.♖d7 ♘b5 38.♖d8 ♗f6 39.♖c8 ♗g5 40.♔f3 c2 41.♘e2 ♖a3+ 42.♔g2**

42...♖c3!! 43.♖c6 c1♕ 44.♘xc1 ♖xc6 45.dxc6 ♗xc1 46.♔f3 ♔g7 47.♔e2 ♔f6 48.♔d3 ♔e6 49.♔c4 ♘d6+ 50.♔c5 ♘xe4+ 51.♔b6 ♘f6 0–1

192: 25.♘xf7!! ♖xe3 25...♕xd4 26.♘d6 ♖xe3 27.♕f7+ ♔h7 28.♘xe8±. **26.fxe3 ♖xe3?** 26...♕e7 27.♘e5±. **27.♘xh6+ ♔h8** 27...gxh6 28.♕g6+ ♔f8 29.♕xh6++–. **28.♘f7+ ♔g8 29.♘g5! 1–0** In view of 29...♖e1+ 30.♔h2 ♖xc1 31.♕f7+ ♔h8 32.♕e8+ ♕f8 33.♕xf8#.

193: 27.♖xg7+!! ♔xg7 **28.♘xe6+ ♔h7 29.♘xc7 ♖xc7 30.♕g5!** ♘e5 30...♖g8 31.♕f4+–; 30...♘f6 31.♖d8 ♖xd8 32.♕g6+ ♔h8 33.♕xf6+ ♖g7 34.♕xd8+–. **31.♕xe5 ♖cf7 32.♕e6 ♖f6 33.♖d7+ ♔h6 34.♕e5 ♖8f7 35.♖xf7 ♖xf7 36.♕e6+ ♔g7 37.h6+ ♔f8 38.♕d6+ 1–0**

194: 24.♘c7! ♖xd6 24...♘d4 25.♘xa6 bxa6 26.♖a1±. **25.♕xd6+! ♘xd6 26.♘e6+ ♔e8 27.♘xd8** And White is clearly better and won later.

195: 26.♕g8+ ♖xg8 27.♘f7# 1–0 That was easy, wasn't it?

196: The f5-pawn is not really protected: **36.♖xf5+! ♔g7** 36...gxf5? 37.♗xh5+ ♔f8 38.♗xe8+–. **37.♖g5+–** And White won eventually.

197: 23.♕d5! The queen must keep an eye on b7. 23.♕d3? allows the defense 23...♖e7 24.♗h3 ♖b7 25.♖ad1 g6 26.♗xd7 ♖exd7 27.♕xd7 ♖xd7 28.♖xd7 ♕f6 when White is much better, but the road to victory is very, very long. **23...♖e7 24.♗h3 1–0**

198: 37.♕b2+ ♔g8 38.♗e4 ♖e8 39.♗xc2 ♖ee2 40.♕b8+ ♔g7 41.♗d3 ♖xg2+ 42.♔h1 ♖a2 43.♕e5+ ♔g8 44.a4+– And White won after some further moves.

199: 45.♕b8! A deadly pin. **45...♔g8** 45...♖e7 46.♕d5 ♗f6 47.♕c6 ♔g7 48.♘xf6 ♔xf6 49.♗h5+–. **46.f6 1-0** Or 46.♕g2+–.

200: 23.♘d6! ♗xd6 23...♔xd6 24.♗f7+ ♔c7 25.♗xe8+–. **24.♖xe8 ♗c5+ 25.♔h1 ♘b6 26.♖g8 g5 27.♖g7+ ♗d7 28.♗e6 1–0**

201: 32.♖c8+ ♛e8 32...♛f8? 33.♗xd5+ ♚h8 34.♖xf8#. **33.♖xe8+ ♚f7 34.♖a8!! +−** 1–0

202: 24...♞e2+ 25.♚h1 25.♛xe2 ♛g4−+. **25...♞fg3+** 0–1

203: 28...♖xa2! 29.♖xa2 ♖xb1+ 30.♚g2 e6 31.♗f3 31.♕d3 ♖b4 32.♗f3 ♖xc4∓. **31...♛xc4∓** And Black won later.

204: 1.♖c7!! ♗xc7 1...♛xc7 2.♗xd5+ ♚h8 3.♗xa8 +−. **2.♛e4!!** 1–0 Or 2.♛f3!! +−.

205: 31...♖xg2+!! 32.♖xg2 32.♚f1 ♖g1+ 33.♕xg1 ♖xg1+ 34.♚xg1 ♛g7+ 35.♚f2 ♛c3−+. **32...♛xb2! 33.♖xg8 ♚xg8 34.♞e2 ♛xb4 35.♞g3 ♗d7 36.♞h5 ♚f7 37.♕g3 ♛b1+ 38.♚g2 ♛c2+ 39.♚g1** 0–1

206: A typical combination to exploit a pin: **24.♖xd4!** 24.♖d2? can be met by 24...♞b5. **24...♖xd4 25.♖d1 ♖xd1 26.♗xb6 axb6 27.♞xd1 ♖xd1 28.♕b3 ♖d5 29.♕a3 ♗d7 30.♕e3 ♗c6 31.♕xe4 ♖d2 32.♕c4 ♗d5 33.♕c8+ ♚f7 34.f5 exf5 35.♕xf5+ ♚e7 36.♕xh7 ♖xb2 37.♚h3 ♚f7 38.♕f5+ ♚e7 39.♕g6 ♖d2 40.♕xg7+** 1–0

207: 33...♗xc4 0–1 34.♚g2 34.♖xc4 ♛xe5−+. **34...♛xf1+ 35.♚g3 ♗e6−+.**

208: 27...♖xe4+!! 27...♞f6? 28.0–0–0! ♞h5 *(28...♞xe4? 29.♕h7+ ♚f8 30.♞xe4 ♖xe4 31.♗xd6+ +−)* 29.♗xd6 ♛xa4 30.♚b1±. **28.♞xe4 ♞xf4 29.0–0–0** 29.gxf4 ♛e6 30.♕e2 ♖e8 31.♞g3 ♛c8 32.♞e4 ♛c6−+. **29...♞h5 30.♞xd6 ♛xa4 31.♚b1 b5 32.g4 bxc4 33.♞xc4 ♞f4 34.♖c1 ♞f7 35.♖c2 g5−+** And Black won later.

209: 40...♖xd5+!! And Black resigned due to **41.cxd5 ♖b7+ 42.♚c6 ♖xb1−+.**

210: 51.♖xd4+ 1–0, e.g. **51...♚xd4 52.♗g7+ ♚d3 53.♗xb2 ♚d2 54.g5+−.**

211: 38...♛h1+ 39.♖e1 ♖a1+! 40.♛xa1 ♛xe1+ 41.♚b2 ♛xe5+ 42.♚a2 ♛xa1+ 43.♚xa1 g5 44.b4 44.♚b2 gxh4 45.gxh4 f5 46.♚c3 f4 47.b4 cxb4+ 48.♚xb4 f3−+. **44...cxb4 45.c5 ♚f8** 0–1

212: 25...♛xd3?? 25...♛a6 was called for. **26.♖d2** "A simple and lethal skewer. If Black's queen moves he loses the rook on d8." (M.Chandler in the ChessBase MEGABASE.) **26...♛xd2 27.♗xd2 ♞xe4 28.♖c2** 1–0

213: 1.♛g2!! 1.♛d4+? ♚e2 2.♛b2 ♚d1 3.♛b3 ♚d2 4.♛a2 ♚c3!!= *(4...♚d1? 5.♚d4 c1♛ 6.♚d3 +−)*. **1...c1♛** 1...♚d3 2.♛g5 ♚c3 3.♛c1 +−. **2.♛g5+ +−.**

214: 1.♚d4! 1.♚d5? a4! 2.♚d4! ♚e6! 3.♚c3! ♚e5! 4.♚b4! ♚d4!=; 1.c5?? ♚e6 2.♚d4 ♚d7 3.♚d5 a4 4.♚c4 ♚c6−+. **1...♚e6** 1...a4 2.♚c3! ♚e6 3.♚b4! ♚e5

4.♔xa4! ♔f4 5.c5+−. **2.♔c5! ♔e5 3.♔b5! ♔d4** 3...♔d6 4.c5+! ♔d5 5.c6 ♔d6 6.♔b6+−. **4.g5** 4.c5?! a4 5.g5!! a3 6.gxf6! a2 7.f7! a1♕ 8.f8♕! wins as well, according to the Nalimov tablebase. **4...fxg5** 4...f5 5.g6 f4 6.g7 f3 7.g8♕+−. **5.c5! g4** 5...a4 6.c6! a3 7.c7! a2 8.c8♕! a1♕ 9.♕h8+!+−. **6.c6! g3 7.c7! g2 8.c8♕! g1♕ 9.♕c5+!+−.**

215: This example could of course also be used in the section on back rank problems: **22...♕xc3!! 23.♗xd8** 23.a3 ♕c8−+. **23...♕f3!! 24.♗c7+ ♔xc7 25.♕f7+ ♕xf7 26.♖xf7+ ♔d7 0−1**

216: 24.♘c7! ♖xb1 24...♖xc7 25.♖xb8++−. **25.♘xa6 ♖xc1 26.♗xc1 ♘d3 27.♗d2 ♗d4 28.♘b4 1−0**

217: 23...♘b4! 24.♗f4 ♘xa2 25.♗xc7 ♖d5 0−1 In view of **26.♗xa5** 26.♖b8? ♖d1#. **26...♖xg5 27.c6** 27.♖b8 ♖xc5−+. **27...♖xa5 28.♖b8 ♖xa4 29.♖xc8+ ♔f7 30.c7 ♖c4−+.**

218: 17.♕xg7?? was a fatal blunder. Before taking such pawns you must be absolutely sure that your queen will not be trapped! **17...♕f5! 18.♘h4** 18.d5 ♗e5 19.♘xe5 ♘xe5 20.♕g3 ♖hg8 21.♕e3 ♖xg2−+. **18...♕e4+ 19.♔d1 ♖h7 20.f3 ♕xh4** 20...♕d3!?−+. **21.♖xh4 ♖xg7−+** And Black won after some further moves.

219: 33...♖h4! 34.e6 34.♘xh7 ♗f3 35.♘f6+ ♕xf6−+. **34...♖h1+ 35.♔xg2 ♗f3+ 36.♘xf3 ♖xh6 0−1**

220: 30...♔c6! 0-1 Trapping the queen.

221: In Germany Rafael Vaganian is called "Mr. Bundesliga" due to his fantastic overall score. The 2002-2003 season didn't go well for him, but the following finish is very nice. Vaganian uncorked **58...g4!** and Hübner resigned due to **59.♖xh5 ♔g7 60.♔xg4 ♖e3** White is completely powerless and has to watch the d-pawn run down the board. A fantastic domination!

222: 21...♖xd5! 21...♕e6? 22.♗xc6 ♗xc6 23.♘e7+ ♔xe7 24.♕xc6±. **22.♕xd5 ♘a5!** 22...♘b8? 23.♕b3±. **23.♗a6 ♗xa6 24.♕a8+ ♔d7 25.d5 ♗b7?** 25...♕d8! 26.e6+ ♔e7 27.♕xa7 ♗b7 and Black defends as 28.b4 is met by 28...♕h8 29.bxa5 ♕a1+ 30.♔d2 ♕d4+=. **26.♕g8! ♘c4 27.e6+ fxe6 28.dxe6+ ♔c6 29.♕xg6 ♕b4 30.e7+ ♔c5 31.♕f6 ♗c6 32.♖he1 ♔b5 33.e8♕ ♗xe8 34.♖xe8 ♖xh2 35.a3 ♕c5 36.♕c3 ♖f2 37.a4+ ♔a6 38.b4 1−0**

223: 80.♔b7 ♔c5 81.♔b8 ♔b6 82.♗c8 ♗f3 83.♗f5 ♗b7 84.♗d3! 1-0 Zugzwang, as the diagonal a6-c8 is too short. There were of course other ways to reach this final winning position. Black to move can't prevent this winning procedure, e.g. 1...♔d6 2.♔b7 ♔c5 and we have reached the White to move case.

224: 29...♖f3! 29...♖h8 wins as well. **30.c4** 30.♕xf3? ♕h2#. **30...♔h6!?** Reminds White that he will soon run out of pawn moves, so **0-1**.

225: 49...♗d4? 49...♗d6! 50.♘b6 ♔b4! zugzwang 51.♔g2 *(51.♘c8 ♗c5! Corralling the knight. 52.♔f4 ♔xa4 53.♔xf5 ♔b3 –+)* 51...♗c5 52.♘d7 ♗e7 53.♘b8 *(53.♘b6 ♗d8 54.♘d7 ♔xa4 55.♔f3 ♗c7 56.♘c5+ ♔b5 57.♘b3 a4 58.♘d4+ ♔c4 –+ loses as the rook pawn is notoriously dangerous for the knight.)* 53...♔xa4 54.♘c6 ♗g5! –+. **50.♘b8! ♔xa4 51.♘c6 ½–½**

226: 35.h3! Zugzwang. 35.c5+? bxc5 36.bxc5+ ♔xc5 37.♔xe5 ♔c4=. **35...♔e6** 35...axb4 36.axb4 ♔e6 37.c5 +–; 35...a4 36.h4 ♔e6 37.c5 b5 38.c6 ♔d6 39.c7 ♔xc7 40.♔xe5 ♔c6 41.♔e6 ♔c7 42.♔d5 +–; 35...h4 36.gxh4 axb4 37.axb4 ♔e6 38.c5 +–. **36.g4?** Surprisingly spoils it. 36.bxa5 bxa5 37.c5 g5 38.a4 +– was the way to go. **36...hxg4 37.hxg4 ♔d6 38.g5** 38.bxa5 bxa5 39.g5 ♔c5 40.♔xe5 ♔xc4 41.♔f6 a4 42.♔xg6 ♔b3 43.♔f5 ♔xa3 44.g6 ♔b2 45.g7 a3 46.g8♕ a2= as White's king is outside the winning zone (see e.g. *Fundamental Chess Endings* 9.02). **38...a4!** We have now reached the game Lobron vs. Sehner (see *Secrets of Pawn Endings* 13.06). 38...axb4? is of course wrong: 39.axb4 ♔e6 40.c5 +–. **39.♔d3** 39.c5+ bxc5 40.bxc5+ ♔xc5 41.♔xe5 ♔c4=. **39...♔c6 40.♔e3 ♔d7 ½–½**

227: White puts Black in zugzwang as follows: **1.♖g6!** 1.♖g7? ♗c5 2.♖g2 ♔h5 3.♔a2 ♗d6=. **1...♗c5 2.♔a2!! ♔h3** 2...♔h5 3.♖g3 ♔h4 4.♖xa3 +–. **3.♖g5 ♗d6** 3...♔h4 4.♖xc5 bxc5 5.♔xa3 ♔g4 6.♔a4 +–. **4.♖b5 ♗c5 5.♖xc5 +–.**

228: The winning procedure is as follows: **1.♖d6 ♗b4 2.♖d7+ ♔c8 3.♔c6 ♗c3 4.♖d3 ♗b4 5.♔b6 ♗e1 6.♖d5 ♗b4 7.♖d1** and Black is in fatal zugzwang.

229: Black has the strong zwischenzug **22...♗c6! 23.♘d4!** 23.♕xf5? ♕xg3+ 24.♔h1 *(24.♔f1? ♗b5+ –+)* 24...d4+ 25.♗e4 *(25.♖e4 d3 –+)* 25...♖xe4 26.♖xe4 ♕f3+ 27.♔h2 ♗xe4 28.♕e6+ ♔h8 29.♖g1 ♕e2+ 30.♔g3 ♕d3+ 31.♔h2 *(31.♔g4 ♕e3 32.♖g3 ♗f3+ 33.♔f5 ♕d3+ –+)* 31...♗f5 –+; 23.♖xe8+? ♖xe8 24.♕xf5? ♕xg3+ 25.♔h1 d4+–+; 23.♗c7? d4 24.♖e2 ♖xe2 25.♕xe2 ♕xg3+ 26.♔f1 ♗g2+ 27.♕xg2 ♘e3+ –+. **23...♘xd6 24.♕g6 ♖e1+ 25.♖xe1 ♖e8 26.♖xe8+ ♗xe8 27.♕h7+ ♔f8 28.♕d3 ♘e4 29.♘e2 ♗c6 30.♗b3?** 30.♕e3 h5 ∓. **30...♕h1+ 31.♔xh1 ♘f2+ 32.♔g1 ♘xd3 33.♘d4 ♘xb2 34.♘e6+ ♔f7 35.♘c7 ♘c4 0–1**

230: 21.♘h5+ ♖xh5 22.♖g4+! 1-0 A deadly zwischenzug.

231: With 28.♘d1 White could have kept the upper hand. 28.♖xg6?? works fine against the "automatic" recapture 28...♕xg6?? 29.♖xg6 ♔xg6 30.♕g3++–, but fails to the zwischenschachs **28...♖xh2+! 29.♔xh2 ♕f2+!** And Black forces mate, e.g. **30.♖1g2 ♖h8+ 31.♕h3 ♖xh3+ 32.♔xh3 ♕h4#.**

232: 24...♗a6! A strong intermediate move. 24...♖xe5? 25.♗xh6 ♖xe1+ 26.♖xe1 with the threat ♖e8+ gives White a pleasant endgame. **25.♖g1 ♖xe5 26.♗xh6** 26.♘xg7 ♖xe3 –+; 26.g4 ♗h4 followed by ♖ae8 –+. **26...♖xe1+ 27.♖xe1 gxh6 28.♖e8+ ♔h7 29.♘f6+ ♗xf6 30.♖xa8 ♗f1 31.♖xa7 ♗e5** White is doomed as his kingside pawns are weak. Black demonstrates good technique: **32.g3 ♔g7 33.a4 ♔f6 34.a5 bxa5 35.♖xa5 ♗d6 36.♔c1 ♗h3 37.♔d2 ♗xf5 38.c3 ♔g5 39.♔e3 h5 40.♔f3 ♗g4+ 41.♔g2 f5 42.♖a8 ♗d1 43.♖h8 ♗b3 44.♔f2 ♗d5 45.♖h7 c4 46.♖g7+ ♔f6 47.♖h7 ♔g6 48.♖d7 ♗c5+ 49.♔e2 c6 50.♖d8 ♔g5 51.♖d7 ♗g1 52.h4+ ♔g4 53.♖g7+ ♔h3 54.♖g5 ♔g2!? 55.♖xf5 ♗e6 56.♖f6 ♗g4+ 57.♔d2 c5 58.♖f4 ♔xg3 59.♖xc4 ♔xh4 60.b4 cxb4 61.cxb4 ♔g3 62.♔e1 ♗f2+ 63.♔f1 ♗h3+ 64.♔e2 ♗d7 65.♖c7 ♗b5+ 66.♔d2 h4 67.♖g7+ ♔f3 68.♖f7+ ♔g2 69.♖f5 ♗d7 70.♖g5+ ♗g3 71.b5 h3 72.b6 ♗c6 0–1**

233: 27.♖xa5? 27.♕h2+! ♖h7 (27...♘h7 28.♗xf7 +–) 28.♗xh7 ♘xh7 29.♖xa5 +–. **27...♘h7 28.♔g4?** 28.♖h5 ♗f6±. **28...♖fg7? 28...♔g7 ∓. 29.♕d4?!** 29.♖h5!? ♖xg6 30.♗d4+ ♗f6 31.♗xb2 ♗xb2=. **29...♕xd4 30.♗xd4 ♗f6 31.♗xf6 ♘xf6 32.♖xa6?** 32.♗xc2 ♖xg2+ 33.♔h1 ∓. **32...♖xg6 33.g3 ♖c8 34.♖c1 ♘d5 35.♖a4 ♖g7 36.♔f1 ♖b7 37.♔e1 ♖b1 38.♔d2 ♘b4 0–1**

234: 27.♖a7!! 1–0, e.g. **27...♕xa7 28.d7 ♕xd7** 28...♖cd8 29.♕xg7#. **29.♖xd7 ♖f6 30.♖xg7++–.**

235: 22...♘xf3+!! 0-1, e.g. **23.gxf3 ♗xf4 24.♘c4** 24.exf4 ♖e2 –+. **24...dxe3 25.♕e2 ♖c8 –+.**

236: 32.♕d6!! 1–0, e.g. **32...♕xd6** 32...fxe5 33.♕f6+ ♔g7 34.♕xg7#. **33.♘f7#.**

237: The quickest way to win is **29.♖h6!!** 1–0, e.g. **29...♖e6** 29...gxh6 30.♘f6++–; 29...♖c7 30.h3 ♕g5 31.♕xh7+ ♔f7 32.e6++–. **30.h3 +–.**

238: 32...♕c1+ 33.♔g2 ♖xf2+!! 0–1, e.g. **34.♔xf2 ♘d1+ 35.♔e1 ♕xa3 –+.**

239: 33.♕c6 1–0 33.♕d5 is equally good. **33...♖b1+** 33...♖xa7 34.♕xa8++–. **34.♖xb1 ♕xc6 35.♖b8+ ♗f8 36.♖xf8+ ♔g7 37.a8♕ +–.**

240: 30.♖xh6+! 30.♕xe5?? ♕xc1+ 31.♗f1 ♖xh4 –+; 30.♖xd4?? hxg5 –+. **30...gxh6** 30...♔g8 31.♖h8+! ♔xh8 32.♕h5+ ♔g8 33.♕xe8+ ♕f8 34.♕xe6+ ♘f7 35.♗d5 +–. **31.♕xe5+ ♔g8 32.♖c7! ♖d1+ 33.♗f1 ♕f8?** 33...♖xf1+ 34.♔xf1 ♕d3+ 35.♔g2 ♕d5+ 36.♕xd5 exd5 37.♖xb7± (Ribli in CBM 88). **34.♕h5! ♖xf1+ 35.♔xf1 ♖e7 36.♕g6+ ♔h8 37.♖xe7 ♕xe7 38.♕xh6+ ♔g8 39.♕g6+ ♔h8 40.h4 ♕d7 41.♕h5+ ♔g7 42.♕e5+ ♔h6?! 43.♕e3+ ♔g6 44.♕xa7 ♕c6 45.♔g1 b6 46.♕a3 1–0**

241: 33.♗c5 And Black resigned due to **33...♖d1+** 33...♖xc5 34.♕f8#. **34.♔e2 ♖e1+ 35.♔d2!?** ♖d8+ 36.♔xe1 ♘d3+ 37.♔f1 ♘xc5 38.♕xf6++–.

242: 37.♗xg7 1–0 37...♗xg7 37...♗h1 38.♕h8+ ♔f7 39.♕xf8+ ♔g6 40.♕xf6+ ♔h7 41.♕h6+ ♔g8 42.♖d8+ ♔f7 43.♖f8#. **38.♖d8+ ♗f8 39.♕g6+ ♔h8 40.♖xf8#.**

243: 35.♕g6! ♖f5 35...♖f7? 36.♖h8+ ♔xh8 37.♕h7#. **36.♖h2** 36.♗xf5? ♕e2+ 37.♔h3 ♕f1+ 38.♔h2 (38.♔h4? ♗e7+ 39.♔g4 ♕xf5+ 40.♔xf5 exf5+ 41.♔xf5 ♔xh7–+) 38...♕f2+=. **36...♔f8** 36...♖g5? 37.♖h8+ ♔xh8 38.♕h7#. **37.♖h8+ ♔e7 38.♗xf5 ♕e2+ 39.♔h3 ♕f1+ 40.♔h4 1–0**

244: 21.♖xa7!! And Black resigned due to **21...♕g6** 21...♔xa7? 22.♕xc7 ♕e6 23.♖a1+ ♔a6 24.♖xa6#. **22.♖ea1 ♔c8 23.♖1a6 ♖d6** 23...♕f5 24.♖xb7+–. **24.♖xd6 ♕xd6 25.♖a8++–.**

245: 35...♘d2+! 36.♔g1 36.♘xd2? ♖e1+ 37.♖xe1 ♖xe1#. **36...♘xf3+ 37.gxf3 ♖e1+ 38.♖xe1 ♖xe1+ 39.♔g2 ♘xb4 40.♘xb4 ♖e2 0–1**

246: 37.♕xb6! ♕a2+ 37...♕xb6? 38.♖xc8+ ♔d8 39.♖xd8#; 37...♖xc1? 38.♕d8#. **38.♔g3 ♕xb3+ 39.♔h4 ♖f8 40.♕c5 g5+ 41.fxg5 ♖b8 42.♕d6 1–0**

247: 31.♘c8 31.♖xe4? ♕xe4 32.♕xd6 ♕d4 is only very slightly better for White. Black resigned due to **31...♖xc8** 31...♘xg5 32.♕xf8+ ♔h7 33.♕h8#. **32.♕xf7+ ♔h8 33.♕h7#.**

248: 25.♖xe6!! fxe6 26.♗xe6+ ♔h8 27.♗xc8 ♗d8 28.♗b7 ♗c7 29.♗g2 ♕f6 30.♖d2 ♗a5 31.♖c2+– And White won later.

249: 34.♕e6+! ♔h8 35.♕f7 ♘e4+ 36.fxe4 ♖c2+ 37.♔f3 ♖c3+ 38.♔e2 1–0

250: 33.♖xb7! 33.♕d7?? is met by 33...f3! 34.♕h3 (34.g3? ♗e3 35.h4 ♕c2 36.♕h3 ♕xc4–+) 34...fxg2+ 35.♕xg2 ♕xc4–+; 33.♖b2? ♕xc4 34.♖bxf2 ♗xd5 gives Black some chances to survive. **33...♖xb7 34.♕c8+ ♔g7 35.♕xb7 ♕xc4 36.♕b2+ ♗d4 37.♖xf4 1–0**

251: 32.♖xd3! ♗e6 32...♘xd3? 33.d7+–. **33.d7! 1–0**, e.g. 33...♗xd7 33...♘xd7 34.♖xd7 ♗xd7 35.b7+–. **34.♖d5+–.** Black to move would win by entering the square of the d-pawn with **1...♔f8!–+.**

252: 22.♕e8+ ♗f8 22...♖xe8? 23.♖xe8+ ♗f8 24.♖xf8#. **23.♗xf8 ♖xe8 24.♖xe8 ♕b8 25.♖xb8 ♘xb8 26.♗d6! 1–0**

253: 33.♕xh7+ 33.♖h3?? ♕e1#. **1–0**

254: 26.♕xf7+!! ♔xf7 27.♖xh7+ ♔e8 27...♔f8 28.dxe7+ ♔e8 29.exd8♕+ ♖xd8 30.♖xd8+ ♔xd8 31.♖h8++–. **28.♖xe7+ ♔f8 29.♗g7+ ♔g8 30.♖h1 1–0**

255: 28...♗xg2!! And White resigned very early as his kingside defense is broken. But the position is still not so easy to win for Black, e.g. **29.♔xg2 ♕f3 30.♔f1 ♕xg2+ 31.♔e2 ♕e4+ 32.♔d2 ♕d4+ 33.♔e2 ♕c4+ 34.♔d1 d5∓.**

256: 39...♖xf2!! 40.♖xf2 40.♘xe4 ♖xf1+ 41.♔xf1 ♕xe7−+. **40...c2 0−1**

257: 31...♖xa2!! 32.♔c1 32.♕xa2?? ♕xe1#. **32...♖e2 33.♔f1 ♖xe1+ 34.♕xe1 ♕b8−+** And Black won later.

258: 29...♖e1!! And White resigned as he can't avoid mate, e.g. **30.♖xe1 ♖xh2#.**

259: 34...♖c8! 35.♖xc8+ 35.♖xe6 fxe6 36.♗e4 c2−+. **35...♗xc8 36.♗e4 ♗b7! 0−1**

260: White played **50.♕e5** But 50.♕f8! wins more quickly: 50...♖xf8 51.♘xf8+ ♔g7 52.♘xd7 ♘c7 53.a7 ♘a8 54.f4+−. **50...♘b4 51.♕f6 ♖a8 52.♘f8+ ♖xf8 53.♕xf8 ♘xa6 54.♕c8 ♖d6 55.♕b7+ ♔h6 56.♕e7 ♖c6 57.h4 ♘c7 58.♕d8 1−0**

261: 24.♘f6! ♗a4 24...gxf6 25.♕xh6+ ♔e8 26.♕xf6 ♖f8 27.g5+− (A.Finkel in CBM 90). **25.♘xg8 ♔xg8 26.♖xc3 ♕b2 27.♔d2 ♖b8 28.f3 ♖b3 29.♕e3 ♖xa3 30.♖xa3 ♕xc2+ 31.♔e1 ♕xd1+ 32.♔f2 ♗c2 33.♖xa5 ♗d3 34.♗xd3 cxd3 35.♖a8+ ♔h7 36.♖a2 1−0**

262: 31.♕xe5!! 1−0, e.g. **31...dxe5** 31...♕xe5 32.♖xe5 dxe5 33.♖xd8++−. **32.♖xd8+ ♔h7 33.♖1d7+ ♕g7 34.♗g8+ ♔h8 35.♗d5+ ♔h7 36.♗xc6+−.**

263: 38...♖c3!! 0−1 39.♕e1 39.♕xc3? ♘e2+−+. **39...♕d4+ 40.♔h1** 40.♔f1 ♖e3−+. **40...♘d3 41.♘f3 ♘xe1 42.♘xd4 ♘d3** (Ftacnik in CBM 85.) **43.♘e2 ♘f2+ 44.♔g2 ♘xd1 45.♘xc3 ♘xc3−+.**

264: 21...♖c1+! 22.♖xc1 ♕xd6 23.♖gd1 ♕b6 24.♖xd7 ♗xf3−+ And Black won later.

265: 25.♖f5!! ♕d7 And Black resigned as his king is caught in the middle: **26.♗b4 ♕e6 27.♘d6++−.**

266: 32.♘xf7! 1−0

267: 30.♕xg7+!! ♔xg7 31.♘xe6+ ♔f7 32.♘xc7 a5 33.♖d5 ♖xd5 34.♘xd5 ♗c5 35.♖d1 hxg3 36.hxg3 ♖b8 37.♘c3 ♔e6 38.♖d5 ♗d6 39.♘e2 ♗e5 40.♘d4+ ♗xd4 41.exd4 a4 42.♖b5 1−0

268: 20...♘xb2! 21.♘xb5 21.♔xb2? ♕c3+ 22.♔b1 (22.♔c1? ♕a1#) 22...♕xd2−+. **21...♖ab8!! 22.♔c1** 22.♘xc7 ♘d3+! and mate will follow.

22...♕e5 23.f4 ♕c5 24.♕f3 ♘c4 25.♗xc4 ♕xc4 26.♘d6 ♕xa2 27.♔d1 ♕b1+ 28.♔e2 ♕xh1 0–1

269: Black's Achilles heel is the unanchored knight on e6. This is quite typical, by the way: **33.♗e5! ♖2d6 34.♗xd6 ♖xd6 35.♕e7 1–0**

270: 27.♖xg7+!! ♔xg7 28.♕xg5+ ♔f7 29.♕f6+ 1–0, e.g. 29...♔g8 29...♔e8 30.♖d8#. **30.♖g3+ ♔h7 31.♕g7#.**

271: 31.♖h5! f6 31...♕xe5 32.♘h6+ +– . **32.♕g1 32.♕h6 +– . 32...g5 33.exf6 1–0**

272: 33.♖xf5! ♕xf4 34.♖xf8+ ♕xf8 35.♖xf8+ ♔h7 36.♗xc4 ♖c6 37.♗d3+ ♘g6 38.c4 ♖xc4 39.♗xc4 ♘xf8 40.♔f1 ♘g6 41.♗d3 ♔h6 42.♗xg6 ♔xg6 43.♔e2 a6 44.e4 1–0

273: 34.♗f5+!! ♔xf5 34...♔d5? 35.♕e6#. **35.g4+ ♔e4 36.♕g6+ ♔f3 36...♔d5 37.♗b6+ +– . 37.♕f5+ ♔e2 38.♕d3# 1–0**

274: 39.♕f8+! ♖xf8 39...♔h7 40.♗f5+ ♕xf5 41.♕xf5+ +– . **40.♖xf8+ ♔h7 41.♗g8+ ♔h8 42.♗f7+ 1–0**

275: 28.♕xe6!! 1–0, e.g. 28...♖xe6 29.♘f7+ ♔g8 30.♘xd8 ♖f6 31.♔e2 ♖d6 32.♘b7 ♖e6+ 33.♔d3 ♖f6 34.♘e5 +– .

276: 28...♗f1! 0–1, e.g. 29.♘xf1 ♕xf3 30.♔h2 ♕xe4 –+ .

277: 36.♖b8!! And Black resigned due to **36...♔g7 36...♖xb8? 37.♕xf6#. 37.♖xf8 ♔xf8 38.♕xf6+ +– . NB: not 36.♖b6?? ♘xc4 37.♖xf6 ♘xe5 –+ .**

278: 35.♕e5+ ♔h6 36.♘f7+! ♗xf7 37.♔xg2 ♗d5+ 38.♔g1 ♕xh3 39.♕h2 1–0

279: 29.♗xd6! ♕xd6 29...♗xd6?? 30.♕xg7#. **30.♘xd6 ♗xd6 31.♖xf7 ♘de5 32.♖f5 +–** And White won later.

280: 35.♘gh5! ♕g5 35...♕xf6 36.♘xf6 ♖f8 37.♕b3 ♖xf6 38.♕xb6 ♗b5 39.♖e7 +– . **36.♖e7 ♖f8 36...♗e6 37.♖e8+ ♖xe8 38.♕xe8+ +– . 37.♕xf8+ 1–0 37...♗xf8 38.♖h7#.**

281: 31.♕xe6+! ♕xe6 32.♖xd8+ ♔f7 32...♔h7? 33.♘xg5+ +– . **33.♘d6+ ♕xd6 34.♖xd6 f5 35.♖b1 +–** And White won after some further moves.

282: 33.♖xf7!! ♖xf7 34.♕xe6 ♕xa5?! 35.♕xf7 ♕xe1+ 36.♔g2 ♘g8 37.h6 1–0

283: 26.♘b7! ♖xb7 27.♖xd8+ ♔h7 28.♕xa6 ♕b6 29.♕xb6 axb6 30.♖ed1 ♖a7 31.♖1d7 ♖xa2 32.e6 fxe6 33.♖e7 1–0

284: White's easiest win is **38.♕xe6+! ♕xe6 39.♗d5 1–0**, e.g. 39...♕xd5 40.♘e7+ ♔g7 41.♘xd5+−.

285: 28...♕h6! 29.h3 29.♗xh7+ ♔h8! 30.♔f1 ♕xh2 31.♕g6 ♖f6 32.♕g1 ♕xh7−+. **29...♕g5+ 30.♗g4 h5 31.♘d4 hxg4 32.♘e6 ♕h4 33.♔f1 g3 34.♘xf8 ♖xf8 35.♕g6 g2+ 36.♔e1 ♗g3 0–1**

286: 37.♘e4! ♕xc4 38.♕h6 ♖a6 39.♘f6+ 1–0

287: 22.♗xf5!! 1–0, e.g. 22...♖xf5 23.♕xg4+ ♕g7 23...♔h8 24.♖xh6++−. **24.♖g6+−.**

288: 27...♗xf4! 28.♖e8+ 28.♗xf4 ♕h1+ 29.♖e1 ♕xe1+ 30.♔d1 ♕xd1#. **28...♔g7 29.♕xf4 ♖xe8 30.♗c4 ♕h1+ 31.♗f1 ♔g8 0–1**

289: 30.♖xh7!! 1–0, e.g. 30...♔xh7 30...♖xd6 31.♖ch1 ♘xc4 32.♖g7+ ♔f8 33.♖h8#. **31.♖h1+ ♔g8 32.♖h8#.**

290: 34...♕xf2+ 35.♔h1 ♕g1+!! And White resigned due to the smothered mate **36.♖xg1 ♘f2#.**

291: 21.♕g5! g6? 21...♘e8! 22.♘xd4 h6 23.♕f5 ♕xd3 24.♕xd3 ♘xd3 25.♘xe6±. **22.♘xd4 h6 23.♘xb5** 23.♕xh6 and; 23.♕xf6 win as well. **23...hxg5 24.♘c7 ♖ae8 25.♖ed1 ♖8e7 26.♘xe6 ♖xe6 27.♗xb7+−** And White won later.

292: 29.♕xd7! 1–0, e.g. 29...♕xd7 30.♘f6+ ♔g7 31.♘xd7 ♖d8 32.♘3e5+−.

293: 22.♖c6! 1–0, e.g. 22...♘cd6 22...♕xc6? 23.♘e7++−. **23.♖xa6+−.**

294: 35.♗h4! ♕a1 35...g5 36.hxg6+−. **36.♕xf7+ ♔h8 37.f6 ♗f8 38.♕g6 1–0**

295: 28...♖f5! 29.♖xf5 29.♖h5 ♖xh5 30.♕xh5 ♘f4−+ trapping the queen. **0–1**

296: 34...♘g3+! 0–1, e.g. 35.♖fxg3 35.♕xg3 ♖xg3−+. **35...♕xh2#.**

297: 26...♕d8! 0–1

298: 24.♖xd7! 1-0 A typical overloading. Remember it!

299: 32.♖xh7!! 1–0, e.g. 32...♖xh7 32...♔xh7? 33.♕xg6#. **33.♕xg6+ ♔f8 34.♘e6+ ♔e7 35.♕xh7++−.**

300: 35.♕e5+ 35.♖g4+ ♖g6 36.♕e5+ ♔h7 37.♖h4+ ♖h6 38.♕f4 wins as well. **35...♔f8** 35...f6 36.♕e7+ ♔f7 37.♖g4+ +– ; 35...♔g6 36.♖g4+ +–. **36.♖h8 1–0**

301: 26.♗d5+ 1–0, e.g. 26...cxd5 27.♕h7#.

302: 40.♘d7+!! ♗xd7 41.♕f6+ 1–0, e.g. 41...♔e8 41...♔g8 42.♕g7#. **42.♘g7#.**

303: 33.♕a7!! 1–0, e.g. 33...♕d8 33...♕xa7? 34.♖e8#; 33...♗xe1? 34.♕a8+ +–. **34.♕xa5 ♕xa5? 35.♖e8#.**

304: 14...♘xe4!! 15.♗xd8 15.fxe4 ♕xh4+ 16.g3 ♕e7 –+. **15...♘xc3 16.bxc3 ♖cxd8 17.c4 ♖fe8+ 18.♔f2 ♖e7 –+** And Black won later.

305: 37.♖xh6+!! gxh6 38.♖xh6+ ♔g8 39.♕g6+ ♕g7 40.♕e6+ ♕f7 41.♖h8+ 1–0

306: Black is winning by force: **1...♕e6! 2.d7** 2.♖xd4 ♖e1 3.♖d1 ♖xf1+ 4.♖dxf1 ♗e4 –+; 2.♖fxf5 ♖e1 3.♖f7+ ♔g8 4.♖f8+ ♔g7 5.♖f7+ ♔xf7 6.♕xe1 ♕xd5+ 7.♔h2 ♕e5+ 8.♕xe5+ ♗xe5+ 9.♔g2 ♗f6 –+; 2.♖dxf5 gxf5 3.♕d3 ♖e1+ 4.♔g2 *(4.♖f1 ♕d5+ 5.♔h2 ♗e5+ –+)* 4...♖g1+ 5.♔h2 ♕e5+ 6.♖g3 ♖a1 –+. **2...♖e1 3.♖xd4** 3.d8♕ ♖xf1+ 4.♖xf1 ♕e4+ 5.♔h2 ♕e2+ 6.♔g3 ♕xf1 7.♖xd4 cxd4 8.♗f6 ♕xh3+ 9.♔f2 ♕e3+ 10.♔g2 ♕e2+ 11.♔g3 ♕e1+ and Black mates.; 3.♖dxf5 gxf5 –+. **3...♗e4! 4.♕xe1 ♗xf3+ 5.♔h2 ♕xe1 6.♗h4 ♕e5+ 0-1** Black's attack flew like an arrow!

307: 32...♕xd6! 32...♖xd6?? 33.exd6 ♖xb5? *(33...♕e1+ 34.♕f1 +–)* 34.dxe7+–. **0–1**

308: White resigned due to **20...♕c3!! –+.**

309: 30.♘xe6! 30.g4 wins as well. **30...♖xg2+** 30...♖xh5? 31.♘g7+ +– ; 30...fxe6 31.♖xg5 +–. **31.♕xg2 ♕xe6 32.♖xh7 0–0–0 33.♕g4 ♕xg4+ 34.fxg4 ♖g8 35.♖xf7 ♖xg4+ 36.♔f2 ♗e8 37.♖f8 ♔d7 38.♖xa6 ♔e7 1–0**

310: 36.♕g4! 1–0, e.g. 36...♖d5 36...♕g6 37.♕d7+ ♔g8 38.♖g1 +–. **37.♖xd5 ♕xd5 38.♕xc8 +–.**

311: 18.♗xb6! 18.♕b5 wins as well. **18...axb6 19.♕xa8!** 19.♘c7+ +–. **19...♕xa8 20.♘c7+ ♔e7 21.♘xa8 ♖xa8 22.♗xc6 bxc6 23.gxf5 +–** And White won later.

312: 37.♖xg7+!! 1–0, e.g. 37...♔xg7 38.♗xh6+ ♔xh6 39.♕xd1 +–.

313: 30.♖xb7!! ♕xb7 31.d7 1–0

314: 21...♗h6! Trapping the queen. **22.♕xh6 ♘xh6 23.♘xe6 fxe6 24.♗xh6 ♖f7 −+** And Black won later.

315: 18.♗e4! ♖xe4 18...♕d7 19.♗d5 +−. **19.♕d5+ ♔f8 20.♕xe4 +−** And White won later.

316: 31...♖e1+! 32.♔h2 32.♔f2 ♖xd1 33.♕xf6 ♕d4+ 34.♕xd4 ♖xd4 −+. **32...♖xd1 33.♕xf6 ♕d6+ 34.♕xd6 ♖xd6 35.♔g3 ♖e6 36.♔f2 ♔f7 37.♗d2 c5 38.♗c3 ♔e7 39.♗d2 ♔d6 0–1**

317: 32...♕xd5!! 32...♖xd5?? 33.♕xh1 +−. **33.♔c3** 33.♖xd5? ♖xd5+ 34.♔e2 ♖xd1 35.♔xd1 ♔g7 36.g5 f6 and Black wins easily. **33...♕c5+ 34.♔b2 ♖xd4 35.exd4 ♕d5** And Black won the queen ending instructively: **36.♕d2 ♔g7 37.g5 f6 38.gxf6+ ♔xf6 39.♕f4+ ♔g7 40.♕c7+ ♔h6 41.♕h2+ ♔g5 42.♕xh7 ♕xd4+ 43.♔a3 ♕c5+ 44.♔b2 ♕e5+ 45.♔b1 ♕e4+ 46.♔b2 ♔g4 47.a4 ♕d4+ 48.♔a2 ♕d2+ 49.♔a3 ♕c1+ 50.♔a2 ♕c2+ 51.♔a3 ♕c5+ 52.♔a2 ♕c6 53.♕h2 g5 54.♕e2+ ♕f3 55.♕c4+ ♔h3 56.♔a3 g4 57.♕c8 ♕c6 58.♕f5 ♕d6+ 59.♔a2 ♕d2+ 60.♔a3 ♕d6+ 61.♔a2 ♕c6 62.♕h5+ ♔g3 63.♕e5+ ♔g2 64.♔b2+ ♔f3 65.♔b1 g3 66.♕f1+ ♔g4 67.♕d1+ ♔f3 68.♕d7+ ♔f4 69.♕d4+ ♔e4 70.♕d6+ ♔f3 71.♕f6+ ♔e2 72.♔b2+ ♔f1 73.♕c1+ ♕e1 74.♕h6 g2 75.♕h3 ♕e4 76.♔a3 ♔f2 77.♕h2 ♕g4 0–1**

318: 23...♕xa4!! 24.♘a3 24.♖xa4? ♖e1#. **24...♗xd4 25.♕c2 ♕a6 26.♕c4 ♕a5 27.h4 ♗xb2 0–1**

319: 30...♗a4!! 31.♕xa4 ♖xe2 32.♕d7 ♕f2 0–1

320: 27.♗g6+! 1–0, e.g. 27...♔xg6 27...♔g8? 28.♕e8#. **28.♘xh4+ +−.**

321: 28.♕xf8+! 1–0, e.g. 28...♔xf8 29.♖xd8+ ♔e7 30.♖b8 +− (Tyomkin in CBM 82).

322: 24...♕e4!! 0–1 25.g3!! 25.♕xe4? ♖xd1+ 26.♕e1 ♖xe1#. **25...♕xg4 26.♖xd8 ♕f5 27.♗e7 ♔g7∓.**

323: 27...♖xb7 28.♗xb7 ♗c6!! 0–1

324: 29.♕e5! 1–0, e.g. 29...♕f6 30.♕c7+ ♕e7 31.♖g7+ +−.

325: 37...♘f2!! 0–1 37...♘xh2?! 38.♕d3 ♕h5 (38...♖e1+?? 39.♖xe1 ♕xd3 40.♖e8#) 39.♖c1 ♘f3+ 40.♔g2 ♘e1+ wins as well.

326: 31...♗e3 0–1, e.g. 32.♕g4+ ♔h8 33.♔e2 33.♖xe3? ♕xf2#. **33...♕xf2+ 34.♔d3 ♕d2+ −+.**

327: 29.♘f6+!! ♕xf6 29...♖xf6? 30.♕xd8+−; 29...♗xf6 30.♖xd6 ♕f8 31.♖c1+−. **30.♖xd6 ♕e5 31.♖c1 ♗e6 32.♖c7 ♔h8** Now 33.♖e7! was the quickest win. White played 33.♖d8+ and won eventually. For example: **33...♕a1+ 34.♔h2 ♗c4 35.♖dd7 ♖g8 36.♕xh6+ ♗xh6 37.♖h7#.**

328: 16.♕xb5+!! 1−0, e.g. 16...axb5 17.♗xb5+ ♕d7 18.♗xd7+ ♔xd7 19.♘e5+ ♔e8 20.♘xg4+−.

329: 22...♕g4! 23.g3 ♖g6 0−1, e.g. 24.♕xg6 24.f3 ♖xh6 25.fxg4 ♘xd2−+. 24...hxg6 25.♘xc4 ♕h3−+.

330: 32...♕xh3+!! And White resigned as he is mated. 32...♖xh3+? 33.gxh3 ♕xh3+ 34.♔g1 ♗xf5 35.e7 is not clear.; 32...♖xg2+? 33.♔xg2 ♗xf5 34.h4 ♗xe6 35.♘e5 and White can still fight. **33.gxh3** 33.♔g1 ♕xg2#. **33...♖hxh3#.**

331: 28.♖xg5+! ♔f8 28...♗xg5 29.♕xg5+ ♘g6 30.♗xg6 ♕d3+ 31.♔a1 ♕d1+ 32.♘c1+−. **29.♖xf6 ♕d3+ 30.♔c1 ♗e7** 30...♕e3+ 31.♔d1 ♕d3+ 32.♔e1 ♔e7 33.♖g7 ♕b1+ 34.♔f2 ♘d3+ 35.♔e3+−. **31.♖g3 ♖h8 32.♖e6+** 1−0, e.g. 32...fxe6 33.♖g7+ ♘f7 33...♔f6 34.♕g5#. **34.♕xf7+ ♔d8 35.♕d7#.**

332: 36.♖xc4!! 1−0, e.g. 36...♕xc4 37.♕e8+ ♔h7 38.♕g6+ ♔g8 39.♕xb1 ♕xg4+ 40.♔f1 ♕h3+ 41.♔e2 ♕xh5+ 42.f3 ♕h2+ 43.♗f2 ♕e5+ 44.♕e4+−.

333: 25.♕xf4!! exf4? 25...♘xd3 26.cxd3 ♖c2 27.♕f6 h5 28.♕xe6 fxe6 29.♘f6+ ♖xf6 30.gxf6 ♖xb2 31.♖xg6+ ♔f7 32.♖g7++−. **26.♘h6# 1−0**

334: M.Tal - V.Korchnoi
Candidates sf1 Moscow 1968

Furman, Smyslov and Averbakh analyzed **28.e5!?** 28.h3 was played in the game, which ended in a draw. **28...f6 29.h4+ ♔g6 30.♔f4 a6 31.a3 b5 32.cxb5 axb5 33.b3 fxe5+ 34.♔e3** and claimed that White wins (see Averbakh, *Bauernendspiele*, Sportverlag 1988, p.304-307). In the exercise this should be checked and the surprising result is, that Black can hang on by the skin of his teeth: **34...f4+!! 35.gxf4** 35.♔e4? fxg3 36.fxg3 ♔f6−+; 35.♔d2? fxg3 36.fxg3 e4 37.a4 c4 38.axb5

cxb3 39.b6 e3+ –+. **35...exf4+** 35...♔f5? 36.a4 exf4+ 37.♔d3 bxa4 *(37...c4+ 38.♔c3 ♔e5 39.a5 ♔d6 40.a6 ♔c6 41.bxc4 +–)* 38.bxa4 ♔e5 39.♔c4 ♔d6 40.a5 e5 41.a6 ♔c6 42.a7 ♔b7 43.♔xc5 e4 44.♔d4 e3 45.fxe3 fxe3 46.♔xe3+–. **36.♔xf4 ♔f6 37.♔e4 ♔e7 38.a4** 38.♔e5 ♔d7 39.f3 ♔c7 40.f4 ♔d7 41.f5 exf5 42.♔xf5 c4 43.bxc4 bxc4 44.♔e4 ♔c6 45.♔d4 ♔b5 46.♔c3 ♔a4=. **38...c4! 39.a5 cxb3 40.♔d3 ♔d6 41.♔c3 ♔c6** 41...b2? 42.♔xb2 c5 *(42...e5 43.♔b3 ♔c5 44.f3 +–)* 43.♔b3 e5 44.f3 ♔d6 45.♔b4 ♔c6 46.a6+–. **42.♔xb3 ♔c5 43.f4** 43.♔a3 b4+ 44.♔a4 ♔c4=. **43...♔d5 44.♔b4 ♔c6 45.a6 ♔b6 46.a7 ♔xa7 47.♔xb5 ♔b7=.**

335: 31.♘e5!! ♖e1+ 31...♖xe5 32.d7+ ♔xd7 33.♗xe5+–. **32.♔g2 ♗xd6 33.♗xd6 ♖b1 34.♔h3 ♖xb3 35.♔h4 ♖b2 36.♔xh5 ♖d2 37.♗b4 ♖e2 38.f4 a5 39.♗a3 ♖xh2+ 40.♔g6 ♖h3 41.♔xg7 ♖xg3+ 42.♘g6 1–0**

336: 43...♘b3! 44.♘xe6 d4 45.♘g5+ ♔g7? 45...♔f8! 46.e6 ♘c5+ 47.♔d8 ♘b7+ 48.♔d7 ♘c5+ 49.♔d6 d3 50.♘f3 *(50.♔xc5? d2 –+; 50.♘h7+ ♔g7 51.e7 d2 52.e8♕ d1♕+ 53.♔xc5 ♕c2+=)* 50...♘e4+ 51.♔d7 ♘c5+=. **46.e6 d3** 46...♔f6 47.♘h7+ ♔g7 48.e7 ♘c5+ 49.♔c6 ♔f7 50.♔xc5 d3 51.♘g5++–. **47.e7** And Black resigned due to **47...d2 48.e8♕ d1♕+ 49.♔e7 ♕e1+ 50.♘e6++–.**

337: 34.♗xc6! ♘d6 34...♔xc6 35.♘b3+ ♔d5 *(35...♔b6?! 36.♘xa5 ♔xa5?! 37.♖c5+ +–)* 36.♘xa5 ♗xh3 37.♖c5++–. **35.♗xa4 ♔d8 36.♖c3 g5 37.♗c2 ♗xc2 38.♖xc2 ♖a7 39.♘e6+ ♔e7 40.♘xg5 ♔f6 41.♘f3 ♔f5 42.♔f2 ♔f4 43.♘d2 ♖a4 44.♘b3 ♖a8 45.♘c5 1–0**

338: Black's strike **35...♖bxd7!** forced White to resign. 35...♖dxd7 wins as well. **36.♖xd7 ♖xd7 37.♖c1** 37.♖xd7 c2 38.♖d6+ ♔e7 –+. **37...♖d2 –+.**

339: 48...h3!! 49.gxh3 49.g3 ♗c5 50.♖c2 ♖d5 51.♖c1 ♖d3 52.♔a2 ♗g2 53.♖e2 ♗d4 54.♔b1 f5 –+; 49.♖xf6 hxg2 50.♖xg2 ♖xg2 –+ as 51.♖xf7? is refuted by 51...♖g1+ 52.♔a2 ♗d5+ –+. **49...♖g1+ 50.♔a2 ♗e4! 51.♖h2 ♖c1 0–1 52.♖xf6 ♗b1+ 53.♔a1 ♗c2+ 54.♔a2 ♗b3#.**

340: 32.c7! 32.♘b5?! e6 33.♘d6+ ♔d8 34.♖a5 ♔c7 35.e5±. **32...♗d7 33.♘c6!** 1–0, e.g. 33...f6 33...e6? 34.c8♕+ ♗xc8 35.♖d8#. **34.♘b8 ♗c8 35.♖d8++–.**

341: 30...♖4h3+! 31.♔e2 31.♗g3 ♖xb2 –+; 31.♔g4? ♘h6+ 32.♔g5 ♖h5#. **31...♖e3+ 32.♔f1 ♖f3 33.♖g2 ♖h1+ 34.♔g1 ♖h2 35.♖g2 ♘g3+ 36.♖xg3** 36.♔g1? ♖h1#. **36...♖xg3 0–1,** e.g. **37.♗xg3 ♖h1+ 38.♔e2 ♖xc1 –+.**

342: 44...cxd4+ 45.cxd4 a4! 46.♔d3 46.d5 b3 47.axb3 a3 48.d6 ♔f7 –+; 46.dxe5 b3 47.a3 b2 –+ *(47...♔f7? 48.♔d3 ♔e6 49.♔c3 ♔xe5 50.♔b2=)*. **46...b3 47.axb3** 47.a3 exd4 –+. **47...a3 48.♔c2 exd4 49.b4 d3+ 0–1**

343: 54.♗d5? 54.♗a8! is the only move to draw. For more details on this and

similar fortresses see *Fundamental Chess Endings* 7.49 and *The Magic of Chess Tactics* p.200–207. **54...♖b5! 55.♗c6** 55.♗f7 ♔f3 56.♔h2 *(56.♗xg6 ♔xg3 –+)* 56...g5 57.♗xh5+ g4 58.♗g6 ♖b2+ 59.♔g1 ♔xg3 60.h5 ♖d2 61.♔f1 ♔f3 62.♔e1 ♖h2 –+. **55...♖c5 56.♗b7 g5 57.hxg5 ♖xg5 58.♔g2?!** 58.♔h2 is more tenacious, but Black still wins: 58...♔f2 59.♔h3 ♖xg3+ 60.♔h4 ♖g7! 61.♗c6 ♖h7 62.♗e8 ♔f3 63.♗g6 ♖h8 64.♗f7 ♔f4 65.♗e6 ♖e8 66.♗f7 ♖e5 67.♗b3 ♖a5 68.♗f7 ♔f5 69.♗e8 ♖a1 –+. **58...h4 59.♔h3 hxg3 60.♔g2 ♔f4 61.♗c6 ♖c5 62.♗b7 ♖c2+ 63.♔g1 g2! 64.♔h2** 64.♗xg2?! ♔g3 –+. **64...♖b2 0–1, e.g. 65.♗c6 ♖f2 66.♗b7** 66.♗xg2 ♔g4 67.♔g1 ♔g3 –+. **66...g1♕+ 67.♔xg1 ♔g3 –+.**

344: Did you fall into the trap and say that White wins easily with **74.♖a6+!?** ? Then you missed **74...♔g7 75.♖a7+** 75.♔g5 ♖h1 76.♖a7+ ♔g8 77.♔g6 ♖g1+! 78.♔f6 ♖f1 is Karstedt's draw: 79.♖a8+ ♔h7 80.♖f8 ♖a1 81.♖e8 ♖f1 82.♔e6 ♔g7=. **75...♔f6!!** When White can't make progress. The game went 75...♔g8? 76.♖xh7 ♔xh7 77.♔e5 ♔g7 78.♔e6 ♔f8 79.♔f6 1–0

345: 37.♖d1! ♖a8 38.♖d7 ♘g7 39.♖b7 39.♘e3 +–. **39...♘e8** 39...♔h7 40.♘e3 ♔g6 41.♘c4 +–. **40.♖b8 ♖xa7 41.♖xe8+ ♔f7 42.♖c8 ♖a3 43.c4 b5 44.♖c7+ 1–0**

346: 35.♘xb7!! ♘xb7 36.bxa6 1–0

347: 31.♖xd5! ♖xc4 31...♘xd5? 32.♗xd5+ ♔f8 33.♗xc6 +–. **32.♖d8+ ♔f7 33.♖c1!** The final point. **1–0**

348: Lputian forced the win as follows: **37...♖g4+! 38.♖xg4 fxg4! 39.♔f4** 39.♔h4?! d4 –+. **39...♔f7! 40.f3** 40.♔f5 d4 41.♔e4 h4 42.♔xd4 h3 –+. **40...gxf3 41.♔xf3 ♔e6 42.♔f4 h4** Zugzwang. **43.♔g4 ♔xe5 44.♔xh4 ♔f4 45.g3+ ♔e4** And White resigned as it is over: **46.g4 d4 47.g5 d3 48.g6 d2 49.g7 d1♕ 50.g8♕ ♕h1+ 51.♔g5 ♕g2+–+.**

349: 26.g6+! ♗xg6 26...♔f8 27.♘e6+ ♗xe6 28.♖xe6 c5 29.♖xa6 +–. **27.♖e7+! ♔xe7 28.♘xg6+ ♔e6 29.♘xh8 g5 30.♘g6 c5 31.♗g7 ♔f5 32.♘e7+ ♔e6 33.♘c6 d4 34.♔d2 a4 35.c3 ♔d5 36.♘d8 1–0**

350: 48...♔e8! 48...♔c7? 49.♘c6 ♕xb5 50.♗e5+ is unclear. **49.♘c6** 49.♔g5 ♕a3 –+. **49...♕f8 50.♗f6** 50.♘ce5? ♕f5#. **50...♕xf6 51.♘cd4 ♕h8 52.♔f4 ♔e7 53.g4 ♕f6+ 54.♔e3 ♔d6 55.♘c6 ♔c5 56.♘cd4 ♔b4 57.g5 ♕e7+ 58.♔f4 ♕e4+ 59.♔g3 ♔a4 60.♔f2 ♕g4 61.♔e3 ♔b4 62.♔f2 ♕e4 63.♘e2 ♕e8 64.♘ed4 ♔c4 65.h5 gxh5 66.g6 ♔c5 67.g7 ♕g8 68.♘f5 ♕h7 69.♔e3 ♔xb5 70.♘3d4+ ♔a4 71.♔f3 b5 72.♔f4 b4 73.♘c6 b3 0–1**

351: The siege of the fortress was successful: **39.h5** 39.g5? h5 40.♔g3 ♔e6 41.f4 ♔f5=; 39.♔g3 ♔e6 40.f4 ♔f7 41.g5 *(41.h5? g5= as Black's fortress has no entrance.)* 41...h5 42.f5 gxf5 43.♔f4 ♔e6 44.g6 +–. **39...gxh5 40.g5** 40.gxh5?

♔e6 41.♔g4 ♔f6 42.f4 ♔e6 43.f5+ ♔f7! 44.♔f4 ♔f6=; 40.♔f5 h4 41.♔f4 wins as well. **40...♔e6** 40...hxg5+ 41.♔xg5 ♔e6 42.f4 h4 43.♔xh4 ♔f5 44.♔g3 ♔e4 45.♔g4+−. **41.gxh6 1–0**

352: 40.♕xc7! 1–0 40.♕b8 also wins, but is less forcing. **40...♕xc7 41.♖b7 ♕c7 42.c7+−.**

353: 40.♗d5! 1–0, e.g. **40...♖xa5** 40...♖e2 41.♖e6+ ♔d7 42.a6+−. **41.♖e6+ ♔d7 42.♖xe5 ♔d6 43.♖xh5 ♖xd5 44.♖xd5+ ♔xd5 45.♔g4+−.**

354: The famous Russian chess coach won by a nice combination: **34...d3!** 34...♖xb3? 35.♖7xc5 gives White good chances to draw. **35.♖1xc5** 35.♖7xc5? d2 36.♖xd5 dxc1♕+−+. **35...♖h8! 36.♔g1** 36.♔e1 d2+ 37.♔d1 ♖h1+−+. **36...♖dd8 37.♖c1 d2 38.♖d1 ♖de8! 39.♖f1 ♖e1 40.♖d7 ♖h1+! 0–1**

355: 41.♕e6! ♕f7 41...♖e8? 42.♗d6+ ♖e7 43.f6+−. **42.♗d6+ ♔g8 43.g6!** And Black resigned as he is dominated after **43...♕xe6 44.fxe6 ♖c8 45.e7 d4 46.♗c7 ♖e8 47.♗d8+−.**

356: If you did not know the technique of triangulation, it was high time to learn it: **68...c4 69.♔c2 c3 70.♔c1!?** Now Black loses a tempo by triangulation on c5 and d5: **70...♔c5 71.♔d1** 71.♔c2 ♔c4−+. **71...♔d5 72.♔c1 ♔d4 0–1 73.♔c2** 73.♔d1 ♔d3 74.♔c1 c2 75.♔b2 ♔d2 76.♔a2 ♔c3 77.♔a1 c1♕+ 78.♔a2 ♕b2#. **73...♔c4 74.♔c1 ♔b3−+.**

357: 45.♖g4! ♗d6 45...♖g6? 46.♘g3#. **46.d4 1–0**, e.g. **46...♗b8 47.d5 ♖a6 48.d6!** The motifs are a bit study-like! **48...♖a3+ 49.♘g3+ ♖xg3+ 50.♖xg3 ♗xd6 51.♖d3 ♗e7 52.♖d5+ ♔g6 53.♖xb5+−.**

358: 50.♗h5! ♖f6+ 51.♔e5 ♖e6+ 51...♖f1 52.♖xf7 ♖xf7 53.♔e6 a4 54.♗xf7+ ♔f8 55.e5 a3 56.♔d7 a2 57.e6 a1♕ 58.e7+ ♔xf7 59.e8♕+ ♔f6 60.♕h8+−. **52.♔d5 ♖e7+ 53.♗xf7+ ♖xf7 54.♖xf7 ♔xf7 55.♔xc5 ♔e6 56.♔b5 ♔d6 57.c5+ 1–0**

359: 39.♗xc5! 39.b7? ♗c7 40.♗xc5 ♗b8! 41.♗d4 ♗b5 and Black should be able to hold the draw. **39...♗a4** 39...dxc5 40.b7! *(40.d6+? spoils it: 40...c4! 41.♗xc4+ ♔f8 42.b7 ♗b6+ followed by ♗a7 and Black even wins.)* 40...♗c7 41.d6+ ♗f7 42.dxc7+−. **40.♗a2!** Not 40.♗c4? ♗b5! 41.♗a2 ♗a6 42.♗d4 ♔f7 when Black can still fight. **1–0**

360: The only winning move is **66...♖d3!**, as Hecht has shown in CBM 86: 66...♖xg3? 67.♔g7+! *(67.♔g8 ♖xg4−+)* 67...♔h6 68.♔f7 ♖xg4 69.♖g8! ♔h7 70.♖g7+ ♔h6 71.♖g8=; 66...f5? 67.♖e6+ ♔h7 68.♖e7+= as 68...♔h8?? is refuted by 69.♖e2 ♔h7 70.♔f7+−. **67.♖g7+ ♔h6 68.♖xc7 a3 69.♔f7 a2 70.♖a7 ♖d7+ 71.♖xd7 a1♕ 72.♖d2 ♕a7+ 73.♔xf6 ♕g7+ 0–1**

361: 52.♖xb5! 52.♖xd7? ♗xd7 is only drawn due to the opposite-colored bishops, of course. **52...axb5** 52...♖xd4+ 53.♔c3 ♖xg4 54.♖b6++−. **53.♔e3 ♔f7** 53...♖d6 54.♗c5 ♖c6 55.♔e4 ♔g5 56.♔d5 ♖c8 57.a6+−; 53...♔g5 54.a6 ♔xg4 55.a7 ♖d8 56.♗e5 ♖a8 57.♗b8+− (Hecht in CBM 83). **54.a6 ♔e6 55.a7 ♖d8 56.♔e4 ♔d6** 56...♖a8 57.♗e3! zugzwang 57...♔e7 58.♔e5 ♔d7 59.♔d5 ♔c7 60.♗f4+ ♔b7 61.♗b8+−. **57.♗e3 ♖a8 58.♗f4+ ♔c6 59.♗b8 1−0**

362: White wins, but without the a3-pawn the position is drawn: **80.♔f7** 80.♖g7+? ♔h6 81.♖g4 ♖h1 is only drawn. **80...♔h6** 80...♖h1 81.♖g7+ ♔h6 *(81...♔h8 82.♘g6#)* 82.♔g8 ♖f1 83.♖g6#. **81.♔g8** And Black resigned, as **81...a2** is met by **82.♖g6#**. Without the a3-pawn Black could draw with 81...♖g1!, as 82.♖xg1 would result in stalemate.

363: 36.♗d5! ♖xd5 37.e7 ♖e5 37...♖g5 38.♔g3 b3 39.cxb3 cxb3 40.♔h4 ♖e5 41.♖xg6+ hxg6 42.h7++−. **38.♖xg6+ 1−0, e.g. 38...hxg6** 38...fxg6? 39.exf8♕#. **39.h7+ ♔xh7 40.exf8♕+−.**

364: 64...♔f6! 0-1 And the b-pawn is unstoppable. 64...♗d8? 65.♗f7 b2 66.♗g6 ♗xh4 67.a5=.

365: Black had resigned due to **41.♖xh6+ ♔d7 42.e6+!** Of course not 42.a8♕?? ♖b3+ 43.♔d4 ♖d2#. **42...fxe6 43.a8♕ 1−0** as White's king can now escape via e5.

366: The following winning maneuver is important for the theory of rook endings: **60.♖b6+** 60.♔e8? ♖h8+ 61.♔f7 ♖h7+=; 60.♔c8?! ♖c2+ 61.♔b7 ♖b2+ 62.♔a6 ♖a2+ 63.♔b6 ♖b2+ 64.♔a5 ♖a2+ and White has to return to d8 and start over again. **60...♔c5 61.♖c6+!** 61.♖a6? ♖h8+ 62.♔c7 ♖h7+ 63.♔d8 ♖h8+ 64.♔e7 ♖a8 65.♔d7 ♔b5 66.♖a1 ♖b6=; 61.♔c7?? ♖h7+ 62.♔b8 ♔xb6 63.a8♘+ ♔c6−+. **61...♔b5** 61...♔xc6 62.a8♕+ ♔c5 63.♕c8+ ♔d4 64.♕g4+ ♔d5 65.♕f5+ ♔c6 66.♕d7+ ♔c5 67.♕c7+ and the rook is lost; 61...♔d5 62.♖a6 ♖h8+ 63.♔c7 ♖h7+ 64.♔b6+−. **62.♖b6+??** Did this really happen? I find it hard to believe. Correct was 62.♖c8 ♖h8+ 63.♔c7 ♖h7+ 64.♔b8 ♔b6 65.a8♕+− (of course not 65.a8♖?? ♖b7#). **62...♔c5??** 62...♔xb6−+. **63.♖a6 1-0** with Black's rook on h3 he could take on c6 to reach a real rook vs. queen ending. On the first or second rank the attacker wins the rook by a series of checks.

367: 51...♗c5+! 52.♗d4 52.♖d4+ ♗xd4+ 53.cxd4 a4−+. **52...♗d6 0−1**

368: 24.♗h5! g6 24...♘h7 25.♖f7+ ♔e8 26.♖fd7+ ♔f8 27.♖d8++−. **25.♗h4+! ♔e8 26.♗xg6+ ♘xg6 27.♖xe6+ ♔d7 28.♖d6+ ♔c8 29.♖xg6 ♘b6 30.♖f7 1−0**

369: 38...♗xc3+! 38...♗d4? 39.♘xb5 ♔xb5 40.♗b7 ♗g1 41.♗c8 ♗xh2 42.♗xe6 ♗xg3 43.♗xf5 ♗xf5† 44.♔e2 h2 45.♗e4=. **39.♔xc3 ♗f1!** Surprisingly trapping White's bishop. **40.b4 ♗g2 41.♔c4 cxb4 0−1**

370: 68.♖xg4+!! ♔xg4 **69.c7** 1–0, e.g. 69...♖c2 70.♘e3+ ♔f4 71.♘xc2 dxc2 **72.c8♕+−**.

371: 51.♖h8+!! 1–0, e.g. 51...♔xh8 52.g6 ♖xa7 53.♖c8#.

372: 1.e4 e5 2.♘f3 f6? 3.♘xe5 fxe5? 3...♕e7 is the main line. **4.♕h5+!** ♔e7 4...g6 5.♕xe5+ ♕e7 6.♕xh8 ♕xe4+ 7.♔d1+−. **5.♕xe5+ ♔f7 6.♗c4+ d5** 6...♔g6? 7.♕f5+ ♔h6 8.d4+ g5 9.h4+−. **7.♗xd5+ ♔g6**

Now White must find Greco's surprising solution **8.h4! h5** 8...h6 9.♗xb7 ♗d6 10.♕a5+−; 8...♘f6? 9.♕g5#; 8...♕f6? 9.♕e8+ ♔h6 10.d4+ g5 11.hxg5+ ♔g7 12.gxf6+ ♘xf6 13.♖h6#. **9.♗xb7 ♗d6** 9...♗xb7 10.♕f5+ ♔h6 11.d4+ g5 12.♗xg5++−. **10.♕a5! ♘c6 11.♗xc6 ♖b8 12.♘c3+−**

373: 1.d4 d5 2.c4 dxc4 3.e4 ♘f6 4.e5 ♘d5 5.♗xc4 ♘b6 6.♗d3 ♘c6 7.♘e2 ♗g4 8.f3 ♗e6 9.♘bc3 ♕d7 10.♘e4 ♗d5 11.♘c5 ♕c8 12.a3 e6 13.♕c2 ♗xc5 14.♕xc5 ♕d7 15.b4 a6 16.0–0? Correct was 16.♘c3!=. The game move is a terrible mistake due to **16...♘c4! 17.b5** 17.♗xc4 b6 18.♗xd5 bxc5−+. **17...axb5 18.♕xb5 ♘6xe5 19.♕xd7+ ♘xd7∓** And Black won later.

374: 1.e4 e5 2.♘f3 d6 3.♗c4 ♗g4 4.♘c3 h6? 5.♘xe5! ♗xd1? 5...dxe5 6.♕xg4±. **6.♗xf7+ ♔e7 7.♘d5#** Famous, but too pretty to leave it out.

375: 1.e4 e5 2.♘f3 ♘c6 3.♗c4 ♘d4?! 4.♘xe5? is refuted by **4...♕g5! 5.♗xf7+!** 5.♘xf7? ♕xg2 6.♖f1?! ♕xe4+ 7.♗e2?! ♘f3#; 5.♘g4? d5 6.♗e2 ♘xe2 7.♕xe2 ♗xg4 8.♕b5+ ♗d7 9.♕xb7 ♕xg2 10.♕xa8+ ♔e7 11.♖f1 ♗h3−+. **5...♔e7** And after **6.0-0**, White gets some compensation for the piece, but ultimately it should be insufficient.

376: 1.d4 d5 2.c4 e5 3.dxe5 d4 4.e3? is refuted by **4...♗b4+ 5.♗d2?** 5.♘d2 dxe3 6.fxe3 ♕h4+ 7.g3 ♕e4 8.♘gf3 ♘c6∓. **5...dxe3 6.♗xb4?** 6.♕a4+ ♘c6 7.♗xb4 exf2+ 8.♔xf2 ♕h4+∓. **6...exf2+ 7.♔e2 fxg1♘+!! 8.♔e1** 8.♖xg1? ♗g4+−+. **8...♕h4+ 9.♔d2 ♘c6−+**.

377: 1.d4 d5 2.c4 e6 3.♘c3 ♘f6 4.♗g5 ♘bd7 5.cxd5 exd5 6.♘xd5? is a terrible blunder due to **6...♘xd5 7.♗xd8 ♗b4+ 8.♕d2 ♗xd2+ 9.♔xd2 ♔xd8−+** as Black is a piece up.

378: 1.e4 c6 2.d4 d5 3.f3 dxe4 4.fxe4 e5 5.♘f3 exd4 6.♗c4 ♗b4+? 7.c3 dxc3? Black's greediness is punished by **8.♗xf7+! ♔xf7?** 8...♔e7 9.♕b3 cxb2+ 10.♕xb4+ ♔xf7 11.♗xb2 and White's attack is ferocious. **9.♕xd8 cxb2+ 10.♔e2 bxa1♕ 11.♘g5+ ♔g6 12.♕e8+ ♔h6** 12...♔f6 13.♖f1+ ♗f5 14.♖xf5#. **13.♘e6+ ♗d2 14.♗xd2+ g5 15.♗xg5#.**

379: 1.e4 c5 2.♘f3 d6 3.d4 cxd4 4.♘xd4 ♘f6 5.♘c3 a6 6.♗c4 e6 7.♗b3 ♘bd7 8.♗g5 b5 9.♗xe6 fxe6 10.♘xe6 ♕b6? 10...♕a5 was called for, e.g. 11.0–0 ♕f7 12.♗xf6 ♘xf6 13.♘g5+ ♔e8 14.♖e1 ♗e7 15.♘d5 ♕d8 and White had good compensation in K.Müller-V.Mirumian, Lippstadt 1999. **11.♘d5 ♘xd5 12.♕xd5 ♗b7??** Black must try 12...♘b8! 13.0–0–0!? *(13.♕xa8 ♗xe6 14.♗e3±)* 13...♕b7 *(13...♘c6? 14.e5 +−)* 14.♕xb7 ♗xb7 15.♘c7+±. **13.♘c7+** 13.♘xg7+ works as well: 13...♗xg7 14.♕e6+ ♔f8 15.♗e7+ ♔e8 16.♗f6+ ♔f8 17.♕e7+ ♔g8 18.♕xg7#. **13...♕xc7 14.♕e6+ ♗e7 15.♕xe7#.** A very similar finish occurred in a simul game by Nezhmetdinov (see page 78 of *Nezhmetdinov's Best Games*, by Rashid Nezhmetdinov, English edition by Caissa Editions 2000).

380: 1.e4 c5 2.♘f3 ♘c6 3.d4 cxd4 4.♘xd4 ♘f6 5.♘c3 e5 6.♘db5 d6 7.♗g5 a6 8.♘a3 b5 9.♗xf6 gxf6 10.♘d5 f5 11.c3 ♗g7 12.exf5 ♗xf5 13.♘c2 0–0 14.♘ce3 ♗e6 15.♗d3 f5 16.0–0 ♘e7? A well known theoretical mistake: **17.♘xe7+ ♕xe7 18.♗xf5!** 18.♘xf5 is also possible. **18...♗f7** 18...♗xf5 19.♘xf5 ♖xf5? 20.♕d5+ ♔h8 21.♕xa8++−. **19.♕d3 h6 20.♗e4 ♖ad8 21.♗d5+−** And White won later.

381: 1.e4 c6 2.d4 d5 3.♘c3 dxe4 4.♘xe4 ♘f6 5.♘g3 h5 6.♗g5?! h4 7.♗xf6? White falls into an old trap: **7...hxg3 8.♗e5 ♖xh2! 9.♖xh2 ♕a5+ 10.♔d2** 10.c3 ♕xe5+!! 11.dxe5 gxh2−+ as the h-pawn queens. **10...gxf2+ 11.♔e2 ♕xd2+ 0–1**

382: 1.e4 c5 2.♘f3 ♘c6 3.♗b5 e6 4.0–0 ♘ge7 5.♖e1 a6 6.♗xc6 ♘xc6 7.d4 cxd4 8.♘xd4 ♕c7 9.♘xc6 bxc6 10.e5 ♗b7 11.♘d2 c5 12.♘c4 ♗d5? White won with the beautiful **13.♘d6+! ♗xd6** 13...♔e7 14.♗g5+ f6 15.♕h5+−. **14.♕xd5!! 1–0, e.g. 14...exd5** 14...0–0 15.♕xd6+−. **15.exd6+ ♔d8 16.dxc7++−.**

383: 1.e4 c5 2.♘f3 ♘c6 3.d4 cxd4 4.♘xd4 ♘f6 5.♘c3 e5 6.♘f5 d5 7.exd5 ♗xf5 8.dxc6 bxc6 9.♕f3 ♕c8? 10.♗a6 ♕xa6 11.♕xf5 ♗d6? This is punished by **12.♗h6!! ♖g8** 12...0–0? 13.♗xg7 ♔xg7 14.♕g5+ ♔h8 15.♕xf6+ ♔g8 16.♕xd6+−; 12...gxh6? 13.♕xf6+−. **13.♗xg7 ♖xg7 14.♕xf6 ♖g6 15.♕h8+ ♗f8 16.0–0–0 ♖g7 17.♖he1 f6 18.f4 ♖b8 19.fxe5 f5 20.e6 ♕b6 21.b3 ♕b4 22.♔b2 ♗e7 23.a3 ♕c5 24.♖d7+ ♔f6 25.e7 1–0**

384: 1.e4 c5 2.d4 cxd4 3.c3 dxc3 4.♘xc3 ♘c6 5.♘f3 e6 6.♗c4 ♕c7 7.♕e2 ♘f6 8.0–0 ♘g4 9.h3?? ♘d4! and it is over as **10.♘xd4** is met by 10.♕d3 ♘xf3+ 11.gxf3 ♕h2#. **10...♕h2# −+.**

385: 36...♕xe5! 36...♖c1+? 37.♔h2 ♕xe5+ 38.♖g3+ ♕xg3+ 39.♕xg3+ ♔xf6 40.♕f4++−; 36...♖h8? 37.♖g3+ ♔f8 38.♕b4+ ♕e7 39.♕xb3±. **37.♖g3+** 37.♘xg8?? ♖c1+−+. **37...♕xg3! 38.♘h5+** 38.♕xg3+ ♔xf6 39.♕f2+ gives White some drawing chances. **38...♔h7 39.♘xg3?** 39.♘f6+ ♔g6 40.♕xg3+ ♔xf6 transposes to 38.♕xg3+. **39...b2 0–1**

386: No, **31.♖xh6+** is actually losing: **31...♕xh6!** 31...♔g8? 32.♖g6 ♖e1+ 33.♔f2 ♕xg6 34.fxg6 ♖ae8 35.♕d7 ♗xg6 36.dxc5 and White can continue to fight. **32.♘f7+ ♔h7 33.♘xh6 ♖g8! 0–1**

387: 17.♖xd6 ♖xd6 18.♗xe5 ♖d1? Fonaroff missed 18...♕a5! 19.♗c3 ♗xc3 20.bxc3 ♖g6 21.♘e7+ ♔h8 22.♘xg6+ hxg6 23.♕d6 ♔g8 24.♕b4 ♕xb4 25.cxb4 ♖d8 26.a3 ♖d2 27.♖c1 ♔f8 28.♔f1 ♖d4 29.f3 ♖d2 and Black's activity compensates for the missing pawn.; 18...♗xe5? 19.♕xe5+−. **19.♖xd1 ♗xe5 20.♘h6+ ♔h8 21.♕xe5!! ♕xe5 22.♘xf7+ 1–0**

388: Counterattack is the best defense here: **23.♘xd5!** 23.♔xf2? ♕xe3+ 24.♔f1 b4 ∓ (Dautov in ChessBase MEGABASE); 23.♕xf2? ♘d3 24.♕d2 ♘xc1 25.♕xc1 ♕c5! and Black is better. **23...♕e4?** 23...♕d7! was called for: 24.♕xc5 ♘d3 25.♕d4 ♕xd5= (Dautov). **24.♕xc5 ♘d3 25.♘d2!** 25.♘g5!? was very strong as well. **25...♕e6!** 25...♕e5 26.♘e7+! ♕xe7 27.♕xe7 ♖xe7 28.♖c3 +− (Dautov). **26.♘c7?** 26.♕xb5+− was the way to go. **26...♕h6?** 26...♕d7! gives Black better drawing chances, e.g. 27.♕d4 (27. ♕xb5 ♕xb5 28.♘xb5 ♘xc1 29.♗xb7 ♖xe3 ±) 27...♕xd4 28.exd4 ♘e2! 29.♗xb7 ♘xc1 30.♘e4 b4! ± (Dautov). **27.♕a7 ♘xc1 28.♘xe8 ♗xg2 29.♘c7! g5 30.♔xg2 ♕c6+ 31.e4 ♕c3 32.♕b8+ ♔g7 33.♘e8+ ♔g6 34.♕d6+ f6 35.♕d7 1–0**

389: 33...g4? 33...♖d5! 34.♕xh5 ♖f5 35.♕h6 ♕f1+ 36.♔h2 ♖xf6 37.♖xg5+ ♖g6 38.♖xg6+ fxg6 39.♕xg6+ with perpetual check. **34.♖xg4+ 1–0 34...hxg4 35.♕xg4+ ♔h7 36.♕g7#.**

390: 20...♗b7! 21.♖d8+!! 21.♕e1? 0–0 22.♔d2 ♗xf3 23.gxf3 ♗e3+ 24.♔e2 ♕xe5 25.♗d3 ♘d5 and Black's attack will sweep White away; 21.♕xb7?? ♗e3+ 22.♔b1 ♕a2#. **21...♔xd8** 21...♖xd8? 22.♕xb7 0–0 23.c3 ♘d3+ 24.♔c2 ♘f2 25.♕c6! ±. **22.♕xb7 ♕a1+ 23.♔d2 ♕xh1 24.♕b8+ ♔d7 25.♕b7+** 25.♕xh8? ♕xg2+ 26.♗e2 ♕g6 27.♘e1 ♕g5+ 28.♔d1 ♕xe5 ∓. **25...♔d8 26.♘g5 ♗e3+ 27.♔xe3 ♕c1+ 28.♔f3 ♕xg5 29.♕b8+ ♔d7 30.♕b7+ ♔e8 31.♕b8+ ♕d8 32.♕xb4 h5 33.♗xa6 f5?!** 33...♕d5+ 34.♕e4 ♕xe4+ 35.♔xe4 ♔d7=. **34.♗b5+?!** 34.♕b7!? ♔f8 35.b4 with initiative. **34...♔f7 35.♕d6 ♕g5 36.♗c4 ♕e7 37.b4?** 37.♕c6 ♖e8 38.c3 ♕h4 39.♕d7+ ♔f8 40.♗xe6 ♕e4+ 41.♔f2 ♕f4+ 42.♔g1 ♕c1+ 43.♔f2 ♕xb2+ 44.♔e3 ♕xc3+ 45.♔f4 ♕c1+ 46.♔f3=. **37...♕xd6 38.exd6 ♖d8**

39.b5 ♖xd6 40.♔e3 ♔e7 41.♗d3 g5 42.c4 f4+ 43.♔e2 e5? 43...♖d4 gives Black good winning chances. **44.♗e4?** 44.c5 ♖d4 45.b6 e4 46.♗a6 ♖b4 47.♔d2 ♖xb2+ 48.♔c3 ♖b1 49.♔c2 ♖b4 50.♔c3=. **44...♖d4 45.♗d5 e4 46.b6 e3 47.b4 ♖d2+ 48.♔e1 ♔d8 49.b5 g4 50.♗e4 ♖b2 51.♗d5 h4 52.h3 f3! 53.gxf3 g3 54.f4 g2 55.♗xg2 ♖xg2 56.c5 ♖b2 0–1**

391: 15...♔xe6? 15...♕g8! was called for: 16.♖e1 *(16.♗c4 b5! and I can't see a way for White to continue his attack strongly.)* 16...♗xh1 17.♕xh1 ♕xe6! and Black gets too much material for the queen, e.g. 18.♗c4 ♕xe1+ 19.♕xe1+ ♔d8 20.♕h1 ♗b8 21.h3 ♗f4 with good prospects for Black.. **16.♖e1+**

If 16.♗c4+?:
A) 16...♔d5? 17.♖e1+ ♗e5 *(17...♔f5 18.♗d3+ ♗e4 19.♖xe4 ♘xe4 20.♗xe4+ ♔e6 21.♕g4+ +−)* 18.f4 ♗xc4 19.bxc4± was played in a training game C.Michna-J.Hawellek.
B) 16...♔f5!

There is no way to exploit Black's airy king position.

16...♗e5 16...♘e5 17.f4 and White attack is very forceful.; 16...♔f5 17.h4 +− ; 16...♔f7 17.♗c4+ ♔f8 18.♕g6 ♘e5 19.♖xe5 ♕d7 20.♖f5 +− ; 16...♗e4 17.♖xe4+! ♗e5 *(17...♘xe4 18.♕g4+ ♔e7 19.♕xg7+ ♔e6 20.♕g4+ ♔e7 21.♕xe4+ +−)* 18.♗c4+ ♔f5 19.♖xe5+ ♘xe5 20.♗xe5 b5 *(20...♔xe5? 21.♕g3+ ♔f5 22.♖e1 +−)* 21.♗f7 +−. **17.f4 ♔f7** 17...♗xh1 18.fxe5 ♘d5 *(18...♘e8 19.♗c4+ ♔e7 20.♕g6 +−)* 19.♕g6+ ♔e7 20.♕xg7+ ♔e6 21.♗e2 ♖h4 22.♗g4+ ♖xg4 23.♕xg4+ ♔e7 24.♕g7+ ♔e6 25.♖xh1±. **18.fxe5 ♘xe5?!** 18...♗xh1 19.exf6 *(19.e6+!?)* 19...♘xf6 20.♕xh1 and White's mighty bishops will tear Black apart. **19.♖xe5 ♗xh1?!** 19...♖h4!?. **20.♗c4+ ♔f8** 20...♗d5 21.♖xd5 ♘xd5 22.♕xg7+ ♔e6 23.♕e5++−. **21.♗a3+** And Black resigned in view of **21...c5 22.♗xc5+ bxc5 23.♕xc5+ ♕e7 24.♕xe7#.**

392: 23...♖xc3? 23...♗xg5! 24.♖h3+ ♗h4 25.♕h6+ ♔g8 26.♖xh4 ♕xh4 27.♕xh4 ♘f6 28.f3 is only slightly better for White. **24.bxc3 ♗xg5 25.♖h3+ ♗h4 26.♕h6+** 26.g3? ♕f6 27.♖xh4+ ♕xh4 28.gxh4 ♖g8 −+ ; 26.c4!? ♕f6 *(26...♗xc4? 27.♖e4 +−; 26...♘xc4? 27.♕h6+ ♔g8 28.♖xh4 ♔f7 29.♕h5+ ♔f6 30.♕h7 +−)*

27.Qg3 Rf7 *(27...Qxf2+ 28.Kxf2 Rxf2 29.Rxh4+ Kg7 30.cxd5 Rxa2 31.dxe6 Nf6 32.e7 +−)* 28.Rxh4+ Rh7 29.Rxh7+ Kxh7 30.cxd5 exd5 31.Qh3+±. **26...Qg8 27.Qg6+ Kh8 28.Ree3? Qe7! 29.Reg3** 29.Qg4 Nf6 30.Rxh4+ Nh7 31.Rxh7+ Qxh7 32.Rh3±. **29...Nf6 30.Rxh4+ Nh7 31.Rhg4?!** 31.Rg5 Bxa2 32.Rxh7+ Qxh7 33.Rh5 is slightly better for White. **31...e5! 32.dxe5 Qxe5?** 32...Be6! 33.Qg7+ Qxg7 34.Rxg7 Bd5 is slightly better for Black. **33.Qxh7+!! 1−0**

393: 1.Qf6?! Qxc3?? Kurt Richter discovered the fantastic defense 1...Qc1!! 2.Qxe5 Qxh6 3.Qf6 Qf8 4.Re7 Rf5 5.Qd6 b5 6.Qd7 Rd5 7.Qxa7=. **2.Qg7+ Bxg7 3.Rc8+ Bf8 4.Rxf8#.** For more details see *Magic of Chess Tactics* p.113–129.

394: 17...Bd7? 17...dxc4?? 18.Rxd8+ Bxd8 19.Qe8+ Rf8 20.Qxf8#; 17...Kh8! 18.Bxd5 *(18.Rxd5 is also met by 18...Rd7 ∓)* 18...Rd7 19.Qe4 Na6 20.Rhe1 Nc7∓. **18.Bxd5 Qc7?! 19.Bd6! Qb6 20.Bxf7+ Kxf7 21.Be5! Qe6** 21...Kg8 22.Qc3±. **22.Bxf6 Qxe1?** 22...Kxf6 23.Qe4 Bc6 24.Qxh7 Nd7 was much more tenacious. **23.Rhxe1 gxf6 24.Rd5 h6 25.Red1 Bc6 26.Rd8** A deadly pin. **26...Bxf3 27.Re1 Bc6 28.Red1 Ke7 29.Rh8 Bd7 30.h3 a5 31.Rxh6 a4 32.Rh8 b5 33.a3 Ke6 34.h4 Ke7 35.h5 Bxg4 36.h6 Bxd1 37.h7 1−0**

395: 23...Ra1? 23...Ra8 comes into consideration as well, as 24.exf7+ Kh8 25.Qc7 Na6 26.Qxb7 Nb4 is unclear.; 23...f5! equalizes easily: 24.e7 Qxe7 25.Qxb8+ Kf7 26.Bf3 Ra1=; 23...h5? 24.Rd8 Rxd8 25.Qxf7+ Kh7 26.e7+−. **24.exf7+ Kh8 25.Rxa1 Bxa1 26.Bc8 Na6 27.Bxb7 Nb4** 27...Nc5 28.Bxc6±. **28.c5! Nd5 29.Qa4 Bc3 30.Bxc6 Nc7? 31.Qf4 1−0, e.g. 31...Ne6 32.Qc4 Nd4 33.Qxc3+−.**

396: After the forced **37.Bc8!**, Black must defend with **37...Nxc3+!** In the game Black chose 37...Ng2? and lost after 38.Rxb7+ Qxb7 39.Bxb7 Nxc3 40.bxc3 Nxe1 41.Bxd5 g5 42.Kc1 1−0. **38.bxc3 Qb5+ 39.Kc1 Qe8 40.Rxb7+ Kg8 41.Rb4** 41.Be6+ Qxe6 42.Rb8+=; 41.Rb8=. **41...Qxc8 42.Rxe3 Kf7 43.Rd4 Qc5** and Black should be able to hold the position.

397: 25...Qg6!! 0−1

398: 24...Nd3+!! 24...Qxd6? 25.Bxc5+−. **25.cxd3** 25.Kd2 Qxd6−+. **25...Qf1+ 26.Kc2 Rxh2+ 27.Bd2 Rxd2+ 28.Kxd2 Qf4+ 0−1**

399: 32.f3?! exf3? 32...Bf4! defends. **33.Qh8+ Ke7 34.Re1+ Qe6 35.Qh4+ f6 36.Qh7+ Kd6 37.c5+ Kxc5 38.Qxc7+ Kxb5 39.Rxe6 d3 40.Qc6+ Kb4 41.Re4+ Kb3 42.Qc3+ Ka2 43.Qa3+ 1−0**

400: 35.Na6 Qc8? 35...Qd8! 36.Qe5 f6 37.Qxf6 Qxf6 38.Bxf6 Bb5 39.Nc7 Bc5+ 40.Kh1 Kf7 gives Black good drawing chances. **36.Qe5 f6 37.Qxf6 h5 38.Nc7 1−0** 38...Qxc7 39.Qh8+ Kf7 40.Qh7++−.

401: 54...♕g7? 54...♕b2+ 55.♔h3 ♖e3 56.c7 ♖xg3+ 57.hxg3 ♕c1=. **55.c7 ♕b2+ 56.♔h3 1–0**

402: 23...♗e7! 23...♖xf4? 24.♕d8+! ♗f8 25.♕xf8+!! ♖xf8 26.♖xf8+ ♔h7 27.♖f7+ ♔h8 28.♖f8+= (Bacrot in CBM 86); 23...♗e5? 24.♗xe5 ♕xh4 25.♗xf6+ +–. **24.♖gf3 ♖g6 25.♕f2 ♗e6 26.♖e3 ♕d5 27.♖e5 ♕d7 28.♕e3 ♗d5 29.♗g3** 29.♖xe7 ♗xg2+ 30.♔g1 ♗e4+ –+ (Gershon in CBM 86). **29...♗d6 30.c4 ♗xg2+** 30...♗xc4 –+. **31.♔xg2 ♗xe5 32.♕xe5+ ♕g7 33.♔h1?! ♕xe5 34.♗xe5+ ♔g8 35.♖d1 ♖e8 36.♗g3 ♖ge6 37.♖d7 ♖8e7 38.♖d8+ ♖e8 39.♖d7 ♖8e7 40.♖d8+ ♔g7 41.♗f2 ♖e2 42.♗d4+ ♔g6 0–1**

403: 24...♖xa2? 24...♖c7! stops White's attack: 25.♗d3 ♔c8 26.♕xe6+ ♔b8 and Black's king has escaped into safety.; 24...♗d5? 25.♕xf6!!+– as 25...♗xf6? runs into 26.♖d7+ ♔e8 27.♗g6+ ♔f8 28.♖f7+ ♔e8 (28...♔g8 29.♗h7+ ♔h8 30.♘g6#) 29.♖h7+ ♔f8 (29...♔d8 30.♖d7#) 30.♘d7+ ♔g8 31.♘xf6+ ♔f8 32.♖f7#. **25.♖d1!** Of course not 25.♖xa2?? ♕c1+ 26.♔h2 ♕xf4+ –+. **25...♕d6?!** 25...♖c7 was called for, although it comes one move too late and now only draws: 26.♗g6 ♗c6 27.♕xe6 ♗d5 28.♘f7+ ♔e8 29.♘xh6+ ♔d8 with perpetual check (Korchnoi in CBM 83).; 25...♖ca8?! 26.♗b1 ♖a1 (26...♖2a6 27.♗g6 ♗d5 28.♘xe7 ♘xe7 29.f5) 27.♗g6 ♗d5 28.♕xe6 ♖8a6 29.♕g8+ ♔d7 30.♕b8 and in both cases White has a dangerous attack. **26.♘g6 ♖xb2?** 26...♖ca8! 27.♘xe7 ♘e8 28.♘g6 ♖a1 29.♖xa1 ♖xa1+ 30.♔h2 ♘xg7 31.♕xb7 (Lutz in CBM 83) 31...♘h5 32.♘e5 ♕c7=. **27.♘xe7 +– ♖xg2+ 28.♖xg2 ♗xg2 29.♕xf6 ♕xe7 30.♕xe7+ ♔xe7 31.♔xg2 ♗c4 32.♗d3 ♖c5 33.♔f3 ♖h5 34.♗f1 ♖d5 35.♔e4 ♔f6 36.♖b1 d3 37.♗xd3 ♖h5 38.♗f1 e5 39.♖xb5 ♖h4 40.♖b6+ 1–0**

404: 34.♖d1? 34.♖xe6!! A) 34...♖dxe6 35.♗xe6+ ♔f8 (35...♔h8 36.♘e5=) 36.♗c4 ♕h6 37.♕b4+ ♖e7 38.♗xd3=; B) 34...♖exe6 35.♗xe6+ ♔f8 36.♕b4 ♔e7 37.♕xb7+ ♗d7 38.♗xd7 ♖xd7 39.♕b4+= (Huzman in CBM 93). **34...d2! 35.♕b4** 35.♕xb7 is met by 35...♕c2 ∓. **35...♖ed8 36.♘g5 ♕c2 37.♗b3** 37.♕b3 ♕xb3 38.♗xb3 ♖b6 (38...♖c8!?) 39.♗xe6+ (39.♘xe6 ♖dd6 ∓) 39...♖xe6 40.♘xe6 ♖e8 ∓. **37...♕c6 38.g3 ♕b6! 39.♘xe6 ♕xb4 40.axb4 ♖c8 41.♔f1 ♔h8 42.♘g5 ♖d4 43.♘f7+ ♔h7 44.♘g5+ ♔h6 45.♘f7+ ♔g6 46.♘e5+ ♔h7 47.♘f3 ♖xb4 –+** And Black won later.

405: 30.♖d1? The only move to get an advantage is 30.♕g4! ♕e5 31.f4 ♕xb2 32.♖c8+ ♗xc8 33.♕xc8+ ♔g7 34.♕xb8 ♕xa3 35.♕e5+±; 30.♔g1? ♕d6 31.♕g5 ♕h2+ 32.♔f1 ♗a6+ 33.♔e1 ♕g1+ 34.♔d2 ♕xf2+ 35.♔c3 f6 36.♕d2 ♗e5+ and Black's bishops are at least as strong as White's ♖+♘.; 30.♖e1? ♗f3 31.♕b5 ♔g7 and Black is not worse. **30...♗f3 31.♕b5** 31.♖d8+? ♔g7 –+. **31...♗xd1 32.♕e8+ ♔g7 33.♕xb8 ♕xf2 34.♕e5+ ♕f6 35.♕g3+ ♔f8 36.♕b8+ ♔g7 37.♕g3+ ♔h6 38.♕e3+ ♕g5 39.♘f4 f6 40.♔h2 ♕e5 41.♕d2 ♗a4 42.♔g1 ♕c5+ 43.♔h1 ♕c2 44.♕e3 ♗c6+ 45.♘d5+ ♔g6 46.♕g3+ ♔f7 0–1**

Hints

Test 1
406: Difficulty: 1
407: Difficulty: 2
408: Difficulty: 2
409: Difficulty: 2
410: Difficulty: 3 Hint: Prepare a discovered check by the rook.
411: Difficulty: 3 Hint: White's knight is very strong!
412: Difficulty: 2
413: Difficulty: 2
414: Difficulty: 5 Hint: Attack and reach a favorable ending!
415: Difficulty: 5 Hint: The pawn on f6 has a very promising future!
416: Difficulty: 3 Hint: White "simplified" into a favorable endgame ♖ vs. ♗+♘. How?
417: Difficulty: 3 Hint: Sacrifice the rook and calculate to the end!
418: Difficulty: 2
419: Difficulty: 1
420: Difficulty: 4 Hint: You don't have to move the queen...
421: Difficulty: 2

Test 2
422: Difficulty: 1
423: Difficulty: 1
424: Difficulty: 2
425: Difficulty: 1
426: Difficulty: 4 Hint: Reverse Tal's old recipe: centralize and sacrifice!
427: Difficulty: 3 Hint: Pin and win!
428: Difficulty: 3 Hint: Centralize and sacrifice!
429: Difficulty: 2
430: Difficulty: 1
431: Difficulty: 2
432: Difficulty: 3 Hint: e7 is not very well protected by Black...
433: Difficulty: 4 Hint: The bishop-pair is very strong. Trust in it and attack to force a draw!
434: Difficulty: 4 Hint: Black would be positionally better, so you should strike immediately.
435: Difficulty: 4 Hint: Retreats are always difficult to find...
436: Difficulty: 4 Hint: Remove everything in your way!
437: Difficulty: 3 Hint: Sacrifice the queen!

Test 3
438: Difficulty: 2
439: Difficulty: 1
440: Difficulty:1

441: Difficulty:2

442: Difficulty: 2

443: Difficulty: 4 Hint: The h-file and seventh rank attract the heavy pieces.

444: Difficulty: 1

445: Difficulty: 2

446: Difficulty: 2

447: Difficulty: 1

448: Difficulty: 2

449: Difficulty: 3 Hint: Strike immediately using your knights!

450: Difficulty: 5 Hint: Bring your rooks to the g-file and calculate to the end!

451: Difficulty: 5 Hint: Open ways for your attack very quickly! Sometimes the knights are sacrificed to open gates for the long range pieces.

452: Difficulty: 5 Hint: White's back rank is very weak. Keep an eye on b1!

453: Difficulty: 4 Hint: Attack the king violently! Open lines!

Test 4

454: Difficulty: 2

455: Difficulty: 1

456: Difficulty: 3 Hint: Use a decoy!

457: Difficulty: 2

458: Difficulty: 2

459: Difficulty: 3 Hint: 1.♖b7 is forced, isn't it?

460: Difficulty: 2

461: Difficulty:1

462: Difficulty: 3 Hint: Knight and bishop can give mate!

463: Difficulty: 3 Hint: Pawns can be promoted to knights as well!

464: Difficulty: 2

465: Difficulty: 4 Hint: Black has a lot of pressure on the dark squares. Use and increase it by violent means!

466: Difficulty: 5 Hint: Attack Black's king violently. But Black has more defensive resources than you may think at first sight. You should nevertheless reach a solid advantage.

467: Difficulty: 4 Hint: Grischuk found a very powerful blow based on the b-file and the diagonals h2-b8 and h3-c8.

468: Difficulty: 4 Hint: White's king emigrates in the main line of the solution.

469: Difficulty: 1

Test 5

470: Difficulty: 1

471: Difficulty: 3 Hint: Move the ♗d2 to the most effective square!

472: Difficulty: 3 Hint: Pin and win!

473: Difficulty: 4 Hint: Play for mate and do it the right way around!

474: Difficulty: 2

475: Difficulty: 2

476: Difficulty: 2

477: Difficulty: 3 Hint: A king in the middle often spells trouble, when all the heavy pieces are still on the board. Attack it violently!

478: Difficulty: 2

479: Difficulty: 2

480: Difficulty: 2

481: Difficulty: 3 Hint: Use your bishops in the right way!

482: Difficulty: 5 Hint: In the solution you must take on f2 and g2. You will finally uses the weakened light squares around White's king.

483: Difficulty: 4 Hint: Opposite-colored bishops tend to favor the attacker and the queen is sometimes stronger than two rooks.

484: Difficulty: 3 Hint: f7 is quite often the Achilles heel.

485: Difficulty: 1

Test 6

486: Difficulty: 1

487: Difficulty: 2

488: Difficulty: 3 Hint: The e-file is overcrowded. Use it to strike!

489: Difficulty: 2

490: Difficulty: 3 Hint: Use all your forces to attack! Rooks can operate on ranks.

491: Difficulty: 5 Hint: Destroy the pawn shield of White's king!

492: Difficulty: 1

493: Difficulty: 3 Hint: The knight is like a fish in the water. Calculate to the end!

494: Difficulty: 2

495: Difficulty: 2

496: Difficulty: 2

497: Difficulty: 2

498: Difficulty: 1

499: Difficulty: 4 Hint: The knight and the queen play important roles, but a rook mates at the end of the main line!

500: Difficulty: 4 Hint: Throw the kitchen sink at Black. In the end of the main line the two bishops give mate assisted by the pawn at f6.

501: Difficulty: 5 Hint: White has to start a powerful attack immediately and must try to use his full army doing it.

Test 7

502: Difficulty: 1

503: Difficulty: 2

504: Difficulty: 4 Hint: Create threats with every move! Development is good, but winning a piece is better.

505: Difficulty: 2

506: Difficulty: 2

507: Difficulty: 2

508: Difficulty: 2

509: Difficulty: 3 Hint: Use the x-ray attack of the ♖e1! The bishop makes the final strike.

510: Difficulty: 5 Hint: Use sacrifices to open lines!

511: Difficulty: 3 Hint: Black's king is a bit lonely. Attack it mercilessly!

512: Difficulty: 3 Hint: Sacrifice, and calculate deeply!

513: Difficulty: 3 Hint: The square d5 is Black's pride and joy.

514: Difficulty: 3 Hint: Try to get the maximum out of the position by opening lines!

515: Difficulty: 3 Hint: Your heavy pieces need open lines!

516: Difficulty: 1

517: Difficulty: 2

Test 8

518: Difficulty: 1

519: Difficulty: 2

520: Difficulty: 3 Hint: A double attack decides.

521: Difficulty: 3 Hint: ♘g5 is not the only try to land on h7.

522: Difficulty: 3 Hint: White reaches a favorable endgame in the main line. Find Black's best defense as well.

523: Difficulty: 2

524: Difficulty: 3 Hint: The bishop h3 is pinned, isn't it?

525: Difficulty: 5 Hint: Black's back rank is weak.

526: Difficulty: 3 Hint: Use the knight to open the door!

527: Difficulty: 3 Hint: Black's queen has to protect the ♖b7.

528: Difficulty: 3 Hint: Your Horwitz bishops look menacing. Fuel your attack!

529: Difficulty: 3 Hint: Where is Black's weakest point?

530: Difficulty: 2

531: Difficulty: 1

532: Difficulty: 2

533: Difficulty: 3 Hint: Invite everyone to the party!

Test 9

534: Difficulty: 1

535: Difficulty: 2

536: Difficulty: 4 Hint: Attack first g7 and then h7, or the other way round?

537: Difficulty: 4 Hint: To make it easier to find the amazing defensive shot I give you the motif: decoy.

538: Difficulty: 2

539: Difficulty: 3 Hint: The queen loves to attack and hunt the king.

540: Difficulty: 3 Hint: According to Nimzowitsch the isolani has to be blockaded to hinder its advance.

541: Difficulty: 3 Hint: White's back rank is rather weak.

542: Difficulty: 5 Hint: The a-pawn will become the hero!

543: Difficulty: 3 Hint: Watch out for double attacks!

544: Difficulty: 3 Hint: Knights like to fork!

545: Difficulty: 3 Hint: Centralize and sacrifice! White is already centralized.

546: Difficulty: 1

547: Difficulty: 2
548: Difficulty: 2
549: Difficulty: 1

Test 10
550: Difficulty: 1
551: Difficulty: 2
552: Difficulty: 3 Hint: Search for a very good endgame and beware of possible moves by the ♖g6!
553: Difficulty: 3 Hint: Knights like to fork.
554: Difficulty: 1
555: Difficulty: 4 Hint: The house of White's king is not very stable. Blow it away!
556: Difficulty: 3 Hint: Both queens are on the same diagonal.
557: Difficulty: 3 Hint: Chase White's queen.
558: Difficulty: 2
559: Difficulty: 3 Hint: Black's king is in danger as well. Sacrifice the queen!
560: Difficulty: 2
561: Difficulty: 1
562: Difficulty: 1
563: Difficulty: 4 Hint: You can't take on d6 twice due to ♖c1+. Just prepare it!
564: Difficulty: 4 Hint: Combine the option ♗xg7+ with your dangerous b-pawn!
565: Difficulty: 5 Hint: The ♘f2 must attack!

Solutions to the Tests

Test 1

406: 21...♘xe3! 22.♖e1 22.♘xe3 ♗xd4 23.♗xd4 ♕xd4 24.♖e1 ♘e5–+. **22...♘xf5! 23.♖xe8+ ♘f8 24.♔h1 ♘xd4–+** And Black won later. One point for calculating up to ♘xf5!.

407: 26.♕xa7 ♕xa7 27.♖xa7 ♖xg3 28.♖a8+ ♔g7 29.d7 ♘f4 30.♖g8+ 1-0 Two points for calculating up to 29.d7.

408: 31...♕xd2! 32.♕xd2 ♖xc4 33.f3 ♖c1+ 0-1 Two points for spotting ♕xd2!.

409: 33...♘ed2+ 34.♔c1 ♘b3+! And Black threw in the towel, e.g. **35.cxb3** 35.♔b1 ♘cd2+ 36.♔a2 ♕a5#. **35...♘e3+–+** Two points for spotting the point ♘b3!.

410: 29.♕e6! 29.♕xd6?! ♖f6 30.♕d5 ♗f7 31.♕d7 ♖h6 (Golod in CBM 91) is also better for White, but far less clear. **29...♕xh7+** 29...♕xd4?? 30.♗e4+ ♔g7 31.♖h7#; 29...♗f7? 30.♕xd6+–. **30.♖xh7+ ♔xh7 31.♕xd6 ♖f7 32.d5 ♘a5 33.♕e6! ♖f8 34.♕e7+ ♔g8 35.♕xg5+ ♔h7 36.♕e7+ ♔g8 37.d6 ♘c6 38.♕b7 ♗g6+ 39.♔a2 ♘e5 40.♕e7 ♖e8 41.♕f6 ♗f7 42.b3 b5 43.cxb5 axb5 44.♕xf4 ♖e6 45.♕g5+ ♔f8 46.f4 ♘d7 47.♕xb5 ♖xd6 48.♕b4 ♔e7 49.f5 ♘e5 50.g5 ♘d3 51.♕c3 1-0** Three points for calculating up to 31.♕xd6+–.

411: 26.♕xb4+! ♕xb4 27.♘c6+ ♔f8 28.♖d8+ ♘e8 29.♘xb4 ♗e2 29...♔e7 30.♘c6+ ♔f6 31.b4+– (Lutz in CBM 83); 29...♗c4 30.♖c8 ♗d5 31.♘xd5 exd5 32.a5+– (Lutz). **30.f3 h5 31.b3!** Kramnik is fighting against the bishop by restricting its mobility. **31...♖h6 32.♔f2 ♖g6 33.♔xe2 ♖xg2+ 34.♔d3 ♖g3 35.a5 ♖xf3+ 36.♔c4 1-0** Three points for seeing that 26.♕xb4+ wins.

412: 32...♘d3+ 33.♖xd3 ♖f2 33...♕a1+ 34.♔c2 ♖f2+ 35.♖d2 ♖xd2+ 36.♔xd2 ♕xh1 works as well. **34.♘c2** 34.♖d2 ♕a1+ 35.♔c2 ♖xd2+ 36.♔xd2 ♕xh1–+. **34...♗h6+ 0-1** Two points for ♘d3+.

413: 21.♕xf4! One point for 21.♖h2 or 21.♖h4. **21...♗g7 22.♖xh8+ ♗xh8 23.♕h2 ♗g7** 23...♕g7? 24.♕xd6 ♖b7 (24...f5 25.♗f7+ +–) 25.♗f7+ ♖xf7 26.♕d8#. **24.♕h7 ♕e7 25.♗f7+ ♔d8 26.♕xg7 ♗e6 27.♖h1 ♗xf7 28.♖h7 ♕xe4 29.♕f8+ ♔c7 30.♕xf7+ ♔c6 31.♕c7+ ♔d5 32.♖e7 ♕d4 33.♖e1 ♕d2 34.♖h1 ♖h8 35.♕h7 1-0** Two points for 21.♕xf4.

414: 18...♗h6+! 19.♔e1 19.♕xh6 ♕xc3+ 20.♔e2 ♕xc4+ 21.♔f3 ♔e6–+ (Stohl in CBM 82); 19.♔e2 ♘xc3+ 20.♔e1 (20.♔f1 ♕b4 with attack) 20...♗d2+ 21.♔xd2 (21.♖xd2? ♕c1+ +–) 21...♘xe4+ 22.♔e2 ♕xh3 23.gxh3 ♗xe6∓. **19...♕xc3+ 20.♕xc3 ♘xc3 21.♖d3** 21.♘c7 ♘xd1 22.♔xd1 ♖c8∓. **21...♖c8!** The point!

22.♖xc3 ♗xe6 23.♗xe6 ♖xc3 24.♗b3 ♖e3+ 25.♔f2 ♖xe4 26.♗d5 ♖f4+!
27.♔g3?! 27.♔e2!? was more tenacious. 27...♖b4 28.♗g8 ♗f4+ 29.♔f3 ♗e5
30.♗xh7 a5 31.♗g8 a4 32.♖e1 b5 0-1 One point for refuting 19.♕xh6, one for
refuting 19.♔e2 and three more for calculating up to 21...♖c8!.

415: 20.♖xb4! ♗xe4 20...♘c6 21.♖c4 h6 22.♘xf7! ♖xf7 23.♗h5 g6 24.♗xg6 +−
(Tyomkin in CBM 86); 20...♗xb4 21.fxg7 ♖g8 22.♘f6++−. **21.♘xe4 ♗xb4**
21...g6 22.♖c4 ♘c6 (22...♕a5 23.♖c8+ ♗d8 24.♖fc1 +−) 23.♖b1 ♕a7 24.♕xa7
♘xa7 25.♖b8+ ♗d8 26.♖b7 +− (Tyomkin). **22.fxg7 ♖g8?!** 22...♗c3! 23.gxh8♕+
♗xh8 24.♕h6±. **23.♘f6+ ♔d8 24.♘xg8 ♗c5 25.♘f6! ♗xe3+ 26.♔h1 ♔c8
27.♘xd7 1-0** Two points for ♖xb4! two more for calculating up to 25.♘f6! and
the last for spotting Black's best defense 22...♗c3!.

**416: 32.♗xc5 bxc5 33.♗xh7!! ♕xh7 34.♘g6+ ♗xg6 35.♖xf8+ ♔g7
36.♕xh7+ ♗xh7** 36...♔xh7 37.♖c8 ♘a6 38.♖c6±. **37.♖c8 ♘a6 38.♖c6 ♗d3
39.♖xe6 ♔f7** And now **40.♖c6!±** would have been even better than the game
continuation 40.♖d6?!. Three points for calculating up to 37.♖c8.

417: 35.♖h8+! Two points for 35.♗g6. **35...♗xh8** 35...♔g7? 36.♕h6#. **36.♕h7+
♔f8 37.♗c5+ ♖e7 38.♕xh8+ ♔g8 39.♗xe7+** 39.♕h4 +−; 39.♕e5 +−.
39...♔xe7 40.♕e5+! 1-0 Two points for ♖h8+ and one more, if you saw that
Black is lost after 38.♕xh8+.

418: 29.♕f3 ♖c7?! 29...♖xd7 30.♖xd7 ♕e8 31.♖f1 ♕xd7 32.♕xe4 +−. **30.♗f8
♗e5 31.♗h6 ♗xh2+ 32.♔h1! 1-0** One point for ♕f3 and one extra if you saw
up to ♔h1!.

419: 25...♘xc3+! 26.♗xc3 26.♕xc3 ♖dc7 −+. **26...♖dc7 27.♖gg1 ♖xc4 28.♖c1
♕a6 29.♔f2 ♕c6 30.♗d2 ♗xh4+ 31.♔g2 ♗g5 32.♗xg5 hxg5 33.♖cd1
♖d4 0-1** One point for ♘xc3+.

420: 31...♗g5!! 31...♘h3+? 32.gxh3 ♖xf1+ 33.♕xf1 ♖xf1+ 34.♔xf1 +−
(Kasimdzhanov in CBM 92). **32.♕d2** 32.♖xc7 ♘e2+ 33.♕xe2 ♖xf1+ 34.♕xf1
♗xe3+ 35.♕f2 ♗xf2+ 36.♔h1 ♗xb6 −+. **32...♕e7!** 32...♗xb6? 33.♗xb6 ♘h3+
34.gxh3 ♗xd2 35.♖xf7 ♖xf7 36.♖c2 is not convincing. **33.♖fe1** 33.♘c4 ♕f6
34.♔h1 ♕g6 35.♕c2 h4 −+. **33...♕f6 34.♖c8?** 34.♔h1 ♕g6 35.♖c4 h4 −+
(Kasimdzhanov). **34...♘e2+ 0-1** Three points for ♗g5!! and one more for
32...♕e7!.

421: 28.♖xf7! ♖xf7? 28...♔xf7 29.♕d7+ ♕e7 30.♕xc8 +−. **29.♕xe6 ♘d6
30.♕xg6+ 1-0** Two points for seeing that ♖xf7 wins.

Test 2

422: One point for **1.♕d2! +−.**

423: 24.♖g3! ♗xd5 24...g6 25.♖xg6+ hxg6 26.♕xg6+ ♕g7 27.♕xg7#. **25.♕xd5 ♖a1+** 25...♕xd5 26.♖xg7#. **26.♔b2 1-0** One point for **1.♖g3! +−.**

424: 27.♗xe6!! ♖f8 27...♖xe6? 28.♕xb8 +−. **28.♗b3 ♖be8 29.♘d4 ♕a5 30.♖e3 1-0** Two points for ♗xe6!!.

425: 38.♕d7! "Black is lost due to the break in the coordination of his defenses." (Ftacnik in CBM 84). **38...♕xc1 39.♕xc8+ ♔g7 40.♗d4+ f6** 40...♔h6? 41.♕h3#. **41.♕d7+ ♔f8** 41...♔h6 42.♗xf6 ♕e3+ 43.♔g2 ♕e4+ 44.♔h3 ♕f5+ 45.♕xf5 gxf5 46.♗b5 +−. (Ftacnik). **42.♕d6+ ♔e8 43.♕e6+ ♘e7 44.♗xa7 1-0** One point for ♕d7!.

426: 22.♖xe6!! Sacrifice! **22...fxe6 23.♗e7+ ♔xe7** 23...♔f7 24.♕g6+ ♔xe7 25.♕xg7+ transposes. **24.♕xg7+ ♔d6 25.♘xd4** And centralize! **25...♕c5 26.♗f5** 26.♘b5+ ♔c6 27.♗e2 +− was even easier. **26...♕e5 27.♘f3+ ♕d5 28.♕g3+ ♔e7 29.♖xd5 ♗xd5 30.♕g5+ ♔d6 31.♕f4+ ♔e7 32.♗e4 ♖h5 33.♘h4 ♖g8 34.♘g6+ ♔d8 35.♕f7 ♖e8 36.♗d3 1-0** Two points for ♖xe6!! and two for ♘xd4.

427: 30...♖xf2! 31.♖xf2 ♘f4 32.♕g3 ♗xf2+ 33.♔xf2 ♘xd3+ 34.♔f1 ♘xb2 −+ And Black won later. One point for ♖xf2, two more for spotting ♘f4.

428: 19...♖xe3+!! 20.fxe3 ♕xe3+ 21.♔d1 21.♗e2 ♕xc1+ −+. **21...♗e6! 22.♕b2 ♖d8+ 23.♘d5+ ♔g8 0-1** Two points for ♖xe3+!! and one more for spotting 21...♗e6!.

429: 26.♘xb6!! ♗xb6 27.♗d6 ♘d5 27...♕e8 28.♗xf8 ♕xf8 29.♖c8 ♘e8 30.♕c6 ♖c7 31.♖xe8 +−. **28.♗xe7 ♘xc3 29.♗xf8 1-0** Two points for ♘b6!!.

430: 22.♗xh6! ♘c7 22...♖xh6 23.♘g5+ ♔g8 24.♘f7 ♖xe6 25.♘xd8 +−. **23.♘g5+ ♔g8 24.♘f7 ♕e8 25.♕g5+ ♔h7 26.♕h4 ♘xe6 27.♖xe6 ♖xf7 28.♖fe1 ♖b7 29.♗f8+ ♔g8 30.♖g6+ ♗g7 31.♗xg7 ♖xg7 32.♖h6 1-0** One point for ♗xh6 +−.

431: 36.♖xf6! ♖xf6 36...♘f4+ 37.♔g1 ♖xf6 *(37...♕g5 38.♖xf8+ ♖xf8 39.♕b2 +−)* 38.♕b8+ ♕f8 39.♗xe5 +−. **37.♕b8+! ♖xb8 38.♖xb8+ ♔g7 39.♖g8#** Two points for calculating up to ♖g8#.

432: 18.♘f5! ♘xe5 19.♗xb6! ♕xb6 20.♘xe7+ ♔h8 21.♘ed5 ♗xd5 21...♕xb2 22.e7 ♘g7 23.exf8♕+ ♖xf8 24.♖ab1 +−. **22.♘xd5 ♕xb2 23.e7 ♘g7**

24.♕h4 ♖c8 25.♘f6 h5 26.exf8♕+ ♖xf8 27.♕g5 ♘g4 28.♘d7 ♖c8 29.h3 ♕b7 30.♖xf7 1-0 Three points for calculating up to 21.♘ed5.

433: 31...♖xd4!! 32.exd4 ♗xd4+ 33.♔g3 ♗c3 34.♖xe8+ 34.♕f2? g5 −+. **34...♕xe8 35.♖d1! g5!!** 35...♗e5 36.h4 h6 37.h5 ♕e7 38.♕e4 is not so clear. **36.♘h5?** 36.♘d5! ♗e1+ 37.♖xe1 ♕xe1+ 38.♔g4 ♗b7 39.♕e4 and White retains drawing chances. **36...♗e1+ 37.♔h3?** 37.♖xe1 ♕xe1+ 38.♕f2 was called for. **37...♕e6+ 0-1** Two points for 31...♖xd4!! and two more for spotting 35...g5!! or one more for 35...♗e5.

434: 20.♖xe5! ♗xe5 21.c4 ♗xc4 21...♕d4? 22.♘f3 ♕xb2 23.♗xe5 +− ; 21...♕d6? 22.♘g4 f6 (22...♗xg3? 23.♕xh6+ ♔g8 24.♘f6#) 23.♕xh6+ ♔g8 24.♕xg6+ ♔h8 25.d4 +−. **22.♗xe5 ♕xe5 23.dxc4± ♕d4 24.♕xd4 cxd4 25.♗d3 ♔g7 26.f4 ♖fd8 27.♘f3 ♖c6 28.♔f2 ♖cd6 29.g4 ♖h8 30.♔g3 h5 31.g5 ♖c8 32.♘e5 ♖cd8 33.b4 ♖c8 34.♔f3 ♖c7 35.♖b1 ♖c8 36.♔e4 ♖c7 37.♖b3 ♖c8 38.♖a3 ♖c7 39.♖a6 ♖d8 40.b5 ♖d6 41.a4 1-0** Four points for calculating up to 23.dxc4±.

435: 19.♕e2!! 19.♕xe7?? ♕xf2+ 20.♔h1 ♕f1+ 21.♗xf1 ♖xf1#. **19...♕d6** 19...♕xa1 20.♕xe7 ♕xc1+ 21.♗f1 +− due to the double threat ♕xf8# and ♕xh7#.; 19...♕g7 20.♗b2 f6 21.♘e6 ♕f7 22.♖d1 +−. **20.♗b2+ ♔g8 21.♗c2 ♖d8 22.♖d1 1-0** Three points for calculating up to 21.♗f1 +− in the line 19...♕xa1.

436: 32...♕xb6!! 32...♕f7?! 33.♘xc4 ♕xc4 34.♗d5 ♕d3 35.b3 ♖e1 36.♗c4 ♖xf1+ 37.♕xf1 ♕xd6 38.♕h3 is much less convincing. **33.d7** 33.axb6 ♗xf1 34.♕xf1 ♖xe4 35.d7 ♖e1 −+. **33...♖xe4!** Was stronger than the game continuation 33...♕d8. **34.♕xe4 ♕c5 35.♕e8+ ♗g8 36.d8♕ ♗xd8 −+** Two points for ♕f7?!; Two points for ♕xb6!! and two more for spotting ...♖×e4!.

437: 30.♕xe5!! dxe5 31.♖xd7 ♖f8 31...♗xd7? 32.♖xf7+ ♔h8 33.♗f6+ ♖g7 34.♖xg7 +−. **32.♖fxf7+ ♖xf7 33.♖xf7+ ♔g8 34.♖g7+** 34.♖e7 +−. **34...♔h8 35.♘d5! ♕d6 36.♘f6 1-0** Two points for ♕xe5!! and one more for calculating up to 34.♖g7+ or ♖e7 +−.

Test 3

438: The interference **34.♗e5!! 1-0** wins on the spot. A problem-like finish. Two points for ♗e5!!.

439: 35.♖xd5! exd5 35...♕xf4 36.♘xf4 ♖xd5 37.♘xd5 +− . **36.♘d4+** And Black resigned due to **36...♔d8** 36...♖e7 37.♕xc7 ♖xe1 38.♕b8+ ♔e7 39.♕b4+ +− . **37.♘e6+ ♔c8** 37...fxe6 38.♕xf8#. **38.♘xc7 +−** One point for calculating up to ♘d4+.

440: 8.♘xf7! ♔xf7 9.♕xe6+ And Black resigned as he is mated soon: 9.♘g5+ wins as well. **9...♔g6 10.♕f7+ ♔h6** 10...♔f5 11.♗e6+ ♔e4 12.d3#. **11.d4+ g5 12.♗xg5#** One point for ♘xf7!.

441: 1.♖xh6+ 1.♗f5? ♔h8 and the attack is repelled. **1...gxh6** 1...♔xh6 2.♕g5+ ♔h7 3.♕h4+ ♔g6 4.f5#. **2.♕g8+ ♘xg8 3.♗f5# 1-0** Two points for 1.♖xh6+.

442: White could have seized the opportunity with **41.fxe5+!** Instead of the game continuation: 41.♖xa6? ♖xe4 42.♖xd6+ ♔f5 and a draw was soon agreed. **41...♔xe5 42.♖xb4! cxb4 43. ♔f3 ♔f6 44. ♔f4 a5 45.e5+!!** The point. **45...dxe5+ 46. ♔e4 g5 47 hxg5+ ♔xg5 48. ♔xe5 +−**. Two points, if you saw 45.e5+!!, which wins the pawn endgame.

443: 33.♖h5! ♗xg6 33...♖xg6 34.♖h8+ ♔f7 35.♖h7 +− ; 33...♔g8 34.♖h7 +− . **34.♖h8+ ♔f7 35.♖xc8 ♘xc8 36.♖xb7+ ♘e7 37.♗xg6+ ♕xg6** 37...♔xg6 38.♕g4+ ♔h7 39.♕xg7+ ♔xg7 40.♖xe7+ +− . **38.♕b4** "How embarrassing. Almost any square is better than f6 for the rook!" (McShane in CBM 71). **38...♕f5?!** 38...♔g8 39.♕xe7 ♖f8 40.♖b5 ♖e8 *(40...♖f7 41.♖b8+ ♔g7 42.♕h4 +−)* 41.♕xa7 +− (Stohl). **39.♕xe7+ ♔g6 40.♕h7+ 1-0** Two points for ♖h5 and two more for calculating up to ♕b4.

444: 14...♕c6 15.f3 ♕b5 16.♗a4 ♕xb2 0-1 One point for 15...♕b5.

445: 27.♖xe6! ♖xg3+ 27...♗xe6 28.♖xd4+ ♕xd4 29.♕xd4+ +− ; 27...♔xe6 28.♖e1+ ♔d7 29.♕xe7+ +− . **28.hxg3 ♘f5 29.♕h7+ ♔xe6 30.♕g6+ ♔d7** 30...♔e5 31.f4+ ♔e4 32.♖e1+ ♔f3 33.♕xf5+ +− (Psakhis in CBM 78). **31.♕xf5+ ♔c6 32.♕f6+ ♔c5 33.♕e7+ ♔c4 34.♕e5 ♔c5 35.f4 b5 36.f5 ♔c6 37.♕f6+ ♔c5 38.♕e5 ♔c6 39.♖xd4 ♕a1+ 40.♔f2 ♕h1 41.♖xd5! ♕xd5 42.♕xc3+ ♔d6 43.♕d3 +−** and White won soon. Two points for seeing that ♖xe6! wins.

446: 33.♘xf7! ♔xf7?! 33...♖xg1 34.♘xh8! ♖g8 *(34...♖xe1? 35.♕g5+ ♔f8 36.♔xe1 ♘e6 37.♘g6+ ♔e8 38.♕xf5 ♔f7 39.♕xh5 ♘f8 40.♘f4 +−)* 35.♕h6 ♘e6 36.♖g1 +− . **34.♖xg6 ♔xg6 35.♕g5+ ♔f7 36.♕f6+ ♔g8 37.♖g1+ 1-0** Two points for calculating up to 34.♘xh8! (in the line 33...♖xg1).

447: 30.♗xh6 30.♖g3? g5=. **30...f6** 30...gxh6? 31.♖g3+ ♔g5 *(31... ♔f8 32. ♕h8#)* 32.♖xg5+ hxg5 33.♕f6+−. **31.♗e3 ♕e6 32.b3 c5 33.♕f4 ♔f7 34.h4 ♖e8 35.♕f3 ♕c8 36.♗f4 ♘d8 37.♕h5+ 1-0** One point for spotting ♗xh6.

448: 26...♘xf2!! **27.♗xc6** 27.♔xf2 ♖xe3 28.♖xe3 ♕xf4+−+; 27.♗xf2 ♕xf4 28.♖xe7 ♕xc1+−+. **27...♘xh3+ 28.♔f1** 28.♘xh3 ♕g3+−+. **28...bxc6 29.♘xd5** 29.♘xh3 ♖xe3 30.♖xe3 ♖xe3 31.♖xc6 ♕e7−+. **29...cxd5 30.♖c6 ♕f4+ 31.♗xf4 ♖xe1+ 32.♔g2 ♘xf4+ 0-1** Two points for ♘xf2!!.

449: 33.♘xc6!! **♗d7** 33...♖xe6 34.♗xe6+ ♘xe6 35.♘f5+−; 33...♘xe6 34.♘f5 ♘xd4 35.♘xe7+ ♔h8 36.♘f5+−. **34.♘xc7 ♗xg4 35.♘b5 ♗b4 36.♖c1 ♗f3 37.a3 a6 38.axb4 axb5 39.♖xc3 ♖a7 40.g4 ♗e4 41.♔h2 ♔f7 42.♔g3 ♖a3 43.f3 ♗b1 44.h5 ♔e8 45.♗g7 ♘a4 46.♖c1 ♖xb3 47.♘xd5 f5 48.♖e1+ ♔d7 49.g5 ♔d6 50.♘f6 ♘c3 51.♗f8+ ♔c7 52.♔f4 ♗d3 53.g6 hxg6 54.hxg6 ♘e2+ 55.♔e5 ♗c4 56.♖xe2 ♗xe2 57.♘d5+ 1-0** Three points for spotting ♘xe6!!.

450: 24.♖h3!! ♗xh3 25.gxh3 ♕b6!? 26.♗h7+? 26.♖f1! ♖f8 27.♕f6 *(27.♖f4 +−)* 27...♖ae8 *(27...b4 28.♕xh6 bxc3+ 29.bxc3 f5 30.♗c4+ +−)* 28.♕f5+−. **26...♔h8 27.♕f6+** And Black resigned, but his position seems to be tenable, e.g. **27...♔xh7 28.♕xf7+ ♔h8 29.♕f6+ ♔g8 30.♕g6+ ♔h8 31.♕xh6+ ♔g8 32.♕g6+ ♔h8 33.♕f6+ ♔h7 34.♖e1 ♕c7 35.♖e7+ ♕xe7 36.♕xe7+ ♔h6±** Two points for ♖h3 and three more for seeing that 26.♖f1! is the right way to win.

451: 15.♘a4!! bxa4 16.♗xa4+ ♔e7 16...♘ed7!? 17.♖xc5 ♕xc5 18.♘xe6 ♕c4 *(18...♕b4 19.♘xg7+ ♔f8 20.♗xd7±)* 19.♗xd7+ ♘xd7 20.♘xg7+ ♔f8 21.♕xc4 ♖xc4 22.♗h6±; 16...♘fd7 17.b4 ♕xb4 18.♗xd7+ ♘xd7 19.♖b1±; 16...♔f8? 17.♖xc5 ♖xc5 18.♘b3+−. **17.♖xc5 ♖xc5 18.♘b3 ♖hc8** 18...♘xe4 19.f4 ♗d5 20.♘xc5±. **19.♘xc5 ♖xc5 20.b4!! ♕xb4 21.♕d2! 1-0** Two points for ♘a4!!, one more for refuting 16...♘ed7, and the last two for spotting 20.b4!!, followed by ♕d2.

452: 24...♕g6! 25.♕h3 25.♗xc4 ♘d6−+. **25...♘dc5** 25...♗xf2!? 26.♔xf2 ♕c2+ 27.♔f1 ♖e2 28.♕g3 ♖xg2 29.♕xb8+ *(29.♘d4 ♕e4 −+)* 29...♘f8−+ (Shabalov in CBM 87); 25...♗c8∓. **26.♘c3?!** ♘d2 27.♖bc1 27.♖xd2? ♕xb1+ 28.♗xb1 ♖e1#. **27...♗c8 28.♗b1 ♘xb1 29.♕e3 ♗b7 0-1** Three points for ♕g6! and two more for spotting 25...♘xf2!? or 26...♘d2.

453: 14.♘xd6+!! exd6 15.♕e2+! ♗e6 15...♗e5 16.♖ad1 ♕c5 17.♖xd6 *(17.♖d5 +−)* 17...♕xd6 18.♗xe5 ♕e7 19.♗xh8+−; 15...♘f8 16.♖ad1 ♕f6 17.♖xd6 ♕e7 18.♕d2 ♘d7 19.♖e1 ♗e5 20.♕d5+− (Ftacnik in CBM 81). **16.♗xe6 0–0** 16...fxe6? 17.♕xe6+ ♔d8 18.♖ad1 ♖e8 19.♕g6+− (Ftacnik). **17.♖ad1 ♕f6** 17...♕xb2 18.♗d5 ♘c6 19.♗xd6 ♖fd8 20.♕h5±. **18.♗d5 ♘c6 19.c3±** "White enjoys an enormous advantage due to excellent bishops and better pawn structure." (Ftacnik). Four points for seeing that White wins after 15.♕e2+!.

Test 4

454: 21.f4 ♘c6 22.♘xc6 ♗xc6 23.♗xc5 dxc5 24.♘xe7+ ♕xe7 25.♖xe7 ♖xe7 26.e5 +− And White won later. Two points for seeing up to 23.♗xc5.

455: 25.♕d3 25.♕g3? was played in the game. White won after some further moves. **25...♔g7 26.♖a1 ♘c5 27.♕c3 +−** (Hübner in CBM 89). One point for seeing the line until 27.♕c3.

456: 21...♖f1+! A nice decoy! **22.♔xf1** 22.♘xf1 ♗xe5 −+; 22.♔e2? ♗b5+ 23.♘c4 ♗xc4+ 24.♔d2 ♕d3#. **22...♕d3+ 23.♔f2 ♗xe5 24.♘gf3 ♗xb2 25.♖ab1 ♖c2 26.♖hd1 e5 27.g3 ♗g4 0-1** Three points for 21...♖f1+! −+.

457: 34.♗xh6!! One point for 34.♗xe4. **34...♗xh6 35.♖xf6 ♕xa2 36.♗xe4** The opposite-colored bishops make White's attack irresistible: **36...♖g7 37.♖xc6 ♕d2 38.♔g2 ♕d7 39.♕f6 ♕e8 40.♖e6 ♕g8 41.h4 ♗d2 42.h5 ♗g5 43.hxg6+ ♔h6 44.♕f5 1-0** Two points for ♗xh6!!.

458: 26...♕e3! **27.♗f2** 27.♕b5 ♖xf3+ 28.gxf3 ♕xf3+ 29.♔g1 ♕xd1 30.♕f5 ♕xe1+ 31.♔g2 ♕d2+ 32.♔g3 ♕h6 33.♖f1 g6 −+. **27...♖xf3 0-1** Two points for calculating up to 27...♖xf3.

459: Three points for **26.♖xa7! ♘xc5 27.♕xe8+! 1–0**

460: 1.♘e7+ ♘xe7 1...♖xe7 2.♖xf2 ♖e1+ 3.♖f1 +−. **2.♕g3+ ♕xg3** 2...♘g6 3.♕xf2 +−. **3.♗xf7#** Two points for calculating up to ♗xf7 mate.

461: 34.♖b8 1-0 With the deadly threat ♕f8+. Opposite-colored bishops do favor the attacker! One point for ♖b8.

462: 1.♘f5! ♕xh4 1...gxf5 2.♖g4+ fxg4 3.♕xg4+ ♕g5 4.♕xg5#. **2.♕h5!!** And Black resigned due to **2...gxh5** 2...♕xh5 3.♘e7#. **3.♘h6#** Three points for seeing up to ♕h5!!.

463: 1...♖b8 2.♗xd8 ♖xb2+ 3.♔a1 c2! 4.♔xb2 cxd1♘+ −+ 0-1 Three points for seeing up to the underpromotion.

464: 20.♕c5 ♖b8 20...♖e8 21.♘b6 +−. **21.♘xf6+ 1-0** 21...♕xf6 22.♖d6 A double attack. **22...♕f4 23.♗xc6 ♖bc8 24.♕d4 +−** Two points for ♕c5.

465: 18...♘xf2!! 18...♖xf2?! **A)** 19.♗xf2? ♘xf2 20.♕d2 (*20.♔xf2 transposes to the game.*) 20...♘bd3 −+; **B)** 19.♘g3 ♖d2!! interference 20.♗xd2 ♕xd4+ 21.♗e3 ♕xd1 22.♖bxd1 ♘xg3 and Black is better. But the game continuation is much more convincing. **19.♗xf2** 19.♕d2 ♘bd3 −+. **19...♖xf2 20.♔xf2 ♗xe5 21.♔g1** 21.♖xe5 ♘d3+ 22.♔g3 ♕xd4 −+ **21...♗xd4+ 22.♔h2 ♘d3 23.♖e2 ♗g1+**

24.♔h1 ♘f2+ 25.♖xf2 ♗xf2 −+ And Black won later. Two points for 18...♖xf2?! 19.♘g3 ♖d2 and four points for ♘xf2!, if you saw that White is lost after 20...♗xe5.

466: 19.♗h6!! ♗xf2+! 19...♕xd7? 20.♕g6 +− ; 19...♘e7? 20.♘f6+! gxf6 21.♕g4+ ♘g6 22.♕xg6+ ♔h8 23.♕g7#; 19...♗d2? 20.♘xf8 ♕xf8 21.♗xd2 +− ; 19...♘d4? 20.♗xg7! ♔xg7 21.♕g4+ ♔h6 22.♗xb7 ♖c2 23.♖xe1 +− (Gershon in CBM 81). **20.♔xf2 ♘e5!! 21.♗xg7!** 21.♕xe5? ♕h4+ 22.♔f1 ♖xh6 is slightly better for Black. **21...♘d3+ 22.♔g1?** 22.♔f1! was called for, e.g. 22...♔xg7 23.♕g4+ ♔h6 24.♗xb7 ♖c7 25.♘xf8 ♖xb7 26.♕f3 ♖c7 27.♖d1±. **22...♔xg7 23.♕g4+ ♔h6!** **24.♕h3+ ♔g7 25.♕g3+ ♔h8! 26.♕h3+ ♔g7 27.♗xb7 ♖c7 28.♕g4+ ♔h6!** In the game Black played 28...♔h8? and White won (see puzzle 490). **29.♕h3+ ♔g7 30.♕g4+ ♔h6=** (Gershon). Two points for ♗h6!!, one more for the defense ♗xf2+!, one further for ♘e5!! and the last one for finding 22.♔f1!.

467: 28.♖xc6+! One point for 28.♗xh6. **28...bxc6 29.♕g4+ ♕d7 30.♕g3 ♕d8 31.♗xh6!! ♖xh6 32.♖b8+ ♔e7 33.♕g7+ ♔d6 34.♕xh6+ 1-0** Two points for ♖xc6+ and two more for 31.♗xh6!!.

468: 29.♖xe6! ♘d3+ 29...♕xe6? 30.♖xg7++− a typical deflection. **30.♔d2 ♕b2+ 31.♔e3** 31.♖xd3 ♕a3+ 32.♔d2 ♕xa2+ 33.♔e3 ♕a3+ 34.♔d3 ♕xd3+ (34...♗d4+ 35.♘xd4 ♖c3 36.♕xc3 ♗xc3+ 37.♔e4 ♕e1+ 38.♔d5 ♕h1 39.♖eg6 +−) 35.♔xd3 ♔xe6 36.♖xg7 ♔f6 37.♖h7± (Ftacnik in CBM 91). **31...♗d4+** 31...♕xe2+ 32.♔xe2 ♘xf4+ 33.♔f3 ♘xe6 34.♕d5 ♔f6 35.♖xh5 +− (Ftacnik). **32.♘xd4!** In the game White chose 32.♔f3? −+ . **32...♕xd4+ 33.♕xd4 ♖xd4 34.♔xd4 ♘xf4 35.♖xa6 ♘xg2 36.♖b6 h4 37.♖xb5 +−** (Ftacnik). One point for ♖xe6 and two more for calculating up to 37.♖h7 or three more for calculating up to 35.♖xa6 +−.

469: Both kings are in mortal danger, but White strikes first: **40.♖xg6+! ♔xg6 41.♕g5+** And Black resigned due to **41...♔h7 42.♖h1+ ♗h2 43.♖xh2#.** One point for ♖xg6+.

Test 5

470: 25.♗e7!! ♗d7 25...♔xe7? 26.♕d6+ ♔e8 27.♕d8#; 25...♘d5 26.♕xg7 ♔xe7 27.♕xh8 +–. **26.♗xf6 gxf6 27.♕d6** 27.♕c7 +–. **27...♕b7 28.♖d3 ♕c8 29.♖b3 ♕d8 30.♗e4 f5 31.♗f3 1-0** One point for spotting ♗e7!!.

471: 29.♗b4! One point for 29.♗xa5 ♕c5+ 30.♔h2±. **29...♕xf4** 29...♕xb4 30.♖xb4 ♗xb4 31.♕e6+ ♔h8 32.♖d7 +–. **30.♖d8+ ♔g7 31.♖d7+ ♔h6 32.♗d2 ♖g5+ 33.♔h1 ♕f5 34.♗xg5+ ♕xg5 35.♖g1 ♕f4 36.♖g4 ♕f6 37.♕e3+ g5 38.♖h4+ 1-0** Three points for calculating up to 33.♔h1.

472: 23...♘xg4! 24.♕xg4?! 24.♗d2 ♘e5 25.♖f6 ♖e8 and Black is much better. **24...♖e5! 25.♘xc5 ♗xc5 26.♖xe5 ♕xg4 27.♖xc5+ ♔b8 28.♖e1 ♕h4 29.♗g7 b6 0-1** Two points for ♘xg4 ♕xg4 ♖e5. One more, if you saw that ♗d2 is White's best answer after ♘xg4.

473: 3.g4!! And Capablanca left the board leaving the amazed Kalantarov behind. Black is now lost in all variations. 3.h4? is the wrong way to implement the breakthrough because of 3...g4! *(3...gxh4? 4.g4 h3 5.g5 h2 6.g6 h1♕ 7.g7+ ♔h7 8.g8♕+ ♔h6 9.♕g6#)* 4.♔e6 a5 5.♔d5 ♔g7 6.♔c4 ♔f6 7.♔b5 ♔e6 8.♔a4 ♔d5 9.♔xa5 ♔e5!= distant opposition. **3...♔h7** 3...a5 4.h4 gxh4 5.g5 +–. **4.h4 ♔h6 5.♔f6 ♔h7 6.h5!** 6.hxg5? ♔g8=. **6...a5 7.♔e5** And Kalantarov resigned as his a-pawn will fall prey to White's king. The resulting ending is won, in sharp contrast to that after 3.h4?, as the key square d5 is outside the square of the protected passed pawn on h5. For more details see Endgame Corner 10 in The ChessCafe.com Archives. Two points for g4!! and two more for h5!.

474: 27...♗a4! One point for 27...d5 –+. **28.♕c1** 28.♕xa4 ♗c3#. **28...d5 0-1** Two points for ♗a4.

475: 29...♘f4+! 30.exf4 exf4 31.♖xd2 31.♖h3 f3+ –+. **31...♕xg3+ 32.♔f1 ♕f3+ 33.♔e1 ♕xh1+ 0-1** Two points for ♘f4+.

476: 24.c6! ♗c8 24...♖ac8? 25.♗xe4 fxe4 *(25...dxe4 26.♕c4+ ♖f7 27.cxb7 +–)* 26.♖xf8+ ♔xf8 27.♕f2+ +–. **25.♗xe4 dxe4** 25...fxe4 26.♖xf8+ ♔xf8 27.♕c5+ ♕e7 28.♖f1+ ♗f5 29.♕xd5 +–. **26.♕c4+ ♖f7 27.c7?!** 27.♕d5! ♕e7 28.c7 ♖xc7 29.♕xa8 +–. **27...♗d7 28.♖d1** An instructive attack with opposite-colored bishops follows: **28...♕e7 29.♗xe5! ♖c8 30.♗d6 ♕e6 31.♕c5 h6 32.♖b1 ♔h7 33.♖b8 g5 34.♗e5 ♕a6 35.h3 ♕d3 36.♗d4 ♕a6 37.♕e5 ♕e6 38.♖d1 f4?! 39.♖xc8 ♗xc8 40.♕h8+ ♔g6 41.exf4 gxf4 42.♕g8+ ♔h5**

(See diagram top of next page)

43.罝c1! 罝xc7 44.豐g4+ 1-0 One point for c6, one more if you spotted 27.豐d5! +– .

477: Note that Black can't castle anymore, although it is not relevant to the solution: **27.罝dxe6+!** 27.罝exe6+ works as well, of course. **27...fxe6 28.罝xe6+ 含f7 29.豐c4!** 公xc5 29...公f6 30.罝e7+ 含g6 31.豐f7+ 含f5 32.罝xc7 +– . **30.罝xc6+ 含e8 31.罝xc5! 豐xc5 32.bxc5 含e7 33.豐e4+ 含f7 34.豐f5+ 含e7 35.g4 g6 36.豐e5+ 含f7 37.豐d5+ 含e7 38.豐d6+ 含f7 39.豐d7+ 1-0** Three points for calculating up to 29.豐c4.

478: 21.公bxd6! 公xd6 22.公b6! 拿f8 23.b4! 公cxe4 24.fxe4 拿e8 25.豐f3 拿e7 26.公xa8 豐xa8 27.拿c5 +– And White won later. One point for 公bxd6! and one for 公b6!.

479: 32...豐f3+ 32...豐c4?! 33.公xb2 豐c6+ 34.豐g2 豐xc3 35.豐xf2 豐xb2 is not as convincing as the game continuation. **33.豐g2 f1豐+! 34.罝xf1 豐xg2+ 35.含xg2 罝xc2+ 0-1** Two points for seeing f1豐 (or 罝) +. One point for 32...豐c4.

480: 27...拿e4+ 28.含b2 28.罝xe4 罝xc1+ 29.含b2 拿g7+ 30.罝d4 罝8c2+ 31.含a3 公c5 –+; 28.豐xe4 罝xb5+ 29.含a1 拿g7+ –+ . **28...拿g7+ 0-1** Two points for seeing that 拿e4+ wins.

481: 20...公xe3 20...拿b5? 21.罝xd5±. **21.豐xe3 拿b5 22.c4** 22.罝d4 拿c5 23.拿xe6 *(23.罝fd1 拿xd4 24.豐xd4 豐xf7 –+)* 23...拿xf1 24.含xf1 豐b6 –+ double attack. **22...拿c5 23.罝d4 拿xc4 24.罝c1 b5 25.拿xe6 豐a7 0-1** One point for 拿b5 and two more for seeing that Black wins with 豐b6 or 豐a7 in the end.

482: 15...公xf2! 16.含xf2 公g4+ 17.含g1 公xe3 18.豐d2 公xg2! 19.含xg2 d4! 20.公xd4 拿b7+ 21.含f1 21.含g1 拿xd4+ 22.豐xd4 罝e1+! A typical deflection. 23.含f2 豐xd4+ 24.罝xd4 罝xa1 –+; 21.含f2 豐d7! 22.罝ac1 *(22.公f3 豐xd2+ 23.公xd2 拿d4+ 24.含f1 拿c8 25.公ce4 拿a6+ 26.含g2 拿xa1 27.罝xa1 拿b7 28.罝e1 f5 –+)* 22...拿xd4+ 23.豐xd4 豐f5+ 24.含g1 *(24.豐f4 豐h3 –+)* 24...豐f3 25.公d5 拿xd5 26.豐xd5 罝e1+ –+ . **21...豐d7!** And Black resigned due to **22.豐f2** 22.公db5 豐h3+ 23.含g1 拿h6 –+ . **22...豐h3+ 23.含g1 罝e1+!! 24.罝xe1 拿xd4+ –+.** One point for 公xf2, one for 公xg2, one for d4 and two for 豐d7 and the mating combination.

483: 21.♖h5 f6 21...gxh5? 22.♕g5#. **22.♖xh7! ♕xc3 23.♖h8+!** An important zwischenschach. **23...♔xh8 24.♕h6+ ♔g8 25.♕xg6+ ♔h8 26.♗xc3 d6** 26...♖c8 27.g4+−. Now, as he pointed out himself, Smirin should have played **27.♗d2!** Instead of 27.f3?!. But he won the game nevertheless. **27...♖c8** 27...♖g8 28.♕h6#; 27...f5 28.♗c3+ e5 29.♕xd6+−. **28.♕h5+ ♔g8 29.♗h6+−**. Three points for calculating up to ♖h8+ and seeing that White has a winning attack. One more for seeing 27.♗d2!.

484: 23.♖xf7+!! ♘xf7 24.♘e6 ♕d7 25.♕f6! ♕xe6 25...♘g8? 26.♘xf8+ ♖xf8 27.♕g7#; 25...♘xh6? 26.♕f7+ ♔h8 27.♗xh6 ♗xh6 28.♕g7#. **26.♕xe6+−** And White converted his advantage after some further moves. Two points for calculating up to ♘e6 one more for seeing 25.♕f6!.

485: 21.♖c6! ♗xf4 21...♕xc6? 22.♘e7++−. **22.gxf4 ♖d8** 22...♘b8 23.♖xc7 ♕e6 24.♖e7 ♕c6 25.♕d4 ♖f7 26.♖c1 ♕xc1 27.♖e8+ ♖f8 28.♖xf8+ ♔xf8 29.♕f6++−. **23.♖xa6 ♕f7 24.♘f6++−** And White won soon.One point for ♖c6!.

Test 6

486: 36.♕g6+ 1-0 36.♕g5+ ♕xg5 37.♖xf8# One point for ♕g6+ or ♕g5+.

487: 25.♕h7! ♖e6 26.♗h6 ♔e8 27.♕xg7 ♘xd5 28.♕h8+ ♔e7 29.g7 ♖xh6 29...♖g6 30.♕f8+ ♔xf8 31.gxf8♕+ ♔e6 32.♗g5+−. **30.♖f7+ ♔xf7 31.g8♕+ ♔e7 32.♕d8+ 1-0** Two points for finding ♕h7!.

488: 22.♘xf7!! ♗xf7 22...♔xf7 23.♘xd5 ♖xd5 *(23...♗xd5 24.♖xe7+ ♖xe7 25.♕xf6+ ♔g8 26.♕xe7+−)* 24.♗xd5 ♗xd5 25.♖xe7++−. **23.♖xe7** 23.♘xd5 ♘xd5 24.♗xe7 transposes. **23...♖xe7 24.♘xd5 ♘xd5 25.♗xe7 ♖e8 26.♗d6 ♕f5 27.♗e5+ ♔g8 28.♕g3 ♗e6 29.♖e1 ♕f7 30.a3 ♘b6 31.♗c2 ♗f5 32.♗d1 ♘d7 33.♖e3 ♘xe5?**

34.♗b3! 1-0 Pin and win! One point for ♘xf7, one for refuting ♔xf7 and one for calculating up to 25.♗xe7+−.

489: 27.♘xg7! ♔xg7 28.♕g4+ ♔h8 29.♖d7 ♕b8 30.♕f5 1-0 Two points for calculating up to 29.♖d7+−.

490: 34.♗h6!! gxh6 34...♘b7 35.♗xg7 ♔xg7 36.♖1a4 +− ; 34...♕f5! 35.♖xg7+ ♔h8 36.♕e2±. **35.♖1a4 c4 36.♖xc4 1-0** Two points for 34.♗h6!! gxh6 35.♖1a4 +−, and one more if you spotted that 34...♕f5! is Black's best defense.

491: 28...♗xh4! 29.♗d2? 29.gxh4? ♕f2+ 30.♔h1 ♕xh4+ 31.♔g1 ♕g4+ 32.♔h1 ♕h5+ 33.♔g2 ♖g8+ 34.♔f1 ♖g7!! −+ (Tyomkin using Deep Fritz in CBM 85); 29.♖e3! ∓ is the best defense. **29...♗xg3! 30.♖f1** 30.♕xg3 ♖g8 −+. **30...♗f2+ 31.♔h1 ♕h5+ 32.♔g2 ♕g4+ 33.♔h2 ♖f5 0-1** Two points for ♗xh4 one more, if you noticed that 29.♖e3 is White's best defense, and two more if you saw how to refute gxh4 – especially 34...♖g7!!.

492: One point for **30...♗d7! −+ 0–1**

493: 33...♘xh3+! 34.♔h1 34.gxh3 ♗f2+ −+. **34...♘f2+ 35.♔g1 ♗h2+ 0-1** One point for ♘xh3+ and two more for calculating up to 35...♗h2+.

494: 26.♘f5! ♕b8 26...♗xg2 27.♕h8+ ♖g8 28.♕xe5 (28.♕h6+ ♔e8 29.♗d4 ♕d5 30.♕h7 +−) 28...♘xe5 29.♗c5+ ♔e8 30.♔xg2 ♘d3 (30...♖d2+ 31.♔g1 ♘d3 32.♘d6+ ♔d7 33.♘e4 +−) 31.♘d6+ ♔d7 32.♖d1 ♘xc5 33.♘xf7+ +− (Milov in CBM 83 extra). **27.♗xg5 ♕b6+ 28.♖f2 1-0** One point for 26.♘f5, one more for seeing that the defense 26...♗xg2 is insufficient.

495: 29.♕d4+! f6 29...♔g8 30.♘f6+ ♔g7 31.♘e8+ +−. **30.♕h4+ ♔g7 31.♘xf8 ♕d6!** 31...♕xf8 32.♕g3+ +−; 31...♔xf8 32.♕h8+ ♔e7 33.♕xd8+ ♔xd8 34.♗xa6 +− (Gershon in CBM 81). **32.♗e4** 32.♖d1!? +−. **32...♖c1+?!** 32...♕d4+!? 33.♔f1 ♔xf8 34.♖d1 ♖h7! 35.♕f4! ♘xf4 36.♖xd4 ♖xh2 37.♖d6 +− (Gershon). **33.♖xc1 ♘xc1 34.♗f3! ♕xf8 35.♕g3+ ♔h8 36.♕h3+ ♔g7 37.♕g4+ ♔h8 38.♕h5+ ♔g7 39.♕g4+ ♔h8 40.♕h3+ ♔g7 41.♕d7+ ♔h8 42.♗e4 ♕h6 43.♕e8+ ♔g7 44.♕e7+ ♔h8 45.♗d5 ♕f4 46.♕f8+ ♔h7 47.♗g8+ ♔g6 48.♗f7+ ♔f5 49.♕c5+ ♔e4 50.♗d5+ ♔f5 51.♗f7+ ♔e4 52.♗g6+ f5 53.♗xf5+ ♕xf5 54.♕xc1 1-0** Two points for ♕d4+.

496: 23.♘xh5 ♕xh5 24.♕xe5 1-0 Two points for ♕xe5.

497: 20...♖b2 20...♕e2?! 21.♗f1 ♕d2 22.♕d4 ♕b2 23.♕xe3 ♕xa1 24.♖xa7 is not as convincing as 20...♖b2. **21.♖e1** 21.♕d4 ♕e2 22.♕xe3 ♕xa6 −+; 21.fxe3 ♕e2 22.♗f3 ♕f2+ 23.♔h1 ♕xh2#. **21...♕e2!! 0-1** One point for ♖b2 and one for ♕e2!!.

498: 25.♘xe6! ♗g6 25...♕xe6? 26.♖xf8+ ♖xf8 27.♕xg7#. **26.♘xf8** 26.♖xd6!? ♕xd6 27.♖xf8+ ♖xf8 28.♘xf8 ♖xf8 29.♕c7 ♖f7 30.♕xb6 +−. **26...♖xf8 27.♖xf8+ ♖xf8 28.♖xd6 ♕e4 29.♕e1 b5 30.h3 ♖e8 31.♗d4 ♖e6 32.♕g3 bxc4 33.bxc4 ♖xd6 34.♕xd6 ♕b7 35.♕d8+ ♔f7 36.♕h8 ♕b1+ 37.♔h2 ♕xa2 38.♕xg7+ ♔e6 39.♕e5+ ♔d7 40.♕d5+ ♔e7 41.♗c5+ ♔f6 42.e4 ♕e2 43.♕d8+ ♔g7 44.♕f8#** Opposite-colored bishops favor the attacker! One point for ♘xe6!.

499: 26...♘c3! 27.♘xd4 ♖xb2 28.♖xb2 ♕a2+!! 0-1 29.♖xa2 ♖b1# One point for ♘c3 and three more for ♕a2+!!.

500: The famous Evergreen Game finished amazingly prettily: **20.♖xe7+! ♘xe7!?** 20...♔d8 21.♖xd7+! ♔c8 *(21...♔xd7 22.♗f5+ ♔e8 23.♗d7+ ♔d8 24.♗xc6+ ♔c8 25.♗d7+ ♔d8 26.♗e7#)* 22.♖d8+! ♔xd8 *(22...♖xd8 23.gxf3 +-; 22...♘xd8 23.♕d7+!! ♔xd7 24.♗f5+ ♔c6 25.♗d7#)* 23.♗e2+ ♘d4 24.♗xf3 ♗xf3 25.g3 ♗xd1 26.♕xd1 "with a boring but winning endgame." (Kasparov in CBM 59). **21.♕xd7+!! ♔xd7 22.♗f5+ ♔e8 23.♗d7+ ♔f8 24.♗xe7#** 1-0 Two points for seeing the game continuation until the mate and two more for calculating the line 20...♔d8 up to 25.g3.

501: 37.♘f6!! ♖e5 37...gxf6 38.gxf6 h6 *(38...♖e5 39.♖g1! c2 40.♔h2 ♗g7 41.♕h6 +-)* 39.♖g1! *(39.♘e6 +-)* 39...♕d2! *(39...c2? 40.♗xc2 ♕xd4 41.♔h1 +-)* 40.♕h4 c2 *(40...♗b7 41.♗c2! +-)* 41.♘xc2 ♖c3 *(41...♖xc2 42.♗xc2 ♕xc2 43.♔h1 ♕xe4+ 44.♕xe4 ♖xe4 45.♖g8+ ♔h7 46.♖xf8 +-)* 42.♘e3 ♖c1 43.♔h2! ♖xg1 44.♖xg1 ♖e5 45.♘c4 ♕d4 46.♘xd6+- (Ftacnik in CBM 80). **38.g6! fxg6** 38...hxg6 39.♕h4+ ♖h5 40.♘xh5 +-; 38...gxf6 39.♕xf6+ ♗g7 40.♕d8+ ♖e8 41.♕xe8+ ♗f8 42.♕xf8#. **39.♘d7 ♗e7 40.♘xe5 dxe5 41.♕f7 h6 42.♕e8+** 1-0 Three points for 37.♘f6, 2 more for calculating up to 39.♖g1 or 39.♘e6 in the line 37...gxf6.

Test 7

502: 30.♖xe8+ ♖xe8 31.♖d1 And Black resigned due to **31...♕e2 32.♖e1 +-.** One point for calculating up to 32.♖e1.

503: 21.♗c6! Interference. **21...♗c8** 21...♕xc6 22.♕xf8+ ♔xf8 23.♖e8#. **22.♗xd7 ♕xd7 23.♖d3 ♕c7 24.♕d6** 1-0 Two points for seeing that ♗c6 wins.

504: 8.♕e2! "White's play is a great example of a concrete approach to the opening. From now on White is creating threats with every move and Black proves to be incapable of holding on." (A.Finkel in CBM 95). **8...♕d5** 8...f5? 9.♕b5+ ♘d7 10.♕xb7 ♖b8 11.♕xa7 ♖b6 12.♘b5 ♗xf3 13.♘xc7+ ♔f7 14.♗c4+ +- D.Paz Ladron de Guevara-C.Zurita, Málaga 1999. **9.♘b5! 0–0–0** 9...♖c8 10.c4 ♕e6 *(10...♕c6 11.♘xa7 +- J.Lappage-E.Tomashevsky, Oropesa del Mar 2001)* 11.♘bd4 ♗xf3 12.gxf3 ♕d7 13.♘b3 ♘g5 14.f4 +-. **10.c4 ♕e6** 10...♘d3+ 11.♕xd3 ♕xd3 12.♗xd3 ♖xd3 13.♘e5 +- (Finkel). **11.d4 ♘g6** 11...♗xf3 12.gxf3 ♘d3+ 13.♕xd3 ♘g3+ 14.♗e3 ♕xh1 15.♘xa7+ ♔b8 16.d5 +- M.Ori-I.de Vita, Porto San Giorgio 1999; 11...♘d3+ 12.♕xd3 ♘g3+ 13.♗e3 ♘xh1 14.d5 ♕f6 15.♕b3± (Finkel). **12.d5 ♕f5 13.♘bd4 ♕e5** 13...♘f4 14.♘xf5 ♘xe2 15.♘e3 ♘xc1 16.♘xg4 e6 17.♖xc1 ♗b4+ 18.♔e2 exd5 19.cxd5 ♖he8 20.♘e3 f5 21.a3 ♗a5 22.♕d4+ +- M.Buckley-N.Regan, England 1999. **14.♘xe5 ♗xe2 15.♘xg6 ♗xf1 16.♘xh8 ♗xc4 17.♘xf7 ♖xd5 18.♘e6 ♖f5 19.♘xf8 ♘xf2 20.♖g1 ♗xf7 21.g4 ♘d3+ 22.♔e2**

1-0 One point for ♕e2, two more for ♘b5 and the last for seeing 11.♘bd4 in the line 9...♖c8.

505: 23.f3? 23.♖d7! ♕xe4 *(23...♕e6 24.♕xb4+ +−)* 24.♗b3 ♗d5 *(24...♘e6 25.♗xe6 fxe6 26.♕c7 +−; 24...f6 25.♕c5+ ♔e8 26.♖hd1 +−)* 25.♗xd5 ♘xd5 26.♕xd5 +−. **23...♘e6 24.♕b6 ♖b8 25.♕f2 ♕c5!** And the game was drawn later. Two points for seeing that 23.♖d7 ♕xe4 24.♗b3 wins for White.

506: 27.♕g6+ ♔d8 28.♘xd5! Much more convincing than 28.♖fd1 ♖h6 29.♕xe4 ♔e8 30.♘xd5±. **28...♗xd5** 28...♕xe5 29.♖f5 ♕g3 30.♕e6 ♖e8 31.♖f8 +−. **29.♖fd1 ♕xe5 30.♕f7 ♖h5 31.♖c5 1-0** Two points for ♘xd5, one for 28.♖fd1.

507: 17.♖xe6! 17.♗xf6? 0–0! 18.♗xe7 ♗xb3 ±. **17...fxe6 18.♗xe6 ♕xe6** 18...♕b8 19.♗f4 ♕a7 20.b6 +−. **19.♕xa8+ ♔f7 20.♕xh8 ♘d3 21.bxa6 ♘xf2 22.♖f1 ♘2g4 23.h3 ♕e5 24.hxg4 ♕xg5 25.♕xh7 ♔e8 26.♕h8+ ♔d7 27.a7 ♘xg4 28.♖d1+ ♔e6 29.♖e1+ 1-0** Two points for ♖xe6.

508: Two points for **29...♗g4+** Or 29...♕d2+ 30.♔f1 ♗f4 31.♕f3 ♗g4 32.♕e4 ♗f5 −+ which is also worth two points. **30.♔f1 ♗f4!! 0–1**

509: 21.♘c5+! ♗xc5 22.♕f7+ ♔d6 23.♗e7+! ♔d5 1-0 Three points for calculating up to ♗e7+.

510: 19.♖d7+ ♗xd7 20.♖xd7+ ♔e6 21.♖d6+ ♔f7 21...♔f5? 22.♕d7+ ♔g5 23.♗d2+ ♔h4 24.♕g4#. **22.♖d7+ ♔e6 23.♗g4+! f5 24.♖d6+ ♔f7 25.♖d7+ ♔e6 26.♘f4+!! exf4 27.♖d6+ ♔f7 28.♖d7+ ♔e6 29.♖d6+ ♔f7 30.♕d7+ ♘e7 31.♖f6+ ♔g7** 31...♔g8 32.♕xe7 +−. **32.♕xe7+ ♔h6 33.♖xg6+! 1-0** Three points for calculating up to ♘f4+!! and two more for calculating to the end.

511: 25.♘e5! ♘xe5 25...fxe5 26.♗xc6 ♖d2 27.♘d6 ♖d4 28.♕e3 bxc5 29.♕xe5+ ♔g8 30.♘e8 +− (Gelfand in CBM 86). **26.fxe5 ♘xc5 27.exf6+ ♔f7** 27...♔g8 28.♖cd1 +−. **28.♕h3 ♕g8 29.♗c6 ♖d3**

30.♗e8+!! ♔xe8 31.f7+ ♕xf7 32.♘d6+! ♖xd6 33.♖xf7 ♔xf7 34.♕xh7+ ♔e8 35.♕c7! ♖d4 36.♕xb8 ♔d7 37.h3 1-0 Three points for ♘e5.

512: 18.♘xe6 18.♖xe6!? fxe6 19.♘xe6 ♖xe6 20.♘c7 +− is even easier. After 18.♗b5? ♗xd5 19.♖xd5 Black can defend by the double attack 19...♕a5!. **18...fxe6 19.♖xe6! ♕h8** 19...♖xe6 20.♘c7! +−. **20.♖xc6 bxc6 21.♘c7 ♗e5 22.♕h6 ♖f6** 22...♗xc7 23.♖xd7 +−. **23.♕g5 ♗xh2+** 23...h6 24.♖xd7! +−. **24.♔xh2 ♕xc7+ 25.♔g1 ♕d8 26.♖xd7 1-0** Two points for 18.♖xe6! and one for 20.♘c7, or if you want to play like Degraeve, two points for 19.♖xe6 and one for 21.♘c7.

513: 23.d5!! ♘xd5 23...exd5 24.♘d4! ♘e6 *(24...♗c8? 25.♕xe7! +−; 24...♖g5 25.♘cxb5 cxb5 26.c6 ♗a6 27.♕a3 +−)* 25.♗xb5! cxb5 26.♘cxb5 ♘e5 27.c6 ♕xe3 28.fxe3 ♖gg8 29.♘xe6 fxe6 30.c7+ ♔c8 31.cxd8♕+± (Finkel in CBM 74). **24.♘xd5 ♖xd5** 24...exd5 25.♖e1 ♖e8 26.♘d4 ♖gg8 27.♖a1±. **25.♖xd5 exd5 26.♖e1 ♗d8 27.♗h3 f5** 27...♗c8 28.♕h6!? ♖g6 29.♕xh5 +−. **28.♗xf5 ♖g8 29.♕h6! ♗e7 30.♘e5 ♗g5 31.♕xh5 ♗d2 32.♘d7+ ♔a7 33.♖a1+ ♗a6 34.♕xf7 1-0** Three points for 23.d5!!.

514: 27.♘xe6+!! 27.♕h8+ ♔d7 28.♕xa8 ♗xe2 29.♘xe6 is better for White, but not as convincing as the game continuation. **27...♘xe6** 27...♖xe6 28.♖xd5+ ♔c8 29.♖xc5 ♕d7 30.♖d1 +−. **28.♕h8+ ♖e8 29.♖xd5+ ♕d7** 29...♔c8 30.♕xe8+ ♘cd8 31.f5 +−. **30.♕f6+ ♖e7 31.♖hd1 ♕xd5 32.♖xd5+ ♔c7 33.♖d6 ♗xe2 34.♖xc6+ 1-0** One point for ♕h8+ or one point for refuting ♖xe6 (after 27.♘xe6+!!) and two more for refuting ♘xe6.

515: 35.♘xd5!! 35.♖xg7? ♖e8 36.♕f3 ♗e5 −+. **35...♕xe3** 35...♗xd5 36.♕xa3 ♗xa3 37.♗xc4 ♔e7 38.♗xd5 ♖d8 39.♖xg7+ +−; 35...♕xa5 36.♘xf6+ −; 35...♘xd5 36.♕xa3 ♗xa3 37.♖xc6 ♖e8 38.♖xd5+ +−. **36.♘xe3 ♔c7 37.♖xg7+ ♘d7 38.♘xc4 ♖b8+ 39.♘b6 ♖e8 40.♗f3 ♖e1+ 41.♔a2 ♖a1+ 42.♔xa1 ♗e5 43.c3 ♗xg7 44.♗xc6 ♗xd4 45.cxd4 1-0** Three points for 35.♘xd5!!.

516: 27.♗h6+!! ♔xh6 27...♔f6 28.♕f8+ ♔e6 29.♘xe5 +−. **28.♕f8+ ♗g7** 28...♗g7 29.♕f4+ ♔h5 30.♕g5#; 28...♔h5 29.♕xe7 +−. **29.♘xe5 ♕e6 30.♕f4+ g5 31.hxg5+ ♖xg5 32.♘f7+ 1-0** One point for ♗h6+!!.

517: 28...♕xg2!! 29.♕xg2 29.♕h4 h5 −+. **29...♘d2+ 30.♔c1 ♗xg2 31.♖h4 ♗f3!? 32.♖g1 ♘xb3+ 33.axb3 a5 −+** And Black won later. Two points for calculating up to 29...♘d2+.

Test 8

518: 27...♘f3 And White resigned due to **28.gxf3 ♖d2 29.♔g1 ♕xh2+ 30.♔f1 ♕f2#**. One point for ♘f3.

519: 54.♖a8+ ♔d7 55.a6 And Black resigned due to the skewer **55...h4 56.a7 ♖a1 57.♖f8 ♖xa7 58.♖xf7++−**. Two points for seeing this winning method.

520: 26.♖xd7 ♕xd7 27.♘e2 ♕c7 27...♗e5 28.♕xd5+ ♕xd5 29.♗xd5+ ♔f8 30.♗xc4 ♖xb2 31.♘ed4+−. **28.♕xd5+ ♔f8 29.♘xf4 ♕xf4 30.♕d8+** 30.g3 ♕c7 31.♘c5+−. **30...♔f7 31.♕d7+ ♔g6?** 31...♔f8 32.♕d8+ ♔f7 33.♕d5+ ♔e7 34.g3 ♕c7 35.♕g8+−. **32.♕e8+ 1-0** Two points for calculating up to ♘e2 and one more for spotting 30.g3 or the win in the game.

521: 31.♘f8! ♘f6 31...f6 32.♘g6+−. **32.♘d7 ♗e6 33.♖xe6 1-0** Three points for ♘f8.

522: 29.♖xh7! ♔xh7 30.♕h5+ ♔g7 31.♖h1 ♖d1+!! 32.♖xd1 ♔g8? 32...♕h8!± was called for. **33.g6 ♕g7 34.gxf7+ ♔f8 35.♕h2 ♗f6 36.♕f2 ♗e6 37.♕a7 ♗xf7 38.♕xa4+−** And White won later. One point for calculating up to 31.♖h1 and two more for spotting Black's best defense 31...♖d1+!! 32.♖xd1 ♕h8!.

523: 39.♕a6! ♕c8 40.♖xb3! ♕c1+ 41.♔h2 ♖xb3 42.♕xe6+ 1-0 Two points for calculating up to 40.♖xb3.

524: 25...♗f5!! 26.♕f3 26.♖xh4 ♘xf2+ 27.♔c1 ♘xd3+ 28.♔c2 ♘f4+ 29.♔b3 ♗xb1 −+. **26...♕g5** 26...♘xf2+−+. **27.♖b2 ♘c3+ 28.♔e1** 28.♘xc3 ♗g4 29.♖g2 ♗xf3+−+. **28...♘xe2 29.♖xb4 ♘d4 0-1** Three points for 25...♗f5!!.

525: 26.♘e7+! White played 26.♖b4? which leads to Puzzle #3. **26...♔f8** 26...♖xe7? 27.♖d8+ ♖e8 28.♖xe8#. **27.♘g6+!! hxg6** 27...fxg6 28.fxe3+ ♔g8 29.♕xe8# (Atlas in CBM 95). **28.♖h4!! ♘xf1** 28...♖b8 29.♖h8+ ♔e7 30.♕e4+ ♔d7 31.♖xb8 ♕xb8 32.fxe3 +− (Atlas). **29.♖h8+ ♔e7 30.♖xe8+ ♔d6** 30...♔f6 31.♕f4#. **31.♕a6++−** (Atlas). Three points for calculating up to 28.♖h4!! and two more for seeing through to the end.

526: 19.♘xf7! ♖xf7 19...♗xb2 20.♖xf5 g6 21.♕h6 (21.♘d8+ +−) 21...gxf5 22.♘d8+ ♖f7 (22...♔h8 23.♕xf8#) 23.♗xf7++−; 19...♔xf7 20.♖xe5 +− (Huzman in CBM 84). **20.♕xf5!! g6** Huzman also gives: 20...♗xb2 21.♖d7 ♔h8 22.♕xf7 ♕e5 23.♖ad1 +−, 20...♖xf5 21.♖d8# and 20...♔h8 21.♗xe5 +−. **21.♗xe5 1-0** One point for 19.♘xf7, one more for 20.♕xf5!! and the last for 20...♔h8 21.♗xe5+−.

527: 37.♘e6! ♕d5? 37...♖xb8! 38.♘g5+ ♔h6 (38...♔g7 39.♕c3+ ♔h6

40.♘f7+=) 39.♘xe4 fxe4 40.♕xc4 ♖b1+ 41.♔g2 ♖bb2 42.♕g8=. **38.e4** 38.♘g5+! ♔g7 39.♕c3+ ♔h6 40.♖h8+ ♖h7 41.♖xh7#. **38...fxe4 39.♕f4 ♖xb8 1-0** Two points for 37.♘e6! and one more for 37...♖xb8!.

528: 30...♖h8! 30...♗xg2+ 31.♕xg2 ♖h8+ 32.♔g1 ♕xe1+ 33.♖xe1 e2+ 34.♔f2 ♖g8+ 35.♔h1 ♗xf2 36.♖xe2 is better for Black, but not as good as the game continuation. **31.♕xh8 ♗xg2+ 32.♔g1?!** 32.♖xg2 ♕xe1+ 33.♖g1 *(33.♔h2 ♗d6+ −+)* 33...♕xg1+ 34.♔xg1 e2+ 35.♔g2 e1♕ 36.♕h2 e5 37.♔h3 *(37.♔f3 e4+ −+)* 37...♗f2 −+. **32...♗d5+ 33.♔f1 ♗c4 0-1** Three points for 30.♖h8, One point for 30.♗xg2+.

529: 22.♗xf7+ Two points for 22.♕a2. **22...♔xf7 23.♖xc6 ♕xc6 24.♕xd8 ♕xa4** 24...♖xd8? 25.♘xe5+ ♔e6 26.♘xc6+−. **25.♕d6+−** And White won later. Three points for calculating up to 24.♕xd8.

530: 24.♘e6! d4 24...fxe6 25.♗xe6+ ♖f7 26.♖a8+−. A fatal pin. **25.♘xc7 f5 26.♗f3 ♕xc7 27.♖a7 ♕d8 28.♕xd4 ♘e5 29.♗d5+ ♗xd5 30.♕xd5+ ♘f7 31.♖xf7! ♖xf7 32.♖a8 1-0** Two points for spotting that ♘e6! wins.

531: One point for **10.♕xe6+ fxe6** 10...♕e7 11.♕xe7#. **11.♗g6# 1–0**

532: 16.♘xe6! fxe6 17.♕xe6+ And Black resigned due to **17...♕e7** 17...♗e7 18.♗g5+−. **18.♕xe7+ ♗xe7 19.♗g5+−** (Alvarez in CBM 95). Two points for calculating up to 19.♗g5+−.

533: 31...♕xg5?? A terrible time-trouble mistake. 31...♖f8! 32.hxg6 ♕a1+ 33.♔g2 ♖xf2+ 34.♕xf2 ♖xf2+ 35.♔xf2 ♕f6+ −+. **32.♕xg5 gxh5 33.♖a8 1-0** One point for 31...♖f8 and two more for 33...♖xf2+.

Test 9

534: 17.e5! 17.♘d5? ♘xd5 18.exd5 ♗xb2 19.f5 a3 20.♗h6 a2 21.fxg6 hxg6 22.♗xf8 ♖xf8 23.♖dd1 e5! is unconvincing. **17...dxe5** 17...♘h5 18.♘d5+−. **18.fxe5 ♕xe5 19.♗f4 ♕e6 20.♗xb8 ♖xb8 21.c7 ♖c8 22.♖d8+ ♗f8 23.♘d5 ♘xd5 24.♖xc8+− 1-0** One point for 17.e5.

535: 25.♗xf6! 25.♘g5? is met by 25...♕e7 26.♘xh7 ♕c5+ 27.♗c3 ♘h5! with unclear consequences as 28.gxh5?? ♕f5+ even loses. **25...♗xf6 26.♕xh7+ ♕xh7 27.♘xf6+ ♔h8 28.♖xh7+ ♖xh7 29.♘xh7 ♔xh7 30.g5 ♔g7 31.♔d3 ♔f7 32.♔e4 1-0** 32...♔e7 33.♔e5 a5 34.a4 b6 35.f4 ♔f7 36.♔d6+− Two points for spotting the won pawn ending.

536: 24.♖eh5? 24.♖g5 **A)** 24...g6? 25.♕h5 ♕c1+ 26.♔h2 ♕c7+ *(26...♖c8 27.♖xg6+ fxg6 28.♕xh7+ ♔f8 29.♕h8+ ♔e7 30.♖h7+ ♔d6 31.♕e5+ ♔c6 32.♕xe6#)* 27.♘e5 f6 28.♖xg6+ ♔h8 29.♕h6 ♕e7 30.♖hg4+−; **B)** 24...♕c1+

25.♔h2 ♕c7+ 26.♘e5 f6 27.♕xe6+ *(27. ♕h5? is refuted by 27...♗e4 –+ A nice unguarded guard!)* 27...♖f7 28.♕e8+ ♖f8 29.♕e6+=. **24...♕c1+ 25.♔h2 ♗xf3 26.♖xh7 ♕c7+ 27.♔g3 ♕xg3+ 28.♔xg3 f6 29.♖h8+ ♔f7 30.♖xf8+ ♔xf8 31.♖h8+ ♔f7 32.♔xf3 ♖xa2 –+** And Black won after some further moves. Four points for seeing the whole drawing line 24.♖g5.

537: 1...♗d3!! 2.♖xd3 ♕e7 3.e4 3.♕h6+ ♕h7+ check! **3...♕g7 4.♕h5+ ♔g8 5.♗d4 c5 6.♗xc5 ♖c8 7.f4 ♘a6!** 7...♖xc5? 8.♕e8+=. **8.♗f2 ♘b4+ 9.♔e2 ♖xa2 0-1** Four points for ♗d3!!.

538: 22.♕h6 1-0 22.♘h6+? ♔h8 *(22...gxh6? 23.♕xh6 f6 24.♘g5 ♘xg5 25.♖xe8 ♖xe8 26.♗xf6 ♘e6 27.♖e1 ♘gf8 28.f4 gives White an attack.)* 23.♘g5 ♘xd2 24.♖xe8 ♗e6 and Black defends himself.; 22.♘xg7? ♘xd2 23.♘xe8 ♘xf3+ 24.gxf3 ♘e5=. Two points for ♕h6.

539: 22.♘xf7! +– ♔xf7 23.dxe6+ dxe6 24.♖c7+ ♔g8 25.♕g4 ♗g6 26.♕xe6+ ♔h8 26...♔h7 27.♖xg7+ ♔xg7 28.♕f6+ ♔h7 29.♕e7++–. **27.♖c8 ♘d7 28.♖xa8 ♘f8 29.♖xd8 1-0** Three points for seeing up to ♕g4.

540: 14.d5! exd5 14...♘b8 15.♘g5 h6 16.♘h7 ♖d8 17.♘xf6+ ♗xf6 18.♕h7+ ♔f8 19.♗f4 ♗xc3 20.bxc3 ♗xd5 21.♕h8+ ♔e7 22.♕xg7 ♘c6 23.♗g6 ♕e8 24.♗xh6+–. **15.♗g5 g6 16.♖xe7! ♕xe7** 16...♘xe7 17.♗xf6+–. **17.♘xd5 ♘xd5 18.♗xe7 ♘cxe7 19.♗b3 ♖ad8 20.♖d1 ♖d6 21.♘g5 h6 22.♘e4 ♖dd8 23.♕d4 ♖fe8 24.f3 ♗c6 25.♕e5 ♘f5 26.♘f6+ ♘xf6 27.♖xd8 1-0** Three points for spotting ♖xe7.

541: 1...♗xg3 2.♕xe8+ ♔h7!! 0-1 One point for ♗xg3 and two for ♔h7!!.

542: 26...♖xc4!! 27.♖xb8 27.♕d1 ♖b4 28.♖xb4 ♕xb4 29.♗c3 ♕a3 –+. **27...♖c1+ 28.♗f1 ♖xb8** "with a second rook arriving on b1, and his major pieces offside, White is lost. Of course, the finish still requires some calculation." (McShane in CBM 89). **29.♗c3 ♖bb1 30.♕d3 a3! 31.♕xa6 a2 32.g4 ♖xf1+! 33.♕xf1 ♘e4 34.♗a1 ♘d2 0-1** Five points for calculating up to 28...♖xb8 –+.

543: 26.♖xd8+ ♖xd8 27.♗xg7+! ♔h7 27...♘xg7 28.♕h4 f6 29.♕xh6+ ♔g8 30.♕h8+ ♔f7 31.♕xd8+–; 27...♔g8 28.♕c7+–. **28.♕h4 ♖d2?!** 28...♖d5!? 29.♗d4 ♕g5± is more tenacious. **29.♗xh6! ♔xh6 30.g4 ♕g5 31.♕xh5+** 31.♕e1+–. **31...♕xh5 32.♖xh5+ ♔g7 33.a4 ♖d3 34.c6!? bxc6 35.♖a5 ♖xf3 36.♖xa7 e5 37.a5 ♔f6 38.a6 e4 39.♖a8 ♖d3 40.♖e8 ♖d5 41.b4 ♖d7 42.c4 1-0** Three points for spotting ♗xg7+.

544: 21.♕xf8+! 21.♘f7+? ♖xf7 22.♕xf7 ♖f8 23.♕xf8+ ♗xf8 24.♖xf8+ ♔g7 =/ unclear. **21...♖xf8 22.♖xf8+ ♔h7 23.♘f7** And Black's queen can't escape the mighty knight. **23...♕d7 24.♘g5+ ♔h6 25.♘f7+ ♔h7 26.♘g5+ ♔h6 27.♖h8+!! ♗xh8 28.♘e6+** And Black resigned due to **28...g5 29.♗xg5+ ♔g6**

30.♘f8++−. One point for ♕xf8+ and two more for spotting ♖h8+!.

545: 16.♘xf7!! ♖xf7 17.♖xe6+ 1-0, e.g. 17...♗e7 18.♖xe7+ 18.♖ae1 ♖d7 19.♖f6+−. **18...♔xe7 19.♖e1+ ♔f8 20.♕xh6+ ♔g8** 20...♔g7 21.♕f6+−. **21.♕g5++−** Three points for calculating up to 18.♖xe7+ or 18.♖ae1.

546: 17...♕xf4!! 18.♖xg7+ 18.exf4 ♘d4+ 19.♔e1 ♘xb3 20.♖xg7+ ♔xg7−+. **18...♔h8 19.♖cg1?** 19.exf4 ♘d4+ 20.♔e1 ♘xb3 21.♖xh7+ ♔xh7 22.♗xb3 ♖g8∓. **19...♖xd2+?!** 19...♕xe4!−+. **20.♔xd2 ♕f2+ 21.♔c1 ♕xe3+ 22.♕xe3 ♗xe3+ 23.♔c2 ♗xg1 24.♖xg1 ♖g8∓** And Black won later. One point for spotting 17...♕xf4!! 18.♖xg7+ and king moves to f8 or h8.

547: Two points for **28.♗xf5 1–0**

548: 27...♘xf3! 28.♘xd5 28.♕xf3 ♕xc3 29.♕xf5? ♖f6−+. **28...cxd5 29.♕xf3 ♗g4! 30.♕f4 ♕h4+ 31.♔g1 ♖f6 32.♕g3 ♕xg3+ 0-1** Two points for 27...♘xf3!.

549: 14.♗f4! ♕xf4 14...e5? 15.♗xe5 ♕xe5 16.♗g6#. **15.♗g6+ ♔f7 16.♗xf7++−** And White won after some further moves. One point for 14.♗f4!.

Test 10

550: 32...♖xg2+! 33.♔xg2 ♘e3+ 34.♔f2 ♘xd5 35.♗xe5 ♔f8 36.♗d6+ ♔e8 37.♔e2 And now Black should have chosen **37...♘e7** with the idea of ♘f5-g7, which gives Black good winning chances. One point for ♖xg2+!.

551: 27...♗h3!! A beautiful decoy to deflect White's queen. **28.♘xf8** 28.♕xh3 ♖xf7 29.♕e6 ♖e7 30.♕xe7 ♘xe7 31.♖xe7 ♕d8−+ (Dautov in CBM 95). **28...♗xe6 29.♘xg6+ hxg6 30.♖xe6 ♕xc3 31.♖e4** 31.♗xg6 ♕xd4+ 32.♔f1 ♕f4+ 33.♔e1 ♕h4+! 34.♔d2 ♕b4+−+ (Dautov). **31...♕c1+ 32.♔f2 ♕d2+ 0-1** Two points for ♗h3!!.

552: 28.♖xe8+ 28.bxc3? ♖xe1 29.♖xe1 ♖e6!−+ (Kapengut). **28...♕xe8** 28...♗xe8 29.bxc3 ♖g5 30.♕xf7!? (30.♕xh3±) 30...♗xf7 31.f4 ♖h5 32.c4+− (Stohl in CBM 89). **29.♘xd7 ♗xb2?** 29...♗g7 30.♗xf5 ♕e2 31.♕xh3 ♖h6 32.♕g2+− (Stohl). **30.♘f8!** Dreev exploits the pin nicely! **30...♕xf8 31.♕xg6 c4 32.♗xc4 ♕f6 33.♕xf6+ ♘xf6 34.♖b1+−** And White won soon. One point for ♘xd7 and two more for seeing the endgame after 28...♗xe8. If you wanted to play 30.♕xh3 instead, you get only one point.

553: 24.♗xg7 ♖xg7 24...♔xg7 25.♕h6+ ♔f7 26.♘f4 ♕xd4 27.♘xg6 ♘e6 28.♕h5+−. **25.♖e8! ♕xd5** 25...♕xe8 26.♘xf6++−. **26.♖h8+! ♔xh8 27.♖xf8+ ♕g8 28.♕h6+ ♖h7 29.♖xg8+ ♔xg8 30.♕xg6+ ♔h8 31.♕xf6++−** And White won later. Three points for calculating up to 26.♖h8+.

554: 9.♗xb5+! ♘c6? 9...♗c6 10.♗xc6+ ♘xc6 11.♕d3 ♘d6 12.♘bd2±; 9...♕xb5? 10.♕d8#. **10.♘e5** And Black gave up the ghost, e.g. **10...♕c7 11.♕a4 ♖c8 12.♕xe4 +−** One point for ♗xb5+.

555: 20...♖xe3!! 21.b3 21.♗c3 g6 22.♗xd3 cxd3 23.♕b3 ♖d8∓ (Ribli in CBM 84); 21.♗xe3 ♕xg3 22.♗xd3 *(22.fxg3? ♘xe3+ −+)* 22...♕xh3+ 23.♔g1 cxd3 24.♕xd3 ♖c6 25.♕xd5 ♖g6+ 26.♗g5 h6−+. **21...♘xf2! 22.♗e1** 22.♔xf2 ♖xe2+ 23.♔xe2 ♕xg3−+ (Ribli). **22...♕xg3 23.♖xd5 ♕xh3+ 24.♔xf2 ♖ce8 0-1** Two points for ♖xe3!!, and two more if you calculated the line 21.♗xe3 to the end 26...h6−+.

556: 23.♖xd5!! ♕xa2 23...♕xe1 24.♖xd7! ♕xd1+ 25.♖xd1+−; 23...♖xd5 24.♕xa5 ♖xd1+ 25.♔b2 ♗xc4 26.bxc4+− (Atlas in CBM 95). **24.♖xd7 ♕a1+ 25.♔d2 ♖xd7+ 26.♗d3 ♕a5+ 27.♔e2 1-0** Three points for 23.♖xd5!!.

557: 18...♗f5! 19.♕h6 ♖g6! 20.♕xf4 ♖xg2+! 21.♔xg2 ♕xe2+ 22.♔g3 ♕xh5 23.♗xd4 ♘bc6 24.♖ae1 ♘xd4 25.♕xd4 ♕h3+ 26.♔f2 ♕xh2+ 0-1 Two points for calculating up to 19...♖g6 and one more for spotting ♖xg2+!.

558: 17...♘xf2!! "Vouldis plays a beautiful combination based on complete domination over the dark squares." (Ftacnik in CBM 91). 17...♖xf2 18.♗xf2 ♘xf2 19.♕xf2 ♘g4 transposes. **18.♗xf2 ♖xf2 19.♕xf2 ♘g4 20.♕xd4 ♗xd4+ 21.♔h1 ♘f2+ 22.♔g1 ♘xd3+ 23.♔h1 ♘f2+ 24.♔g1 ♘xe4+ 25.♔h1 ♘f2+ 26.♔g1 ♘d3+ 27.♔h1 ♖xe1 −+** And Black won later. Two points for calculating up to 21...♘f2+.

559: 27.♖xf7!! 27.♕xg8+? ♔xg8 28.♖d8+ *(28.♖xf7 e6 29.♖dd7 ♗xf3 30.♖fe7 ♔f8 31.♖f7+=)* 28...♔g7 29.♖xf7+ ♔h6 30.♘h4 ♕c5+ 31.♔g3 ♕g5 32.♖xh7+ ♔xh7 33.♖g8=; 27.♕e5? e3+! 28.♕xe3 ♕xf6∓. **27...♖xg5 28.♘xg5 1-0** 28.♖d8+? ♖g8 29.♖xg8+ ♔xg8−+ as the rook has no strong discovered check. Three points for 27.♖xf7!! ♖xg5 28.♘xg5+−.

560: 30.♘h6+! ♔h7? 30...gxh6 31.♕g6+ ♔f8 32.♕xh6+ ♔f7 33.♕xd2+−. There is a saying that diagonal queen retreats are more often overlooked than any other moves. So I hope that you did not miss this. **31.♘f5+ 1-0** Followed by the deadly fork on e7. Two points for calculating up to 33.♕xd2.

561: 23.♖b3+ ♔a8 23...♖b6 24.♘c6+ ♖cxc6 25.♕xc6+−. **24.♖xc5** And Black resigned due to **24...♖xc5 25.♗b7+ ♔xb7 26.♖xb7 ♔xb7 27.♕b4++−.** One point for calculating up to ♕b4+.

562: 23...♖xe3+!! 24.♕xe3 24.♔xe3? ♖e8+ 25.♔f4? g5+ 26.♔f5 ♕xf3#. **24...♕xg4+ 25.♔f1 ♕xd7 26.♕xa7 ♕b5+ 27.♔g2 0-1** One point for ♖xe3+!!.

563: 29.♖f1‼ One of those mysterious rook moves? In the game 29.♖d1? was played, which should have been met by 29...♘c4! and Black wins due to White's weak back rank. Of course not 29.♗xd6? ♖xd6 30.♕xd6 ♖c1+! 31.♖xc1 ♕xd6∓; 29.♖e1 ♖e8 30.♖f1 ♖xe5 31.♕xe5 ♕b6 32.♘b3 is slightly better for White, but of course not as good as the main line. **29...♖cd7** 29...♕b6 30.♘c4‼ +− (Mikhalevski in CBM 92). **30.♘c6 +−** Two points for 29.♖e1 ♖e8 30.♖f1 or two points for 29.♖f1‼, and two more for spotting 30.♘c4‼ after 29...♕b6.

564: 38.♗xg7+! 38.♕xf8 ♖xf8 39.♗xg7+ ♘xg7 40.♖d8 ♔g8 41.b8♕ ♖e8 42.♖1d6 +− wins as well. **38...♘xg7** 38...♖xg7 39.♕xf8+ ♘xf8 40.b8♕ +−. **39.♕xf8! ♖xf8 40.♖d8 ♘e6 41.♖xf8+ ♘xf8 42.b8♕ ♔g7 43.♕a7+ ♔h6** 43...♔g6 44.♕e7 ♘e6 45.♖d6 +−. **44.♕f7 1-0** Four points for calculating the 38.♕xf8 line up to 40.♖d8 +− or for calculating the main line up to 40.♖d8.

565: 42.♗c5? 42.♘e4! ♖e6 43.♘f6+ ♖xf6 *(43...♗xf6 44.♖xf8+ ♔d7 45.gxf6 ♖xe3 46.♖xf7+ ♔e6 47.♕e7+ +−)* 44.♕b8+ ♔d7 *(44...♗d8 45.♖xf8+ ♔xf8 46.♕xd8+ +−)* 45.gxf6 ♗xf6 46.♖h2 +−; 42.♘g4! works as well. **42...♖d2! 43.♕b8+** 43.♕a4+ ♔d8 44.♗b6+ ♔c8 45.♕xa6+ ♔d7 46.♕a4+ ♔e6 and Black is still in the game. **43...♖d8 44.♖xf8+ ♗xf8 45.♕e5+ ♔d7 46.♕d5+ ♔e8 47.♕c6+ ♖d7 48.♘e4 ♗e7 49.♕c8+ ♖d8 50.♕c6+ ♖d7 51.♕c8+ ♖d8 52.♕c6+ ♖d7 53.♕c8+ ½–½** Five points for calculating up to ♖h2! +−. You can start with ♘e4 or ♘g4.

Score Chart

You have two hours for each of the ten tests. Solve them from the diagrams and write your solutions on a sheet of paper. To get a more precise value, I advise you to take your average over all ten tests. Of course the values (your "Tactical Elo") must be taken with a large grain of salt.

0-1: Study the first chapters again!
2-3: Below 1000
4-5: 1000
6-7: 1100
8-9: 1200
10-11: 1300
12-13: 1400
14-15: 1500
16-17: 1600
18-19: 1700
20-21: 1800
22-23: 1900
24-25: 2000
26-27: 2100
28-29: 2200
30-31: 2300
32-33: 2400
34-35: 2500
36-37: 2600
38-39: 2700
40-42: Over 2700 Challenge the World Champion!

Sources/Additional Material

De la Maza, Michael, *Rapid Chess Improvement,* Everyman 2002

Dvoretsky, Mark, *Secrets of Chess Tactics,* Batsford 1993

Emms, John, *The Ultimate Chess Puzzle Book*, Gambit 2000 (with 1,000 puzzles!)

LeMoir, David, *How to Become a Deadly Chess Tactician*, Gambit 2002

Levitt, Jonathan & Friedgood, David, *Secrets of Spectacular Chess*, Batsford 1997

Matanovic, Aleksandar, *Encyclopedia of Chess Middlegames*, Editor in Chief, Sahovski Informator Beograd 1980

Meyer,Claus Dieter & Müller, Karsten, *The Magic of Chess Tactics*, Russell Enterprises 2003

Neistadt, Jakow, *Zauberwelt der Kombination*, Sportverlag 1987

Plaskett, James, *Can You Be a Tactical Chess Genius?*, Everyman 2002

Rowson, Jonathan, *The Seven Deadly Chess Sins*, Gambit 2001

Teschner, Rudolf, *Sie sind am Zug*, Wilhelm Goldmann Verlag 1981

ChessBase Magazine, ChessBase GmbH

ChessCafe.com, especially the columns by Richard Forster and Tim Krabbé and my Endgame Corner column.

Chess Today, daily internet chess newspaper edited by Alexander Baburin

MEGABASE 2003, ChessBase GmbH 2002

MEGACorr 3, compiled by Tim Harding, Chess Mail 2003

New in Chess 5/2000, Interchess B.V. 2000

New in Chess Yearbook 68, Interchess B.V. 2003

The Week in Chess, weekly internet chess newspaper edited by Mark Crowther

If you find the puzzles in *The ChessCafe Puzzle Book* too difficult, I suggest that you start with *How to Beat your Dad at Chess* by Murray Chandler, Gambit 1998, and then come back to it.

If you have studied this book and are in need of a fresh and more difficult challenge, you can try *John Nunn's Chess Puzzle Book* by John Nunn, Gambit 1999 or *The Most Amazing Moves of All Time* by John Emms, Gambit 2000. You can of course also study a game collection of Mikhail Tal or Rashid Nezhmetdinov to improve your tactical skills.